Edward Weston Forms of Passion

Harry N. Abrams, Inc., Publishers

Edward Weston Forms of Passion

Edited by Gilles Mora

With essays by

Gilles Mora

Terence Pitts

Trudy Wilner Stack

Theodore E. Stebbins, Jr.

Alan Trachtenberg

Design and sequence by

John and Dorothy Hill

Library of Congress Cataloging-in-Publication Data

Edward Weston: forms of passion / edited by Gilles Mora:
designed by John and Dorothy Hill: with essays by Gilles Mora... [et al.].
p. cm.
Includes bibliographical references and index.
ISBN 0-8109-3979-7
1. Weston, Edward. 1886–1958. I. Weston, Edward. 1886–1958.
II. Mora, Gilles. 1945– . III. Hill, John T.
TR140.W45E376 1995
770'.92—dc20 95-10640

Printed and bound in Italy

Contents

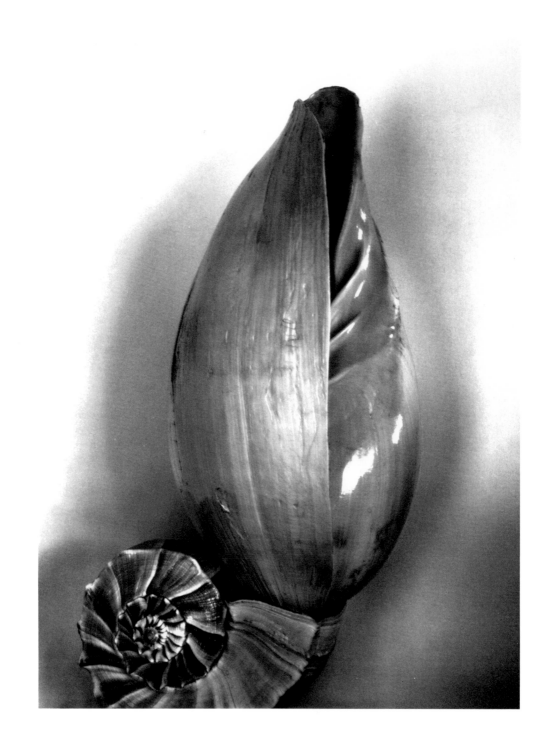

Shell, 1927

Introduction: Weston the Magnificent Gilles Mora

"I see no reason for recording the obvious."
(*Daybooks*, II, 252)

Throughout this book Edward Weston's own titles appear in italics.
Later descriptive captions by others are set in roman.

Portrait of My Father, 1917, Lane Collection

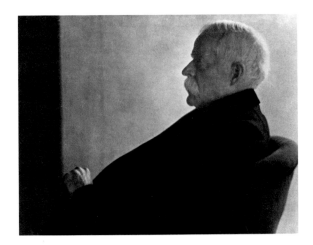

Most Weston specialists have commented on one of the few original documents to survive from his early years: a letter, not from son to father *á la* Kafka, but from father to son, when the elder Weston sent him his first camera in the summer of 1902. Beaumont Newhall, among others, describes it as "remarkably prophetic," a harbinger of the aesthetic Edward was to embrace in the years ahead. But one could interpret it differently. His father encouraged him to "take only *snaps*," whereupon Edward went on to do just the opposite.[1] He made prolonged exposures and, with few exceptions, avoided fortuitous or circumstantial subject matter. Furthermore, his father's admonition not to "waste any pictures on things of no interest" has more than a whiff of the middle-class American pragmatism that was to rankle the artist his whole life long.[2] His father's thoughts on the subject were entirely geared to practicality, not art. It never occurred to this physician, expert archer, and fresh-air fiend that photography could be anything as consummately spendthrift—morally, not monetarily—as an art. It took Edward Weston a while to acknowledge that "spending" energy and creativity was unavoidable.

Weston photographed in his spare time until 1907, when his plans to marry Flora Chandler inspired him to enroll in the Illinois College of Photography in Chicago. He became a professional photographer soon thereafter, and was never to give up commercial portraiture entirely (although after meeting Alfred Stieglitz in 1922 he was less inclined, at least intellectually, to look at what he did as just another way to earn a living). Not until he went to Mexico in 1923 did he begin gradually to accept the photographic medium on purely aesthetic terms, and his commitment to it lasted until illness ended his active career in 1948.

The belief that a particular artist anticipates the art of his or her time is as misguided as it is widespread. Retrospective assessments of this sort are apt to skew our perspective, overstate individual achievement, and credit it with a prescience it does not possess (or at least claim to possess). Art historians—historians in general—tend to sum up a period with a few names and works and argue strenuously that all around them followed irresistibly in their wake. Such was not the case with Edward Weston. He was in step with his medium's aesthetic evolution; at no point did he ever precede or herald it. Between 1906, the year he broke into photography, and 1948, when stricken with Parkinson's disease he made his last photograph, Weston was never, strictly speaking, an innovator in the mold of Alfred Stieglitz, someone whose compelling work alone is enough to jolt his contemporaries out of their artistic ruts. Weston started out in pictorial photography and moved toward pure photography in stages. He did not single-handedly pioneer either of them. Instead, and perhaps more important, he helped bring one to a close and proved instrumental in validating the other.

Weston's photographic career is customarily split into two markedly different periods, and specific dates and photographs seem to bear this out. Until the early 1920s, he enjoyed immediate and lasting success as a professional pictorialist photographer. During the Mexican period that began in 1923, he started advocating what is commonly known as "pure" photography. This simplified breakdown

1.
See Ben Maddow, *Edward Weston: His Life* (New York: Aperture, 1989), 57.

2.
Ibid.

3.
Quoted in Maddow, 53.

4.
Nancy Newhall, ed., *The Daybooks of Edward Weston: I. California; II. Mexico.* (New York: Aperture, 1990), II, 38.

Edward Weston as archer, 1920, CCP

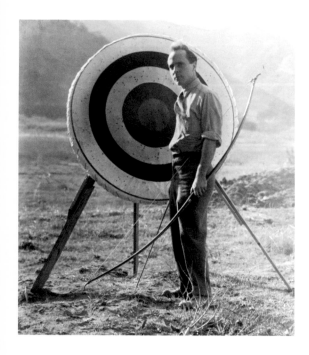

has its advantages. For one thing, it identifies Weston (along with, and in the wake of, Stieglitz) as part of photography's victorious struggle for acceptance on the basis of its inherent attributes. Unlike other photographers actively involved in that struggle (such as Paul Strand and Walker Evans early in their careers), both Stieglitz and Weston underwent an awakening and evolution in keeping with with the progressive ideology of their time. An art form, they realized, could have no relevant meaning unless the artist respected his medium's unique characteristics, parameters, and limitations. Thus, photography had nothing to gain by imitating painting.

Stieglitz, and then Weston, proceeded to shape an aesthetic predicated on the same kind of breach and ensuing struggle that was to shape New Photography in 1920s Germany. The shift in both cases was momentous and persuasive precisely because the artists had been on friendly terms with the enemy. Stieglitz's and Weston's impact on the emerging modernist aesthetic was more strongly felt because they had repudiated pictorial photography for it.

A different, equally valid approach to Weston's work is based on the assumption that modern American photography was not a relatively homogeneous monolith, but consisted of at least two branches. One evolved without really losing touch with painting as its model and touchstone, but unlike pictorialism did not mimic painting to win artistic legitimacy. Rather, the relationship of the two arts was defined within the wider framework of the problematics of form, yet exponents were loath to openly acknowledge this link, especially to modern painting.

The other branch severed all ties to painting and set photography on the path of documentation, the recording of the factual world. Weston, Stieglitz, and Paul Strand are readily associated with the first. The second, although its roots reach back to Atget and certain nineteenth-century primitives, did not really burgeon until Walker Evans. Weston focused primarily on form; Evans, on the ambivalence between the real world and its representation in photographs. Pure art? Pure document? The main thing is that each was committed to probing his respective approach and pushing it to its limits. Photography continues to feel the repercussions of what they both did to this day.

Yet, there was little in Edward Weston's background that augured a life in art. Born in Illinois in 1884, he was the son of a physician whose own background was far more attuned to science than art. Edward's mother died when he was five; his sister May became the protective female in his life. Weston's aversion to classroom education persisted through childhood and adolescence. He attended high school grudgingly, and later warned his son Brett that school, "is a good place to train and mold the minds of those who are to be the slaves of the world."[3]

Weston's lifelong love of sports, physical exercise, and the great outdoors began at an early age. He trained for track events, took boxing lessons, excelled in archery, took cold baths, and periodically went on quasi-vegetarian diets (a regimen he claimed purged him body and soul: "Why all this intestinal purity? To clear my mind for my work!"[4]). He was a lifelong nudist and sun-worshipper, believed in astrology, rejected traditional medicine, and disputed the virtues of vaccination.[5]

The traditional European (read: Romantic) view of the artist was that his body

5.
In 1924, Weston nearly panicked when he found out he needed a vaccination certificate for his exit visa from Mexico and entry visa into the United States. (See Maddow, 16.)

6.
Daybooks, II, 164. Weston and others described the many parties he attended while in Mexico, during which he would dance, dress up, and change clothes with Tina Modotti.

7.
See especially *Daybooks*, II, 243.

8.
See Weston Naef's excellent study, "Edward Weston: The Home Spirit and Beyond," in *Edward Weston in Los Angeles*. The J. Paul Getty Museum, Malibu, 1986.

Edward and Flora swimming at the creek, 1909, CCP

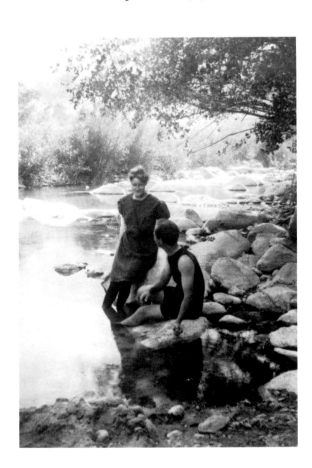

was the evanescent shell of pure genius; artistic creation was the fruit of disembodied spirituality. Not according to Weston. From adolescence on, he regarded the human body as a functional imperative, a fact of life, and believed that its smooth running order conditions and determines everything we do. The body, he thought, is also the sound box of the senses. His Mexico journal is full of comments about smells and flavors, about the tensing and unwinding of a body continually susceptible to changes in the weather, in the throes of passion or revulsion, energized or subdued, actuated by the slightest stimulus. To say that Weston loved to dance would be an understatement. He positively reveled in it every chance he got, especially if it meant he could dress himself up (often as a woman, in frank displays of gender-switching).[6] All newcomers to Weston's work must bear in mind that the body was the motive as well as the motif of his work, its urgent rhythms and attendant transformations providing a springboard.

Weston's belief system was somewhat ambivalent, which is never more striking than when we hear him voicing his mistrust, if not repudiation, of theories of evolution, the achievements of democracy, city life, the masses, and modern-day progress.[7] Even in his youth Weston had a maverick streak in him, a self-contradictory urge to be anywhere but in the mainstream. It drove him to become an artist and seek out a wildly uninhibited social life (especially during his actively pictorialist phase from 1906 to 1920) and at the same time yearn to stand back and withdraw from the world, which he ultimately did in 1929 by settling in Carmel, on the Pacific coast. In that respect he was the opposite of the active promoter and propagandist Stieglitz, the photographer he first emulated.

From the moment he first handled a camera in 1902, Weston demonstrated a commitment to the workmanlike approach that had been the hallmark of nineteenth-century photography. First he became a serious amateur and learned his craft; only then did he subscribe to pictorialism, the dominant aesthetic of the day. The fact that a good deal about Weston's early photographic career remains hazy gives that much more weight to those aspects of his life story that elucidate his future artistic development.[8]

After a dead-end stint working alongside his uncle in a Chicago department store, Weston went to live with his sister May in Tropico, now Glendale, California. There he fell in love with Flora Chandler, who came from a wealthy family. Soon, Flora and he were engaged to be married, and Weston realized that he would soon need steady income for his future family—incentive enough to want to turn his hobby into a livelihood. Many other amateur photographers, likewise drawn to this potentially lucrative field, were making the same transition to professional status.

Weston returned to his home state of Illinois and enrolled in a trade school. He gained hands-on, technical experience, but no vision to go with it; that was not on his agenda at the time. He was trained in studio portraiture: long exposures, standard lighting techniques, negative and print retouching, the time-honored concept of the portrait as an emanation of the subject's inner self. The imprint this rigorous training left on him was not so quick to fade. Weston was to struggle against the roots of his art his whole life long, but they held fast just the same.

Clearly, the early stages of Weston's career were no different from those of other commercial photographers. But one thing stands out. The tenacious training

Alfred Kreymborg–Poet, 1920, Lane Collection

9.
"Portraits so nauseating that I have covered them over when signing my name . . . I am prostituting my spiritual self every week in the year." (*Daybooks,* II, 227).

10.
Especially *American Photography* and later *Camera Craft* magazine. See Peter C. Bunnell, ed., *Edward Weston on Photography* (Salt Lake City: Peregrine Smith, 1983), an indispensable anthology of Weston's published writings.

11.
Naef, 14.

12.
A portrait of his frend Johan Hagemeyer as "Jean-Christophe" dates from that year.

that ensnared him in commercial portrait photography until the 1930s—a spiritual prostitution, he once lamented[9]—also implanted in him a craftsman's turn of mind he never lost through all the stands he took on photography and through all the articles he wrote for photographic publications.[10] To Weston, photography was more than images. It was the *making* of images, the creation of a finished product by means of a technical protocol that must be strictly adhered to every step of the way. Procedures, processes, and tricks of the trade are a recurrent theme even in Weston's minor statements about his art.

In late 1908, Weston returned to California, married Flora, and found employment in Los Angeles portrait studios until 1911. In 1912 he opened his own studio in the Los Angeles suburb of Tropico and settled into commercial portraiture. Even at that early stage, Weston was more curious about his medium than many of his fellow photographers. He kept a sharp eye on what was happening in the wider world of photography, a world that the pages of Alfred Stieglitz's *Camera Work* opened up to him in 1908.[11]

Stieglitz imparted to his quarterly, the organ of the Photo-Secession movement, the same zeal and self-confidence that he infused into his crusade to make photography a genuinely creative art form. A quasi-official movement since the late nineteenth century, pictorial photography gave photographers an illusory means to palliate what some considered an overly mechanical medium. All too often it amounted to nothing more than handwork or manipulation that added "artistic" touches to photographs in a calculated effort to mimic academic painting; Stieglitz and Clarence White were exceptions to the rule. Stieglitz's overriding concern was to provide photographers with compelling aesthetic models (such as symbolism, which was then enjoying widespread popularity in Europe). The aim of *Camera Work*'s founder was to validate photography, not by plagiarizing painting, but by fostering its aesthetic development in ways that would put it on a par with painting. One approach to that goal was through philosophy: Stieglitz was conversant with Swedenborgian theosophy and helped win Weston over to its doctrine of correspondences. Another was through music and literature: in 1920 Weston became intensely interested in Jean-Christophe, the fictitious German musician in Romain Rolland's eponymous novel.[12]

Although Stieglitz broke away from the Photo-Secession and the musty cobwebs of the pictorial tradition in 1917, his objective remained the same. His brand of photography laid the groundwork for a modernist vision focused on cityscapes and technical progress. His increasingly reductive approach to subject matter was in step with the modern artwork he routinely hung in his newly opened New York gallery, "291." Paul Strand's *The Fence, 1917,* Stieglitz's own *Dancing Trees, 1921,* and the sharply angled interiors of Charles Sheeler's *Doylestown House* series, 1917, were photography's response to currents in modern European painting that Edward Steichen (painter turned photographer) had helped to introduce to the United States. The work of Cézanne, Matisse, Picasso, and Kandinsky (but also Rodin and Brancusi) was inspiration to this activity. From this perspective, the branch of photography that came to be known as "pure" maintained an underlying link with painting.

Small wonder, then, that when Weston first awakened to the aesthetic issues surrounding photography, it was *Camera Work* that gave him food for thought

13.
"The pictures I am showing today, with a few exceptions . . . are straight photographs without handwork, shading or manipulations of any kind." ("Photography as a Means of Artistic Expression, 1916," in *Edward Weston on Photography*, 19.)

14.
Weston himself confirmed this when asked about his repudiation of pictorialism (letter to Nancy Newhall, 1944): "The whole soft-focus period in retrospect seems like a staged act; I even dressed to suit the part: windsor tie, green velvet jacket—see, I was an artist." (Edward Weston Archive, Center for Creative Photography, University of Arizona, Tucson).

15.
In "Photography as a Means of Artistic Expression, a lecture delivered before the College Women's Club, Los Angeles, 18 October 1916" (Edward Weston Archive, CCP, Tucson). Stieglitz later accused Weston of being "ashamed of the tradition of photography" (*Daybooks*, II, 237), and in fact Weston never mentioned a photographer by name as an influence: "I feel that I have been more deeply moved by music, literature, sculpture, painting than I have by photography" and "I almost feel [Bach] has been my greatest 'influence'." (*Daybooks*, II, 234).

16.
Ibid.

17.
"I was suddenly thrown into contact with a sophisticated group—actually they were drawn to me through my photography . . . They were well-read, worldly-wise, clever in conversation . . . they drank, smoked, had affairs—I had practically no experience with drinking and smoking, never a mistress before marriage, only adventures with two or three whores. I was dazzled—this was a new world—these people had something I wanted . . . I had to pretend much, to become one of them, parrot their thoughts, ape their mannerisms." (*Daybooks*, II, 209).

and exposed him to a wide range of viable stylistic options. He was drawn to the prevailing pictorialist approach, particularly the work of California photographer Anne Brigman (who later became a friend and, in 1921, one of his models). Until the early 1920s Weston pursued a purposefully symbolist aesthetic in a misty, Whistlerian vein that concentrated on faces and bodies but, unlike Brigman's, left out natural contexts.

Weston's work was widely exhibited and well received. He sent it to photographic salons and won numerous medals and prizes. What's more, the prints he sent were unmanipulated. Following Stieglitz's lead, Weston emphatically pointed out back in 1916 that his photographs were "straight," that is, completely free from embellishing handwork on negatives or prints.[13] Actually, Weston's creditable involvement in pictorialism had more to do with a social game plan than with commitment to an artistic credo: he was out to prove that he belonged to the world of art and artists.[14]

His many published articles in photographic magazines, the first of which appeared in 1911, reveal a gradual shift from strictly craft-related concerns to an awareness of aesthetic issues and a willingness to take a stand on them. Photography, he contended, was an unexplored medium; he was "bound by no traditions."[15] Throughout his life, Weston struck the heroic, yet faintly pathetic attitude of a self-taught man bent on securing a niche in the rarefied realm of artistic creation. There was never an inch of backsliding from the moment he delivered a lecture entitled "Photography as a Means of Artistic Expression"[16] in 1916. He was already laying the foundation of what would become his unswerving philosophy of art in general and photography in particular: technique is all-important;

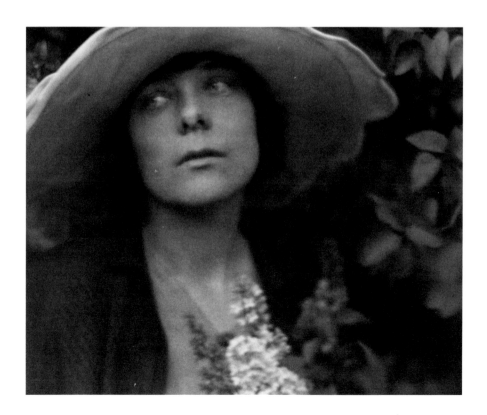

Margrethe, with phlox, 1921, CCP

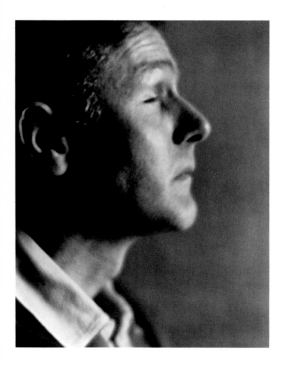

Blind (Ramiel McGehee), 1922, CCP

18.
A documented connection has yet to be established between Weston and Powys. However, the writer was approached by the photographer in 1920, and his book, *Defence of Sexuality* (1930), must have influenced Weston even though (and this could be a telling omission) he never alluded to the man or the book. But its blend of sensuality and mysticism, its message that one should at once reflect upon and revel in life, is very much in tune with Weston's philosophy of art.

19.
For a description of the Los Angeles art scene, see "Encouraging the Artistic Impulse: The Second Generation, 1890-1920," in *101 Years of California Photography, 1849–1950*. Santa Barbara Museum of Arts, 1992.

20.
See especially Margaret Hooks, *Tina Modotti: Photographer and Revolutionary* (London: Pandora, 1993), in particular, the chapters on Weston's and Modotti's circle of friends (pp. 32–62).

21.
Many of these self-portraits were in Flora Weston's family albums. They are now in the J. Paul Getty Museum, Malibu.

photography demands total commitment; it must stand on its own, without manual interference; it must be based on the recognition of its own "limitations and possibilities."

Weston wrote this lecture in the flush of excitement he must have experienced as he discovered Stieglitz's work and thought. Moreover, he was still reeling under the impact of what he had seen at the 1915 Panama-Pacific International Exposition in San Francisco, which included an impressive sampling of avant-garde artwork from Europe. At this juncture, the photographer was also being gradually drawn into subcultures for which neither his upbringing nor his professional training had prepared him.[17] Some of his relationships overlapped with intellectual circles that had begun to flourish in and around Los Angeles between 1910 and 1920. They included photographers such as Anne Brigman, Johan Hagemeyer, Imogen Cunningham, and his apprentice and associate Margrethe Mather; dancers, including his close friend and confidant, Ramiel McGehee, a homosexual; the sculptor Peter Krasnow; and writers. Among the latter were the Welshman John Cowper Powys, who circulated in the California literary scene in 1920,[18] and the influential critic Sadakichi Hartmann. (Hartmann formed a bridge between the West Coast and the spirit of *Camera Work*, which occasionally published articles by him when he lived in New York.) The cultural climate in which Weston's early career developed had as much to offer as its counterpart back East. The California art scene, however, had a distinctively Oriental cast in that it took a more philosophical attitude toward the act of creation and showed a Japanizing penchant for abstraction, reductivism, flowers, and formal interplay for its own sake.[19] Weston was still absorbing these tendencies when Imogen Cunningham actually incorporated them in her pioneering photographs of magnolias in 1923.

The exuberant, rollicking, stimulating company that Weston now kept was part and parcel of his growing awareness of the role art and artists play. It would be misguided and misleading to think of Weston as a kind of California loner, cut off from the intellectually vibrant East Coast atmosphere that Stieglitz and so many other New York photographers were thriving on. The motley artistic community with which he associated, the social whirl he actively sought at the time (and which has been documented in Ben Maddow's biography and elsewhere[20]), the persona of artist he was trying to project as much for himself as for the outside world—all were part of Weston's self-conscious search for intellectual and social identity from 1911 until his departure for Mexico in 1923. During this period, he not only posed before his own camera in costume (athlete, bohemian artist[21]), but photographically struck out into often eclectic stylistic directions, including the pictorialism that was itself something of an artistic pose.

Weston cultivated a richly textured social life throughout his career, even during the apparently reclusive periods at Point Lobos. His *Daybooks* abound in meetings, confrontations, friendships, and love affairs, each of which proved useful to him in one way or another. Some bolstered his self-confidence: for example, the soft-focus pictorial work that Johan Hagemeyer kept turning out during the 1920s and 1930s provided a benchmark by which Weston could gauge his own artistic progress. Other relationships were catalysts. Henrietta Shore's influence on Weston after 1927 needs to be carefully weighed. Her stylized, abstract paintings

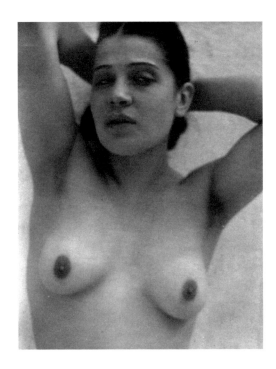

Tina, nude, arms behind head, 1924, CCP

22.
Merle Armitage was largely responsible for *The Art of Edward Weston* (New York: E. Weyhe, 1932), the first monograph to be published in Weston's lifetime. He also edited *Fifty Photographs: Edward Weston* (New York: Duell, Sloan and Pearce, 1947).

23.
In 1933, Ansel Adams criticized Merle Armitage's books on Weston for being "inferior to the subject" (*Creative Art* 12, May 1933) 366–82.

24.
Nancy Newhall organized the first Weston retrospective at New York's Museum of Modern Art in 1946. In 1948 she began the work of recasting Weston's *Daybooks* for publication and occasionally made important editorial decisions (as when she deleted Weston's descriptions of Mexican toys). Clearly, she "cut the *Daybook* to its truly magnificent testimony of the growth of a photographer." (Nancy Newhall to EW, 12 December 1949. Edward Weston Archive, CCP, Tucson).

25.
"those supreme instants which pass with the ticking of a clock, never to be duplicated." ("Random Notes on Photography, 1922," in *Edward Weston on Photography*, 29).

26.
Daybooks, II. 72.

27.
"All these women—what do they mean in my life—and in theirs? More than physical relief . . . Actually, it means an exchange, giving and taking, growth from contact with an opposite." (*Daybooks*, II. 110).

of rocks and flowers, although technically weak and far less intriguing than Georgia O'Keeffe's, nevertheless inspired the photographer to begin experimenting with close-ups of vegetables and shells. In 1921 Imogen Cunningham, wife of etcher Roi Partridge and a good friend of Weston's, began photographing cypresses at Point Lobos as well as close-ups of agaves and flowers. He was literally to follow in her footsteps.

Characteristically, Weston was also influenced by individuals who played a collateral role in the art world. One was the controversial Merle Armitage. This resourceful onetime impresario, Weston's de facto business manager after the photographer returned from Mexico, was instrumental in getting his work published in book and portfolio form.[22] Weston's career was usually handled quite skillfully, and despite reservations on the part of some, Merle Armitage figured prominently in it.[23]

Beaumont and Nancy Newhall (especially Nancy) lavished attention on Weston's work and art later in his career, from 1937 until his death.[24] Some may fault Beaumont for an overly narrow reading of Weston's photography, for reducing it to a series of mystical epiphanies (the "Supreme Instants"[25] Weston first mentioned in 1922), and for his failure to sufficiently discriminate between it and the work of Ansel Adams. (To paraphrase Andy Grundberg, Adams was also on the cutting edge of modernity.) Weston met Adams in 1927, but the relationship that ultimately developed between them was more ambivalent than one might imagine. Although Weston doubtless appreciated Adams's critical insight, he quickly realized that his work and the doctrines of Group *f/64* were too assiduous, inflexible, shallow, and (which might be more accurate) "prettified," a grave shortcoming Weston later decried in the name of authentic Beauty.

And then there were the women who formed the tapestry of Edward Weston's love life. Whether true companion-advisers or a ball and chain, they were present at every major stage of his artistic career.[26] Indeed, some were actively involved in its development. Between 1915 and 1923 Margrethe Mather broadened Weston's cultural horizons: she posed for his first noteworthy nudes in 1923. Tina Modotti, the beautiful Italian revolutionary, was the photographic disciple and all-important mistress of his Mexico period. Sonya Noskowiak was his mistress and pupil during the years 1927 to 1935 in California, when Weston's aesthetic blossomed into maturity. And there was Charis Wilson, his traveling companion during the Guggenheim photographic expeditions of 1937 and later.

These women comprise the carnal, sensual component of his photographic activity; it is their bodies that grace Weston's most beautiful nudes. To various degrees and on various levels, they also all affected his personal and artistic development. That there were so many of them, and that they carried such weight, speaks for his elemental vitalism, for an emotional and sexual virility so intense, if not abnormal, that it troubled him. His urge to womanize was so unthinking that at times he couldn't help wondering whether this perpetual state of physical and emotional overdrive bespoke a deeper craving for exchange and communication.[27]

Weston had ambivalent feelings about the demanding business of fatherhood. He had a protective side—the letters he wrote from Mexico to his sons back in California are those of a responsible, loving father dispirited by separation. His

Brett Weston.
Family Protrait, ca. 1937
on loan from Dianne Nilsen.

28.
A comparison of the prints Weston personally made and those produced by his sons reveals subtle differences: his show a more consistent density, bolder contrasts, an astonishing mastery of modulation in the dark tonal range. From this perspective, the two thousand prints in the Lane Collection of Boston's Museum of Fine Arts—virtually all of them vintage Westons—help us better understand his insistence on absolute technical consistency and maximum print readability.

29.
"I am away from the family—from domestic scenes." (*Daybooks*, II, 218), and "Chan must go now . . . I cannot go on living with the confusion and conflicting interests of the two families . . . I have had my share of babies. . . . So the little family must go, for their own good as well as mine." (*Daybooks*, II, 223).

30.
"I give [Stieglitz] all due credit for an important contact at a moment in my life when I knew what I wanted, and got it. That time has long since passed." (*Daybooks*, II, 238).

31.
Weston described his meetings with Stieglitz at length in a series of letters to his friend Johan Hagemeyer (in *Edward Weston on Photography*, 35–43).

32.
Ibid.

33.
Daybooks, I, 72.
34.
Daybooks, II, 24.

35.
"I cannot, never have been bound by any theory or doctrine, not even my own. Anything that excites me, for any reason, I will photograph." (*Daybooks*, II, 155).

Sonya Noskowiak, 1933, CCP

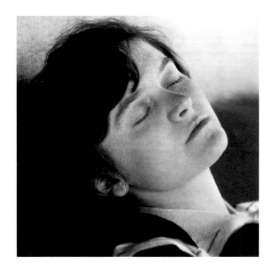

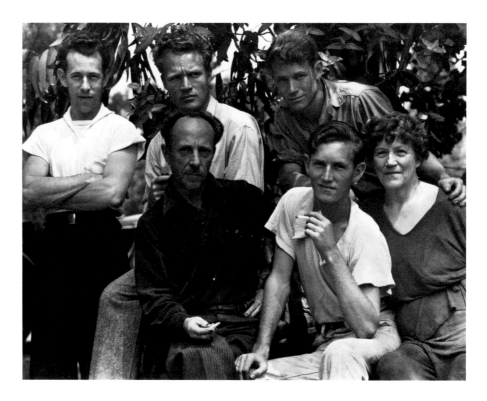

sons were around him most of his life, seeing to his well-being, and going so far as to emulate his career. They later managed their father's legacy, sometimes printing his negatives and, thus, making it difficult to tell vintage Westons from theirs.[28] Of his four sons, Brett understood him best, at least as a photographer. Although he never shut out his children completely, his willingness to distance or even temporarily cut himself off from them suggests that fatherhood was not always a role he assumed with undiluted pleasure. Weston's *Daybooks* are peppered with confidences that reveal how much he hated the institutional family and its stifling conventionality, especially when it jeopardized his art.[29]

The same ambivalence characterized the artistic relationship he had with his photographic guru, Alfred Stieglitz. Attraction, then dissociation—Weston thought this only natural.[30] When Weston first met *Camera Work*'s helmsman in New York in 1922, he found himself face to face with an exemplar, a critic (a fair one, Weston admitted), a father figure spouting words of wisdom when not reprimanding his photographer son.[31] Yet, no sooner was personal contact made than a healthy detachment set in. ("In my enthusiasm, I do not accept Stieglitz absolutely—as an infallible master."[32]) In 1924, when his own photographic vision was becoming more sharply defined, he noted in his Mexico journal a patently symbolic dream in which he was informed that Stieglitz, the father figure, had died. Now confident in his future progress, he proposed an insightful interpretation: "The obvious way to interpret the dream . . . would be in the forecast of a radical change in my photographic viewpoint, a gradual 'dying' of my present attitude . . . toward which I have worked in recent years."[33] By 1927, the Stieglitz chapter was closed once and for all: "One admits the fall of a hero unwillingly!"[34]

Weston demanded considerable leeway when it came to family, institutions, and exemplars, and he demanded the same freedom of movement when it came to his art. He always had to feel, however, as though something was boxing him in before he could repudiate it. Lucid self-contradiction was his way of flouting the system, any system: Weston invariably refused to be pigeonholed into pure photography or particular subject matter.[35] He was a wary, if not reluctant, founding

36.
For a discussion of this group, see *Seeing Straight in Photography: Group f/64.* (Oakland, California: The Oakland Museum, 1992), 22.

37.
Ibid., 53.

38.
"My work is always a few jumps ahead of what I say about it!" (*Daybooks*, II, 221).

39.
Kandinsky quote as copied by Weston. (Edward Weston Archive, CCP, Tucson).

40.
"I've never had any cut-and-dried philosophy; I can do an abstract close-up of the bark of a tree, and a sentimental picture the same day! I like it." (quoted in Van Deren Coke, "The Pursuit of Personal Vision," *Aperture*, 1956). And from the *Daybooks* (II, 174): "Don't try to pigeonhole me! I might photograph a sweet pea one hour—the next hour a coil of guts."

41.
Daybooks, II, 197.

42.
Weston alluded to this a great many times. For example: "I have recorded the quintessence of the object." ("Statement, 1927," in *Edward Weston on Photography*, 46).

43.
In a first-rate piece of methodological research (*Edward Weston Omnibus*, 175–79), Peter C. Bunnell argues that the works displayed at this much-discussed exposition were less radical than previously thought and that its importance as a trailblazing modernist manifesto—a virtual West Coast counterpart of the 1913 Armory Show in New York—may have been somewhat overstated.

44.
"Photographing California, 1939," in *Edward Weston on Photography*, 96.

45.
In "Random Notes on Photography, 1922" (*Edward Weston on Photography*, 29), Weston argues that portraiture is the only branch of photography in which time, and controlling time, are essential considerations. His object lesson is *Galván Shooting* (1924).

member of Group *f*/64, the group that Willard Van Dyke, Ansel Adams, and five others organized in 1932.[36] When he exhibited that year at Delphic Studios in New York, he put visitors on notice, lest there be any misunderstanding, that he was not to be categorized: "I have no unalterable theories to proclaim, no personal cause to champion."[37]

Yet, proclaim he did, throughout his career and to a degree no other photographer had ever done before. He worked hard at formulating his credos and published them whenever he thought it opportune to do so, as if he feared being misconstrued. Weston once noted in his *Daybooks* that, in his case, theory and practice were never far apart.[38] This determined effort to provide a self-clarifying perspective on what he was creating—a commentary on the work as well as the work itself—strikes us as resolutely modern. Not once did he reach a new stage in his art without issuing one of his now-famous statements, and their rationale was obvious from a tactical standpoint. Kandinsky had written, "In real art, theory does not precede practice, but follows her"; as far as Weston was concerned, the narrower the gap the better.[39] If there were times in his personal life when he knowingly contradicted himself, he was careful never to exhibit anything he wished he hadn't because it might undermine his pronouncements on photography. That's what some find exasperating about Weston's work even as they get wrapped up in it. He promulgated an art form, all the while professing to set it free. But he was tactful enough to underplay his advantage: hence his assertion—which is all it ever amounted to—that if he were so inclined, he could just as easily photograph one subject as another, however antithetical.[40] He dealt with modernism the same way. He professed allegiance in the 1920s, but no sooner had he given it his personal stamp than he couldn't wait to break free. By 1927, he seemed to recoil in horror at the mere mention of "modern": "I am so sick of the word!" he exclaimed in 1927, already tired of this latter-day "academic" art.[41]

Which brings us to the very label everyone so confidently attaches to Edward Weston, the one that lumps him together with Charles Sheeler, Paul Strand, and Alfred Stieglitz. If we define modernity in terms of timely or topical subject matter, then Weston's work falls well short of the mark. Once photography started registering the impact of Paul Strand's images of 1916, the medium found itself assimilated into the prevailing artistic trend toward subjects drawn from contemporary life: an urban, industrial world where transience and speed were the order of the day. That may be rather a summary definition of modernism, but it's one that would rule out the Weston corpus except for the ARMCO steel plant photographs of 1922 and a few other stylistic trial runs. At any rate, the theme of transience was anything but relevant to Weston's aesthetic, which, as he himself made abundantly clear, revolved around the concept of "essence."[42] Not that Weston wasn't fully alive to the complicity between his medium and fleeting phenomena. Jolted by the futuristic artwork he saw in 1915 at the Panama-Pacific International Exposition in San Francisco (which by his own account exerted more than a little influence on him[43]), he appreciated photography's potential for dealing "with the immediate present, and with only one moment of that present."[44] Only, as Weston saw it, the camera's split-second capacity to register images was valuable insofar as it enabled him, not to take so-called snapshots (which he never did, preferring the contemplative prolonged exposure to instantaneous recording[45]),

46.
"Quality, in quantity, is possible in photography to a degree unequaled in any other medium." (in *U.S. Camera Annual 1940*, p. 37).

47.
Quoted by Beaumont Newhall in *Edward Weston Omnibus*, 76.

48.
"If I could become even slightly successful as a writer . . . I could give up professional portraiture." (*Daybooks*, II, 244).

49.
Daybooks, II, 218.

50.
Reproduced in Beaumont Newhall, *Photography: Essays and Images*, Museum of Modern Art, New York, 1980.

51.
"Random Notes on Photography, 1922," in *Edward Weston on Photography*, 27.

52.
Daybooks, II, 24.

53.
Ibid.

54.
Daybooks, II, 197.

55.
They are now in the Center for Creative Photography, Tucson.

56.
"Egg slicer . . . I suppose it is purchased because it's modern." (*Daybooks*, II, 197).

57.
As far as the influence of Germany's New Objectivity on Weston is concerned, we need only read his comments about it in a 1944 letter to Nancy Newhall (Edward Weston Archive, CCP, Tucson): "I remember seeing some of Europeans. The prints were horrible, enlarged with no spotting, no quality, much grain. They would have influenced *no one!*"

58.
"Getting closer . . . a new field is opening to me—on the horizon I see a microscope!" (*Daybooks*, II, 187).

59.
"The 'N.Y.' done by Charles Sheeler had a genuine grandeur—nobility." (*Daybooks*, I, 190).

60.
"There was another reason I discovered, questioning myself, for leaving the city, any city—a psychic rather than a physical reason . . . Every time we drove away in the country from S.F.—returning, nearing again the city streets, my heart would sink, my stomach turn in revulsion." (*Daybooks*, II, 107).

but to turn out large quantities of pictures,[46] which he always thought preferable to a concentrated body of work. When Beaumont Newhall pressed him to reduce his selection of prints for the 1946 Weston retrospective at the Museum of Modern Art, he flared up. "I will be criticized for the size of my show. But I am a prolific, mass-production, omnivorous seeker. I can't be represented by 100, 200, or even 300 photographs to cover forty-four years of work."[47] He was as prolific with a pen as he was with a camera. Weston was a writer and aspired to write for a living.[48] Until 1935, he wrote and photographed, sometimes simultaneously ("I am more inclined to write when in a period of exciting work"[49]), sometimes switching from one to the other in a synergistic flow of creative energy.

On the surface of it, the modernism Weston initially subscribed to was in tune with contemporary comment on the subject, in particular, critic Paul Rosenfeld's 1921 article on Stieglitz.[50] We know that this piece played a pivotal role in Weston's thinking at the time. He started quoting from it extensively in 1922, most notably in what amounted to his modernist credo, "Random Notes on Photography" (1922). However, remarks like "We do strive too hard for novelty, but let us have fresh vision" suggest that he was already taking it with a grain of salt.[51] Weston's intuitions took on a veneer of topical, contingent modernity that saw in photography a quintessentially contemporary medium uniquely suited to "the themes and life of the day." But what about the subjects he himself was photographing at the time? They show that he seldom practiced what he preached—the very thing Stieglitz decried when he wrote that Weston's prints "lacked life, fire, were more or less dead things not a part of today."[52] Indeed, Weston took a vehement stand against arbitrary divisions of subject matter and the kind of conventional modernity exemplified by Stieglitz's New York cityscapes or the emblematic images of Georgia O'Keeffe's hand against an automobile wheel rim (*Hand and Wheel, 1933*). "Are not shells, bodies, clouds as much of today as machines?" Weston asked. "Does it make any difference what subject matter is used to express a feeling toward life?"[53] The standard repertoire of "modern" objects never really appealed to him. He quickly tired of the few he did photograph (*Egg Slicer, 1930* and *Bedpan, 1930*) and thought them unconvincing, facile stylistic exercises ("the egg slicer, one of my worst"[54]). The shots of desk lamps and other staples of early 1930s contemporary design never got past the negative stage.[55] Mere studies in the then fashionable style, they may have, at best, been done for commercial reasons.[56] He learned about the photography of the Bauhaus and László Moholy-Nagy through the modernist avant-garde set he cultivated in Mexico, but was underwhelmed by its "trivial mannerisms."[57] That may shed some light on his reticence about Germany's New Photography. Despite the fact that both Albert Renger-Patzsch and he were interested in larger-than-life, clinical observation of objects at close range, Weston was concerned not so much with objects in themselves as with their *form*.[58] Of all the photographers who leaned toward topical modernism, only Charles Sheeler was spared his ire.[59]

In any event, the environment modernism looked to for inspiration was alien to Weston. He had a visceral abhorrence of big cities and big city life and steered clear of both his entire life.[60] His *Daybooks* bristle with remarks indicative of the physical and spiritual malaise cities triggered within him. His stint in San Francisco (1927–28), before his permanent move to Carmel, prompted a litany of

61.
"Though city-bred I always preferred the country, all that hills and valleys, lakes and skies symbolize . . . Even then I was trying to understand, getting closer, becoming identified with nature. She was then as now, the great stimulus" (*Daybooks*, II, 239).

62.
"Random Notes on Photography, 1922," in *Edward Weston on Photography*, 29.

63.
Daybooks, II, 197.

64.
"Photography . . . is for the man of action and awareness, who as a cognizant part of contemporary life uses the means most suitable for a clear statement of his recognition. This recognition is not limited to contemporary physical means or manifestations (machinery, skyscrapers, city streets): anything—flower, cloud or engine—is subject matter." ("Statement, 1931," in *Edward Weston on Photography*, 67).

65.
Weston's Guggenheim Fellowship proposal (1936) made it quite clear that his project would not be documentary in nature and that he had decided to photograph the western United States simply because it was convenient and rich in subject matter. He added a further clarifying remark: "This 'theme' of mine could of course be done anywhere from the Tropics to the Arctic." (*Edward Weston on Photography*, 79).

66.
Ibid, p. 79.

67.
Daybooks, II, 221. Repeated in "Statement, 1931," in *Edward Weston on Photography*, 67.

disparaging generalizations about city life. Nothing brought Weston closer to truth as he understood it than physical contact with nature in all its awesome splendor: California and the American West.[61] (His pantheistic belief in the organic unity of the universe was shaped in part by Swedenborgian theosophy, the mystical theories of painter Wassily Kandinsky, and British writers D. H. Lawrence and John Cowper Powys.) A strong supporter of environmentalist issues, he wrote in 1922—fully aware of its personal implications—that "an artist's work is influenced by his surroundings—his material at hand."[62] In his view, being modern had more to do with the way one looked at things than the things one looked at. "One's spirit of approach may be contemporary," he wrote," but subject matter is immaterial," an elementary observation that some have seen fit to misconstrue.[63] If modernism's chief mission—and photography played a major, if not spectacular role in it—was to winnow out the new (i.e., the contemporary) from the old, then Weston was not a team player. Instead of making a knee-jerk decision in favor of one or the other, he drew on both and forged a new alternative. The well of conventionally modern subject matter was fast running dry: photography, he argued, needed to broaden its scope dramatically.[64] The standard fare of contemporary photographers—industry and factory workers, cities and the masses, manufactured goods and consumer society—is the exception in Weston's work. When he did photograph such things as shoes, tin cans, automobiles, and other manufactured objects, he made sure that they were visibly eroded by time as a way of underscoring their short-lived fragility. Since most of these photographs date from 1922, the Mexico period (1923–26), intervening months in California (1925), and especially 1941, when he traveled through the South and East photographing for an illustrated edition of Walt Whitman's *Leaves of Grass*, they curiously bracket his core output. At all other times, Weston's images run counter to the visual mainstream of his time. In that respect, he was an outsider. Clearly defining a field of action, as he did for his project in the West, did not mean one theme was inherently more worthy than another.[65] Everything was fair game for his camera, provided its contingent, accidental characteristics did not obtrude. Like Kandinsky, Weston firmly believed that the local and the particular are secondary: instead of taking an image out of time, they date it. Therefore, the general must outweigh the particular; essence must take precedence over outward appearance. All of which seems to fly in the face of the very nature of photography. The word *document*, at least in the sense of a Walker Evans–style visual fact, was not part of Weston's vocabulary. He replaced it with what he called revelation of the subject, "the revealing of its significance."[66] For all these reasons, the subjects Weston photographed look as though they have no context, no history. They seem to exist in time out of time; yet, in many instances, they are visibly ravaged by time. One might say that they are all the more modern for it.

Weston took an unflinching stand against what he called self-expression, not only in photography but in art in general. Although it may have begun as a tactical maneuver, he came to regard the pictorialism he once espoused as a hotbed of *interpretation*, a neurotic throwback to romanticism, "a smoke-screen artificially cast over life," an unpardonable betrayal of the mechanical impersonality and objectivity unique to the photographic medium.[67] Just when his photographs of vegetables (1928) proclaimed a burgeoning maturity, his writings became overtly

68.
"Art is weakened in degree, according to the amount of personality expressed . . ." (*Daybooks*, II, 221).

69.
Daybooks, II, 232–33.

70.
"those who bring to it their own obviously abnormal, frustrated condition: the sexually unemployed belching gaseous irrelevancies from an undigested Freudian ferment." (*Daybooks*, II, 224–25).

71.
"I would have a microscope, shall have some day." (*Daybooks*, II, 155).

72.
"Photography, 1926" and "Statement, 1930," in *Edward Weston on Photography*, 45 and 63, respectively.

73.
"I had a queer experience; Dr. G. offered to turn the X-rays on us. Tina was first—we watched the weird revealment—saw her heart beat—noted that her lungs were in fine shape—then my turn—'Your lungs are fine too,' said Dr. G. 'Turn profile now'—but my ears began to ring—my eyes blurred—my legs gave way and I went down and out!—the fact that I actually had a heart—and lungs and a liver was too much for me—it's enough to suspect such things are existing!" (Letter of 20 February 1924. Edward Weston Archive, CCP, Tucson).

74.
"I like the idea of a scientist introducing me to the art-hunting public." (*Daybooks*, II, 189).

75.
"showing to [others] what their own unseeing eyes had missed" and "A seer is one who sees with the inner eye and is able to give concrete expression to his knowledge of facts, things . . ." (*Daybooks*, II, 222).

76.
"Statement, 1932," in *Edward Weston on Photography*, 70.

77.
"A Contemporary Means to Creative Expression, 1932," in *Edward Weston on Photography*, 68.

78.
Daybooks, II, 180.

repudiative and advocated uncompromising objectivity consistent with the Precisionist aesthetic exemplified by painters Charles Demuth and Charles Sheeler or photographers like Paul Strand. In Mexico he had already begun to use glossy paper for maximum crispness of detail. Weston's shift from an interpretive to an optical objectivity stemmed from his unshakable determination to purge his art of all psychological undertones, any taint of personality.[68] In a telling passage in the *Daybooks*, a self-satisfied Weston rather too insistently describes himself as psychically well-balanced and fortunate to have been spared the frustrations that usually plague artists.[69] We know how he lashed out at critics who read sexual meaning into his photographs (even when it was irrefutable) and disavowed all phallic or vaginal symbolism. He would invariably attribute such interpretations to their own unfulfilled prurience.[70]

Weston's preoccupation with literal and figurative clear-sightedness—for himself, his photography, the world around him—bordered on the morbid. One of its more extreme manifestations was his wish to possess clinical, scientific vision beyond the threshold of normal eyesight, the power to blow things up the way a microscope does. (The subject of microscopes crops up several times in his *Daybooks*.[71]) Weston aspired to see penetratingly, down to the minutest detail, as if that alone held the key to superhuman power. He drove the point home repeatedly: "Photography . . . sees more than the eye sees."[72] Yet, when actually granted preternatural sight (through X-rays, for example), Weston, or his unconscious, could not cope with the result and backed away. An incident he reported in a letter from Mexico—but curiously omitted, inadvertently or not, from his journal—casts an odd, Freudian light on Weston's ambivalence about his insistence on forcing things concealed or repressed into the open. The first time he was X-rayed, he passed out at the sight of what was actually inside his body.[73]

This longed-for power, this determination to encroach on the territory of surface reality, went far beyond the aspirations of the modernist generation that saw photography, coupled with art, as a new tool with which to probe the visible world. Weston often thought of himself as an explorer of reality and assumed the trappings of science.[74] Then, taking it a step farther, he claimed to possess the second sight of a visionary or prophet or "see-er" (his spelling), someone with the ability to puzzle out the "quintessence" of the world and the objects in it.[75] By virtue of this revelatory and, therefore, uniquely poetic role, photography, he believed, grants us unblemished, undistorted vision. Weston's photography is contemplative in that it allowed him to look at the world metaphorically, to effect the qualitative transformation he alluded to when discussing photography's power to sublimate "things seen into things known"[76] through "fusion of an inner and outer reality."[77] Weston's brand of contemplation, however, was anything but passive. It was rapacious, predatory, virtually masticatory. Reality was something to be grasped and taken in—at times literally, according to a remarkable passage in his *Daybooks*. He had a habit of putting peppers he had just photographed in that evening's salad: "It has been suggested that I am a cannibal to eat my models after a masterpiece! But I rather like the idea that they become a part of me, enrich my blood as well as my vision."[78] Much the same could be said of his nudes and the sexual relationships he had with the women who posed for him.

Commentators have tended to gloss over the influence that Wassily Kandinsky

79.
Daybooks, II, 30.

80.
Weston personally copied them on two sheets of paper. They are in the Edward Weston Archive, CCP, Tucson.

81.
"to become identified with nature, to see or *know* things as they are, their very essence . . . a *revelation* . . . an absolute, impersonal recognition." (*Daybooks*, II, 221).

82.
Daybooks, II, 221.

83.
"Photography is of today. If [Velazquez] were contemporary he would assuredly use a camera, and be a great photographer." ("Photography, 1926" in *Edward Weston on Photography*, 45).

84.
In a review of Weston's [1933 Chicago] exhibition (*Chicago Herald and Examiner*, 23 September 1933): "These pictures are . . . only three-dimensional shapes They possess the attributes which a painter insists on adding. . . . The more of these pictures you see, the more you realize their artistic emptiness. They illustrate how Weston finds 'patterns' dear to the heart of abstract painters in the most commonplace objects." (Edward Weston Archive, CCP, Tucson).

Charis, 1935, CCP

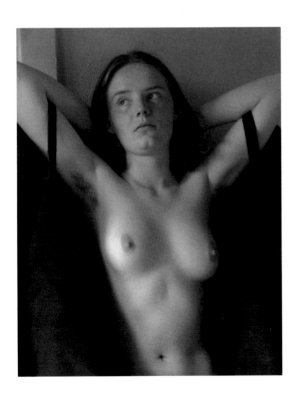

had on Weston, particularly through his text *Concerning the Spiritual in Art*. In 1912, the year that the painter's treatise came out in Germany, Stieglitz published excerpts from it in the thirty-ninth issue of *Camera Work*; a complete American edition appeared in 1913, the year of the Armory Show. In 1927, after his return from Mexico, Weston got the chance to see original Kandinskys in the Los Angeles homes of private collectors he knew. On 21 July of that year, he purchased a Kandinsky lithograph for the princely sum of three dollars, whereupon he noted: "Kandinsky seems to me one of the few moderns whose work will live: he has something very personal, genuine—he has both intellectual and emotional ecstasy. This print will bring me much joy."[79] While it is true that Kandinsky's name crops up only sporadically in Weston's *Daybooks* and not once in his theoretical publications, we know that the photographer was conversant with the painter's writings: he often quoted from him and meticulously copied more excerpts from his writings than from those of Elie Faure or Henri Focillon.[80] Three Weston photographs (including the highly abstract *Wall Scrawls, Hornitos, 1940*) shared space with Kandinskys at the Museum of Modern Art's 1948 exhibition "This Is Contemporary Art"—further proof that they were kindred spirits.

Weston's pantheism mirrored the painter's metaphysical conception of the world and belief in Swedenborgian correspondences. Both considered themselves decipherers of nature, mediums.[81] Like spiritualists, their powers of perception were enhanced by an ability to substitute neutrality and objectivity for subjective interpretation, which they felt interfered with the artist's role as "an instrument through which inarticulate mankind speaks."[82] From this perspective, Weston's preference for "revelation" over the more photographically appropriate "document" comes as no surprise. Unfortunately, the word was to suffuse his photography in an aura of sometimes exasperating ponderousness that set the stage for the high-flown metaphysics of Minor White.

That is why Weston stressed the close relationship between "pure" photographic equipment—that absolutely impartial mechanical eye—and the human eye of which it is an extension. The real purpose of the much-talked-about "previsualization" (Beaumont Newhall's word, not his) he started advocating in 1922 was to bring the photographer's deciphering eye and the camera's scrutinizing eye into a state of mutual influence and accommodation. Keeping the two types of vision separate, treating the personal and the photographic as if they were unrelated, would make the photographer-artist's role that much more apparent and thereby obviate it. With typical insightfulness, Weston validated his medium's unique characteristics by reconciling them with aesthetic guidelines (Kandinsky's, in particular) that had been formulated for painting when the modernist movement was still very young. In a stroke of genius, he narrowed the gap between photography and an aesthetic that was initially painting-oriented (and abstraction prone)—more so than Stieglitz did, but also perhaps too systematically. But all the while, he proclaimed that photographers could best painters on their own turf and would eventually supplant them in the modern arena.[83] This stance sparked adverse reactions as early as 1933[84] and was to draw even heavier fire, especially in critic Clement Greenberg's 1946 review of the first Weston retrospective at the Museum of Modern Art in New York. Greenberg contended that Weston was a photographer who had "followed modern painting too loyally," who was obsessed with

85.
"The Camera's Glass Eye,"
The Nation, 162, 9 March 1946, 294–98.

86.
"If one wants to see modern art photography at its best let him look at the work of Walker Evans, whose photographs have not one-half the physical finish of Weston's." (*Ibid.*).

87.
"Weston concentrates so much upon seeing his cabbages and sand dunes clearly that he forgets to feel them." (*The Nation*, 162, 27 April 1946, 518–19).

88.
Daybooks, II, 211.

89.
Daybooks, II, 240.

90.
Tina Modotti to EW, 26 June 1927.
Edward Weston Archive, CCP, Tucson.

91.
According to Willard Van Dyke (quoted in Ben Maddow, *op. cit.*, 181): "He liked women as companions, as sexual objects. . . . He found each new sexual adventure vastly stimulating as far as his work was concerned." When Ansel Adams reviewed *The Art of Edward Weston* in 1932, he downplayed the alleged sexual intent of Weston's work ("the pathologic and erotic suggestions discovered in his work by purist crusaders") and concluded that they "derived from his frank acceptance of the importance of living forms." (*Edward Weston Omnibus*, 50).

92.
Daybooks, II, 210.

93.
Precisely Janet Malcolm's rather untenable point when she contends that "the nudes are strikingly sexless and impersonal . . . parts of bodies transmuted into forms." (*Diana and Nikon*, Boston: Godine, 1980, 23, 24).

geometric patterns ("the picture itself becomes nothing more than a *pattern*"), who "concentrates too much of his interest on his medium."[85] Then came what must have seemed to Weston the kiss of death: "The result . . . shows a tendency to be artiness rather than art." With this damning statement, and by dubbing Walker Evans an exemplary photographer,[86] Greenberg enshrined Evans's photography ("let photography be 'literary'") and blackballed Weston's on the grounds that it lacked feeling and inspiration.[87] This deceptively sound assessment was as wrongheaded as it was precipitate. It was largely to blame for the label of aestheticism that has, to his discredit, stuck to the California photographer to this day.

Yet, aesthetic autonomy is what Weston's contribution is all about. Photography, he maintained, has a unique and pivotal part to play in fulfilling the aspirations of modern painting and modern sculpture—and can do so with a perfectly clear conscience—precisely because of its inherent characteristics. Unlike their fellow-artists, photographers need only select out forms from a preexisting stock, forms that bona fide sculptors and painters (not the ones he once called in a fit of class-consciousness "bourgeois painters and their satellites in photography"[88]) were still slaving to create: "Actually, I have proved through photography, that nature has all the abstract (simplified) forms that Brancusi, or any other artist, could imagine. With my camera I go direct to Brancusi's *source*. I find *ready to use*—select and isolate—what he has to 'create.'"[89] Weston's ingenuous conceit was yet another facet of his total commitment to his medium.

Thus, he made form and its revelation the nucleus of his photography and brought it to life by infusing it with unprecedented vitality, a driving force that came from within (even if he clung to the delusion that it didn't). For what he thought he found in nature he simply put there himself. This anthropomorphic vision that supposedly emanated from rock and vegetable forms emanated, in fact, from his own cravings, his own sexuality. Incredibly, he was virtually the only person unwilling to acknowledge it. When Weston sent Tina Modotti his first prints of peppers in 1929, she quickly wrote back telling him of her reaction: "They disturb me not only mentally, but physically," but hastened to clarify, "I hope you take it for granted that, in spite of using the words disturbing—erotic, etc.—I am *crazy* about your latest creations."[90] In the same letter Tina reported that Diego Rivera, who was anything but a prude, had been taken aback at the vulvar *Shells, 1927* as if he thought them obscene and inquired, "Is Weston sick at present?" Anyone who had any contact with Weston sensed the power of the sexuality he so intensely projected upon his activity and the subjects he photographed.[91] But the same man who, as we have seen, so strenuously objected whenever critics put that down to mere perversion or neurosis, was the first to admit that it was vitally important to his work, if not a prerequisite for its development. The mechanics of desire fueled the engines of Weston's creativity: "To really blossom, one must feel wanted, loved."[92]

His many sexual partners figure as often and as prominently in his photographic work as do vegetables and rocks. Many have noted the similarity between the great nudes from between 1935 and 1940 (including those of Charis) and the landscape photographs from the same period, the dunes in particular. In his journal (March 1927), Weston commented on the similarity between the curves of dancer Bertha Wardell's legs (she was his model at the time) and the curves of his

Exposition of Dynamic Symmetry, 1943, CCP

94.
Daybooks, II, 17.

95.
Daybooks, II, 63–64.

96.
The release in 1956 of Lou Stoumen's 71-minute film, *The Naked Eye,* with footage of Weston, created a mild sensation that doubtless came as no surprise to a photographer who had long struggled against sexual puritanism. It was the first time Hollywood censors allowed nudes to be shown in public movie theaters. (*Huntington Park Signal,* 3 October 1956. Edward Weston Archive, CCP, Tucson).

97.
"Random Notes on Photography, 1922," in *Edward Weston on Photography,* 31.

98.
"The form . . . is the most clarified, forceful way the seer (see-er) can command for the presentation and communication of his experience." (*Daybooks,* II, 222).

99.
In *Edward Weston Omnibus,* 182, Weston's opinion of Atget's work was mentioned in a piece about Willard Van Dyke: "He felt there was a lack of interest in form for the sake of form: [he saw Atget as a good photographer, a faithful chronicler of his place and time]". (In Jacob Deschin, "Willard Van Dyke Reminisces about His Early Years with Edward Weston," *Popular Photography* 77 (July 1975), reproduced in *Edward Weston Omnibus,* 182).

100.
Daybooks, I, 150. This was indeed what Stieglitz meant when he advised "a maximum of simplification."

101.
Weston found confirmation of this idea in a letter from Henrietta Shore (January 1933): "To be true to nature one must be abstract." (Edward Weston Archive, CCP, Tucson).

shells. Weston's forms are nothing if not sensually motivated. As soon as Weston drifted away from this guiding principle, a brittleness smacking of conventionality set in and registered in his figure studies immediately.[93] Palpably carnal, sexual bodies gave way to mere declinations of a *genre,* albeit formally elegant ones. Henrietta Shore hit the nail on the head in 1927 when she told him, "I wish you would not do so many nudes—you are getting used to them—the subject no longer amazes you—most of these are *just* nudes."[94] Then again, take away form and Weston's nudes are just this side of obscene. (Weston, who feared that most persons who saw his *Nude of Fay Fuquay, 1928* would "only see an ass," realized this.[95]) But that is not what made his approach to the nude so triumphant, no more than did unabashed display of pubic hair (which he once wryly misspelled "public hair" in an antipuritannical outburst sparked by Beaumont Newhall's efforts to negotiate its removal from prints the public would see at the 1946 Museum of Modern Art retrospective).[96] His triumph lies more in the compelling give-and-take he set in motion between form and desire, order and chaos, and in the resulting tension between them. In this respect, Weston's nudes are very much in keeping with his general photographic take on the world around him.

When viewed in his ground glass, the merely physical presence we call an object emerged from the *chaos* of nature. Order/chaos: to Weston these were two sides of the same coin. Since nature is "crude and lacking in arrangement," order separates out from chaos only through the process of human selection.[97] If one object is chosen over another, it is primarily and fundamentally because it is formally significant. It is form, and form alone, that allows an object to stand out from the background and become expressive. Without organic form we should be unable to meaningfully communicate with what our eyes experience.[98] Weston started to grasp this concept in Mexico (*Tres Ollas, 1926*), and Kandinsky's theories reinforced and confirmed his newfound appreciation of form for form's sake.[99] At the same time, however, Weston became increasingly aware of its pitfall: abstraction. Starting with Kandinsky, modern painting underwent a gradual shift in emphasis away from organic form and toward abstraction. We know from Paul Strand's early work after 1916 that some photographers found the temptation to do likewise hard to resist, at least initially. But those who succumbed ran the risk of lapsing into what Weston quickly concluded were "intellectual juggleries" once he had tried them out himself in Mexico. Continuing in that vein, he feared, might drain objects of their very objectness and lead to the purely formal approach that surfaces in some of his more conspicuously abstract photographs.

Instead of eliminating abstraction, Weston held it in check by redefining its role in photography as "elemental form" or "simplified form" and by underscoring the essential, ubiquitous part it plays in the natural order.[100] He gave form its due, using its offshoot, composition, as a way to validate it and intensify its presence. In so doing he turned the photographed object into a photographic object. There was little to lose (because of the medium's unerring precision) and much to gain (because by making an object's form visible, photographic art expresses its "inner necessity"[101]). Therein lies the true wellspring of Weston's *organicism.* Impelled by his deep-seated, visceral attraction to nature, organic forms proved an inexhaustible source of inspiration: not just vegetables, but the rocks, human beings, and landscapes he considered organisms no less capable of participating in

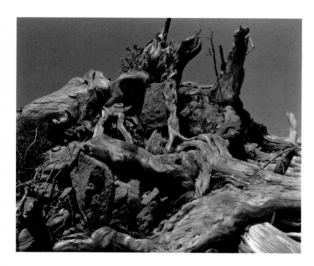

Point Lobos [roots and rocks], 1940, CCP

102.
"Art is based on order." (*Daybooks*, II, 139).

103.
As Ansel Adams pointed out, "Edward was a clean man in body, spirit, and mind." ("Edward Weston," *Infinity*, 13, February 1964, 25).

104.
Daybooks, II, 252.

105.
EW to Ansel Adams, 3 December 1934: "The tension between opposites is necessary." (Edward Weston Archive, CCP, Tucson).

106.
He started photographing animal carcasses, wrecked cars, and decaying buildings in 1935. The arresting *Dead Man, Colorado Desert* dates from 1938.

107.
On the subject of his peppers, he wrote that he had "brought attention to the dual force in this hybrid, the outer covering and inner lining." (*Daybooks*, II, 252).

108.
"I wonder if Blake, the visionary, could be called 'theatrical' because he saw things out of the ordinary! ...the 'grotesque'." (*Ibid.*)

form's compelling revelation.

In much of Weston's work, the struggle for form is tantamount to a struggle for order and against chaos. Outwardly, Weston's world was tightly organized both personally and aesthetically.[102] His strict photographic technique was as fastidious and disciplined as his life, his life as crisp and clean as his images.[103] However, forces were at work beneath the surface: implosions he described as "different contractile forces inherited from diverse ancestral sources,"[104] the inescapable tension between opposites, among them "feminine/masculine, radical/conservative."[105]

We know from Weston's *Daybooks* that the seething and churning spilled over into his private life, try though he sometimes did to hold it back. But the turbulence registered in his photographs, too: the convoluted forms, the twisted and gnarled cypress roots reminiscent of Van Gogh's trees, the increasingly menacing presence of death,[106] and—a metaphor of his own dualities—the counteracting lines of force of his peppers.[107] Weston's great photographs throb with this implosive energy, this burgeoning disorder, occasionally giving rise to a grotesquely "theatrical" quality he associated with another great visionary, William Blake.[108] Weston was determined to hold it all securely together, so much so that his landscapes always seemed structured a shade more conspicuously than they needed to be. Wherever the battle was joined—Mexico, in the West during the Guggenheim project, or through the South and East for the *Leaves of Grass* assignment—there he was, brandishing form at the chaos all around him. Yet, what a wasted, flimsy world it could be: witness his portrait of Galván, that miracle of resonance immobilized. Now and then, the angst disorder aroused deep within him would burst to the surface in his *Daybooks*, disorder that even his impeccably neat handwriting seemed to be trying to contain.

Little by little, cracks began to show. There was a noticeable transition to less methodical composition, starting with the landscape photographs from the West (1937). Interest shifted from the emptied center of the image (*San Carlos Lake, Arizona, 1938*) and collected at its edges, setting up a boundary which, though uncrossable, might easily extend beyond the picture frame.[109] Elsewhere, he gave his subjects more context; no longer do they seem to float in a sidereal void (*William Edmondson's Sculpture, Nashville, 1941*). Yet, even as he made these kinds of photographs (and continued to do so until 1948 as if to underscore their significance), Weston, now in twilight of his active career, caricaturized his passion for form, now acknowledged as unavailing (*Exposition of Dynamic Symmetry, 1943*), as well as the pictorialism of earlier days: *Winter Idyll, the Big Sur, 1945* is a startling self-parody.

With the coming of age and experience, Weston seems to have gained a deeper understanding of cosmic uncertainty, for it was around this time that he shed the photographic inhibition of composition. He was now willing to allow his approach to be guided simply by the subject as it presented itself to his camera, without the safety net of form: witness the Point Lobos photographs of cliffs, kelp, and debris. As his life drew to a close, Weston became absorbed in the same issues that preoccupied Walker Evans late in life: *absence of form*, the province of a pure photography beholden only to the laws of entropy and of the medium bearing witness to it.

109.
John Szarkowski insightfully noted a telling shift in Weston's work from late 1930s onward: "From about his fiftieth year, Weston's pictures more and more often describe a space that is continuous not only in depth, but (by implication) continuous beyond the rectangle that defines the picture plane. . . . Paradoxically, these more and more sophisticated pictures seemed on the surface more casual, more natural, and somehow less *artistic* than the graphically more dramatic early work" ("Edward Weston's Later Work," *MoMA*, No. 2, Winter 1974–75).

110.
"I can't stop the flow of my salivary glands, they have taken the place—almost—of my other troubles." (EW to Nancy Newhall, 2 December 1955. Edward Weston Archive, CCP, Tucson).

Tragically, the disorder he was now willing to accept was at work within him. Weston was stricken with Parkinson's disease. Gradually, inexorably, he lost control of his body between 1948 and his death ten years later. Only once in a great while, in his increasingly illegible letters, did he confess his frustration at not being able to overcome the disaster that had befallen his body.[110] Sadly, his biological fate bore out his photographic intuitions. The last photograph Edward Weston ever made (*Eroded Rocks, Point Lobos, 1948*) is of the natural, uncontrollable scattering to which he was now resigned. He dealt with his illness the same way. Weston was magnificent to the very end.

Translated from the French by I. Mark Paris

Fritz Henle.
Edward Weston in Carmel, 1942

1911
1923

Before Mexico:
The Early Photographs Terence Pitts

In October 1922, in the midst of a transcontinental trip from Glendale, California to New York City, Edward Weston visited his sister in Middletown, Ohio, where he photographed the nearby plant of American Rolling Mills Company (ARMCO). The photographs that he made there were unlike any he had ever made before—almost abstract pictures of smokestacks, pipes, factory buildings, wires, and utility poles, silhouetted against a wintry Ohio sky. In the ARMCO photographs Weston's artistic past and future can be seen overlapping. We can see the final traces of the pictorialist style that he had practiced for a decade and we can see the modernist direction that his work would take for the next quarter century.

The triumph of modernism as the quintessential style of the twentieth century has cast the entire pictorialist movement into disrepute, relegating Weston's early work to a minor role, a prelude to the remarkable body of modernist photography that he began producing with his trip to Mexico in 1923. But during the decade prior to 1922, Weston had developed an international reputation as a photographer in the pictorialist manner. His photographs were widely published and had been accepted into many important juried exhibitions, winning awards from Hong Kong to London. In later years, Weston himself played down the importance of most of the work he had done in those early years. By 1946, when a retrospective exhibition of 251 prints was organized at the Museum of Modern Art, only eleven platinum and palladium prints represented the entire decade before the ARMCO photographs. Only in recent years, as more and more of these early works surface and as the stigma of pictorial photography slowly disappears (a stigma that Weston himself helped put into place), is the achievement and challenging nature of his early work becoming more accessible and more apparent.

Having taken up photography passionately during his teens after the gift of a camera from his father, Weston briefly studied photography at a technical school in Illinois in 1907–08. He opened his own portrait studio in suburban Los Angeles in 1911. While trying to support himself and his family through his commercial efforts he also began to navigate the international world of art photography and the growing local community of artists.

In his pictorialist work Weston made the most of a few, simple ingredients, letting light, shadow, texture, and the poses of figures create an ambiance of mystery. He often employed a few simple, but highly expressive props—a flower, an oriental fan, a mirror—as exotic references or to help evoke the sense of narrative. Whether indoors or out, the figures in Weston's photographs are bathed in a bright, natural light that highlights faces, hands, and breasts. Light gleams across the surfaces of his studio's burlap-covered walls, the multi-paneled silver screen that he often used as a backdrop, the polished wooden floors, the spartan furniture, and the mirrors; shadows create a double world, casting distorted echoes of the figures across the wall and revealing the existence of objects not seen within the frame of the pictures themselves.

If Edward Weston had never made another photograph after 1922, we would still have to regard him as an exceptional artist. Over a span of ten years he

Edward Weston's First Studio, Tropico, California, 1911
Courtesy Dayton Art Institute

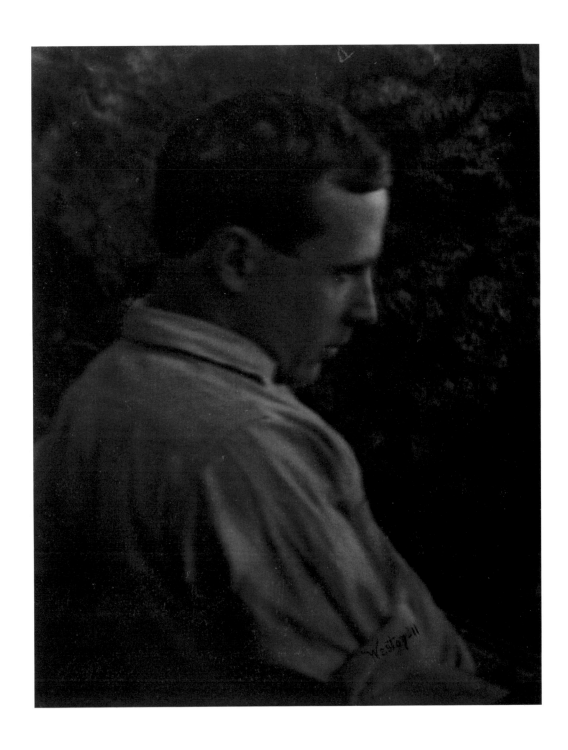

Self-portrait, California, 1911, CCP

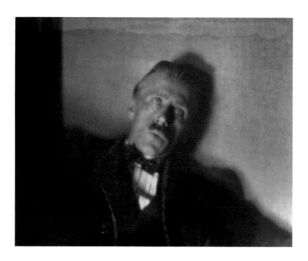

Fig. 1
Air for the G String, 1919, (Portrait of Johan Hagemeyer), CCP

1.
Edward Weston. "Random Notes on Photography,"
Edward Weston: Photographs and Papers. (Guide Series
No. 3). Tucson: Center for Creative Photography, 1980,
p. 4

produced dozens of images of great beauty and made radical innovations within the basic boundaries of the pictorialist aesthetic. His restless energy and artistic integrity led him to master—and ultimately to exhaust—nearly every avenue open to a photographer during the teens, before bursting forth into unmapped territory in 1922.

Like nearly every pictorialist photographer, Weston tried his hand at narrative images. In *Epilogue,* 1918 [page 40] and *Prologue to a Sad Spring,* 1920 [page 49]—much of the emotional impact derives from the implication that all of the significant action is taking place outside the frame of the camera, hints of which reach us only in the shadows on the wall. In *Jean Christophe,* 1920, [page 48] Weston's close friend and fellow photographer Johan Hagemeyer played the role of the main character in the series of Romaine Rolland novels, which both men had been reading and talking about. And in *Air for the G String,* 1919 (Fig. 1) Hagemeyer whistles the Bach melody they both admired.

Music and dance were particularly important to Weston, influencing his photography throughout his career. He and Hagemeyer listened to and discussed recorded classical music. With Hagemeyer and other artistic friends he attended concerts of contemporary music and performances of ballet and modern dance; he also photographed members of the dance troupe founded by Ruth St. Denis and Ted Shawn as well as the composer Leo Ornstein. For Weston, these arts, along with European literature, spoke of new artistic possibilities, new social and sexual freedoms. They were bold and modern and spoke to the daring side of Weston, who felt trapped in staid, puritanic southern California.

Given the tremendous influence on Weston's personal and artistic life played by his friends and fellow artists and the larger circle of collectors, patrons, and transitory visitors to the Los Angeles art scene, it is not at all surprising that almost every photograph Weston made between 1912 and 1922 included people. "It is in portraiture and figure studies that photography's opportunity lies," he wrote in 1922.

> Only the photographer can register what lies between himself and the object before his lens at a given moment of time, catch fleeting facial expressions, sudden twitching smiles, momentary flashes of anger and pain, or arrest apparently insignificant motions of the hands sewing, gestures of the hands poised fitfully on the breast, motions of hands peeling apples . . .[1]

Based on the concepts of academic portraiture, the pictorialist portrait depended on a standard repertoire of poses and gestures, a sign language of classical references and expressions as a means of making visible the inner personality of the sitter. Likewise, the figure study depended upon firmly established principles in pictorial photography. The figure study represented a classically accepted subject embodying both the most noble aspirations of art and a thinly veiled eroticism. By contrast, Weston struggled in his portraits to find a new language for expressing character, and in his figure studies of Tina Modotti, Margrethe Mather, his son Neil, or an unknown male, he turned the poser into a dancer. Weston took one of the principle tenets of pictorialism—the search for the universal and the eternal—and turned it on its head, exploiting photography's quickness to seek out the

2.
Ibid., p. 5

momentary, the rare. Underlying this was Weston's insistence, even during his pictorialist period, that photography be an extension of vision, not of thought. "The greatest photographers must be 'intuitives.' How fatal it is in photography to be uncertain. . . ."[2]

In his nude figure studies, Weston made a significant break with pictorialist conventions. His nudes smoked cigarettes, leaned against walls, or simply sat on a chair in the middle of his studio. Their flesh is real, the light plays across their skin in unexpected ways, and the eroticism is almost palpable. In several instances, Weston pushed his camera beyond the barrier that had traditionally separated decorum and intimacy.

Throughout his early work, Weston constantly approached composition unconventionally, often building his images asymmetrically and letting empty spaces dominate the picture frame. Critics suggested that he was influenced by Japanese prints and the work of painters from the preceding generation, notably Whistler. To this Weston replied: "Now I do not protest against any intimated influence, but I do say that mostly the artist takes the customs and types of the day—ugly or fine—and recreates them in his fancy."[3]

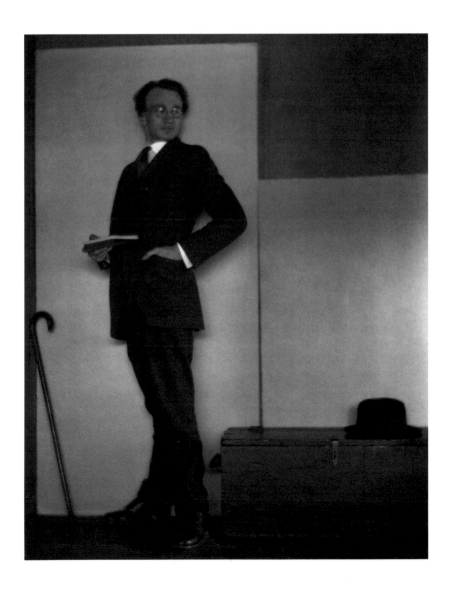

Franz Geritz, 1920, Lane Collection

About 1920 he went even further in a series of photographs made in friends' attics, transforming oddly-angled alcoves and ceilings into massive planes and angles that overwhelm the meditative figures of his friends as they sit or stand in corners [page 50–51]. In these attic pictures, Weston seems on the verge of photographing the architecture for its own sake and creating purely abstract images. But he was still not quite at the point when he could eliminate the human element entirely, even though the people in these pictures can do nothing more than try to blend in with or hide from the Cubist-inspired geometry. Predictably, critics did not respond well to these pictures: one called the image *Betty in her Attic*, 1920 [Fig. 2], "pure cussedness" and "queerness for its own sake."[4]

In a dramatic print from 1922, *R.S.—A Portrait*, Weston extended the architectural abstraction of the attic pictures by strategically placing the head of Ruth Shaw in front of some geometric shapes that have no reference whatsoever to their actual origins. Shaw's cropped profile and severe haircut echo and begin to merge with the strong linear pattern behind her.

Even at the height of his pictorialist period, Weston had been cutting against the grain of mainstream pictorialism, rejecting its most formulaic approaches and turning its primary devices against themselves as he searched for an altogether new relationship between technique, composition, and image. With the ARMCO photographs of 1922 he began to include more aspects of modern life in his photographs, and he felt that the soft or selective focus of pictorialist photography was "an inexcusable fault when it comes to photographing modern architecture and machinery."[5] Technique should respond appropriately to the times and composition should emerge from the subject itself. Together, they should let the subject be nothing more and nothing less than itself, neither diminished through irrelevant and outdated artistic conventions, nor pushed into the service of metaphor or symbol.

Something dramatic was happening to Weston's thinking in 1922. That summer he wrote that the artist must respond to "the architecture of the age, good or bad—showing it in new and fascinating ways." And further:

> It would seem as though the greatest work from those who paint, etch or
> photograph must come from ugly or sordid surroundings—or at least
> from surroundings not too near a completion of grandeur—for one feels
> the artist's greater achievement when a New York slum—in all its sordid-
> ness—is raised to a glorification of reality. . . .[6]

This suggests that Weston was doing more than grappling with aesthetic issues, he was searching for new subject matter. Specifically, he was looking for a "sordid" subject to elevate through his art, a subject that he found at the ARMCO plant, an architectural example that could never be like a masterpiece such as the Taj Mahal, a building he felt was "already an end in itself."[7]

There are three known prints of the ARMCO plant and a fourth image that apparently exists only as a negative. In an untitled view of the skyline of Middletown [page 32], the smokestacks of the ARMCO plant are in the distance, little more than echoes of the utility poles and powerlines that recede from the foreground to the rear of the picture. In the second image, *Steel: ARMCO,*

3.
Ibid.

4.
F. C. Tilney. "Pictorial Photography in 1921," *Photograms of the Year: 1921*. London: Illife and Sons, n.d., p. 17. Quoted in Amy Conger, *Edward Weston: Photographs from the Collection of the Center for Creative Photography.*

5.
Edward Weston.
The Daybooks of Edward Weston, vol. 1: Mexico.

6.
Edward Weston. "Random Notes on Photography," pp. 5–6.

7.
Ibid. p. 6.

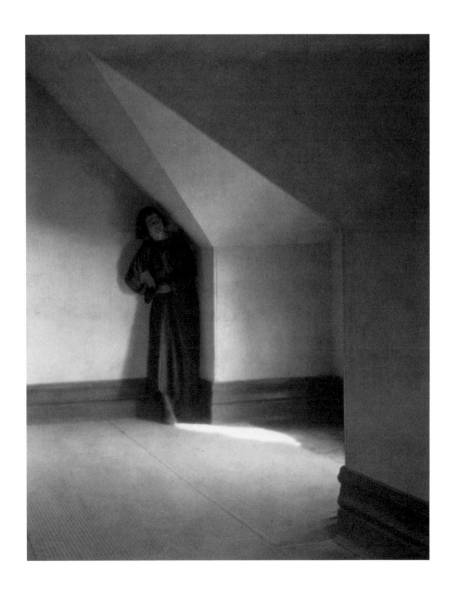

James McNeill Whistler,
Caprice in Purple and Gold No. 2 – The Golden Screen, 1864
Courtest Freer Gallery of Art, Washington, DC

Fig. 2
Betty in Her Attic, 1920, CCP

Margrethe Mather.
Johan Hagemeyer and Edward Weston, 1921, CCP

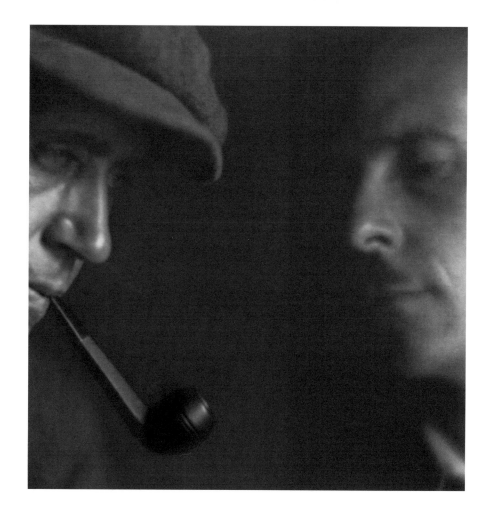

Middletown, Ohio, [page 57] the smokestacks tower almost directly overhead, fragilely linked by some powerlines to two dark, geometrical shapes that turn out to be fragments of the flanking buildings. In the third image, *Pipes and Stacks: ARMCO, Middletown, Ohio* [page 58], the smokestacks are framed by two immense, curving pipes and the side of one of the factory buildings. In palladium prints of these three images, the eerily transparent smokestacks and the sky, hazy with clouds or smoke, are elements directly out of the pictorialist tradition. But the unrelenting, minute detail of wires, windows, and tiny ladders running up the sides of each smokestack forms the essence of the modernist desire to equate clarity and detail with truth. The composition of stark, abstract shapes connected by rows of delicate, parallel lines is unequivocally Constructivist—an admiring and suitably geometric response to modern industry.

The ARMCO photographs complete Weston's long struggle to strip away from his art any references beyond the four edges of his pictures, to free his art from allegory, from allusions to any painting or print or photograph made before, from narrative and the sentimental, from history. Looking back at the pictorialist work, it is understandable how the cloth walls and polished wooden floors of his California studio and the sunny, white attics of his friends houses, seem almost quaint, restrained and self-consciously *artistic* in comparison with these images of power and physical presence beyond human scale.

But if the ARMCO photographs of November 1922 signal Weston's discovery of modern subject matter and a corresponding modernist aesthetic, an April 1923 session of photographing Margrethe Mather nude on the sand of Los Angeles' Redondo Beach in the bright sunlight [page 33] confirms that Weston had finally

left all traces of pictorialism behind him. There is very little in the history of photography before then that prepares us for Mather's unidealized nakedness.

At that point Weston had absorbed everything he could from his small circle of artist friends in Los Angeles, and he knew that to continue growing he would have to go to a city where the artistic fervor was at a higher pitch, and where art itself was being revolutionized and reinvented. For Weston, that place was Mexico City.

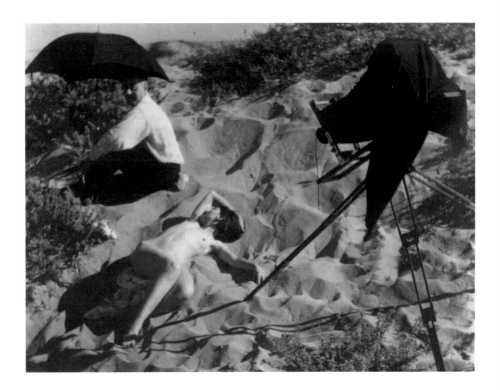

[Margrethe and Ramiel with camera on the beach] 1923

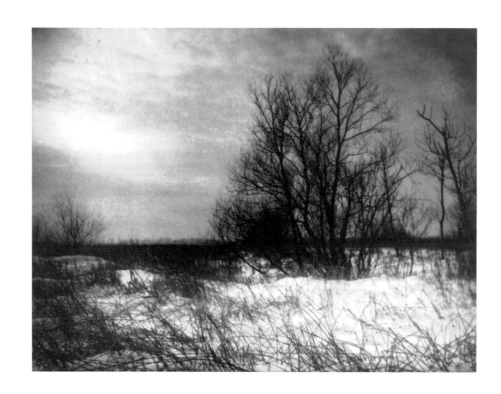

Snow Scene, Jackson Park, Chicago, 1903

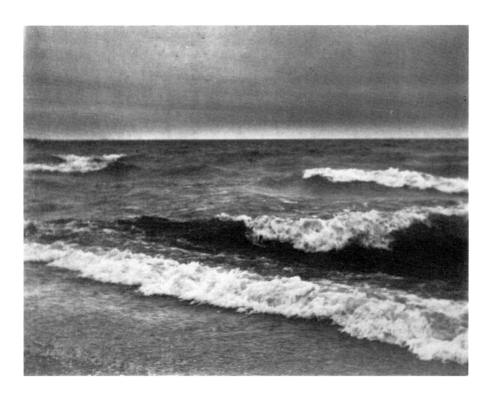

Lake Michigan, Chicago, 1904

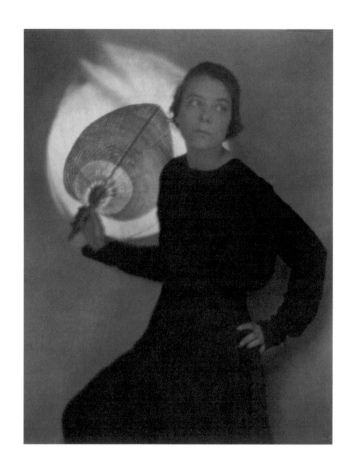

The Fan, 1917

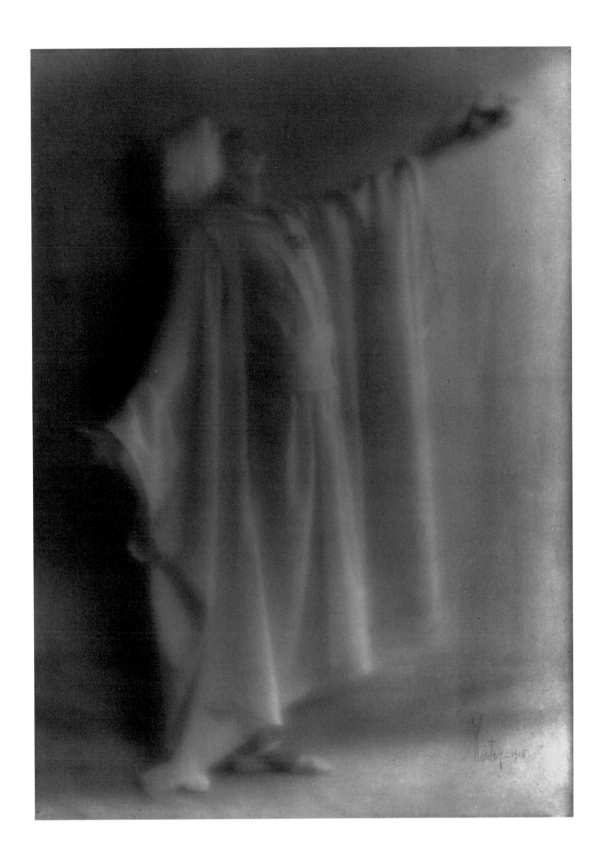

Ted Shawn, 1915

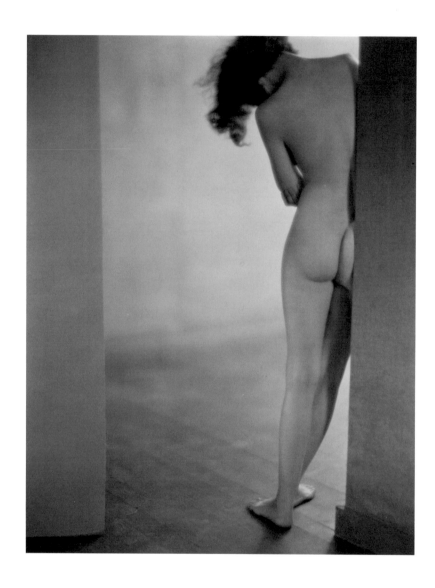

Nude, 1918

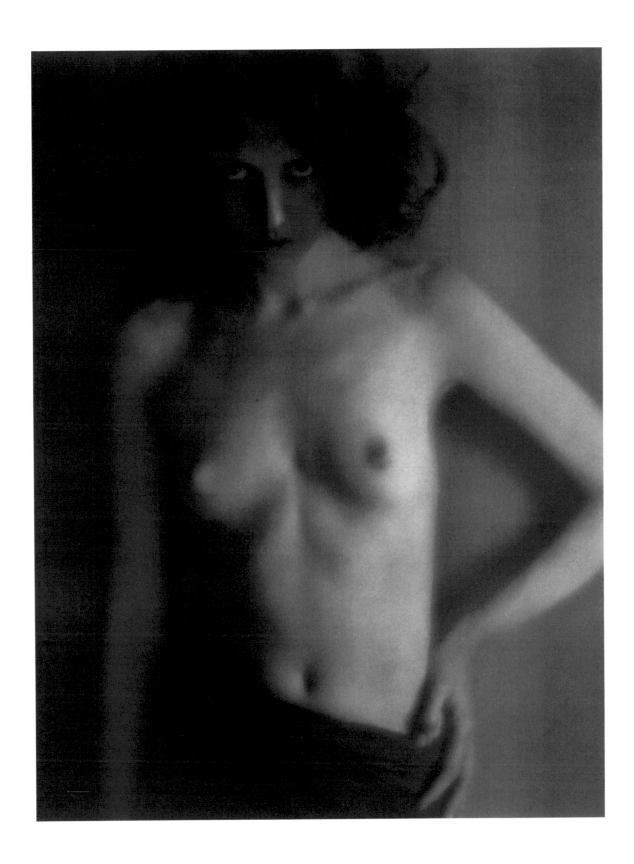

Nude, ca. 1918

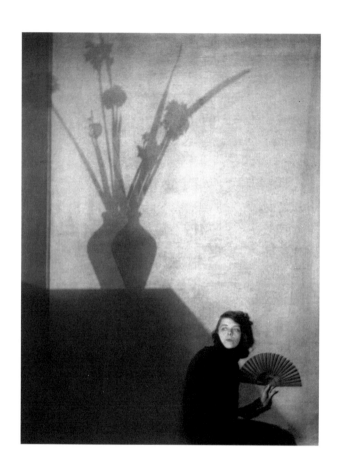

Epilogue, 1918

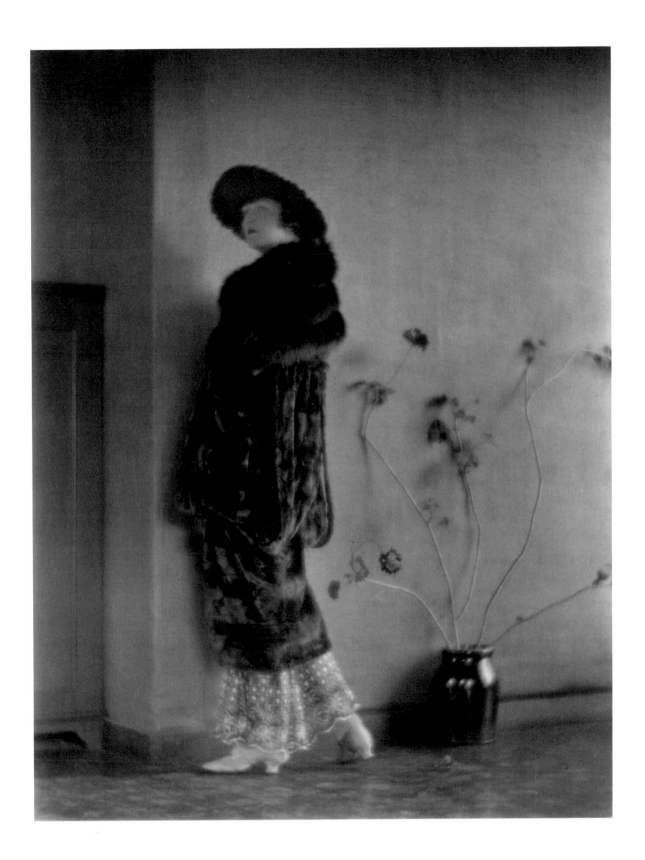

Untitled [Margarita Fisher in fur coat and hat, for Willard George Furs], 1919

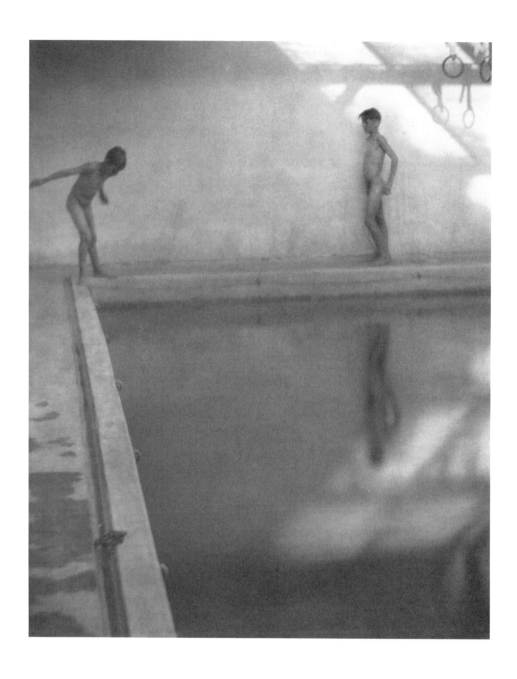

Bathers, 1919

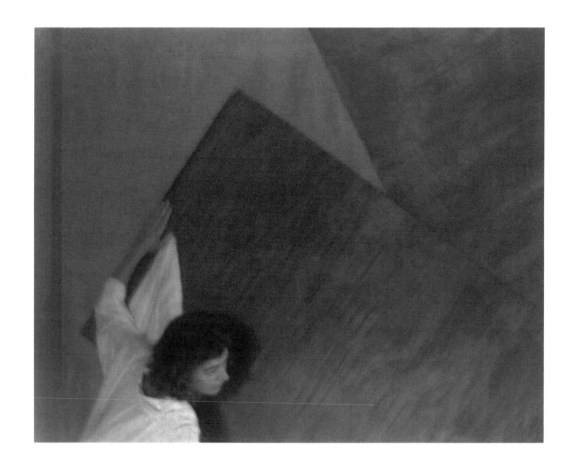

Betty Brandner, 1920

44

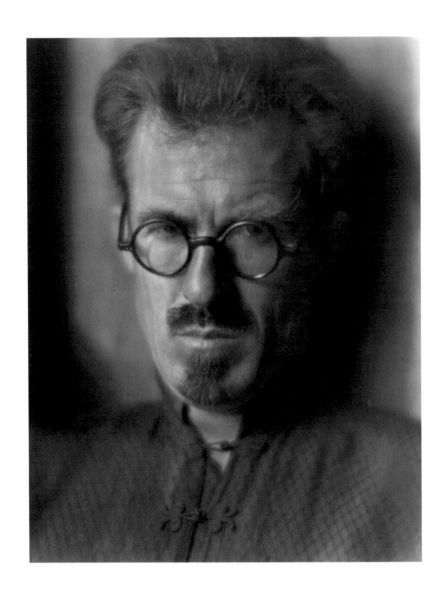

Roi Partridge, ca. 1921

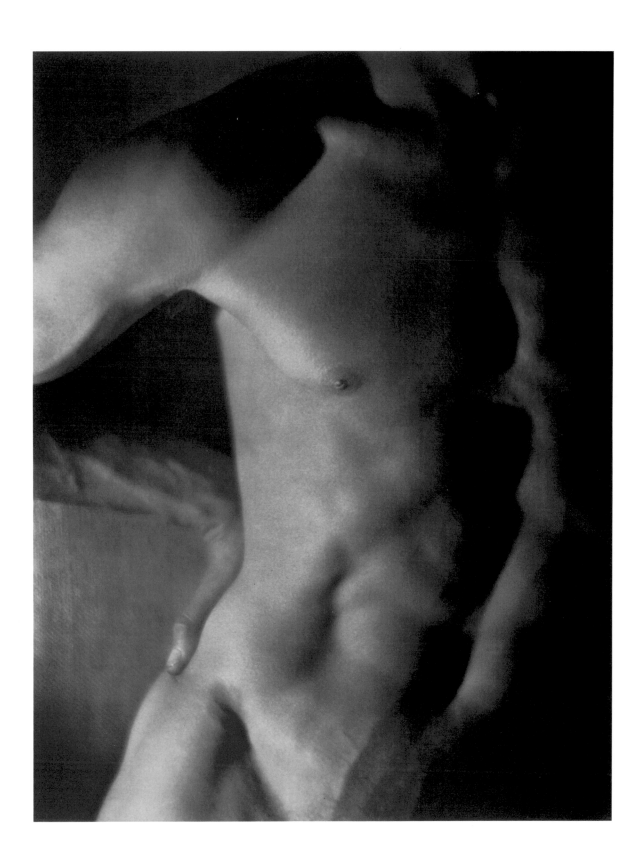

Torso, ca. 1918

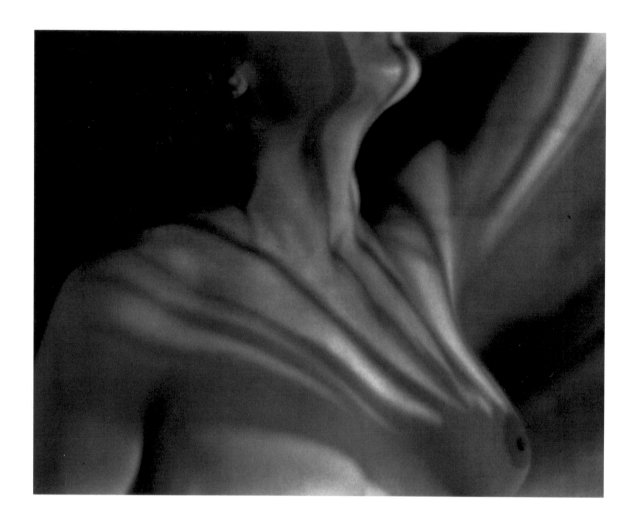

The Breast, 1921

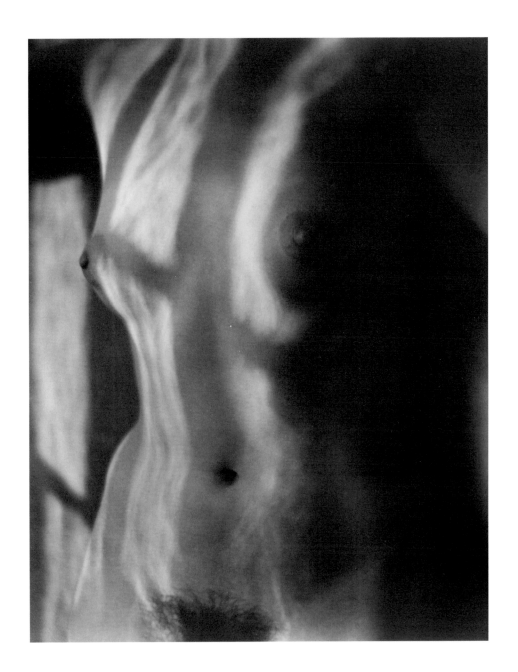

Refracted Sunlight on Torso, 1922

48

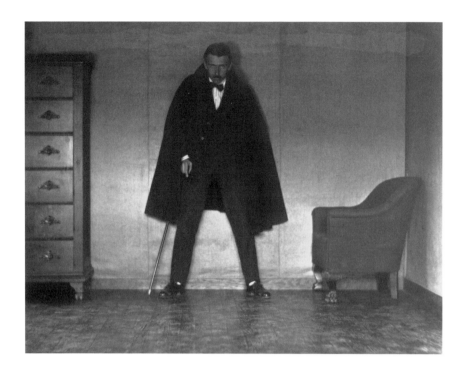

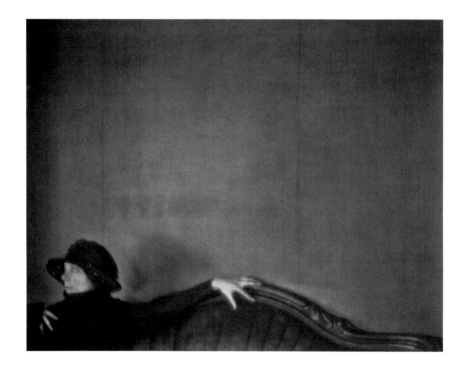

Jean Christophe, 1920

Untitled [Margrethe on couch, Glendale Studio], 1920

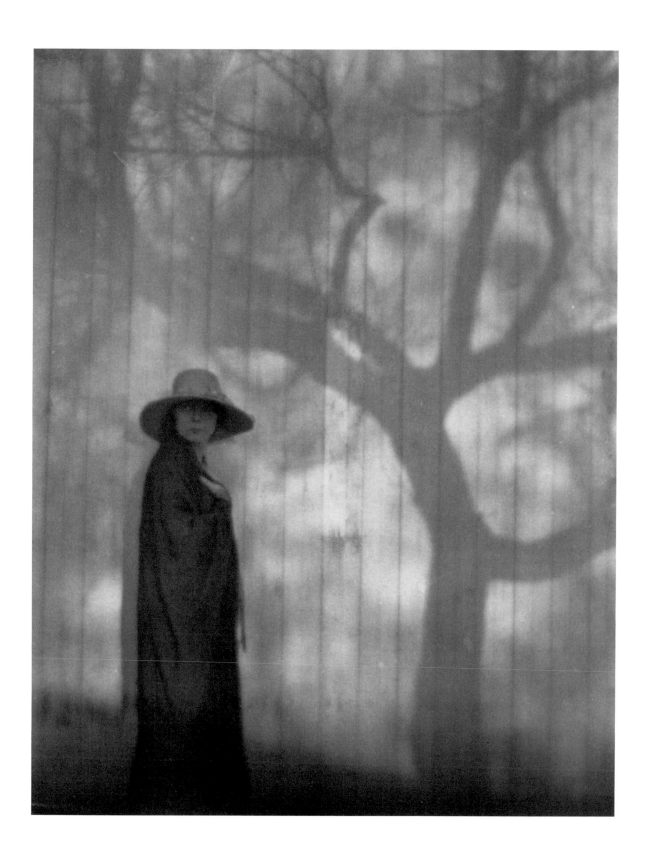

Prologue to a Sad Spring, 1920

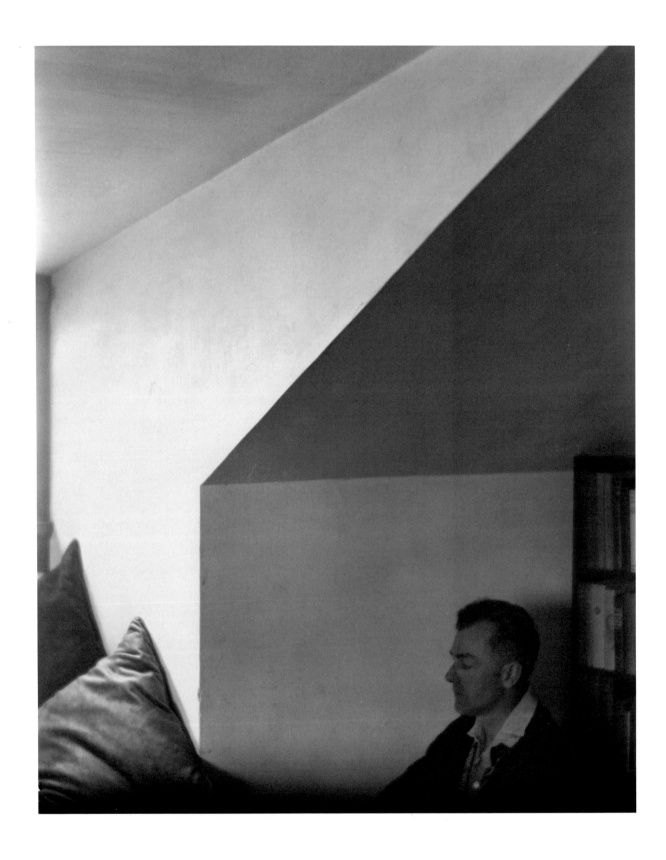

Ramiel in His Attic, 1920

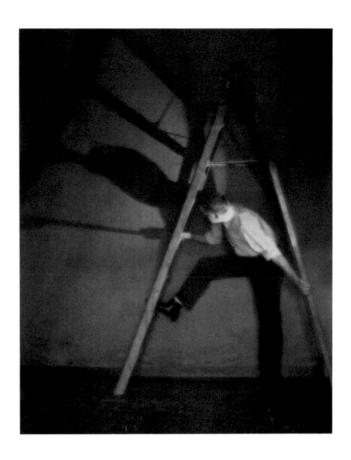

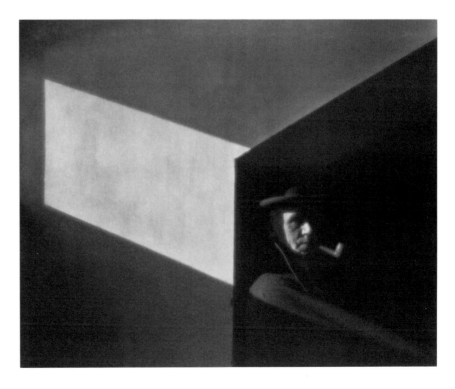

Scene Shifter, 1921

Sunny Corner in an Attic, 1921

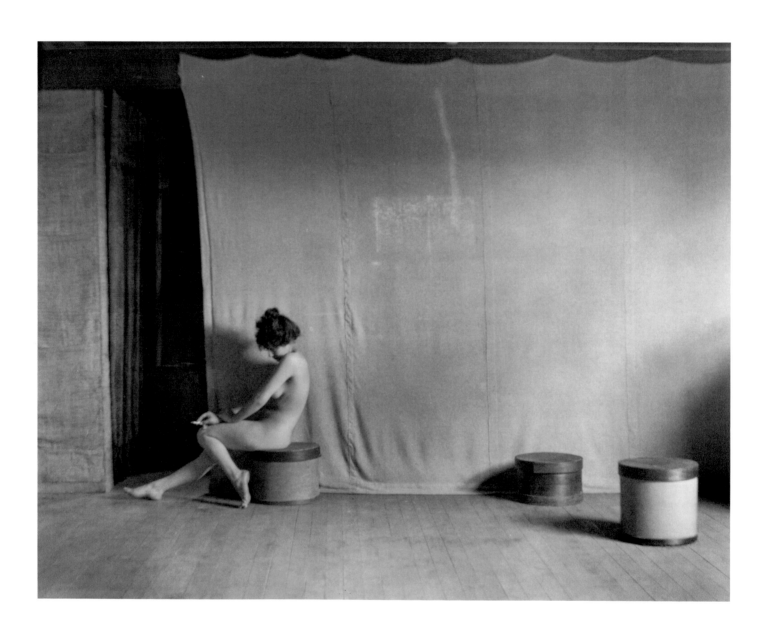

Tina, 1922

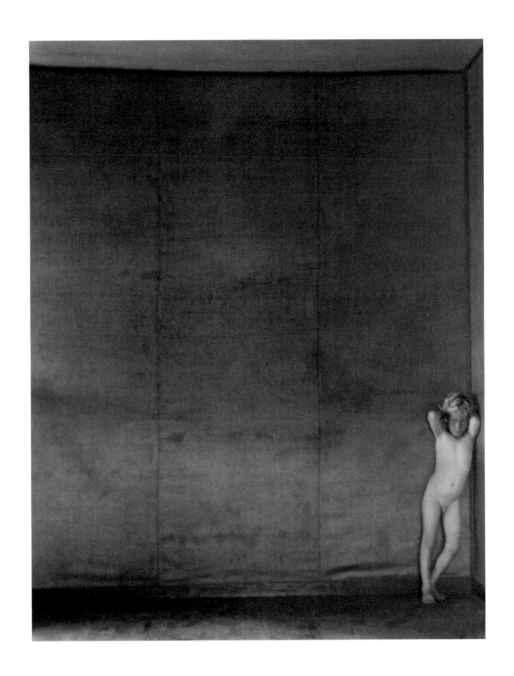

Neil, 1922

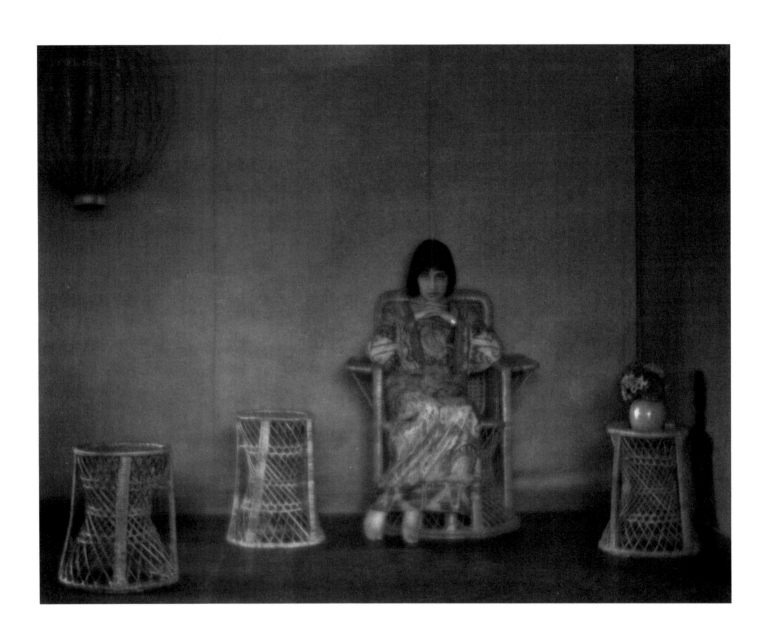

Tina Modotti, 1922

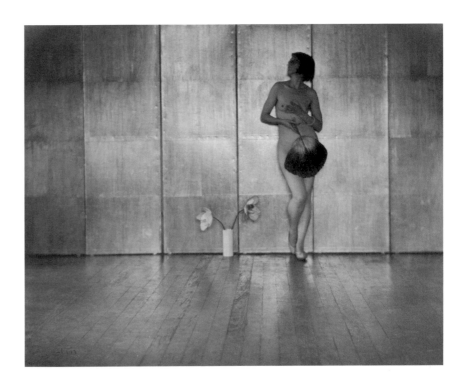

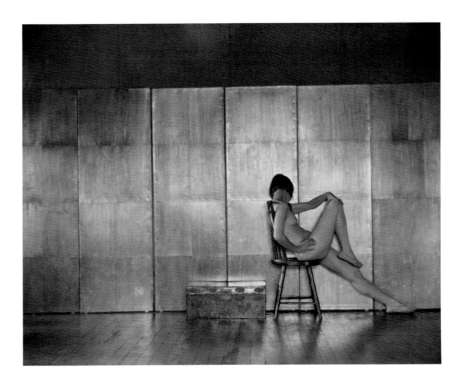

Margrethe, 1923

Margrethe, 1923

Ruth Shaw—A Portrait, 1922

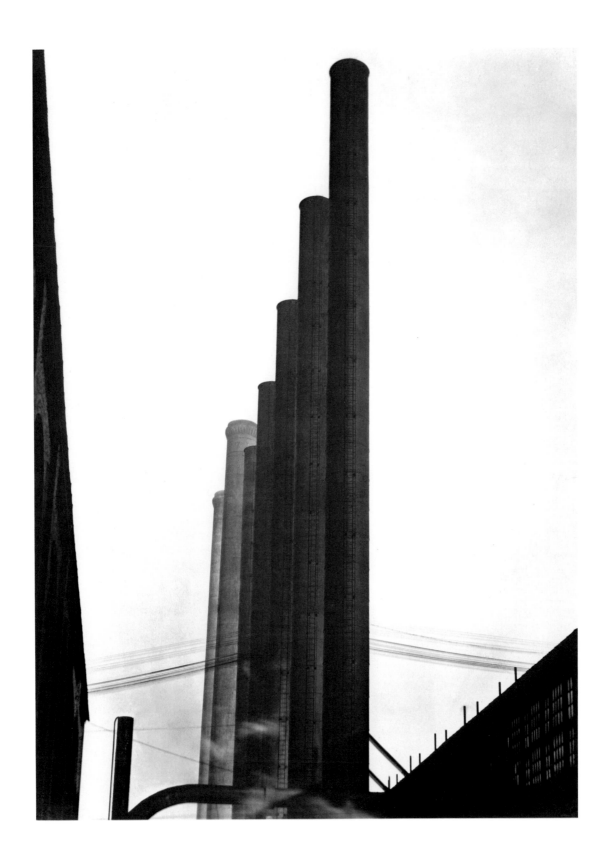

Armco Steel, 1922

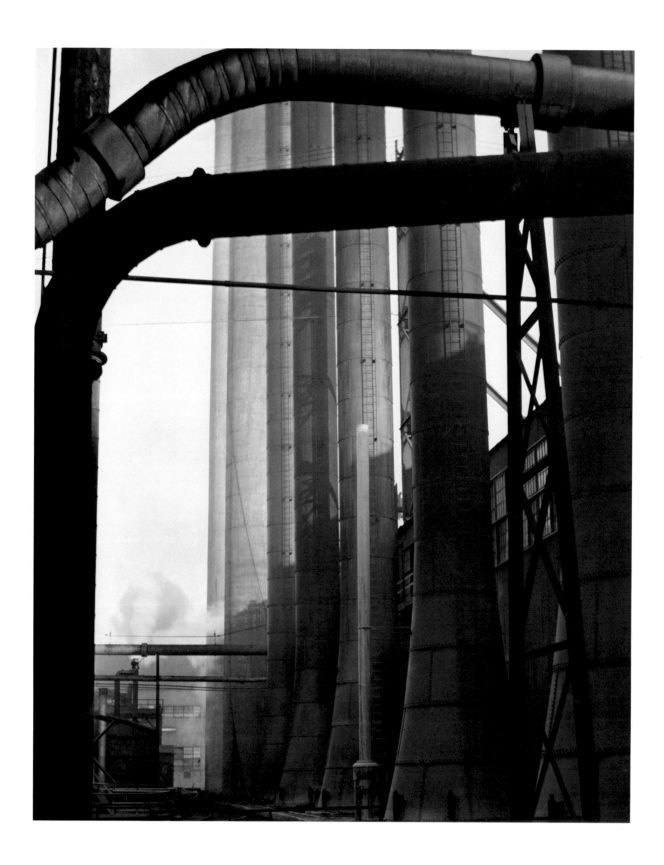

Pipes and Stacks: Armco, Middletown, Ohio, 1922

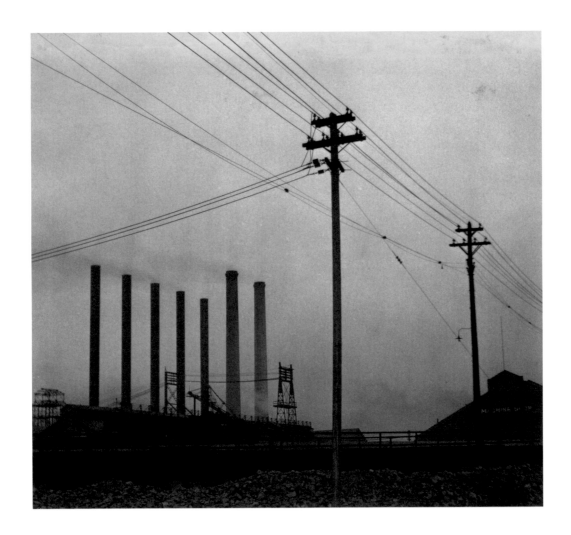

Armco, 1922

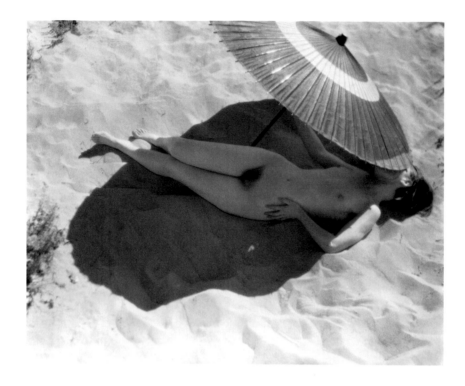

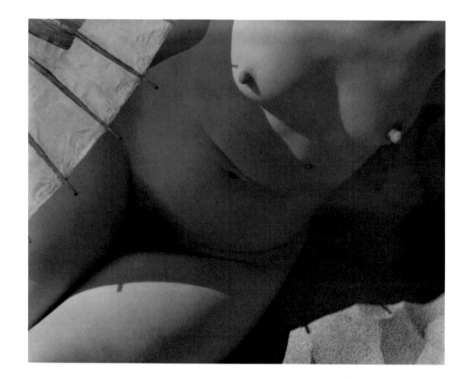

Nude, 1923

Nude, 1923

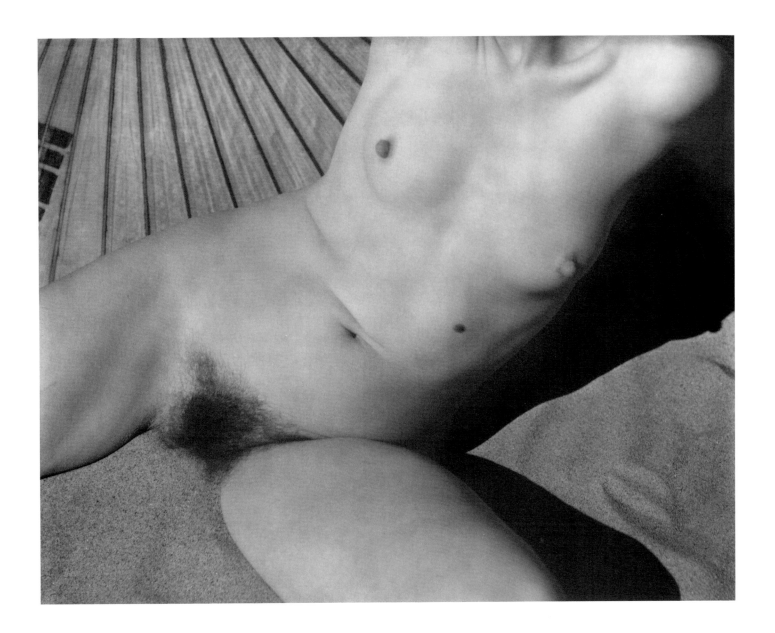

Nude, 1923

1923 1926

Photographer Unknown. *Edward and Tina in Mexico, 1924*, CCP

Weston in Mexico: A Testing Ground Gilles Mora

At the outset, Mexico meant one thing to Edward Weston: Tina Modotti. The urge to follow his Italian mistress may not have been the the only reason the California-based photographer felt compelled to desert his wife, his children, his business partner Margrethe Mather, and his friends in 1923; but it seems to have overriden all other considerations. He had grown weary of conventional domesticity, most of all his relationship with a wife he found uninspiring and schoolmarmish. (Yet he kept feeling twinges of guilt about Flora during his Mexican sojourn and sent her letters explaining why he had moved to a foreign country and—to put it bluntly—walked out on his family.[1]) Confident that the misguided phase of pictorial photography he had been gradually outgrowing since 1915 was now behind him, and with Tina, his photographic disciple, spurring him on, Weston was ready to wipe the slate clean. He craved a new life in a new land where he could be free both as a man and as an artist.

That land was Mexico, and Tina Modotti was to prove instrumental in opening it up to him. It hadn't been easy. He postponed his sailing date at least four times during the six months prior to his departure. There were a great many unresolved problems that needed ironing out, including the complicated business of rearranging his professional and family life.[2] The career he was jettisoning had thus far won critical acclaim; but with it came a sinking feeling—intensified by the previous November's trip to New York and personal contact with Stieglitz—that things had reached an impasse. Unless he found some way out, he might have to give up photography altogether.

His mistress Tina and his eldest son Chandler were at Weston's side when he finally boarded the S.S. *Colima* on 29 July 1923. Flora and their other three children (Brett, Cole, and Neil) looked on from the dock. Weston had no idea what the future might bring. Curiously, the man he had to thank for realizing how important Mexico might be to his career was Tina Modotti's husband, the painter Roubaix de l'Abbe de Richey (Robo). Even while Tina had been cheating on him, Robo had been instrumental in arranging an exhibition of American artists and photographers at Mexico City's Academia de Bellas Artes that included some of Weston's personal work. Robo died before it opened in March 1922. Tina, who had rushed back to be with her husband but got there too late, reported that Weston's work had scored a success among the artists who, even then, were known collectively as the Mexican Renaissance.[3]

Weston had a knack for clearheadedly assessing the impact of cultural climates on his developing thought and work. California was a dynamic hub of pictorial photography, and his personal work there had attracted not only notice but a measure of critical acclaim. The pictorialist entries Weston sent to American and foreign photographic salons between 1906 and 1915 won more than their fair share of awards and prizes. (Although Weston never manipulated his negatives or prints, his work at the time was suffused with the romantic, often allegorical haziness exemplified by Anne Brigman and Clarence White.) He was also a

Revolucion, 1926, Lane Collection

1.
"Did my departure and subsequent life have any of the ear-marks of a desertion? . . . When I reached Mexico City, my first move was to establish a business—why? To attempt to make money—why? for my family." (EW to Flora Weston, 22 February 1924. Edward Weston Archive, Center for Creative Photography, University of Arizona, Tucson).

2.
While he was away, Weston was to leave his Glendale studio in charge of his business partner, Margrethe Mather. He also worked out an unusual professional arrangement with Tina Modotti. Once they were in Mexico he would teach her photography, in return for which Tina would be responsible for running the portrait studio Weston planned to open there and, since he spoke no Spanish, also help with everyday matters.

3.
Writing to his friend Johan Hagemeyer, Weston quoted a now-lost letter Tina had sent from Mexico: "Tina wrote me that the exhibit is a great success in Mexico: 'already many of your prints have been sold.'" (EW to Johan Hagemeyer, 6 April 1922. Edward Weston Archive, CCP, Tucson).

4.
Under the influence of his friends, photographer Johan Hagemeyer and dancer Ramiel McGehee, Weston widened his circle of acquaintances to include Los Angeles intellectuals. For this period of his life see Ben Maddow, *Edward Weston: His Life* (New York: Aperture, 1989), 78-88.

5.
Quoted in Maddow.

6.
For a discussion of the influence of the Panama-Pacific International Exposition (San Francisco, 1915-17) on Weston, see Peter C. Bunnell's "Letter to the Editor" in Beaumont Newhall and Amy Conger, eds., *Edward Weston Omnibus: A Critical Anthology* (Salt Lake City: Peregrine Smith, 1984), 175-78.

7.
Nancy Newhall, ed., *The Daybooks of Edward Weston: I. Mexico; II. California.* (New York: Aperture, 1990), I, 55.

commercial photographer specializing in children's portraits. But all that—most of all the drudgery of the endless studio work and retouchings that were his bread and butter—left him dissatisfied.

Increasingly, Weston was heeding the voice within. But he was also attuned to the world of photography around him, to the urgent call of the newly emerging order of modern creativity. He had broadened his cultural horizons by associating with West Coast intellectuals[4] and had come to realize that it was not enough to be a commercial craftsman, a mere professional photographer: he had to be an artist. He suspected that might mean striking down whatever had been holding him back until then. As he put it to Stieglitz, his spiritual father, in July 1923, "To reconcile a certain side of one's life to another . . . to accept a situation without at the same time destroying another . . . it almost seems at this time I must be cruel— or else give up my own desires."[5] Thus, Weston had reached a point at which compromise seemed tantamount to a sellout. Living in Mexico would, he hoped, have a liberating effect not only on his personal life but on the aesthetic life with which it was so inextricably intertwined.

By the time he sailed from Los Angeles, the process of deconstruction was already under way. Weston felt an instinctive urge to find a virgin testing ground that would put his newly emerging art on sounder footing. Under the influence of the Photo-Secession, he had focused on pictorial photography. He began to reappraise this approach after coming into contact with modern art in 1915 and the aesthetics of straight photography that Stieglitz's and Strand's work exemplified.[6] But since a precipitate repudiation of pictorialism might jeopardize his livelihood, he had no alternative but to slough it off by degrees. Exposure to the then fashionable current of abstraction—he made some cubistic photographs inspired by Strand and modern painting—loosened the bonds somewhat for a while. But these exercises, which by 1923 he was already describing in Mexico as "intellectual juggleries," were less than wholly satisfying.[7] As early as 1922 Weston was awakening to the fact that photography's field of action had shifted toward realistic rendering of modern life. That was the year he made a few industrial photographs of the ARMCO steel plant in Ohio; they are noteworthy only in that they marked a new stage in his evolving

Caballito de Cuarenta Centavos, 1924, CCP

8.
"Weston to Hagemeyer: New York Notes, 1922," in
Peter C. Bunnell, ed., *Edward Weston on Photography.*
(Salt Lake City: Peregrine Smith, 1983), 42.

9.
Ibid., 43.

10.
Ibid., 37.

11.
Ibid., 39.

career and cannot compare with Charles Sheeler's factory landscapes in quality.

By year's end Weston had been to New York and met Stieglitz, Strand, Sheeler, and the exponents of a pictorialism he now considered anemic: the same Clarence White he once admired now struck him as "disappointing, lacking any vitality . . . I feel too much calculation in his work."[8] Weston reeled under the city's visual impact and the possibilities it held out to a photographer in search of a modern vision. The man who abhorred city life suddenly found himself rhapsodizing over what he thrillingly described in a long letter to his friend, photographer Johan Hagemeyer, as "man's most sublime folly—the 'proud and passionate' city of Manhattan."[9] In staccato spurts of thought that fairly explode with emotion, he seemed to repudiate wholesale the photographic credo he had clung to for so many years. Stieglitz's radical advice ("My last message to you is *work*—experiment—seek") struck home.[10]

In the same series of notes to Hagemeyer he resolutely announced, "We leave for Mexico in March—Tina, Chandler and I—this seems quite definite at this writing—I am working desperately in order to 'burn my bridges' behind me." That was in January 1923. But it took a confluence of people, events, and blighted hopes for him to bite the bullet. (Among other things, Flora had learned of Edward's many love affairs, which may have included his complex relationship with the dancer Ramiel McGehee, a close friend.)

When he returned to California in December 1922, it became increasingly obvious to Weston that his surroundings were at odds with what his art demanded of him. Fortified by a freshly aroused self-centeredness, Weston turned his back not just on one but two lives. (He justified this by pointing to Stieglitz: "Alfred Stieglitz, you are a superb egoist—madly—blindly in love with your work—but well you may be—and I am with you—and respect you for it."[11]) He defected from his role as upstanding husband, father, and upholder of Anglo-Saxon morality, and largely abandoned his position as a craftsman in the straitjacket of a career he had come to detest.

Not that he wasn't more than a little confident about the new course he was charting. He got into heated discussions with his friend Hagemeyer about an idea he had been mulling over in his mind, but whose revolutionary impact he had not fully grasped until he met Stieglitz and Strand: "Nevertheless—Johan—photography has certain inherent qualities which are only possible with photography—one being the delineation of detail . . . Photography is an objective means to an end—and as such is unequaled." (That thought became a *Daybook* entry of 20 April 1923).

That same month, with his departure from the United States only weeks away, Weston did some nudes of his apprentice and assistant, Margrethe Mather, at Redondo Beach, where at long last they made love. A new set of photographic priorities burst into view: interest in sculptural volume, use of close-ups, and unexpectedly frank, intense, if not provocative sexuality. (Here, revealing the subject's pubic hair proclaimed an unprecedented eroticism that resurfaced the following year in Weston's photographs of Tina Modotti on the flat tiled roof *[azotea]* of their first Mexico City apartment.)

This series signaled the emergence of a new aesthetic, not just of the human body, but of the way photography renders palpable qualities—sand, the texture of skin, the sensual realism of a beauty mark. These are the very things that Diego

12.
Daybooks, I, 26.

13.
Tina Modotti often acted as Weston's spokesperson when Mexican journalists interviewed him. A review in *El Universal Ilustrado* (18 October 1923) quoted her as saying that they had "left the United States because living there is unthinkable: restrictive laws, Prohibition, the Ku Klux Klan make it impossible for an artist to live there," thus implying that her lover took a more active role in liberal politics than was actually the case. Mexicans so closely identified Modotti with Weston's photographic aesthetic that they considered them virtually indistinguishable. There were a number of reasons: their joint exhibitions (the Guadalajara show of August 1925, where their work was regarded as interchangeable (only Modotti's name is mentioned in the announcement in the August 31 issue of *El Sol*); the fact that they sometimes photographed the same subject at the same time (the well-known *Circus Tent* series of 1924); and uncertain attributions (including many of the negatives from the Anita Brenner assignment in 1926).

14.
Edward Weston Archive, CCP, Tucson.

15.
Edward Weston Omnibus, 101.

16.
El Mundo, 11 October 1922. Weston kept this press notice in the exhibition visitor's book.

17.
El Heraldo, 28 September 1923.

18.
From Weston's Scrapbook D (Mexico years) (translated from the Spanish). Edward Weston Archive, CCP, Tucson.

Rivera, the father of the Mexican Renaissance, was to find so riveting a few months later. ("This is what some of us 'moderns' were trying to do when we sprinkled real sand on our paintings or stuck on pieces of lace or paper or other bits of realism"[12]). Weston seemed to be groping for a photographic idiom that had realism at its core, one he hoped an unfamiliar setting would coax to blossom.

What could he look forward to once he got to Mexico? Uncertainty and unpredictability on all fronts. The keen, exhilarating realization that he was making a fresh start did not alter the fact that, professionally speaking, things would be touch and go. Since he did not speak Spanish and for the time being found himself at a disadvantage when it came to relating to people around him, he relied completely on Tina Modotti to act as interpreter, explain unfamiliar social codes, and cushion the culture shock awaiting him.[13] The one thing he felt sure of was that the novelty of Mexico's politics—in which he took a purely intellectual interest—and cultural atmosphere could not help encouraging the freedom he longed for. To him, the most striking thing about Mexico was the way it mingled and distilled the beauty of pre-Hispanic cultures and the aberrations of modern life. "Mexico is a queer mixture of the old and new," he wrote young Brett in September 1923. "Right in the center of the city they are excavating an old Aztec city, buried for centuries. . . . We have together the old Mexico and . . . the new: electric signs—billboards—movies—autos and all."[14]

Weston's *Daybook* is at once a log of his years in Mexico—divided into two periods by a hiatus in California (January-August 1925)—and a chronicle of his aesthetic development. Although it is the gradual process of self-discovery that people find most intriguing, those who wish to understand it fully must not overlook the day-to-day events that accompanied and sometimes stimulated it. The cultural climate that greeted Weston in Mexico was overwhelmingly receptive to the new approach toward which his work was drifting. As Nancy Newhall put it, "In the real Mexico, the land and the people helped him to lose layer after layer of blindness."[15]

When an exhibition of one hundred prints that Weston had culled from his output since 1922 opened at the Aztec Land gallery on 17 October 1923, the Mexican Renaissance artists he had already met through Tina promptly hailed it as an "admirable and splendid vision of modern life."[16] Weston's first Mexican show garnered glowing press notices. Critics were surprisingly consistent in their appraisal of Weston's work as "an indication that photography should be in tune with the spirit of the time and therefore responsive to the modernity of objects seen through the lens . . . and not take machinery and industrialization for granted."[17] So favorable a reaction could not help confirming the radically new tack the American's photographs had taken in recent months.

Weston quoted theorist Marius de Zayas (a friend of Stieglitz's) on an exhibition panel as if to sound the knell of his onetime "artiness": "Photography is beginning to be photography, for until now it has only been art." Since Mexicans knew nothing of Weston's pictorialist past and little more of Stieglitz's, Strand's, and Sheeler's work, he found himself not only welcomed unconditionally but acclaimed sole champion of modern photography. As an article in *El Heraldo* concluded on 28 September 1923, "Weston's mission . . . is to make photographic art independent . . . and root out all ambiguity."[18]

Throughout his years in Mexico, Weston basked in the wholehearted approval

19.
From Weston's Scrapbook D (translated from the Spanish). Edward Weston Archive, CCP, Tucson. Weston copied part of this review in his daybook entry of 22 September 1925 and called Siqueiros's article" an exceptionally understanding treatise on photography."

20.
Weston looked up to Diego Rivera as a kind of teacher and often echoed the Mexican muralist's opinions. Rivera's past association with modern artists in Paris (Picasso, Matisse) fascinated him.

21.
Daybooks, I, 147 (entry of 15 January 1926).

22.
 "I might call my work in Mexico a fight to avoid its natural picturesqueness." (*Daybooks*, I, 66).

23.
"If Picasso had been in Mexico, I should feel that he must have studied the *pulquería* paintings, for some are covered with geometrical shapes in brilliant primary colors to excite the envy of a European modernist" (*Daybooks*, I, 73). Weston was interested in *pulquerías* linguistically as well as photographically. His Mexican scrapbook contains a handwritten list of some sixty bars, with English translations of their names. (Edward Weston Archive, CCP, Tucson).

24.
Daybooks, I, 188.

Fig. 1
Circus Tent, 1924, CCP

of the nation's leading artists, including Diego Rivera and the painter who was to organize Weston's first New York exhibition in 1930, David Alfaro Siqueiros. On 4 September 1925, Siqueiros's review of the Weston-Modotti exhibition in Guadalajara (August 1925)—the first meaningful critique of the photographer's work—appeared in *El Informador*. Its thrust was that the realism of his photographic idiom dovetailed with the medium's unique characteristics: "In Weston's photographs, the texture—the physical quality—of things is rendered with the utmost exactness: the rough is rough, the smooth is smooth, flesh is alive, stone is hard . . . In the impression of reality these photographs make upon the viewer . . . lies the beauty of the photographic aesthetic, which is inherently different from a pictorial aesthetic."[19] Concurring with Siqueiros's appraisal in his review of the exhibition (*Mexican Folkways*, April-May 1926), Diego Rivera drew a distinction between image (Weston's photography) and plastic creation (painting). He concluded that the prints on display embodied "*the* American artist, one whose sensibility draws on both the extreme modernity of . . . the north and the living traditions of the land of the south." That Mexico's artistic community so warmly embraced and endorsed Weston's photographic work was one of the great driving forces behind its efflorescence. For the first time he was receiving accolades not just as a craftsman, but as an artist, as a standard-bearer of the emerging school of modernist photography. And they were coming from the likes of Diego Rivera and other figures of undisputed stature.[20]

Certain aspects of Weston's body of work in Mexico command attention. To begin with, his range of subject matter broadened dramatically. Aside from the handful of industrial photographs from Ohio, 1922, he had confined himself from the outset to fairly conventional portraits and figure studies (not counting the Redondo Beach nudes of April 1923). It was as if the modern vision he craved could not be fulfilled for lack of ammunition, that is, the right kind of subject matter. But a veritable barrage of impressions hit his eyes the moment he set foot in Mexico. His first "negative with intention" (which he pointedly distinguished from his commercial work) was of a somewhat phallic cloud he photographed in Mazatlan on 6 August 1923 [page 74]. This "towering white column" signaled a philosophical turnabout, for with this literally natural shot there suddenly emerged a theme that was to loom large in Weston's future work: *evocative form*. It was to reappear in the "pear-like nudes" of Anita Brenner, 1925 [page 113].[21]

Mexico was not, however, totally unproblematic. For one thing, he found it difficult to keep his mind focused in a place where a seemingly limitless array of subjects vied for his camera's attention.[22] Weston the photographer was awakening to the outside world for the first time. His occasional nods to Cubist painting (*Ramiel in His Attic, 1920,* page 50) and his industrial photographs had been nothing more than exercises in a pro forma modernism widely practiced at the time. He had always shied away from everyday occurrences, the nuts and bolts of life itself. Not that Weston suddenly took his camera into the streets, although *Calle Mayor* or *Pissing Indian, Tepotzotlan, Mexico, 1924* (page 97) which he photographed from the terrace of his first Mexico City apartment, have the look and feel of a snapshot. The great lesson he was to learn from the Mexican culture around him, and from the artists who celebrated it, was the function and potential of vernacular realism. Merely seeing the artwork of Rivera, Siqueiros, and other artists in Mexico motivat-

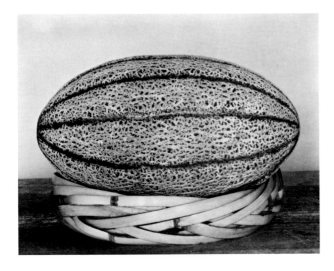

Fig. 2
Two Swan Gourds, 1924, CCP

Fig. 3
Melon, Glendale, 1927, CCP

ed Weston to shed the heavy-handed abstraction that had informed his early for-malist photographs and culminated in the schematic patterns of the *Circus Tent* series, 1924 (Fig. 1), and *Piramide de Cuernavaca with Two Landings, 1924* (page 99). They helped open his eyes at long last to everyday life at its most mundane (the undisputed object lesson being the now famous *Excusados* of 1925, page 109).

Mexico taught Weston to be responsive, not just to the beauty of perfect form, but to folk art, imperfections and all. Witness his countless photographs of toys, crockery, *pulquerías* (bars)[23], the everyday backdrops and props whose visual poetry he came to appreciate. Close contact with this alien land and culture, this hybrid of European (read: Hispanic) complexity and Indian handicraft, cast away the reference systems that had sapped his vision of vitality from the outset. Freed from truisms, this aspect of Weston's approach suddenly showed signs of real freshness, although—and perhaps it was just as well—his "serious" work still varied markedly in quality.

Weston's many photographs of the Mexican toys he collected have often been dismissed as little more than a pastime. In the early 1950s, Nancy Newhall omitted the photographer's countless, painstakingly drafted descriptions of these *juguetes* from what was to become the first volume of the *Daybooks.* However, these seldom repro-duced pictures represent more than an endearing hobby. They are full-blown still lifes. Weston rearranged them again and again, and the care he lavished on them sug-gests how much they meant to him. In terms of sheer quantity, he photographed toys and handicrafts more often than any other subject while he was in Mexico. Their per-sistent frontality, neutral backgrounds, and formal reductiveness foreshadow the aes-thetic that was to inform the plants, vegetables, and other objects he began pho-tographing when he returned to California in 1927. Some were purely documentary pictures for *Idols Behind Altars,* Anita Brenner's book on Mexican folk art. Others— *Two Swan Gourds, 1924* (Fig. 2), the elegant *Bird, Penguin, Palma* (1926), and above all the famous *Tres Ollas, 1926,* (page 77) in which René d'Harnoncourt, future director of New York's Museum of Modern Art, saw "the beginning of a new art"—were already infused with the aesthetic of revelation that blossomed with the shell series of 1927.[24] At the same time, the understated candor of these Mexican still lifes lends them a delicate freshness and charm that Weston was to avoid thereafter. (He recaptured it once in *Melon, Glendale, 1927* (Fig. 3), which was shot on the same wicker stand he had used for many of the Mexican objects).

In Mexico City, Weston soon realized that the city itself had very little in com-mon with the American cities that provided the modern vision of photography with most of its subject matter. Like the country surrounding it, the capital had an untamed, primitive, barbaric quality he found fascinating. Jean Charlot, a French painter living there at the time and whose company Weston greatly enjoyed, was one of the first to take the true measure of the shift in his friend's attitude. The new photographic vision emerging in both the United States and Europe drew most of its inspiration from urban and industrial themes. From his earliest Mexican land-scapes, Weston seems to have systematically bucked the trend.

During Weston's nine-month California interlude in 1925, Charlot made a per-suasive case for returning to Mexico: "Professionally, I think you can do better work here than in the States. Many artists are trying to capture through photogra-phy the spirit of modern industrial life, but you will be the first to use this medium to convey the simplicity of primitive life."

25.
In April 1926, Anita Brenner, who had posed for the "pear-shaped" nudes of 1925, commissioned Weston to photograph Mexican religious and folk art around Oaxaca and Guadalajara (400 negatives to be printed in three sets). With Brett's assistance, Tina and Edward accomplished this feat of photography during an odyssey that lasted from June to November 1926.

26.
Edward Weston Archive, CCP, Tucson.

27.
In many letters to Flora, Weston repeatedly intimated that he might publish a report on Mexico combining text and photographs. "I continue on with my work and writing—gathering material from Mexico . . . which is very possibly for publication too."
(Edward Weston Archive, CCP, Tucson).

28.
Daybooks, I, 55.

29.
Weston seems to have had mixed feelings about Lawrence's books. He was in favor of what they had to say, particularly about love and sex, but also thought them ponderous and often didactic: "Better to write a book of facts and statistics on sex psychology." (*Daybooks*, I, 120). Moreover, Weston was never satisfied with the portrait he did of Lawrence while in Mexico.

30.
See Margaret Hooks, *Tina Modotti: Photographer and Revolutionary*. (London: Pandora, 1993), 36–37.

Fig. 4
San Cristobal Ecatepec, 1923, CCP

Mexico taught Weston simply how to stop and look at what was around him. His interest in its largely agrarian folk culture had anthropological overtones that reflected a trend he learned about through the artists of the Mexican Renaissance and avant-garde publications. One of Weston's industrial photographs (*Smokestacks, 1922*) appeared on the cover of the third issue of *Irradiador*; its second issue, which he carefully kept among his papers, ran an editorial ("El Estridemos y la Teoria Abstraccionista") that took a stand against overzealous abstraction. Contributors to *Mexican Folkways*, a bilingual illustrated magazine "*dedicata a tradiciones y constumbres indigenas*," included the painter Rafael Sala, Diego Rivera, José Clemente Orozco, Communist writer Carleton Beals, and Anita Brenner.[25] An advertisement for Modotti's and Weston's studio appeared in its very first issue.

The earthy, teeming pageant of real life Weston found himself thrust into, and which the local intelligentsia had validated, was worlds away from the hypocritical middle-class values of North American culture. "These Mexican cities!" he enthused in a letter to his family (8 August 1923). "How beautiful! Beyond my expectations . . . I feel intensely the drama of life here, it is always either black or white, never gray. Gone are the gray people, the gray houses, and grayer minds of Los Angeles or Glendale."[26] Exhilarated, captivated, Weston felt that the time had come to give the documentary aspect of photography its due.[27] Of course, he did not put it as matter-of-factly or pragmatically as that. But he obliquely addressed the issue in his *Daybook* by making a number of statements about "life," which he now considered all-important and consistent with the inherent objectivity of his medium. "The camera," he wrote, "should be used for a recording of *life*, for rendering the very substance and quintessence of the *thing itself*. . . . I feel definite in my belief that the approach to photography is through realism."[28]

Mexico's exuberant culture and often violent way of life lent fresh urgency to his need for a physical art pulsing with life, for photography rooted in the real world. Weston is known to have met D. H. Lawrence while he was in Mexico.[29] The extent

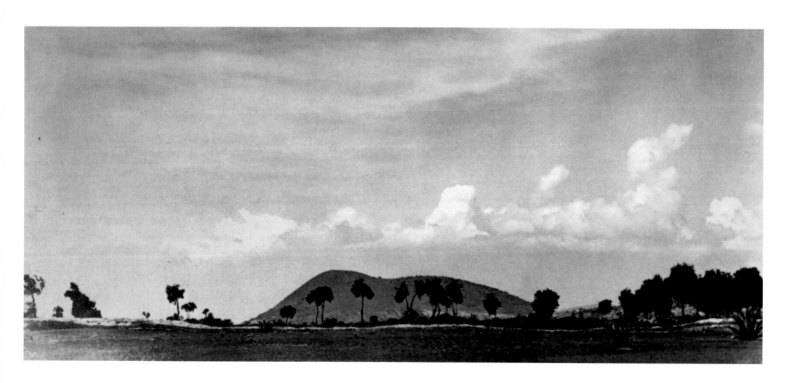

31.
Edward Weston Archive, CCP, Tucson.

32.
"Economic pressure . . . kept me waiting in the studio for work which seldom came. It turned me to photographing toys—juguetes, which have their place, still life: but I should have had more chance to go out." (*Daybooks*, II, 247).

33.
"These landscapes, practically the first I have done since I began photography . . . The reason, lack of time and opportunity . . . mainly lack of desire." (*Daybooks*, I, 89).

34.
"In fact, the camera proves that nature is crude and lacking in arrangement, and only possible when man isolates and selects from her . . . Most photographic landscapes, unless they be mere fragments, could have been better done using some other medium." ("Random Notes on Photography, 1922," in *Edward Weston on Photography*, 31–32).

35.
"Statement, 1930," in *Edward Weston on Photography*, 62.

36.
"I do respond to nature as she is presented here in Mexico. This view is a beauty, a real joy to me." (*Daybooks*, I, 89).

37.
"Considering my recent photographs—a landscape done near Ajusco I shall finish; it is simple, quite dependent on a delicate sky of horizontal clouds, almost ruled lines across the negatives." (*Daybooks*, I, 107).

Fig. 5
Palma Cuernavaca, with leaves, 1924, CCP

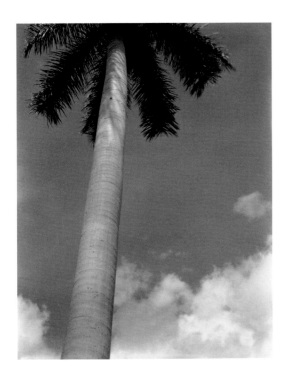

to which he may already have been influenced by John Cowper Powys, a leading advocate of uninhibited sensuality and sexuality and a member of Weston's California circle in 1920–21, is less certain.[30] At any rate, the realism that was working its way into Weston's photography—not only in portraits and nudes (particularly those of Tina Modotti) but in his early Mexican landscapes—throbs with sensuality. This newfound concern is apparent in a note from 1924: "I should like to be able to instill in the mind of each boy a profound concern with life itself. . . . The trouble with the whole sad—drab—hectic mess we so proudly boast of as 'civilization' is in the fact that we are almost totally concerned with the means toward life than life itself. . . .We are indeed a sorrowful lot to be scorned by the veriest savage."[31]

A primal, redemptive vitalism seemed to pervade everything he saw in Mexico: the natural landscape, the sky, the clouds and other great organic forms he felt increasingly drawn to, the *corridas* (bullfights) he was so fond of, the portraits he started making soon after he arrived, of Nahui Olin (page 79), and Guadalupe Marín de Rivera, both in 1923, and Lupe Rivera herself, Diego's fascinating wife. Weston was now photographing out of doors and would have done so more often had the commercial portraiture on which he depended for a living not confined him to his studio.[32] But what natural scenery he managed to see elicited an elegant formalism (*San Cristobal Ecatepec, 1923,* Fig. 4) and a resourceful handling of distant views that would not be seen again with any regularity until he traveled through the West for his Guggenheim project (1937–39).

At this stage of his career, Weston had never given landscape serious attention. (Yet, the very genre he seemed to avoid ought reasonably to have appealed to him given its close ties with pictorialism in general, and the work of California photographers Anne Brigman and Roger Sturtevant in particular.) It took twenty years for Weston finally to come to grips with nature as a photographic subject.[33] Up to that point he reacted to it with a host of preconceived notions, the most serious of which, in his view, was that landscape unaltered by man "is simply chaos." In a series of notes (1922), Weston went so far as to argue that landscapes did not lend themselves to the medium of photography precisely because unadulterated natural elements were, from the standpoint of form, uncontrollable "unless they be mere fragments." "Photography," he concluded, "is much better suited to subjects amenable to arrangement or subjects already co-ordinated by man."[34]

As Weston began photographing landscapes in Mexico, he found out how difficult it was to meaningfully structure the disorder of nature with a camera. Later on, in 1929, when he began working at Point Lobos, California, he found a way around the problem of the inchoate landscape through close-ups of rocks and plant life, by dividing nature into fragments he believed were part of a mighty "coherent whole" in which "rhythms from one become symbols of all."[35] In Mexico, however, spurred on by the sights constantly beckoning him, he met the problem head on.[36] He would allow clouds to act as powerful organizing elements in his photographs of the sky.[37] His rooftop *azotea* became an observation point for shots looking down on plazas or surrounding streets; often densely packed and horizonless, these compositions occasionally include the human element (*Cross, Tepotzotlan, 1924*—page 96—and *Pissing Indian, 1924*—page 97). The ones he did of the inner courtyard of his first Mexican residence in Tacubaya (pages 80 and 81), are characterized by a planar intricacy that recurs in *Desde la*

38.
Daybooks, I, 92.

39.
Daybooks, I, 79.

40.
In his daybook entry of 12 December 1924, Weston describes one of the symbolic dreams he often had, and which speaks volumes about his fear of losing control: "A dream I had of the night just passed: someone . . . perhaps Tina or Chandler—came running to me and called, 'Come quick. There are the most wonderful cloud forms for you to photograph.' I hurried, regulating my Graflex as I went. But once out of doors I was terrified, for black ominous clouds bore down on me, enveloping me: I seemed about to be overwhelmed, I dropped my head into my arms to protect myself from the sweeping forms and slammed the door to keep them from me." (*Daybooks*, I, 109).

41.
Weston could never relate to the aesthetics of New Photography in Europe; he thought its formalism too gratuitous. "Neither do I contact with the photography by Moholy-Nagy—it only brings a question—why?" (*Daybooks*, I, 190).

42.
Daybooks, I, 91.

43.
"Statement, 1930," in *Edward Weston on Photography*, 61.

44.
Ibid.

45.
Ibid.

46.
"Statement, 1930," in *Edward Weston on Photography*, 62.

47.
EW to Flora Weston, October 1924. Edward Weston Archive, CCP, Tucson.

Azotea, 1924 (page 98), "an attempt to amalgamate widely diverse objects, to unify them, to present them as a complex but coherent whole."[38]

Weston's photographic activity in Mexico could thus be viewed as an attempt to bring order to a country where disorder was the norm. "The instability of Mexico . . . is maddening," he commented at one point.[39] The appropriate response was form, the now-famous "coherent whole." Weston proceeded to strip form of non-essentials; that would be his bulwark against the endemic anarchy he found so distressing.[40] His photographs were already drifting away from the "intellectual juggleries" he had written about earlier and setting the stage for an entirely new kind of photography.[41] His print *Palma, Cuernavaca, with Leaves, 1924,* marked the first step toward the revelation that would, in time, become an article of faith.

That was the first of two versions of a palm tree. In the earlier photograph, (Fig. 5), the subject's fronds make it immediately recognizable. But the strikingly stark image of 1925 (page 107), where all we see is a cylindrical trunk, brought Weston that much closer to the decontextualization that gradually became the hallmark of his photography. As he pondered the outcome, he sensed something uniquely and fascinatingly beautiful about an object that was not only a factual record of a palm trunk, but a work of art, a formalized image of a tree trunk created through pure photography: "Yet, this picture *is* but a photograph of a palm, plus something—something—and I cannot quite say what that something is—and who is there to tell me?"[42] A clear-cut answer to that question was not to come until 1930: the "plus" his photography was edging toward in Mexico was what he called "significant representation . . . not interpretation."[43] Elsewhere he referred to it as "the thing itself . . . the quintessence revealed direct."[44] As a result, the photographic object—the print—assumed unprecedented importance as something "which is but a duplication of all that I saw and felt through my camera."[45]

Thus Weston's Mexican photographs fall naturally into a number of categories, ranging from documentation (including the countless pictures of Mexican folk art, particularly the toys), to the formally sublimated images of utterly mundane objects (toilet bowls, water gourds, tree trunks).

But many of the photographs from Mexico linger in a transitional area between documentation and revelation. Perhaps that is why the portraits from this period are so extraordinarily powerful, and why nothing quite like them ever reappeared in his subsequent work. The famous *Manuel Hernández Galván, Shooting, 1924* (page 93), and other portraits Weston made in Mexico possess an unprecedented urgency that could not have stemmed either from his commercial experience or his evocative but stagey pictorialism. A comparison of his early portraits of Tina Modotti (*The White Iris, 1921*, Fig. 6) and the *Tina Reciting* series from Mexico, 1924, Fig. 7, shows that he had progressed to experimenting with photography as a means of instantaneous recording, "to attempt the registration of her remarkably mobile face in action." That is precisely what he had in mind when he photographed Galván's face the moment the Mexican senator fired his Colt. In these few images, Weston had shifted from the sphere of conventional portraiture—the dubious business of conveying a subject's presumed inner self—to the kind of emotion in motion that only still photography can capture. It is the resonance of that motionless instant that gives *Galván Shooting* its emblematic impact. In 1930, possibly still influenced by futurist theories of motion in art, Weston spoke of photography's capacity to record instan-

48.
EW in San Francisco to Flora Weston, 4 April 1925 (Edward Weston Archive, CCP, Tucson). Yet, he was to voice misgivings about what he had done there. Looking back on the Mexican period a few years later, he wrote, "I admit my failure in Mexico—not complete, I have some strong records—but as a whole, I now realize how much more profoundly I could have seen" and attributed that partial failure to "immaturity, psychic distress, and economic pressure." (*Daybooks*, II, 247).

49.
Daybooks, I, 55.

50.
EW in Mexico City to Ramiel McGehee, 18 April 1926: "Analyzing the recent work (in Mexico), I might say that in the past my aim was interpretation; now I am content with presentation . . . I am becoming more definite." (Edward Weston Archive, CCP, Tucson).

Fig. 6
The White Iris [Tina Modotti] 1921, CCP

Fig. 7
Tina reciting, 1924, CCP

taneously as one of the unique characteristics that set it apart from other mediums: "shutter coordinating with vision at the second of intensest impulse . . . The creative force is released coincident with the shutter's release."[46] A click echoed by Galván's unseen trigger.

Thus, for nearly three years, Mexico proved a productive testing ground for the new attitude Weston was bringing to bear upon his photography. That he did so wittingly is apparent in his letters to Flora: "I am doing work here which shall sooner or later create a grand 'splurge' in New York or elsewhere."[47] Back in California six months later (but anxious to get back to Mexico, and Tina), Weston was already taking stock of what he had accomplished thus far in Mexico: "I was doing the first creative work of any importance in my life."[48]

He had learned that "the approach to photography is through realism—and its most difficult approach."[49] He was to stick to that approach, unswervingly, from that point forward. The insightful, self-conscious Weston realized, even as he was living it, that his experience in Mexico was fostering his growth as a photographer and providing the key to what would become a distinctive aesthetic idiom. Between the *interpretation* of his pictorialist phase and the *revelation* that was to inform his vision in the years to come, Weston had to go through an intermediate stage of *presentation*, a quasi-direct approach to subject matter. That is what he did in Mexico.[50]

Translated from the French by I. Mark Paris

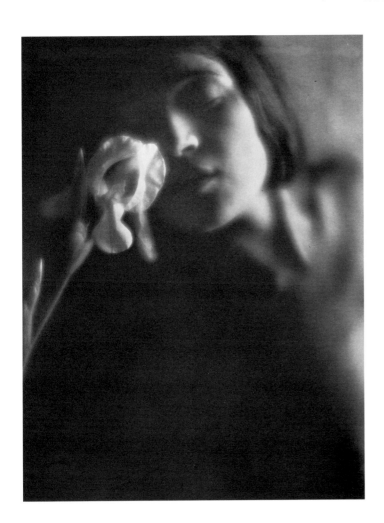

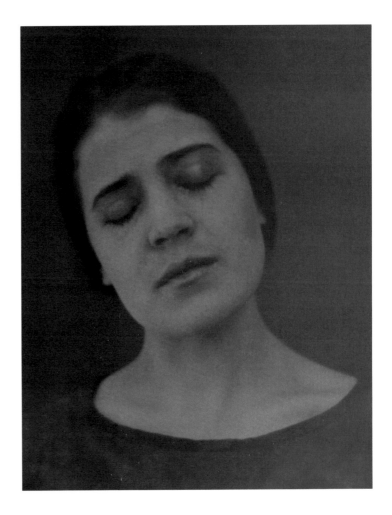

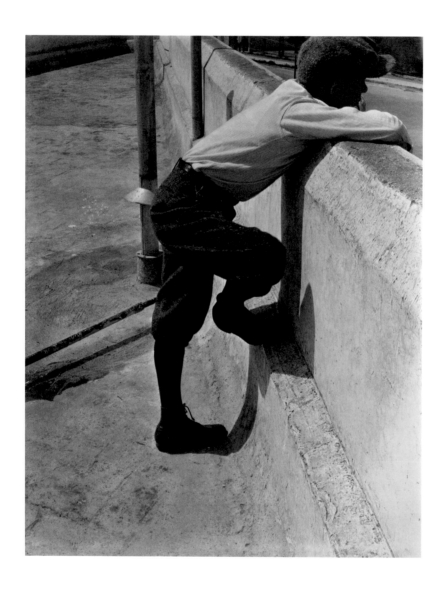

Chandler, 1924

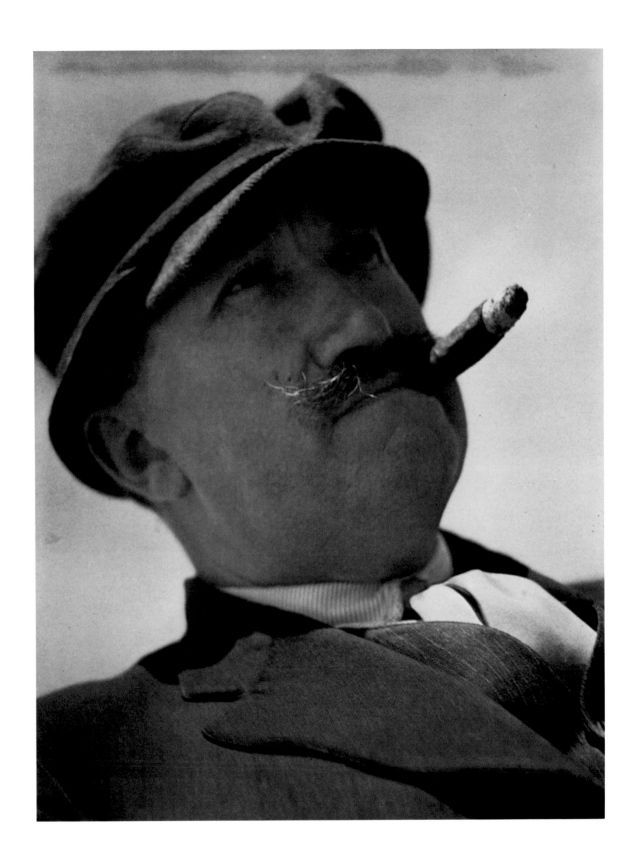

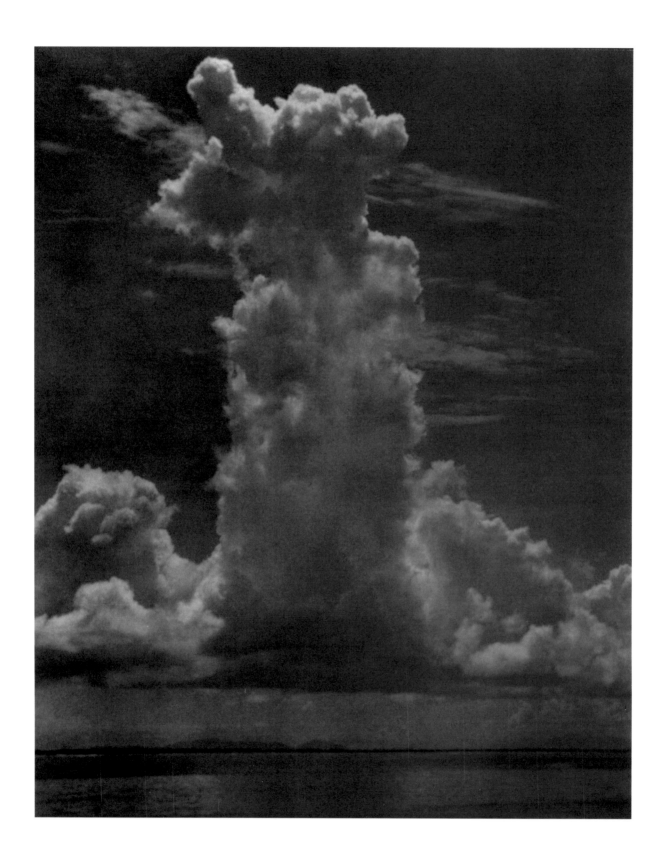

The Great Cloud, Mazatlàn, Mexico, ca. 1924

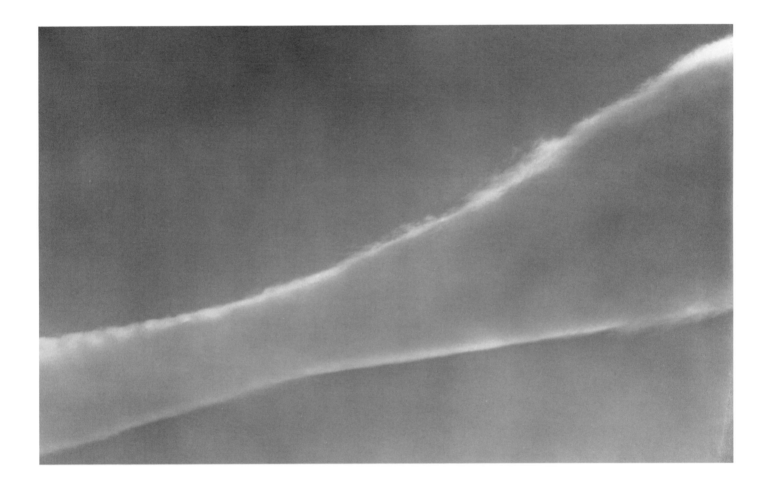

Cloud, Mexico, 1926

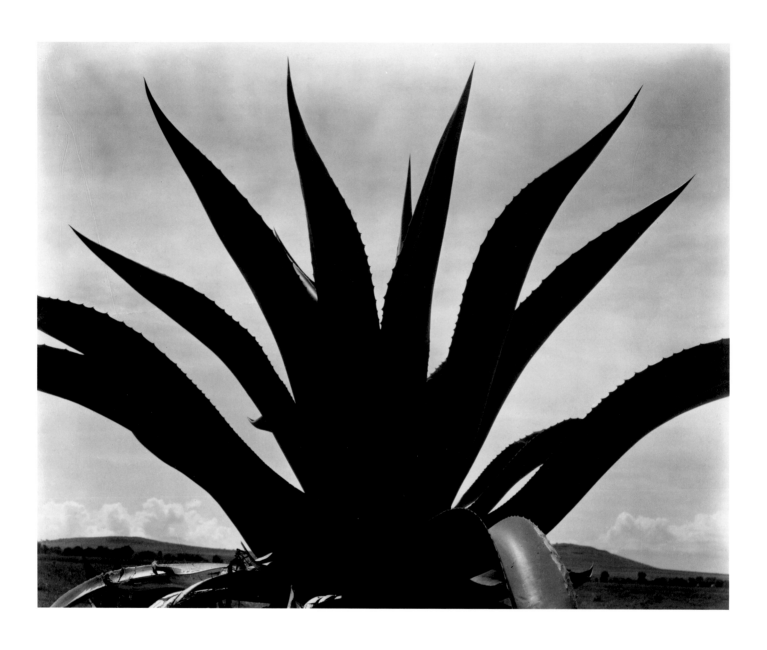

Maguey, 1926

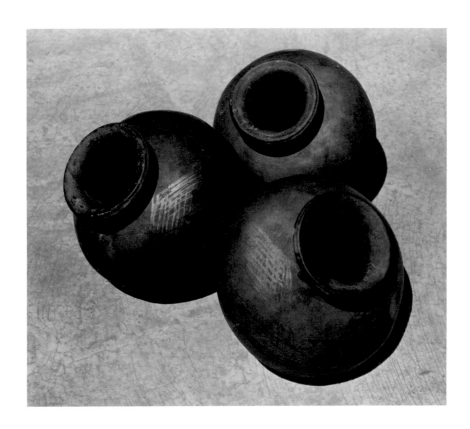

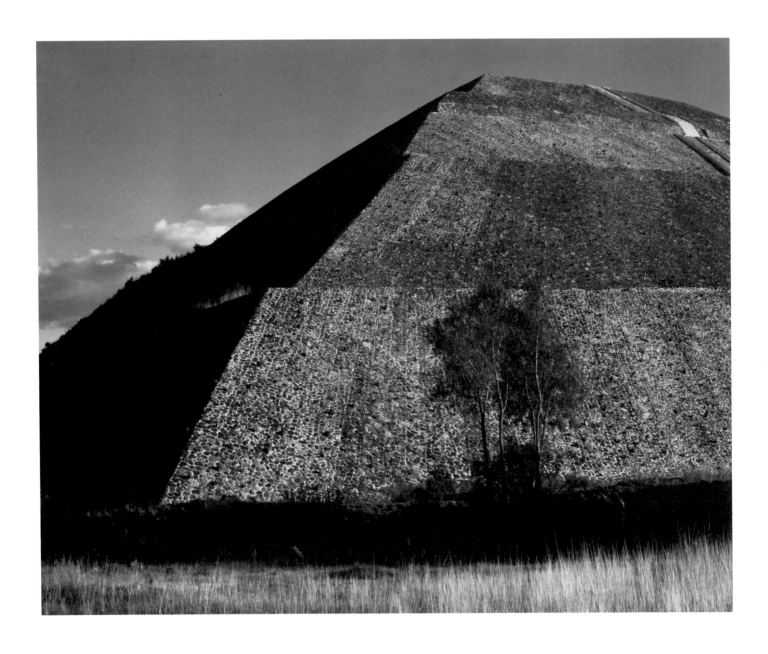

Piramide del Sol, 1923

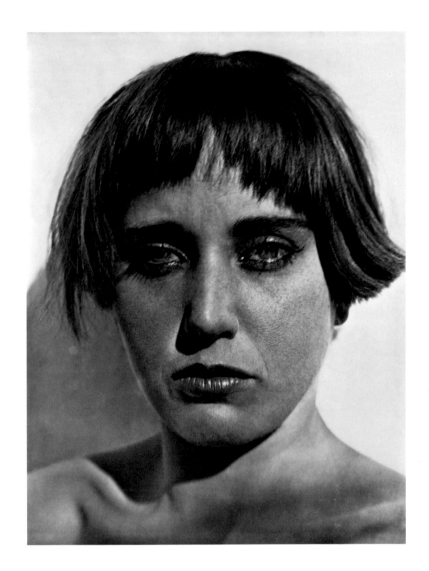

Nahui Olin, 1925

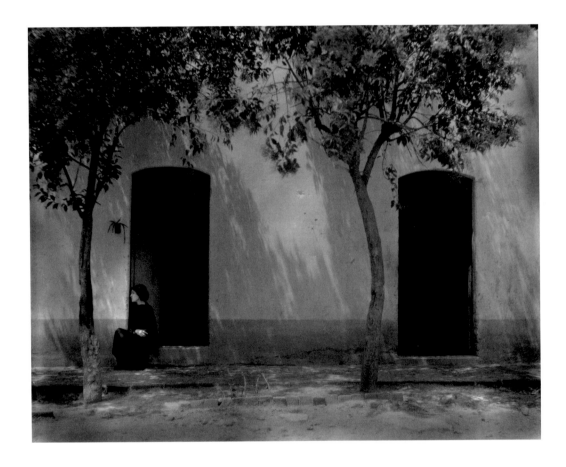

Tina, 1923

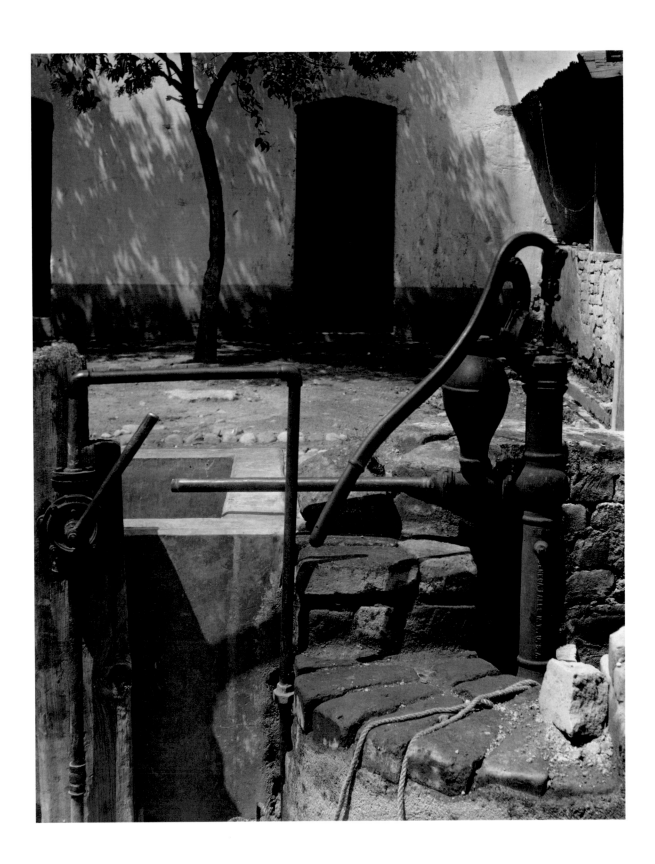

Bomba en Tacubaya, 1923

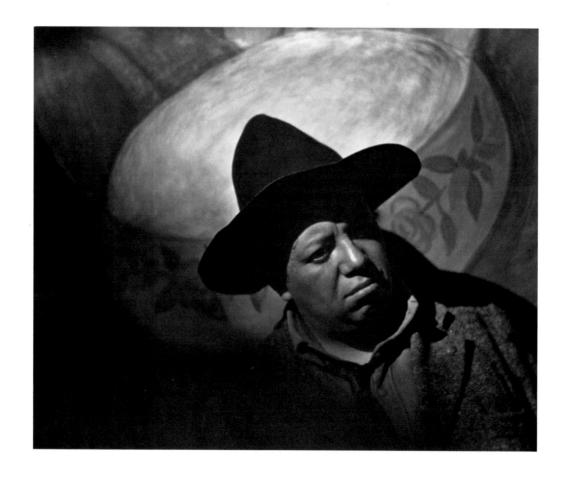

Diego Rivera, 1924

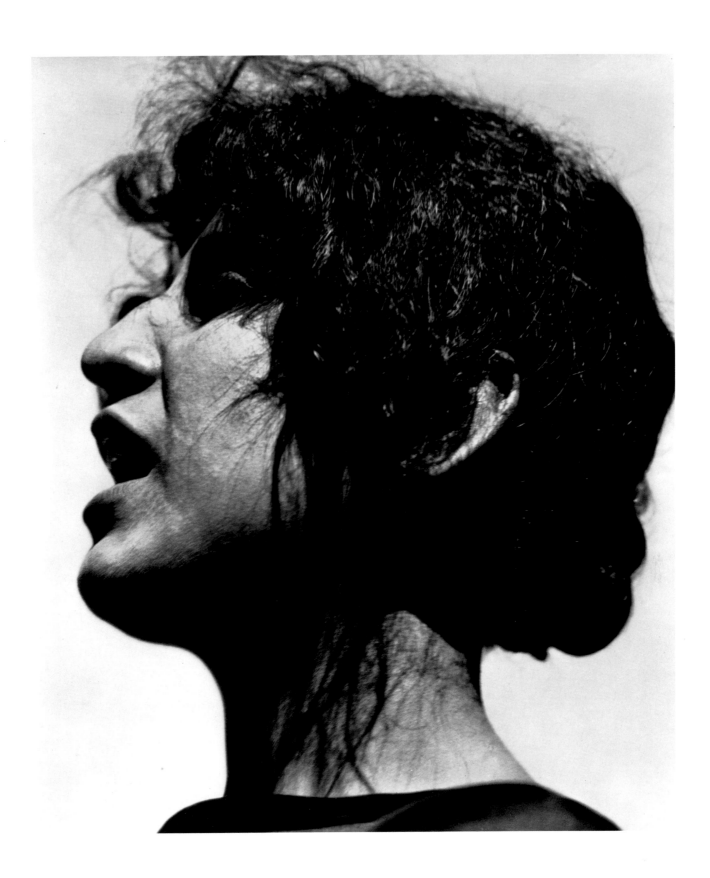

Guadalupe Marín de Rivera, 1923

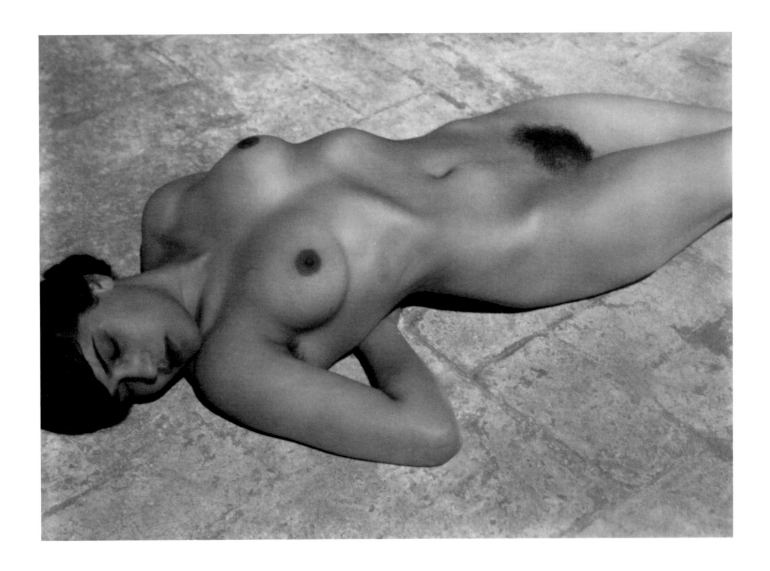

Tina on the Azotea, 1923

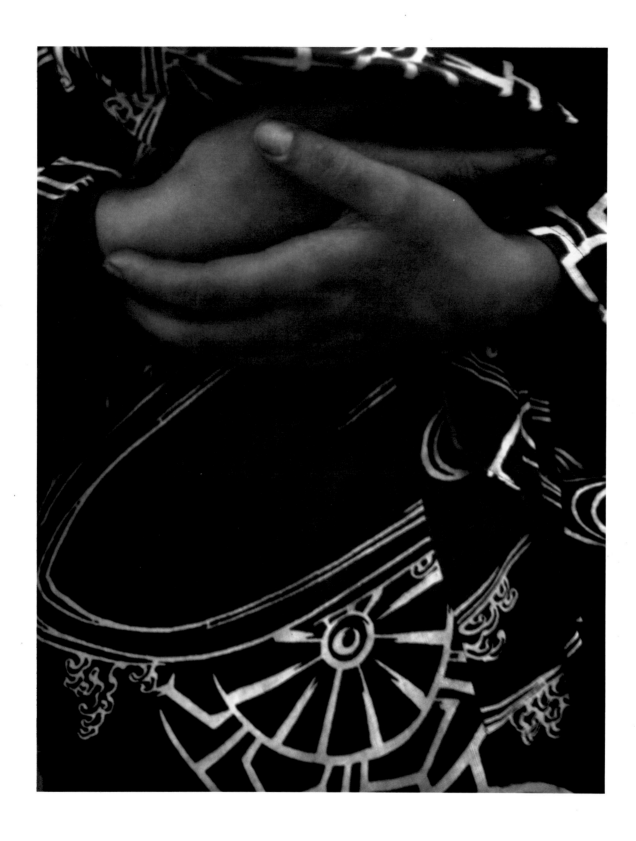

Hands, Mexico, 1924

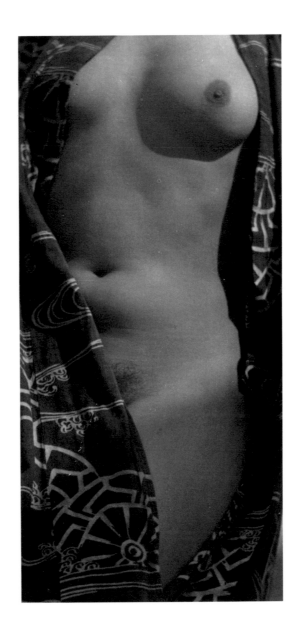

Tina, 1924

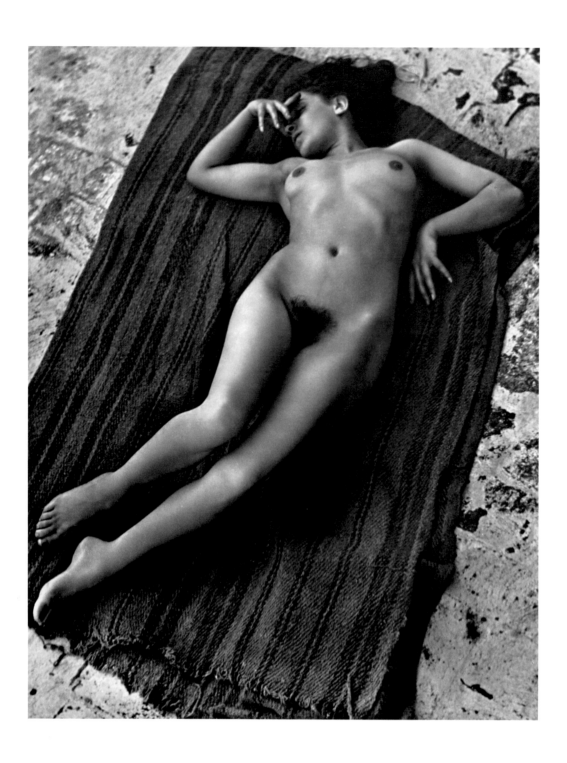

Tina on the Azotea, 1924

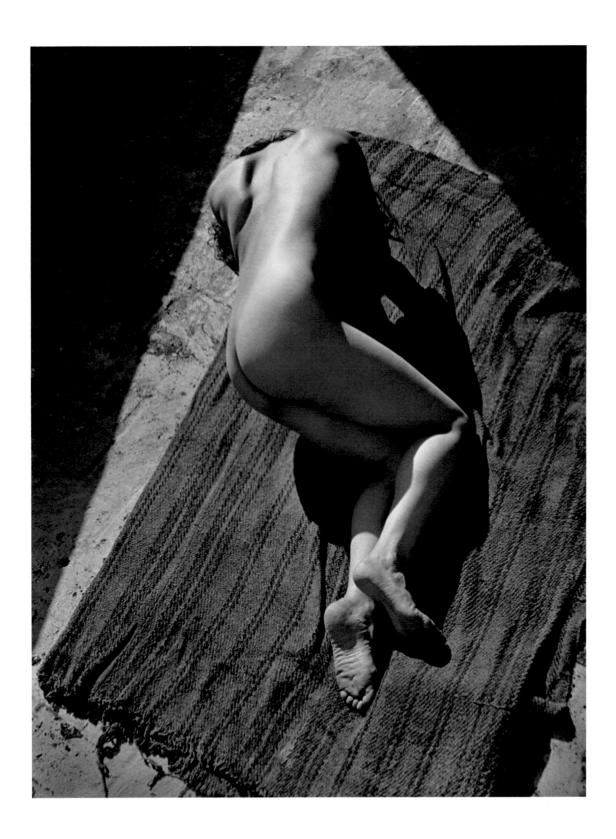

Tina on the Azotea, 1924

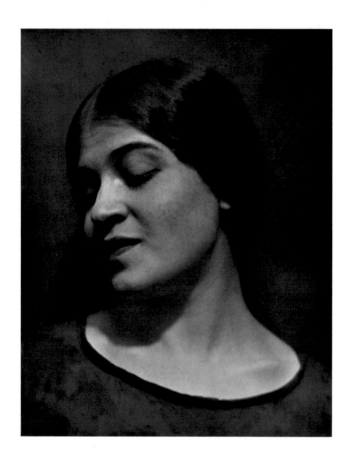 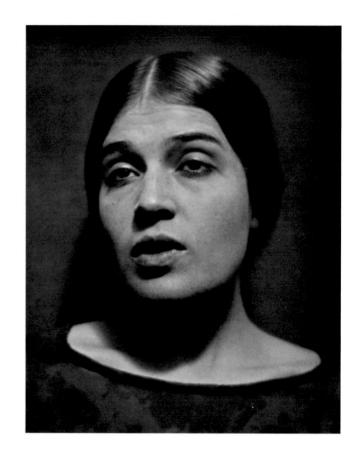

Tina Reciting, 1924

Tina Reciting, 1924

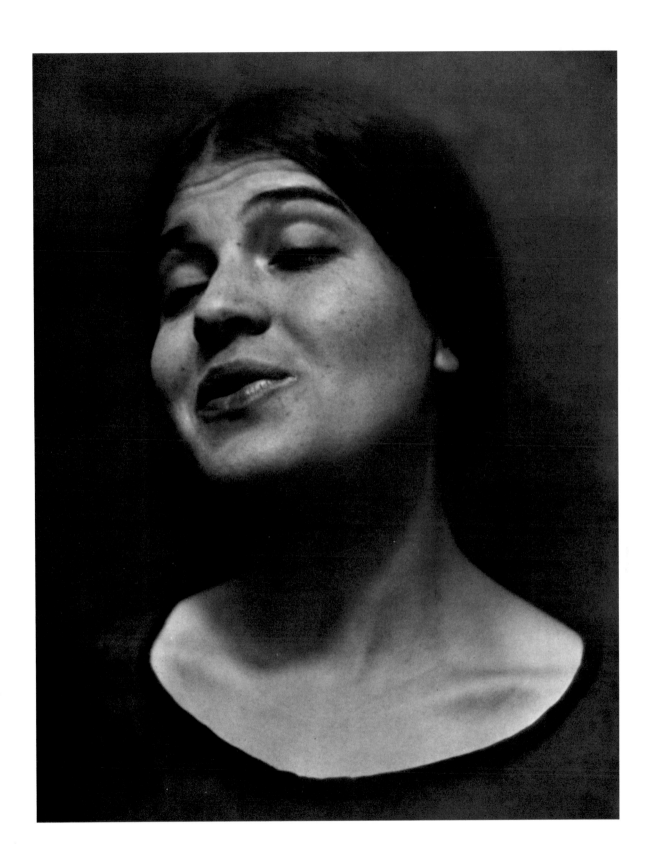

Tina Reciting, 1924

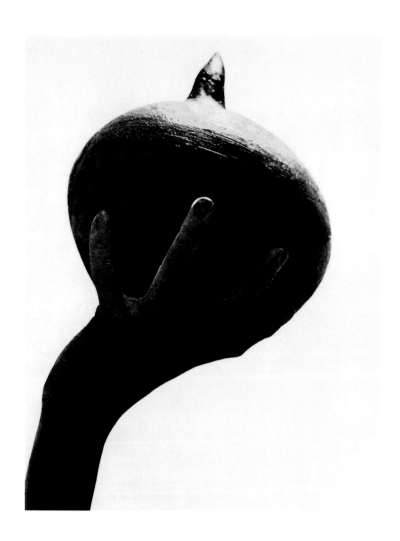

Hand of Amado Galván, 1926

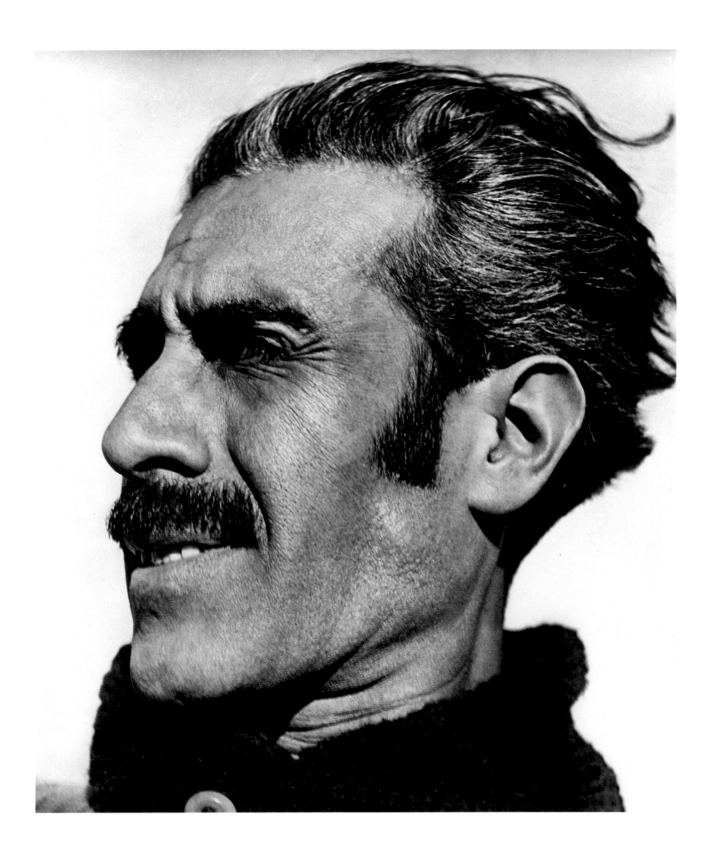

Galván Shooting, 1924

Untitled [bell tower, Pátzcuaro], 1926

Arch, Tepotzotlàn, 1924

Plaza Tepotzotlàn, 1924

Tepotzotlàn, Mexico, 1924

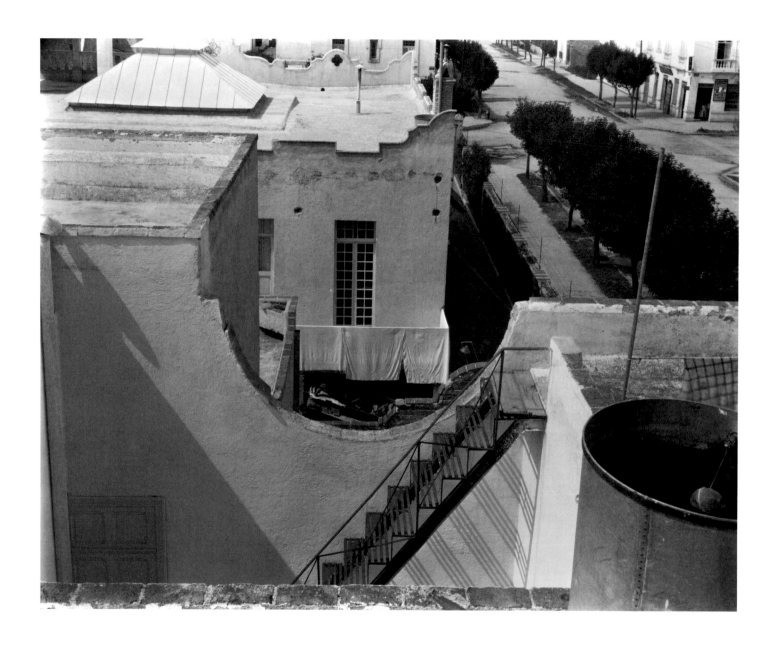

Desde la Azotea, 1924

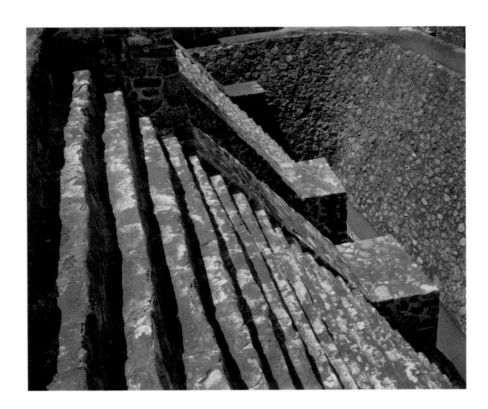

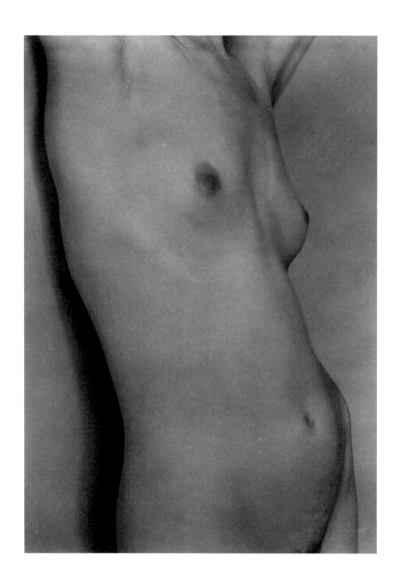

Nude, 1924

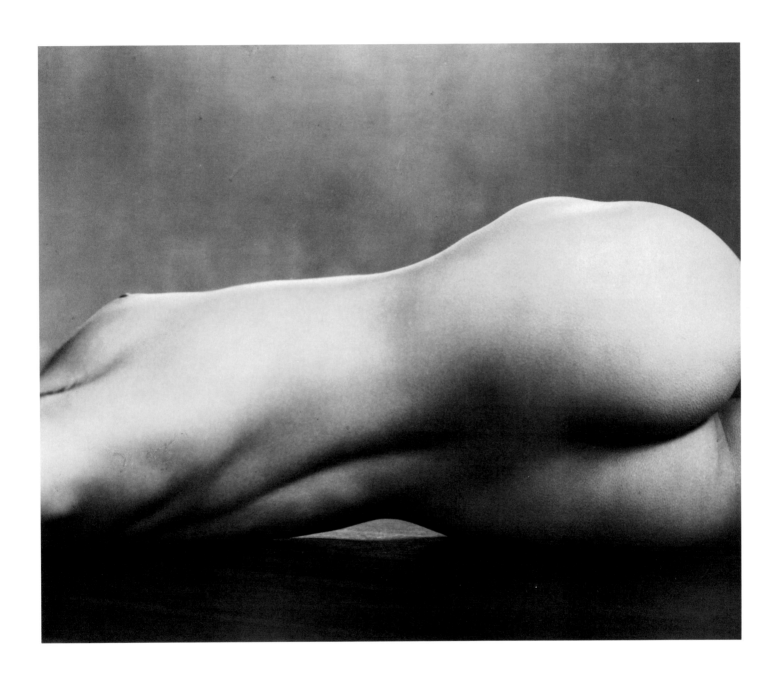

Nude, 1925

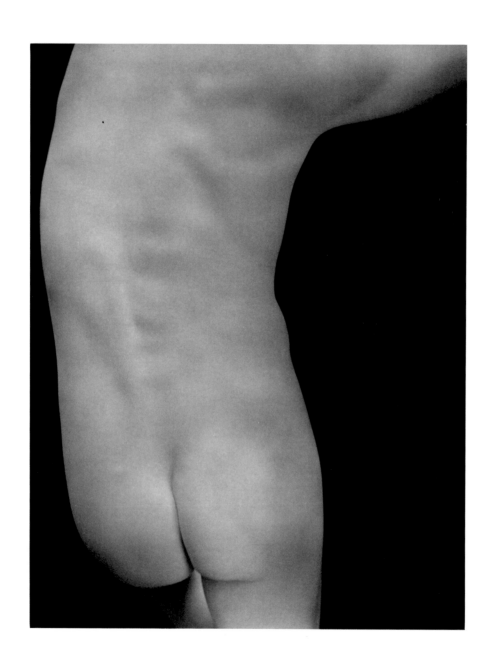

Neil, 1925

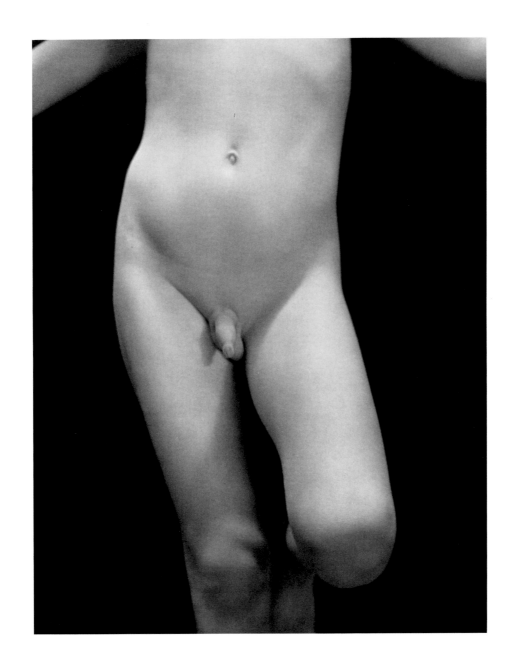

Neil, 1925

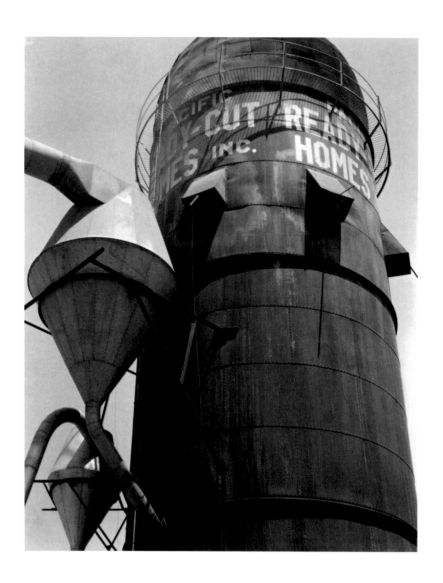

Factory, Los Angeles, 1925

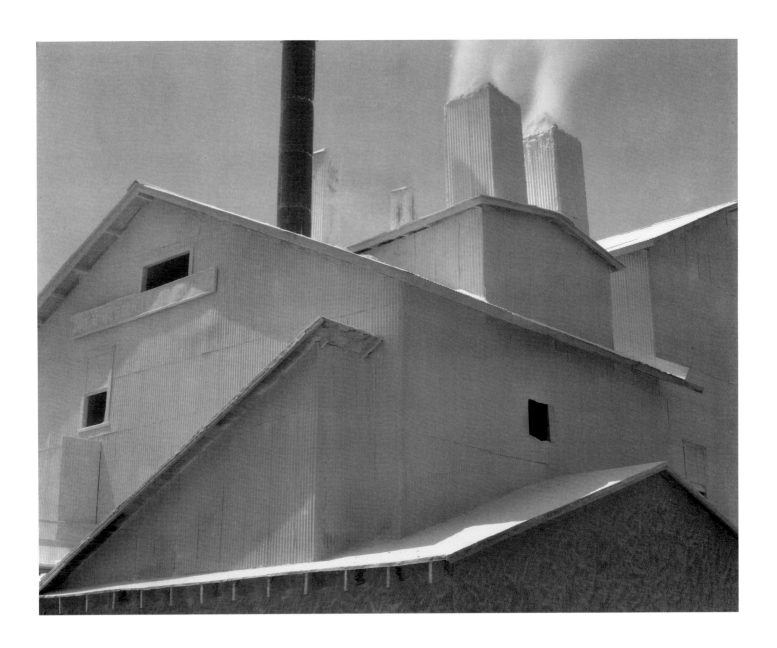

Plaster Works, Los Angeles, 1925

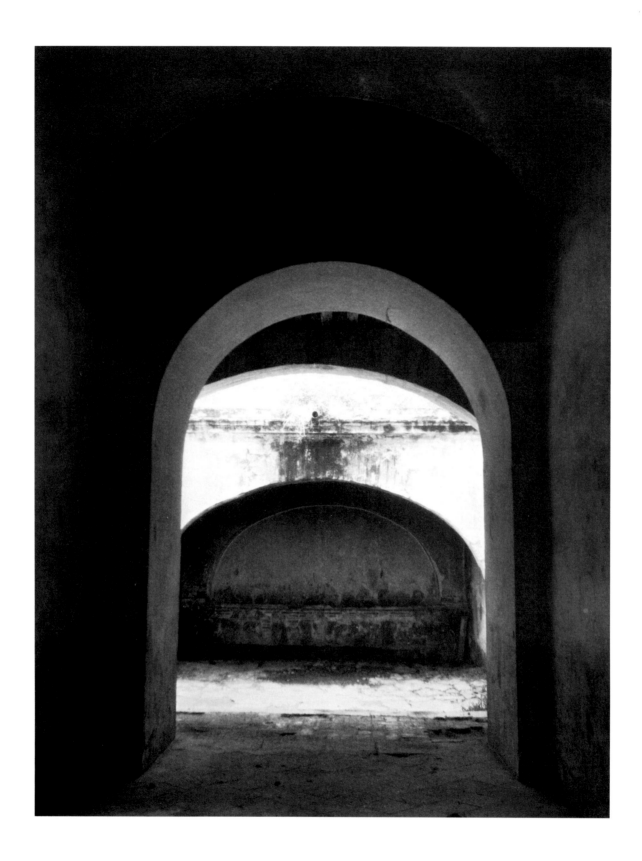

Arcos, Oaxaca, 1926

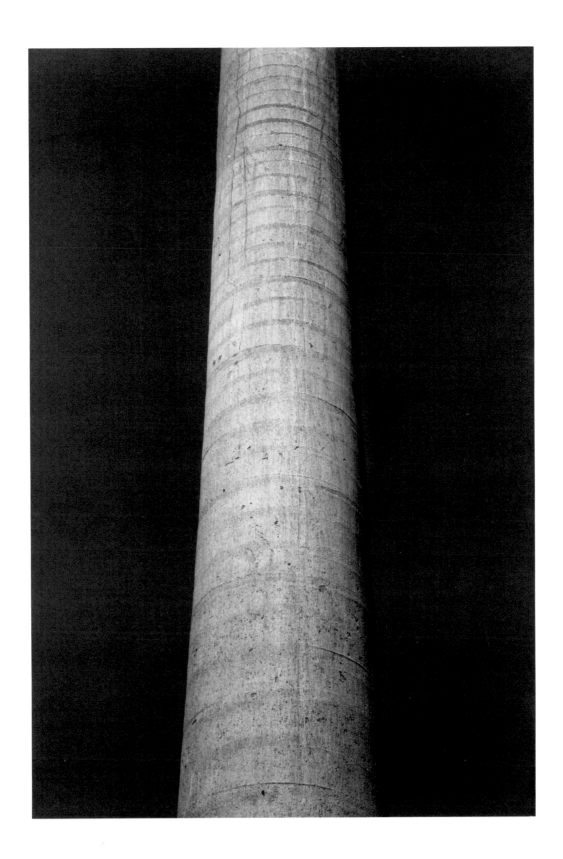

Palma Cuernavaca, 1925

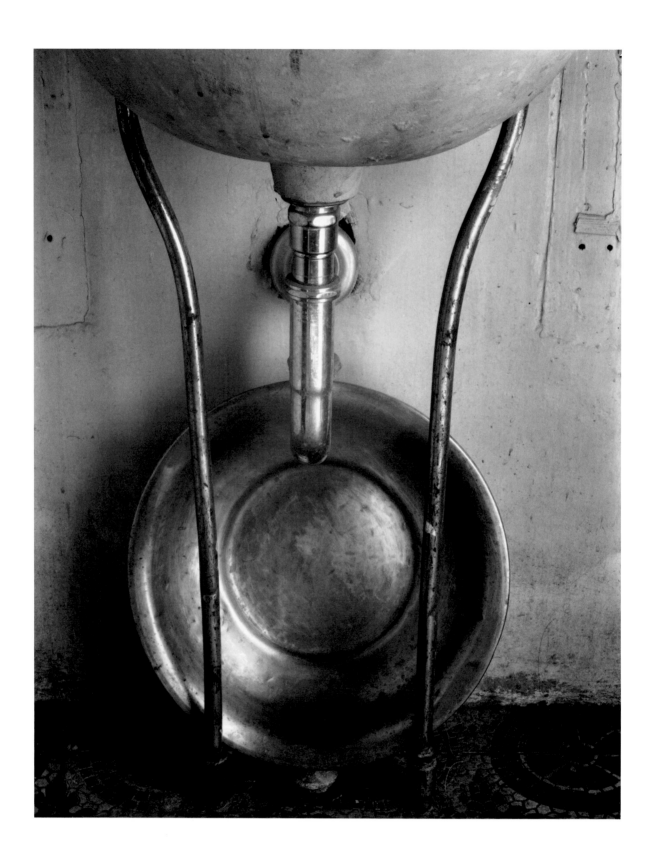

Washbowl, 1925

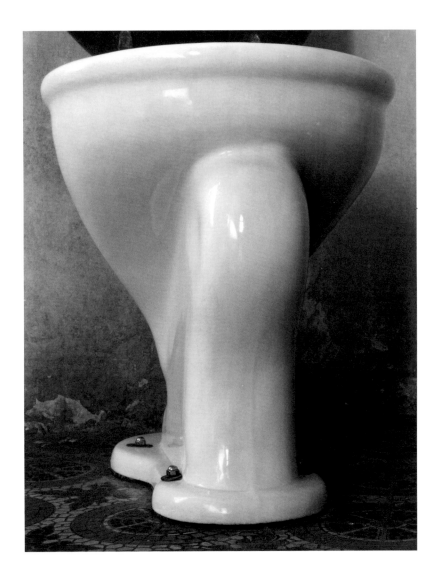

Excusado, 1925

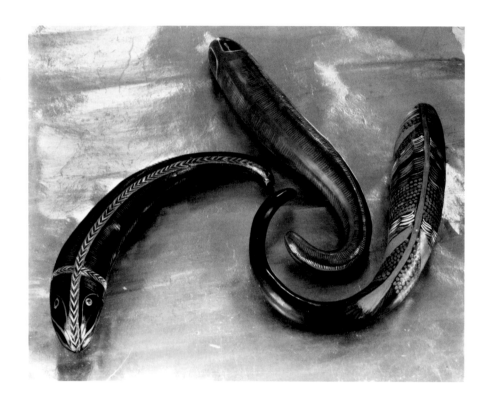

Gourds, Three Fish, 1925

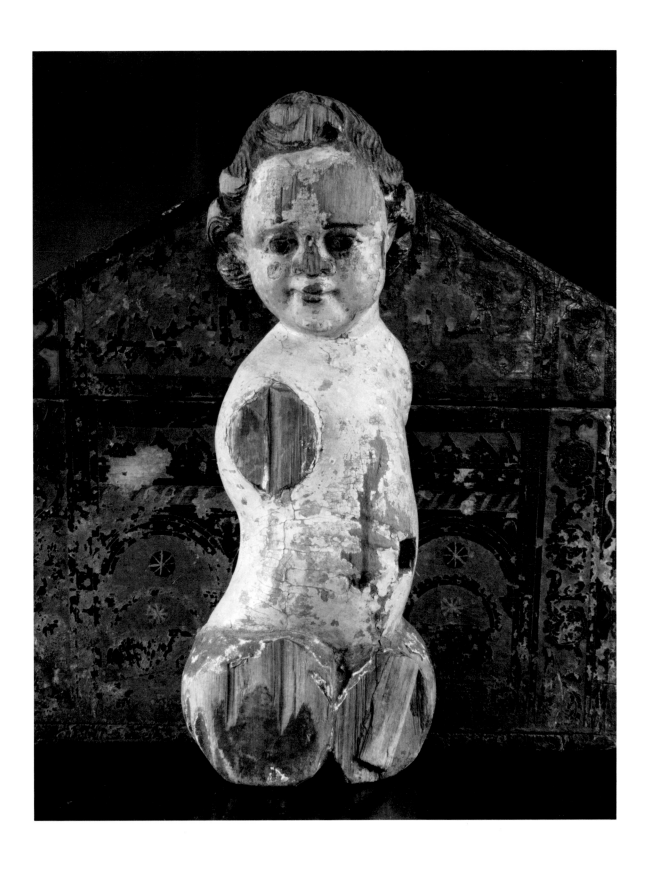

Angelito, 1926

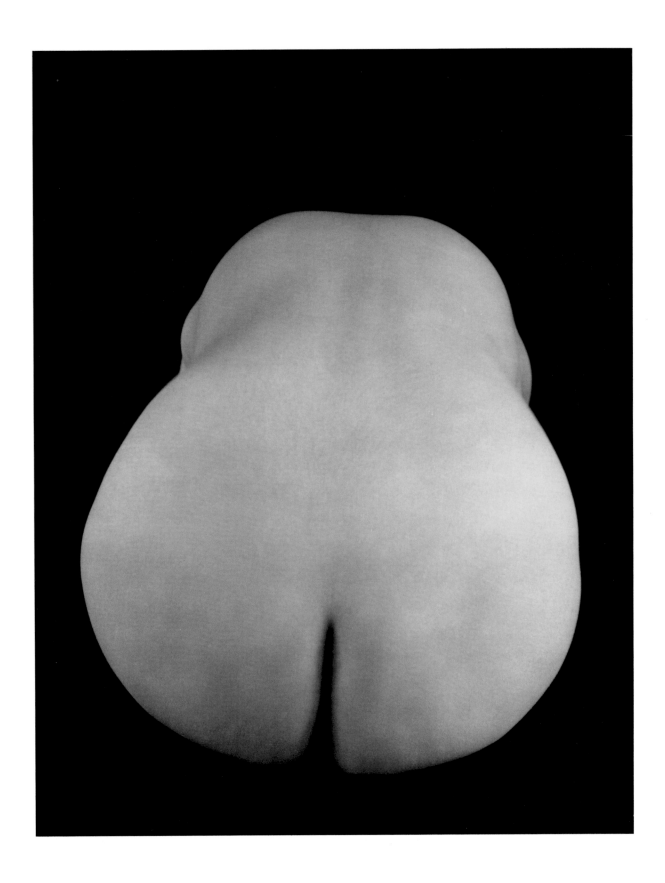

Nude, 1925

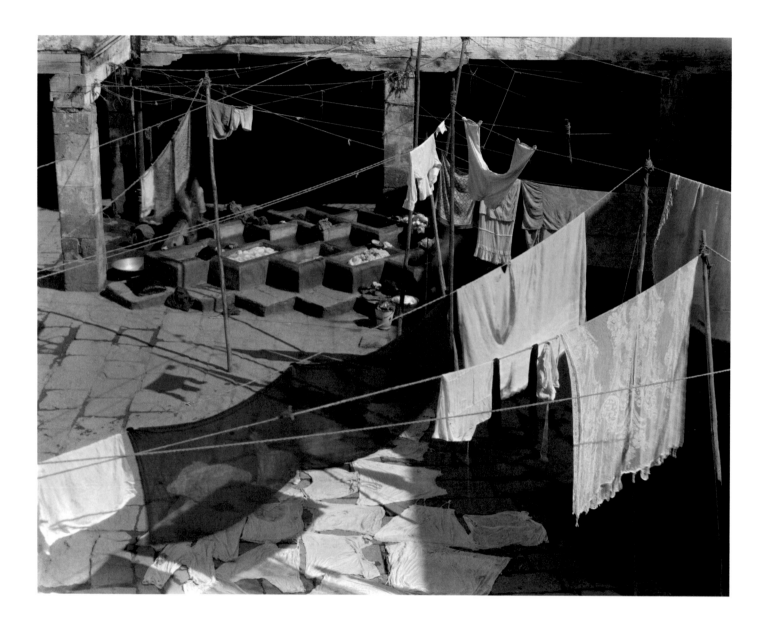

Casa de Vecindad, 1926

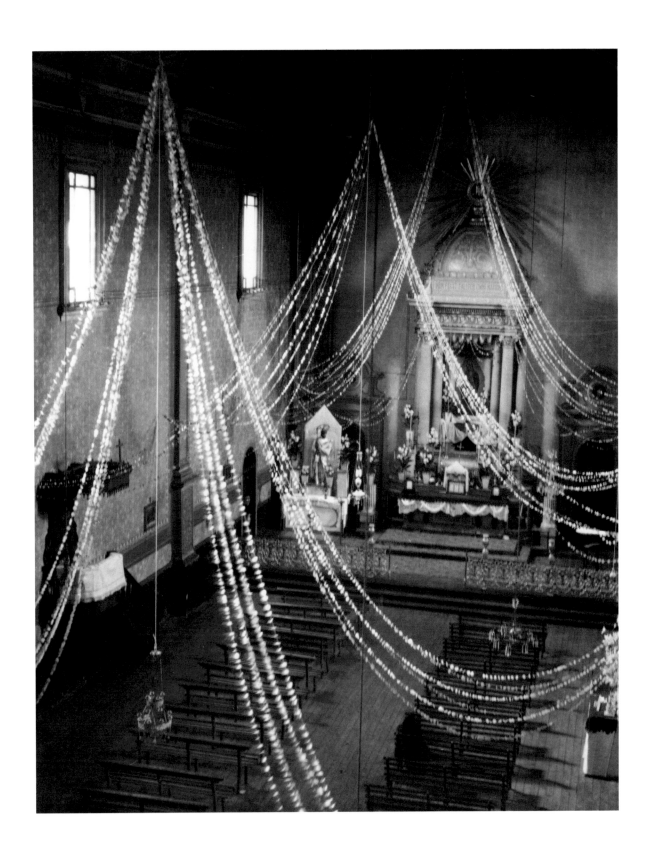

Untitled [interior of Nuestra Señora de Guadalupe, Pàtzcuaro], 1926

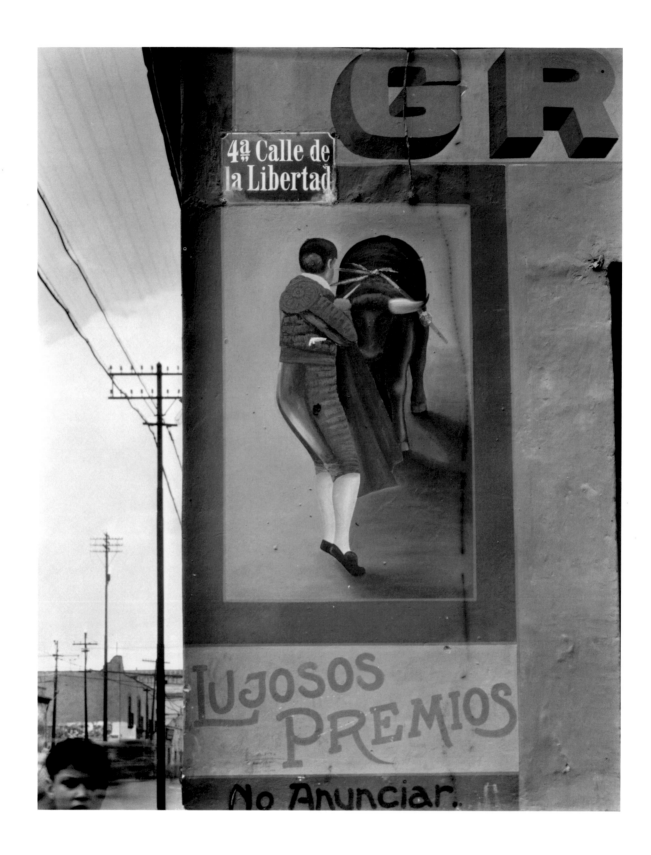

Pulquería, Mexico City, 1926

Untitled [bullfight, Mexico City], 1926

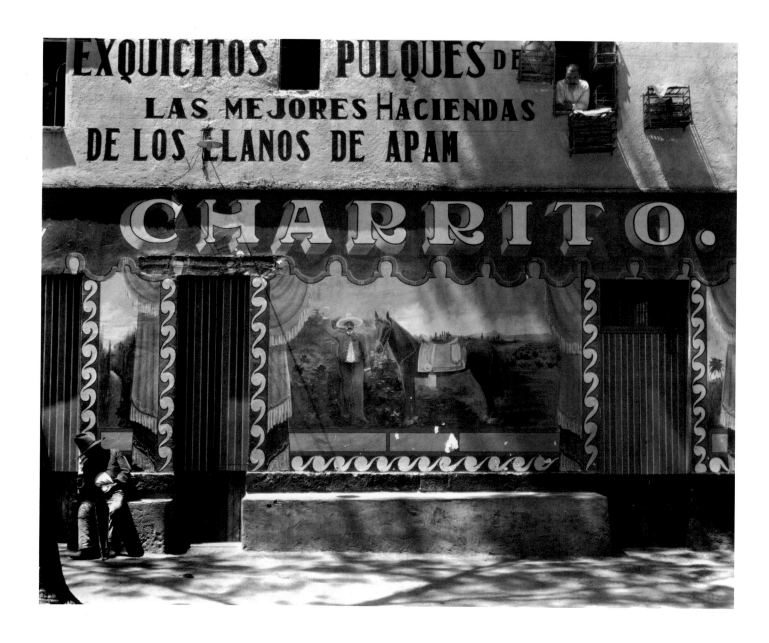

Pulquería, Mexico City, 1926

Pulquería, Mexico City, 1926

Pulquería, Mexico City, 1926

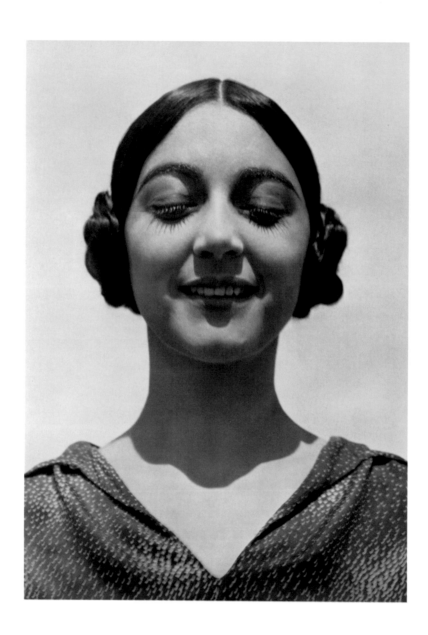

Rose Roland de Covarrubias, 1926

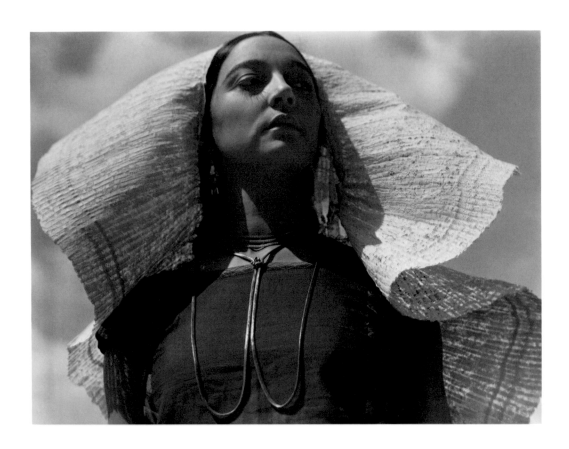

Tehuana Costume, 1926

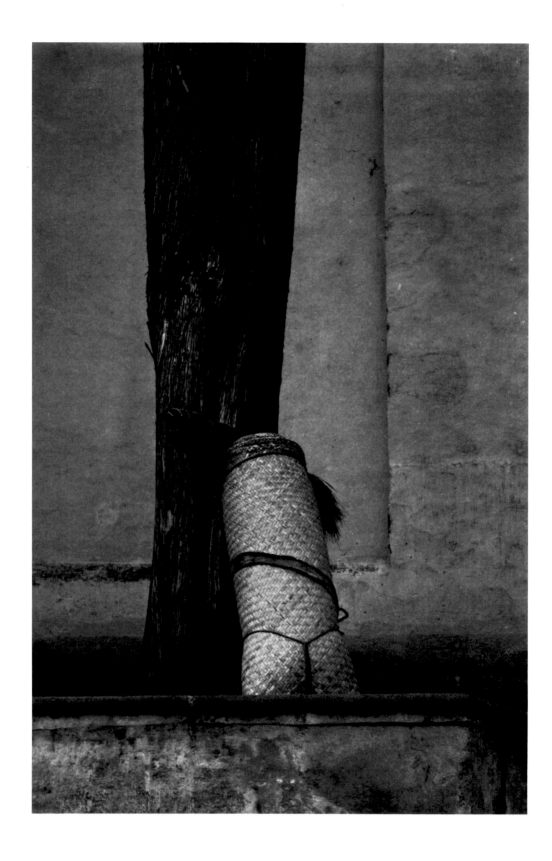

Descanso, Pátzcuaro, 1926

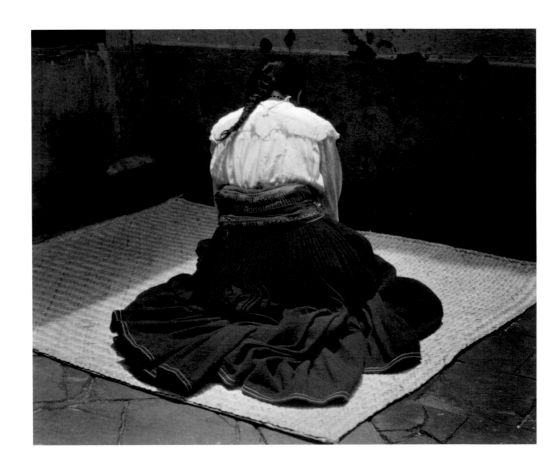

Untitled [woman seated on petate], 1926

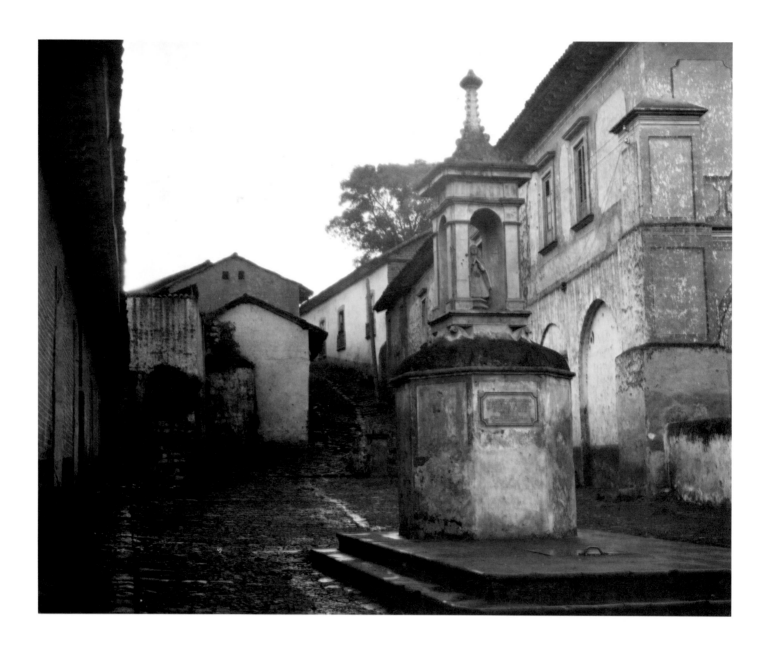

Untitled [fountain, Pátzcuaro], 1926

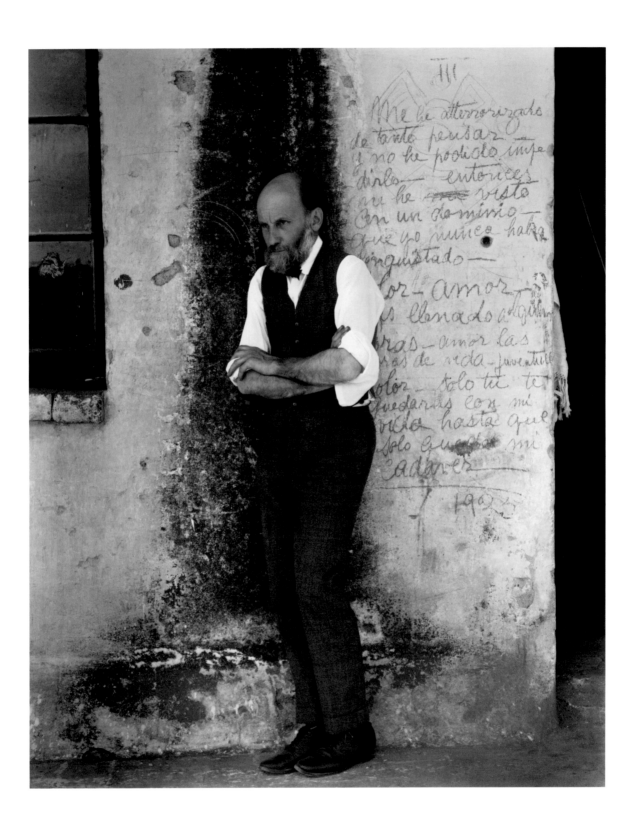

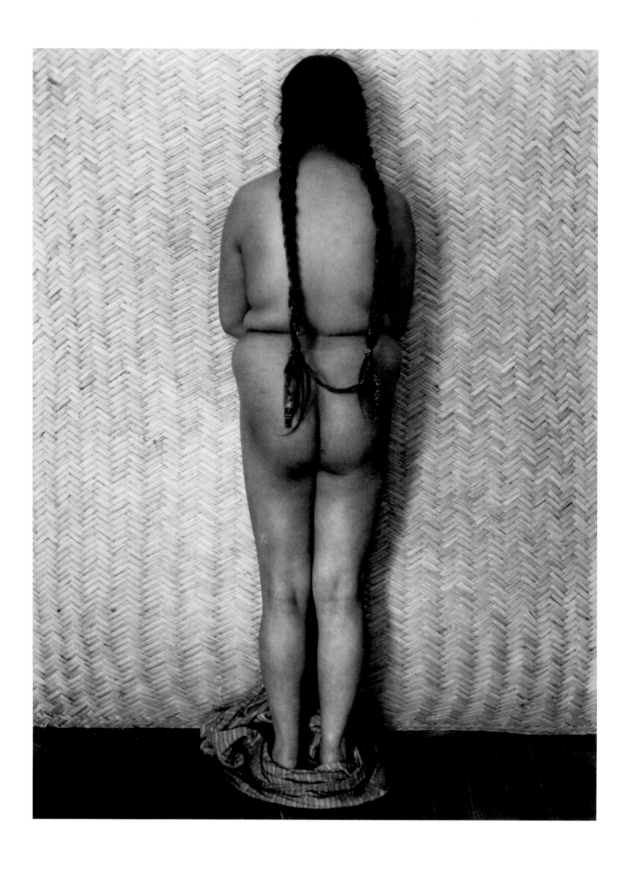

Nude, 1926

Untitled [ceramic sculpture of angel], 1926

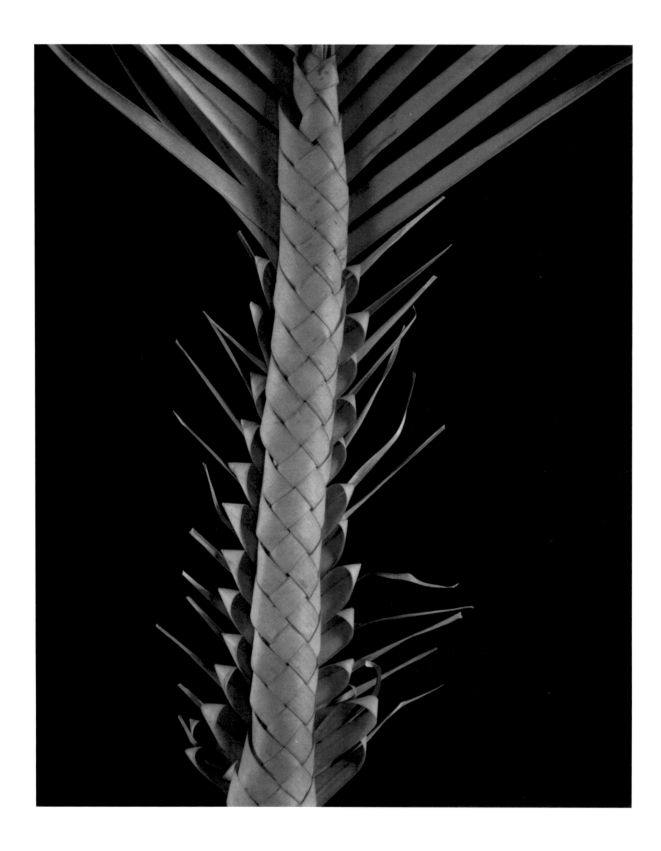

Palmilla, 1926

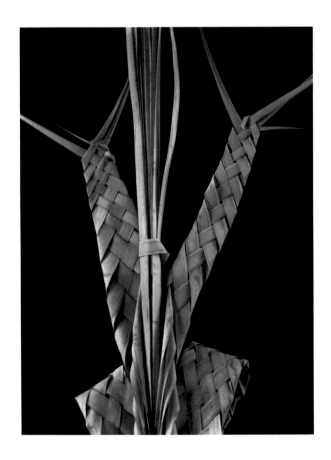
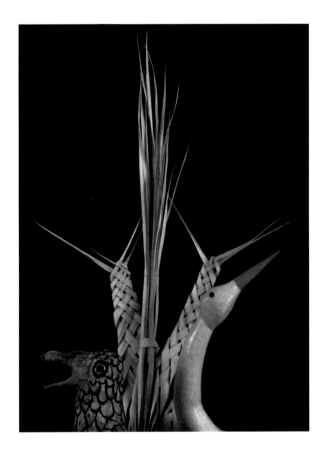

Palma Bendita, 1926

Pascua, 1926

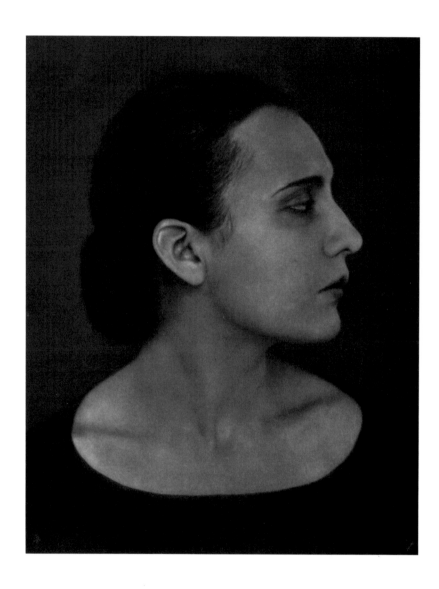

Victoria Marin, 1926

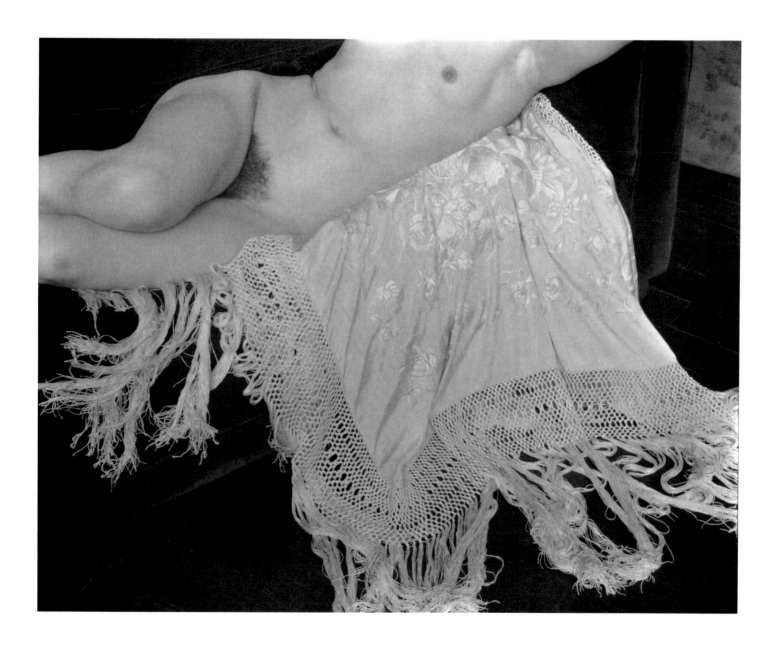

Nude, 1925

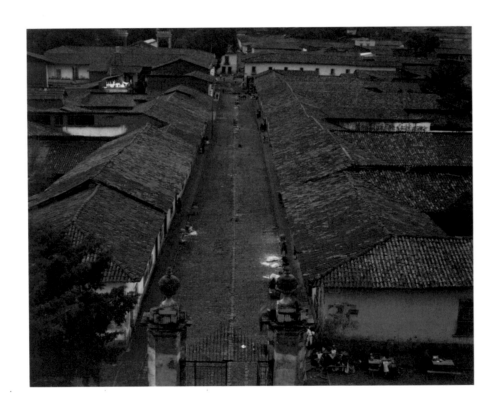

Pátzcuaro, 1926

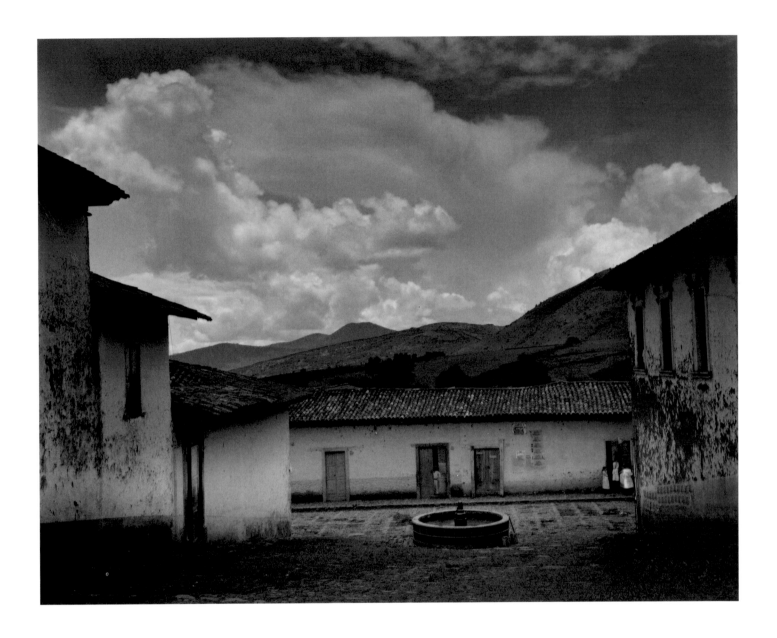

Pátzcuaro, 1926

1927
1937

To see the Thing Itself is essential . . . Edward Weston

Brett Weston. *Edward Weston's Favorite Portrait, 1929*
Lane Collection

An Appetite for the Thing Itself:
Studio Vegetables and Female Nudes Trudy Wilner Stack

If indeed "A rose is a rose is a rose," then so it is with an Edward Weston pepper. It appears as he would have had it: quintessential, supreme, majestic, pure, transcendental, filled with "livingness."[1] These ready adjectives seem to emanate from the dusky, polished skin of the photographed bell pepper. They are frequently invoked and seem synonymous with the sinuous surface—words and image now inscribed upon the Weston chapter of the history of photography. It is a chapter informed and defined not solely by the work of an artist, but by the artist's life: self-described, fervent, intriguing. The experience of Edward Weston can be a tangle of imagery and personal record. Or it can be singular: *Pepper No. 30* (page 171).

The simplicity of understanding Weston's art through a lone image (the quintessential pepper or one of a handful of others), as do many who do not otherwise know of the man and his work, might have appealed to the photographer himself. For it is the intention of this photograph to function as an encapsulation of natural form and life's mystery. And yet, the pepper is also the ball on the chain of contemporary appreciation for the photography of Edward Weston. In the late twentieth century, to express universality and the beauty of the particular through a skillfully lit and arranged, photographically captured, simple grocery store vegetable can be construed as silly or pretentious. Has not our century moved us past such idealist artistic concerns as Weston's search, in photo historian Estelle Jussim's words, for "the soul of a pepper, the pepper beyond the pepper, the Platonic Ideal True Pepper, or the essence of pepperness . . . to photograph the life force itself, that ultimate essence of all the material world."[2] Can the contemporary viewer/reader swallow the vaunted claims of the artist's journal writings: "It is classic, completely satisfying—a pepper—but more than a pepper; abstract, in that it is completely outside subject matter. It has no physical attributes, no human emotions are aroused: this new pepper takes one beyond the world we know in the conscious mind."[3] Weston's *Daybooks* were thinly veiled as private musings; one feels history looking over his shoulder as he wrote. The *Daybooks*, as complements to his photographs and actual life, have indeed helped secure Edward Weston himself as a quintessential artist in the hearts and minds of many photographers and enthusiasts. For them, his modernist thought is firmly grounded, if homegrown; or it is the perfect palliative to the cynicism and confusion of our high-tech age.

But others view him as out-of-date, painfully indefensible, and tiresome. So much so that, of those who dismiss him, few have thought it necessary to write down the reasons. Much Weston literature is laudatory, sympathetic, uncritical, and heavily biographical, often abiding within the positive context of commercial and museum monographs (which commemorate Weston's prints as valued art objects and his images as popular icons). Yet, by the 1970s, Susan Sontag had already declared that, "For several decades American photography has been dominated by a reaction against 'Westonism'—that is, against contemplative photography, photography considered as an independent visual exploration of the

1.
In his writings, Weston occasionally used the term *living-ness* to refer to the palpable sense of his photographic subject being alive or, of life and the natural world, an effect he prized when communicated in a photograph. "I spotted a swiss chard in the Japanese Market, so fine in color, form, livingness that I bought it at once, and made two negatives" (*Daybooks* II, p. 35)

2.
Estelle Jussim. "Quintessences: Edward Weston's Search for Meaning," in *EW 100: Centennial Essays in Honor of Edward Weston*, Peter C. Bunnell and David Featherstone, eds. (Carmel, California: The Friends of Photography, 1986), pp. 57–58.

3.
Daybooks II, p. 181.

4.
Susan Sontag. *On Photography*. (New York: Dell Publishing Co., 1977), p. 142.

5.
Alan Trachtenberg. "Weston's 'Thing Itself'," *The Yale Review* (October 1975), p. 105.

6.
He did lug the large camera on expeditions as well. His most notable sites during this period were Point Lobos and the Oceano Dunes.

world with no evident social urgency."[4] In fact, this reaction has been more recently fed by at least one unintentional social issue of significance in his work—easily recognized, rarely explored: the cultural concerns raised by his many female nude studies. For contemporary viewers, this subject is far more troubling than the more benign pepper or Weston's other organic models. His approach to the unclothed female body in the studio paralleled his still-life process, and there exist numerous formal equivalents between his vegetable studies and nudes. For some, this is another prime cause for the current rejection of Weston. One need not be a feminist, or even a woman, to feel disturbed by his intense, confining approach to the female figure, to correlate his philosophy of the essence of things with issues of the objectification of his companion sex.

But there is another trend that works to counteract the current philosophic disaffections with Weston's essentialist project. There is renewed interest in his work coming from a quite different set of concerns, ascribable to a marked characteristic of Weston photographs, regardless of subject: print quality. Since the seventies, photography has come into its own as a highly collectable and popularly appreciated art form. Edward Weston was a technically astute photographer, who valued excellence in the final photographic print. Eight by ten inches in format, contact printed, glossy, largely unmanipulated, trimmed and mounted on neutral white board—a Weston print is, more often than not, an exquisite object. For the collector, institutional or individual, this heightens acquisitorial instincts. His prints are scarce, they are precious, they are beautiful. They are by an acknowledged lion in the field, "one of the genuine heroes of modern photography"[5] well placed in established historical canons. Now, rethink the pepper, its purity of form, its bigger-than-life lusciousness, its splendid, sensuous, immodest exploitation of the potential of black and white photography, and you assuredly have yourself a masterwork.

Pepper No. 30 is obviously not, however, the lone example of Edward Weston's interest in the botanical species *capsicum grossum*. (pages 158 and 176) He made some forty-three exposures of various peppers in 1929 and 1930, twenty-two negatives of which survive in the Edward Weston Archive at the Center for Creative Photography. This output occurred during a decade in the photographer's career when many of his most recognizable and often reproduced images were created. It began in 1927, the time of his return home to California after a formative few years in Mexico, and ended in 1937, when he began his Guggenheim Fellowship trips with Charis Wilson. During these years he spent much of his time in the studio, close to home. There he was more available to his children (in Glendale) and for hire as a portraitist (in Glendale, San Francisco, and Carmel). The studio produced studio genres: portraits, nudes, and still lifes. Of those, his most personal work usually fell in the second two categories. His preference was for natural lighting and the precision 8 x 10-inch camera, an ungainly apparatus that yielded more easily in the controlled studio environment.[6]

Unwinding from the rich, invigorating delirium of his Mexican experience, Weston continued to pursue ideas he had begun there. With the exception of a few early nudes and portrait heads, it was not until Mexico that Weston addressed the object for itself, in isolation from a scene, tableau, or other multi-part composition. Rather than setting subjects off in relation to each other, building

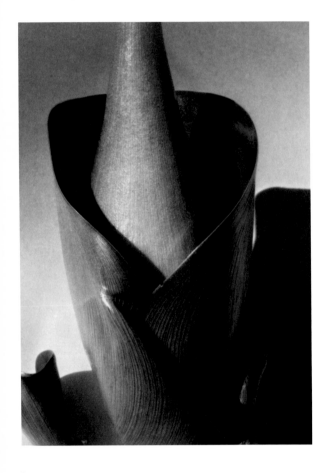

Fig. 1
Ansel Adams. *Rose and Driftwood, San Francisco, c. 1934,* CCP

Fig. 2
Imogen Cunningham. *Water Hyacinth 2, 1920s*
Imogen Cunningham Trust

7.
Daybooks I, p. 132.

a picture piece by piece like a painter, Weston embraced his subject whole, gathering it fully within the frame, flush with the existing form that so excited him. Back in California, he maintained his newfound appreciation of clear seeing, the formal pleasure afforded by the found, the everyday; though now his everyday was less exotic, domestic by comparison. Aspects of his earlier Pictorialist expression were also not abandoned: he still bowed to the beautiful (though he saw it in new places) and modeled his subjects with a practiced understanding of effervescent light and persuasive shadow.

Despite the aura of self-invention projected by the *Daybooks*, Weston was not a complete maverick in his approach to photography. In the early 1930s, he was even the senior member of a short-lived association of California photographers called *Group f/64.* Formulated to counteract what they now saw as the degradation of photography at the hands of Pictorialism, they espoused many of Weston's most firmly held aesthetic and technical principles. While the members, Ansel Adams and Imogen Cunningham among them, [Figs. 1 and 2] were variously influenced by their advisor, their shared concerns were also a result of the time and circumstances in which they found themselves and creative photographic practice. They advocated a direct, unmanipulated approach that took advantage of photography's particular attributes and avoided the effects of other media. For the members and others in their circle, Weston also served as a conduit for information on European and East Coast photographers who were important, if distant influences. Since his earliest work with a camera, Weston had been quick to attend to distinguished activity in the medium through publications, exhibitions, and personal contacts. He was very familiar with and admired the photography of Alfred Stieglitz, Charles Sheeler, and Paul Strand, all of whom had investigated the well-defined modernist close-up of their quotidian world. In Europe, the work of New Vision photographers such as Germans Karl Blossfeldt [Fig. 3] and Albert Renger-Patzch is similarly connected to Weston's highly formal, contained and abstracted studio views of shells, vegetables, and objects like bedpans and egg slicers (pages 166 and 167).

The immediacy that photography could elicit—its aspect of realism and concrete seeing that was exaggerated, abstracted and renewed—stimulated all these photographers. The medium could both reduce and simplify, complicate and amplify. Edward Weston's own attachment to this new sense of the photographic took hold in Mexico, where his life and art began a dialogue of discovery that did not cease until a quarter century later, when he could no longer photograph or print. In his Mexican home he made photographs; strong, personal images of what surrounded him: toilet, washbasin, the figure and face of his companion and lover, small handmade toys and folk art objects, fruit. He thought these subjects were beautiful and exquisite in and of themselves and he recorded them plainly, accentuating their form and character with his fine technique and carefully chosen views. His enthusiasm for their quality of appearance was almost childlike, giddy: "I have been photographing our toilet, that glossy enameled receptacle of extraordinary beauty. . . . My excitement was absolute aesthetic response to form. For long I have considered photographing this useful and elegant accessory to modern hygienic life, but not until I actually contemplated its image on my ground glass did I realize the possibilities before me. I was thrilled! — here was every sensuous curve

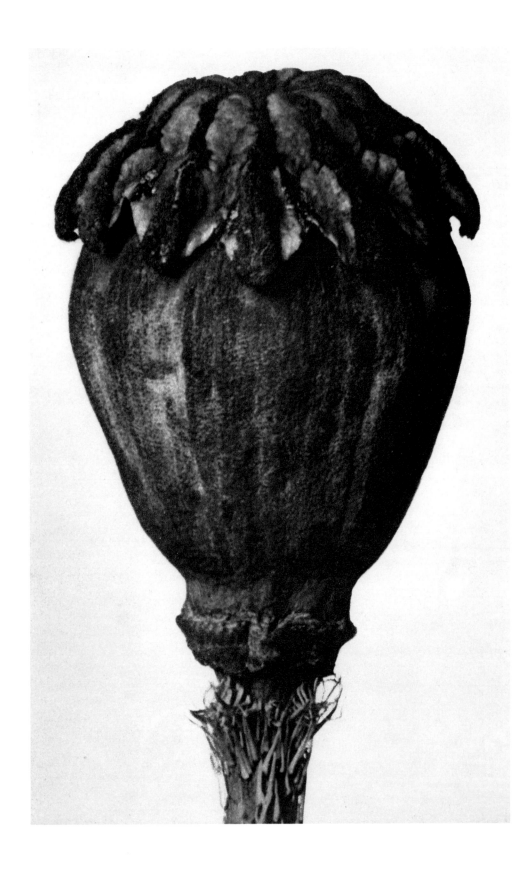

Fig. 3
Karl Blossfeldt. *Papaver orientale. Orientalischer Mohn.*
Samenknospe, 5 mal vergrössert, 1900–1928.
[Oriental poppy. Ovule 5 times enlarged]

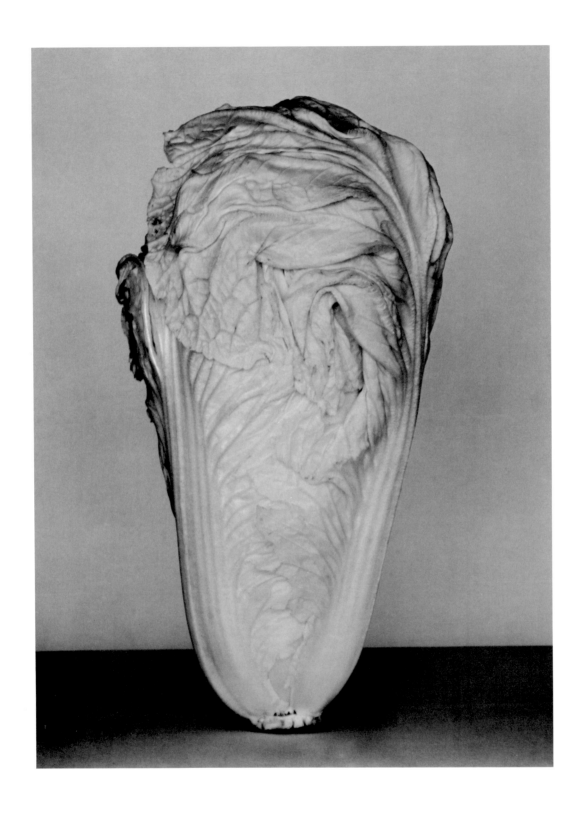

Chard, 1927, CCP

Fig. 4
Marcel Duchamp (R. Mutt). *Fountain*, 1917

of the 'human form divine' but minus imperfections"[7] (page 109).

That Weston found divinity in this most humble of human conveniences and that it was only fully realized when inverted through the lens of his camera, predicts his continuing delight in turning the commonplace into an *objet d'art*—a Duchampian impulse but without the irony. [Fig. 4] In Weston's California studio work he saw that those things which sustained him became timeless icons in his ground glass. Physical reliance on and desire for his subjects were particular factors in his vegetable and nude studies. While the gleaming, pearlized and tantalizing nautilus shells (page 153), and even the equally whitened *Excusado*, were resplendent subjects, they were not alive: they only referred to life, harbored it, sanitized it. They were regular, hard, with a kind of perfection impossible for flesh, their shape and countenance invulnerable to the artist's willful appetite. For Weston did tend to consummate his relationship with his photographic subject, be it vegetable, fruit, or female. Knowledge of his appetites, which his well-documented life ensures, helps explain the palpability his pictures so powerfully effect, and the discomfort the formal parallels between them engender.

In a review of Weston's 1975 Museum of Modern Art exhibition in *The Village Voice*, Roberta Hellman and Marvin Hoshino point out that even the casual viewer can recognize how Weston treated many of his subjects equally as forms, and that "Since he was both a vegetarian and a great lover, he also treated them equally as delicacies."[8] Just as we know the intimacies behind Stieglitz's O'Keeffes and Strand's Rebeccas, we know Weston's procession of partners were invariably his models. And his dinner was likely to be the dignified chinese cabbage ("standing alone with no accessories. It pleases me."[9]) or some other equally photogenic readymade foodstuff ("my favorite pumpkin the model.") He readily and wryly acknowledged the connection. "It has been suggested that I am a cannibal to eat my models after a masterpiece. But I rather like the idea that they become part of me, enrich my blood as well as my vision. Last night we finished my now famous squash, and had several of my bananas in a salad.[10] Perhaps the vegetables and fruits were not always literally bound for the kitchen after their sitting, but according to Weston it was not uncommon: "Tonight my pumpkin will achieve its final glorification, in a pumpkin pie!"[11]

Weston's formal perception of that which he relished for its more carnal functions honors the sensual object without denaturing it. Some of the vegetable and fruit studies—squash, pepper, bananas, white radish, eggplant, and the aforementioned chinese cabbage or chard—are presented whole, uncropped by the photographic frame, settled gently in some indeterminate space and lit to their advantage. It is as though they are commissioned portraits: likenesses that show them at their best, turning their oddities to assets, dignifying them as exemplars of their kind. Others of these are close-up cross-sections of cabbage, onion, artichoke (pages 174–175). They celebrate the intricate patterning of nature, its inner secrets, a complexity of being that their familiar curvilinear outer shapes initially disguise. And, yes, they are sexual portrayals. Fruits and vegetables are, after all, an expression of the plant's reproductive cycle. Moreover, their swelling contours, smooth skins, and dark orifices cannot help but recall human sexuality, at least in the Freud-inflected West. But they are vegetables, and all this attention aggrandizes them in ways more purely expressed than in centuries of still life

8.
Roberta Hellman and Marvin Hoshino. "'The Thing Itself'," *The Village Voice* (February 17, 1975), p. 85.

9.
Daybooks II, p. 37.

10.
Daybooks II, p. 180.

11.
Daybooks II, p. 46.

12.
Lynda Nead. *The Female Nude: Art, Obscenity and Sexuality.* (London and New York: Routledge, 1992), p. 20.

140

13.
Trachtenberg, p. 113.

14.
Liam Hudson. *Bodies of Knowledge: The Psychological Significance of the Nude in Art.* (London: Weidenfeld & Nicolson, 1982), p. 133.

Weston rarely acknowledged any photographic interest in the sexual, but rather his preoccupation with the formal, as this entry from the *Daybooks* suggests: "She bent over forward until her body was flat against her legs. I made a back view of her swelling buttocks which tapered to the ankles like an inverted vase, her arms forming handles at the base. Of course it is a thing I can never show to a mixed crowd. I would be considered indecent. How sad when my only thought was the exquisite form. But most people will see only an ass! and guffaw as they do over my toilet." *Daybooks* II, pp. 63–64.

15.
Wendy Lesser. *His Other Half: Men Looking at Women through Art.* (Cambridge, Massachusetts: Harvard University Press, 1991), p. 266.

16.
Lesser, pp. 264–265.

paintings that came before their photographic resurrection.

The female nude is another classical subject that Weston adapts to his emerging medium of expression. She, too, is an image of fecundity, desire, and idealized form, as envisioned by her opposing sex, her other. After centuries of the aestheticization of the female body by male artists, the resulting presumption is that (shapely) women are the ultimate raw material from which to construct the sublime. The founding belief, as influentially espoused by art historian Kenneth Clark and described by his contemporary feminist counterpart Lynda Nead, is that "the female body is naturally predisposed to the contours of art; it seems simple [for it] to await the act of artistic regulation. Things, however, are not quite as under control as might first appear, and signs of the physical, sensory world regularly interrupt the smooth contours of the female nude. The most significant causes of these breaks appear to be the personal desires of individual artists."[12] The desire that Weston felt for most of his subjects (clear from knowledge of his life, not his work), combined with photography's directness and his direct style, assure a tangibility that sets the nude just shy of naked: there is a danger that a real woman will emerge. Perhaps for this reason, Weston's women are truncated, unnaturally posed, and virtually always left faceless. "Weston's headless torsos, hips, buttocks, pubic areas achieve their remarkable formal elegance by explicit denial of individuality. Modesty or discretion might be a motive; his models were often his lovers. But the pictures present themselves as formal esthetic decisions based on a definite conception of the medium. They decide to exclude the contingency of a frontal encounter that would betray a relationship, one that exists in time, is subject to change, is vulnerable to inner ambiguity and to danger."[13]

Many of Weston's studio nudes have been described as purely formal equivalents, anatomical arrangements that are neither sexy nor seductive. But while these feminine body parts seem maneuvered for optimal formal innovation and not choreographed to necessarily accentuate classical female beauty, the avoidance of contact in celebration of its anticipation is felt. [Fig. 5] Beside the possible heightening of his own desire, there is the matter of possession. Psychologist Liam Hudson claims that Weston was one of the first to make this tricky business so public, showing "precisely detailed and sexually revealing portraits of [in the case of Charis Wilson] a young wife whom, in some sense, he must have wanted to keep for himself." Hudson goes on to say that "The evidence of clinical inquiry suggests rather strongly that the proffering of the model's naked body to the spectator meets more complex needs. . . . By making images of his model public, he gives other men access to her; but an access that is only symbolic, and constrained by limits that he himself has set."[14]

It is clear that Weston continues to eternalize, even with this more volatile and suggestive subject. The Thing Itself is dangled before his ground glass and he seeks to capture it, epitomized as well as photography's nature allows. While some images are more clinical in aspect, others are brilliant renditions of the pliant female body. His women are not only idealized, they are ideal (by contemporary cultural standards): lean yet pithy, sometimes dancers, other times merely young and firm. It seems certain that they were more than complicit in the picture-making process. Weston claims, in fact, that they often sought him out, offering themselves for the sake of art. Whatever the public or private intentions

of the women or Weston, it is possible to read the nudes as a collective whole in relation to Weston's interior being. Cultural critic Wendy Lesser discusses the male artist whose figurative work images women "to create or render his lost female self." She says that "Each male artist defines his relation to the feminine—both its closeness and its distance. . . ."[15] With the artists she examines, the "figure is more likely to be a mute and faceless sister. . . . But even when she is silent or hidden, she is nonetheless expressive . . . she is not quite alive and larger than life....She is the unborn self who lies behind the artist's work, the 'ghost' writer who makes his work possible."[16]

Such speculations aside, beginning with his startling nude studies of Margrethe Mather made on Redondo Beach in 1923 just prior to sailing to Mexico (page 33), Weston methodically built a library of female imagery—tough, beautiful, intense—that together represents, literally or not, a lifetime of female companionship. While his ego and his estimable concentration on his artistic quest may have frustrated his fidelity, he remained faithful to the magnetic, photographable Thing itself.

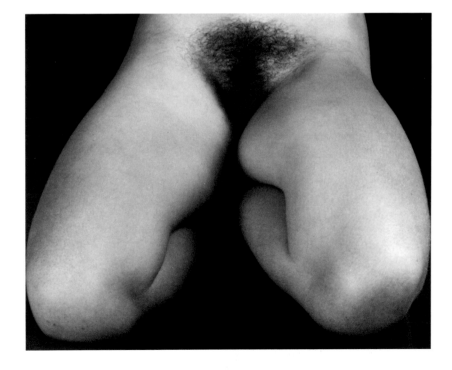

Fig. 5
Nude, 1934, CCP

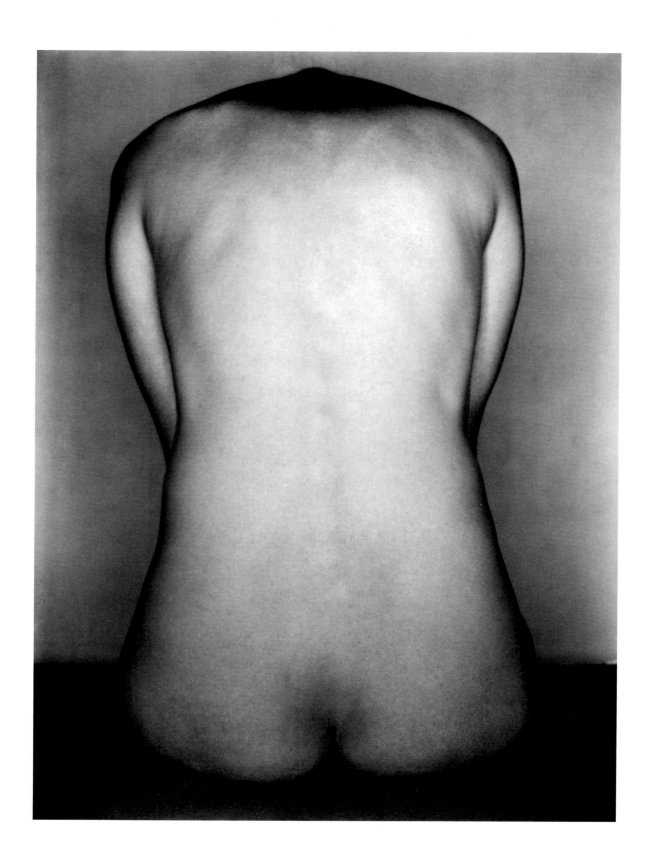

Nude, 1927

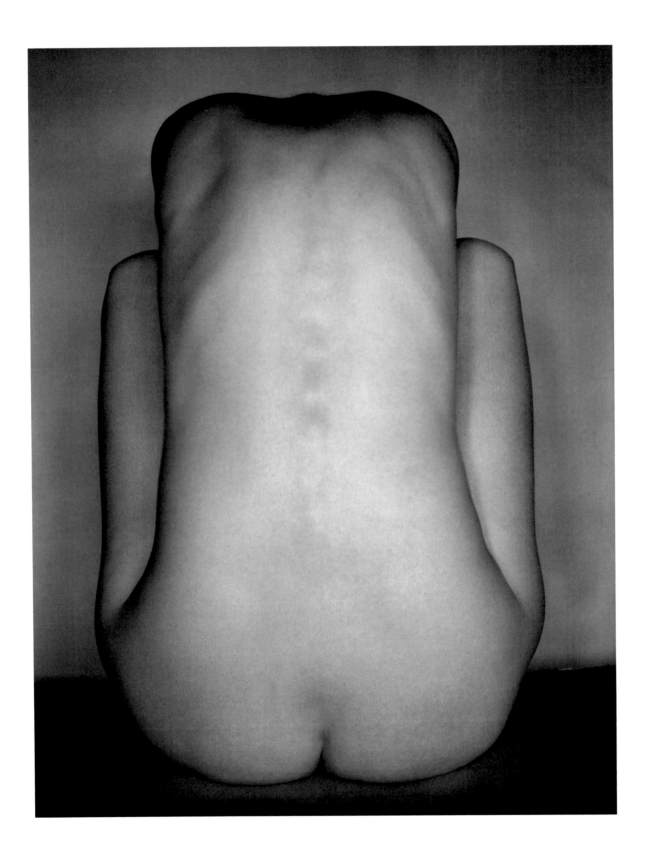

Nude, 1927

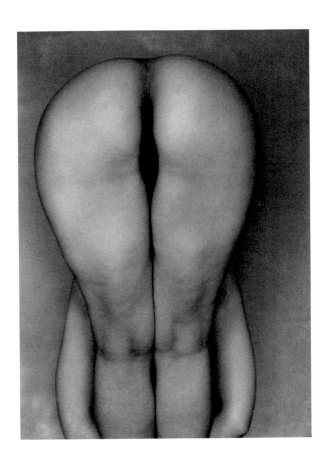

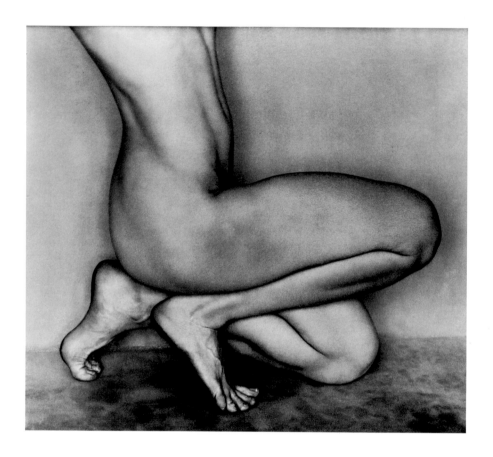

Dancer, 1927

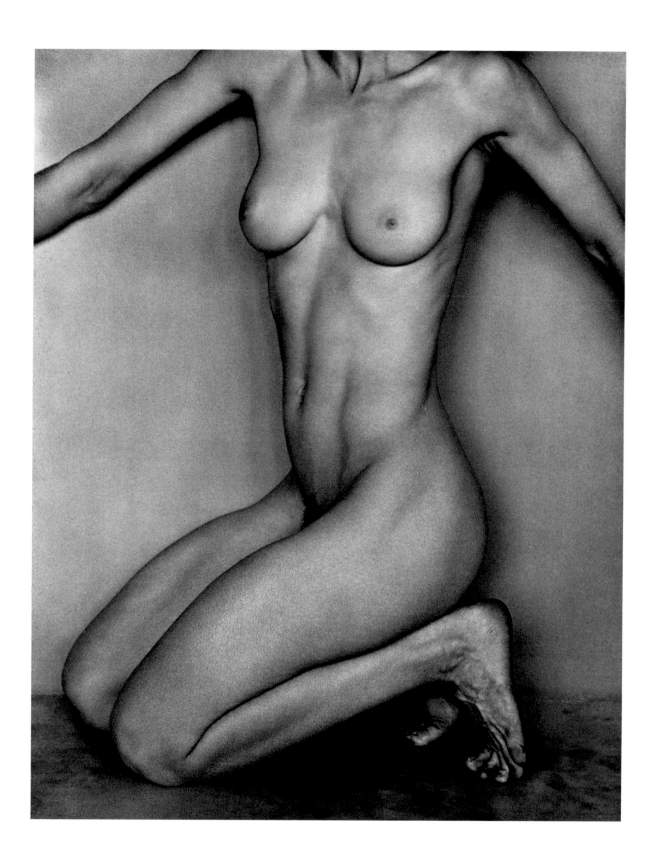

Dancing Nude, 1927

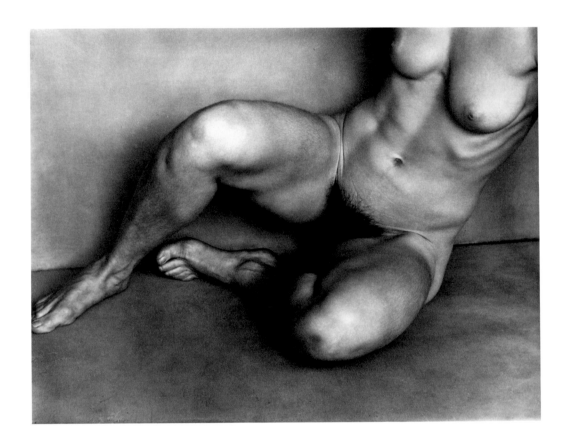

Nude, 1927

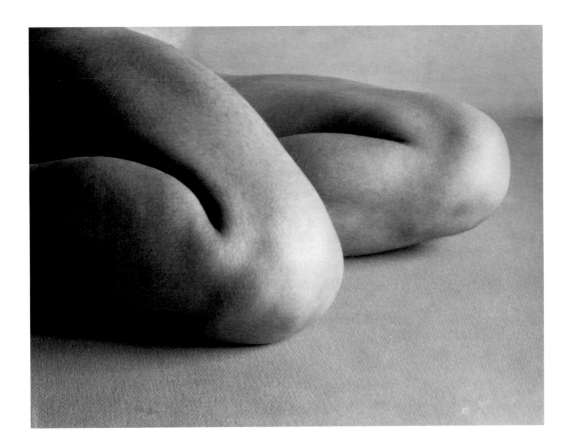

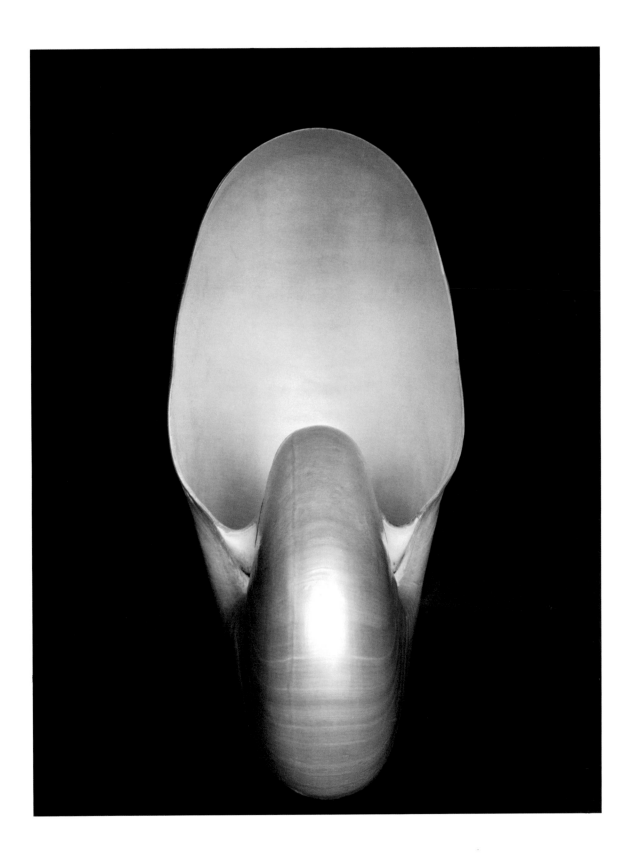

Chambered Nautilus, 1927

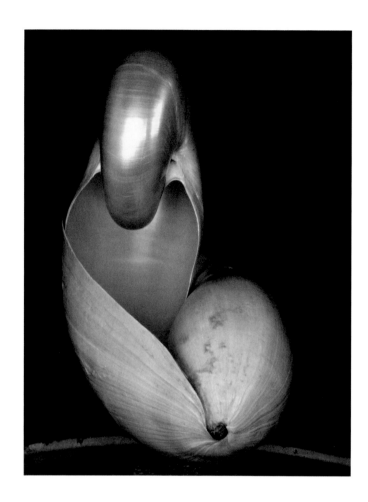

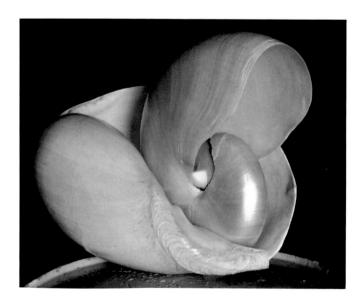

Shells, 1927

Shells, 1927

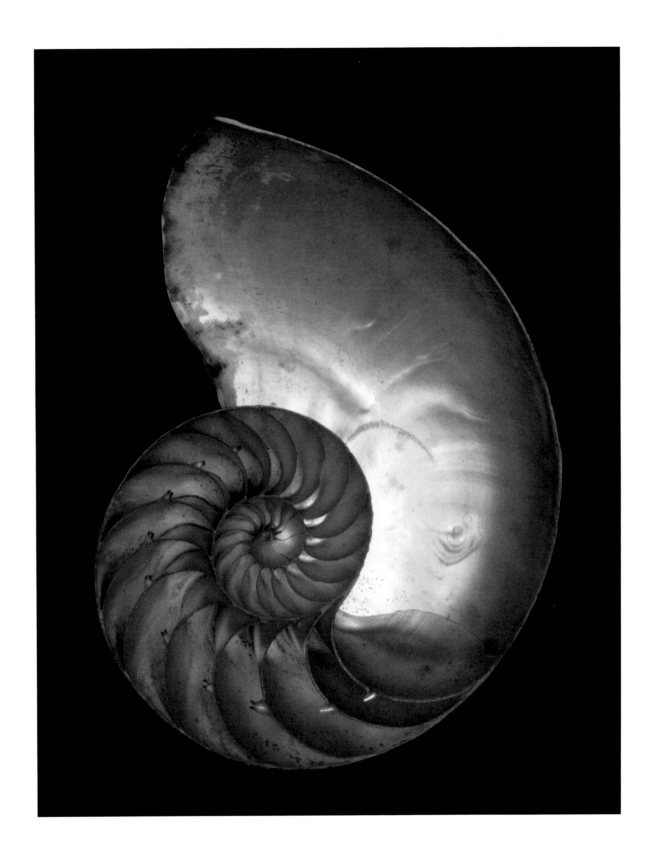

Shell, 1927

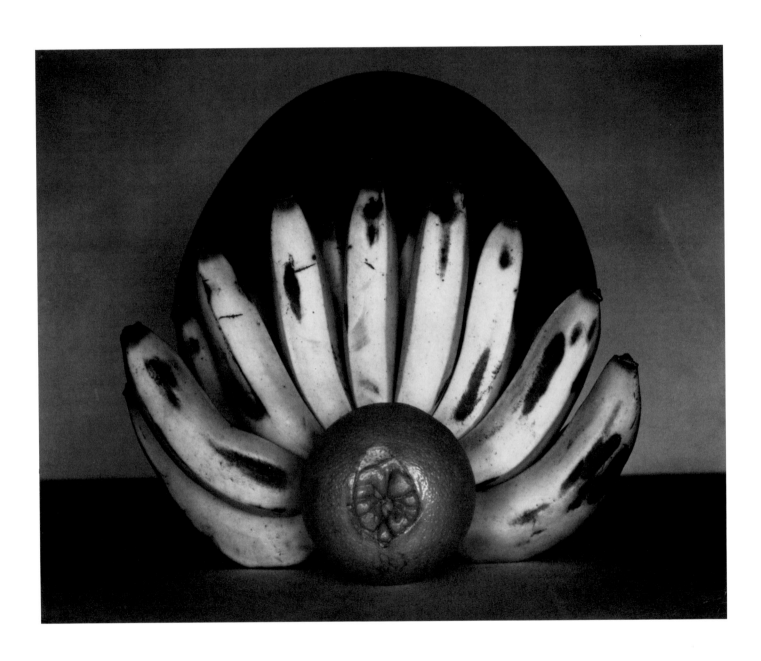

Still Life with Bananas and Orange, 1927

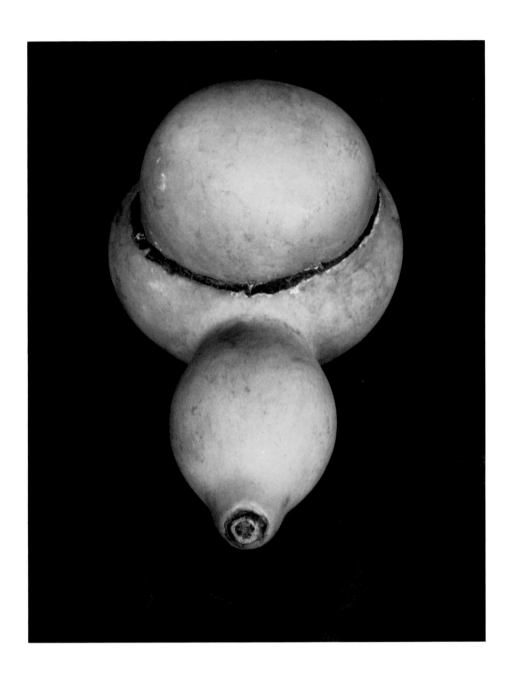

Gourd, 1927

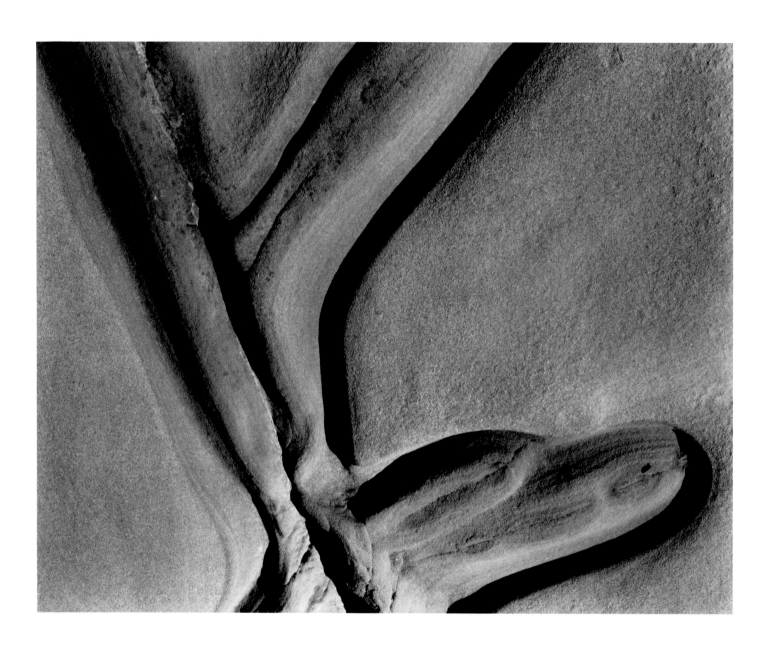

Rock, Point Lobos, 1930

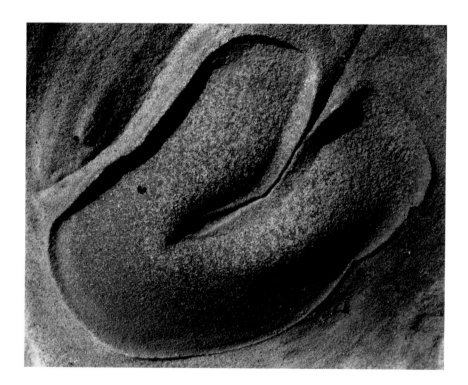

Rock Erosion, Point Lobos, 1929

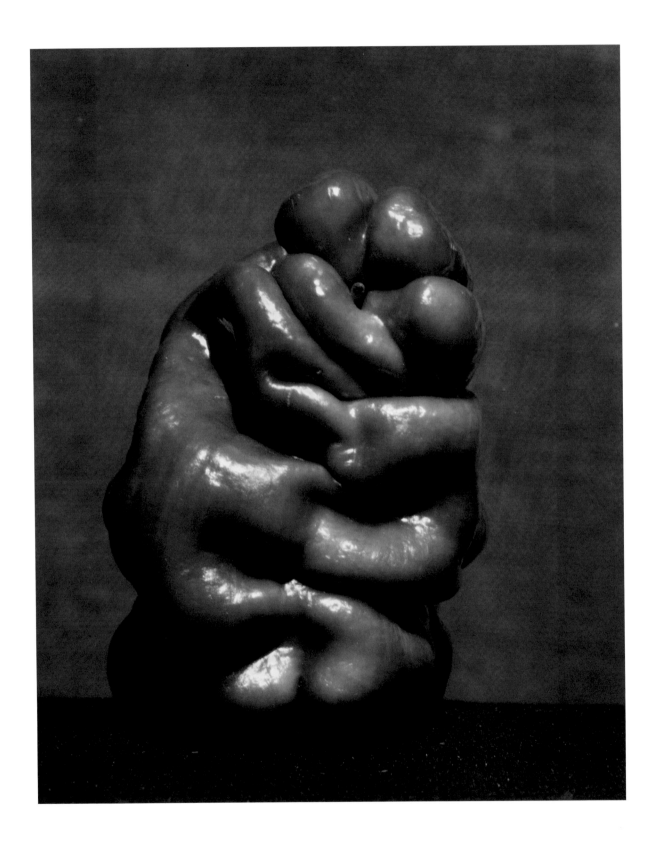

Pepper, 1929

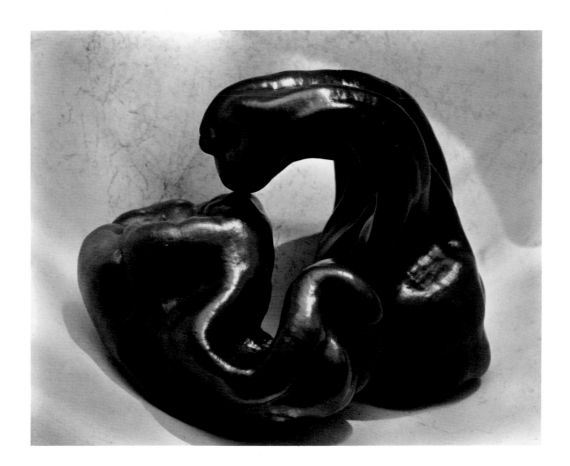

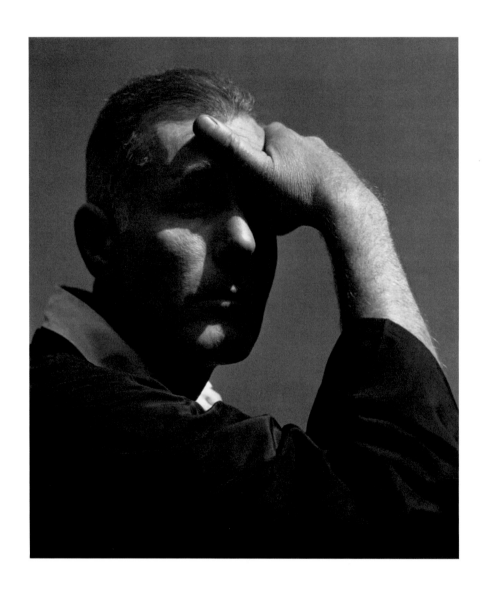

Ramiel, 1929

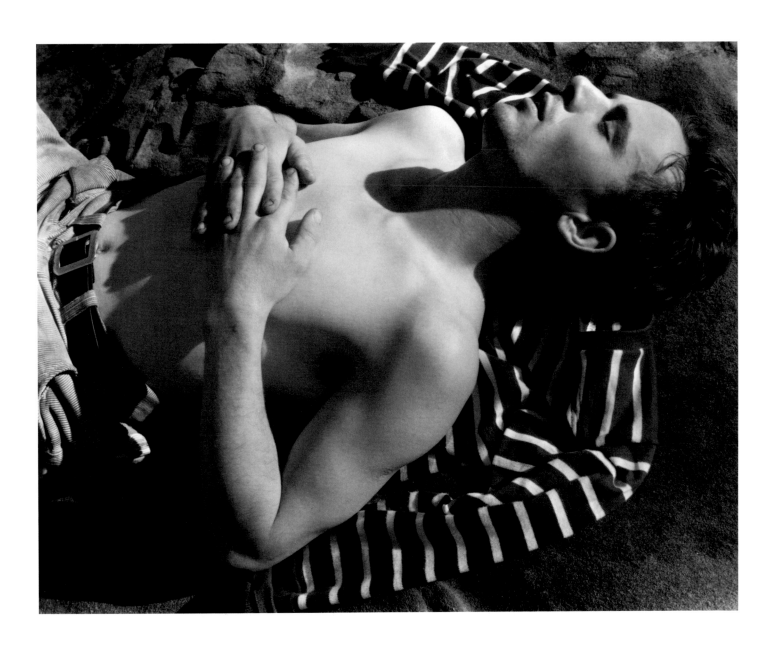

Preston Holder Asleep, 1930

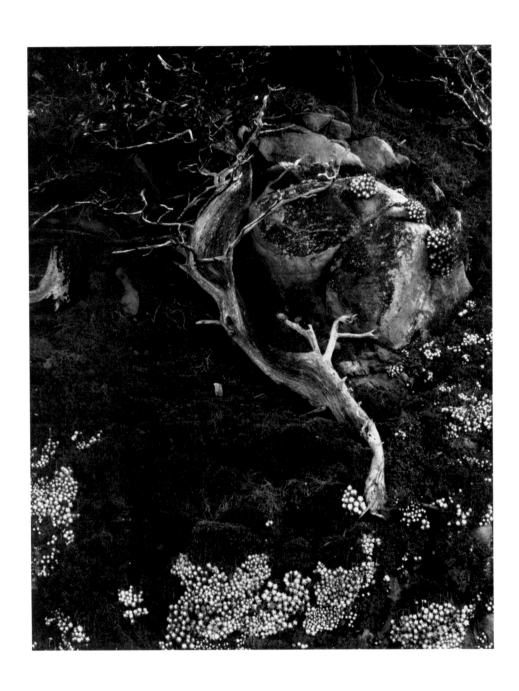

Cypress and Stonecrop, 1930

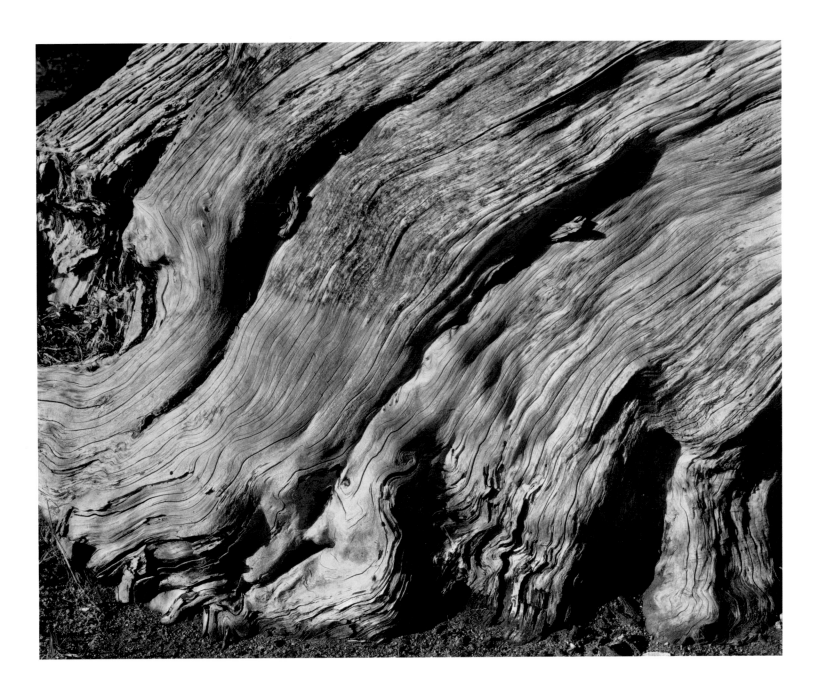

Cypress, Point Lobos, 1929

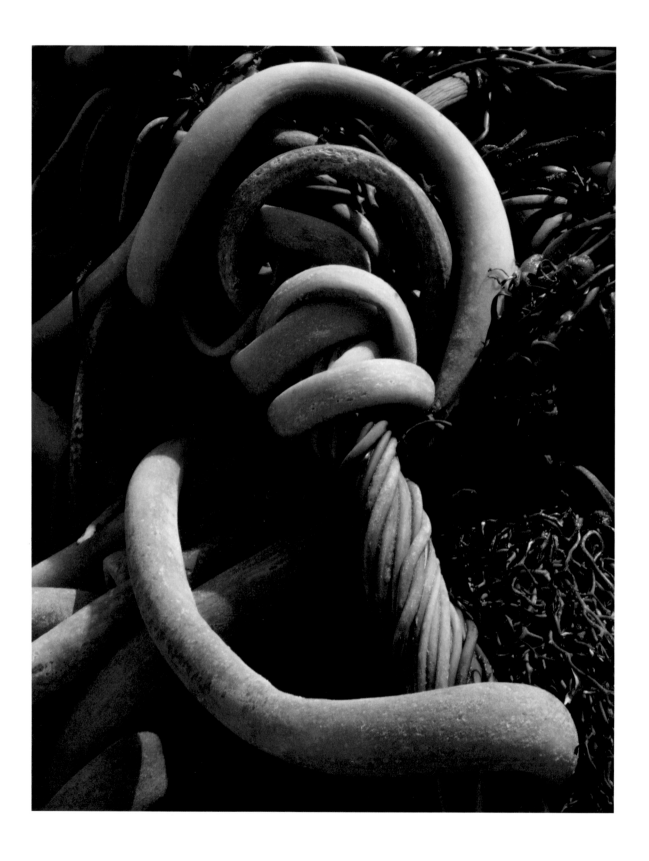

Kelp, 1930

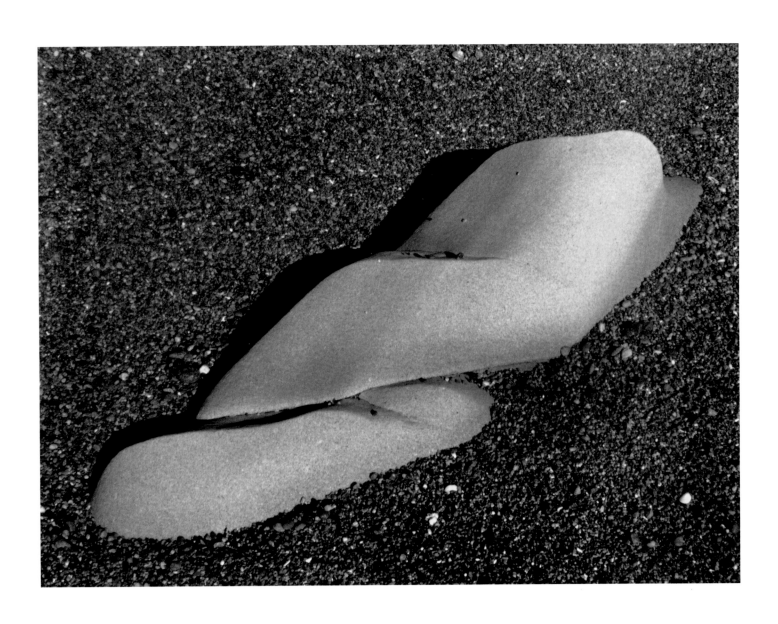

Eroded Rock, 1930

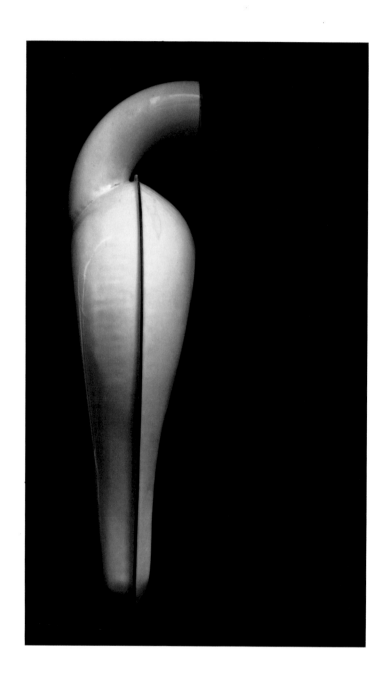

Bedpan, 1930

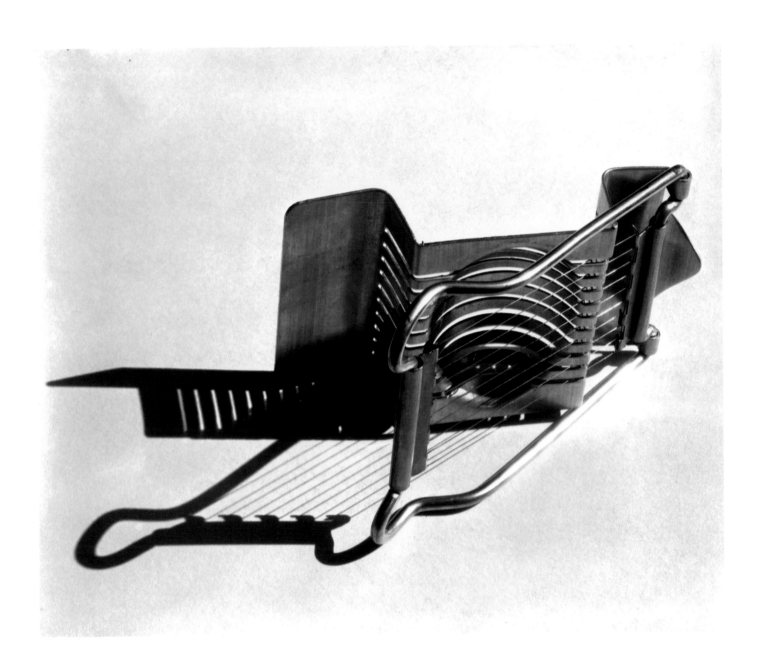

Egg Slicer, 1930

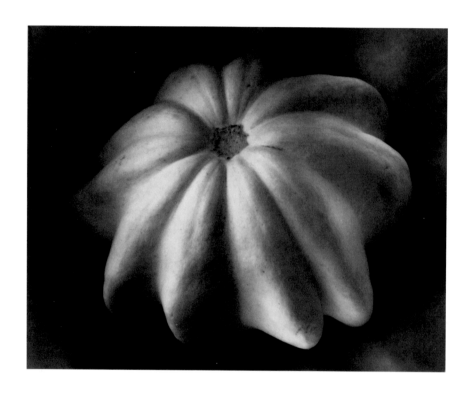

Winter Squash, 1930

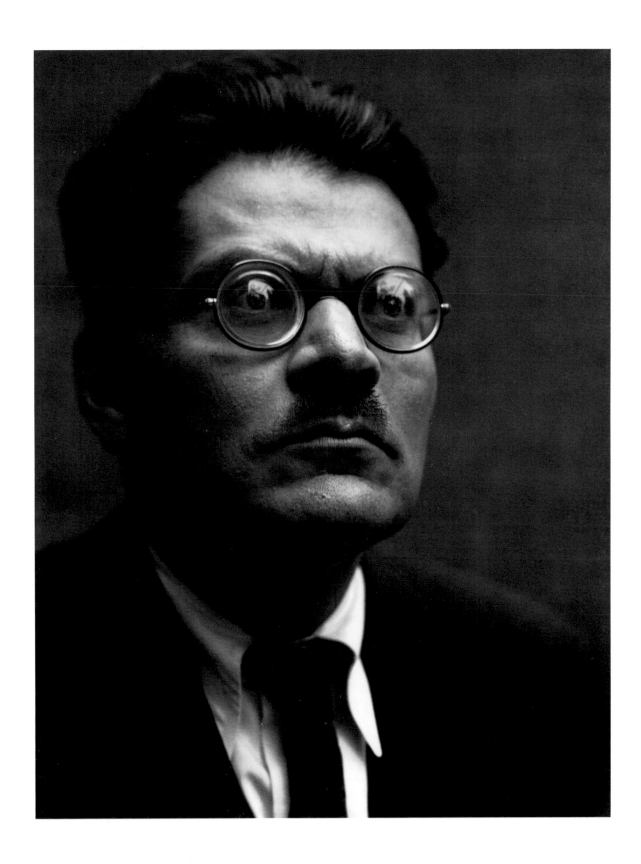

Jose Clemente Orozco, 1930

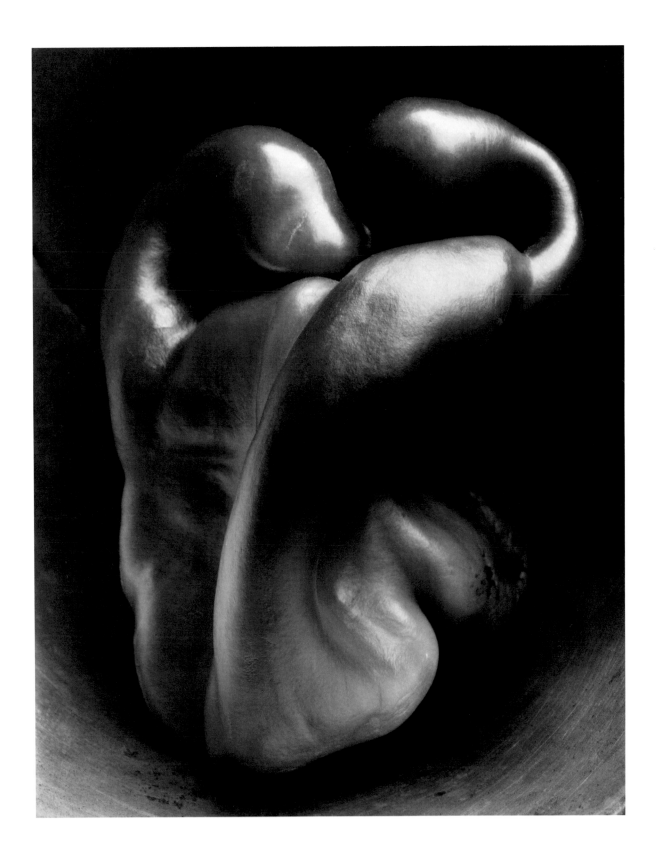

Pepper, 1930

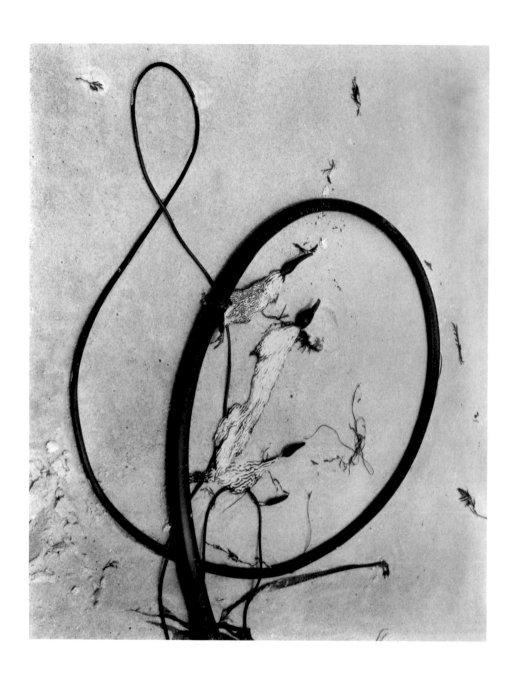

Kelp, 1930

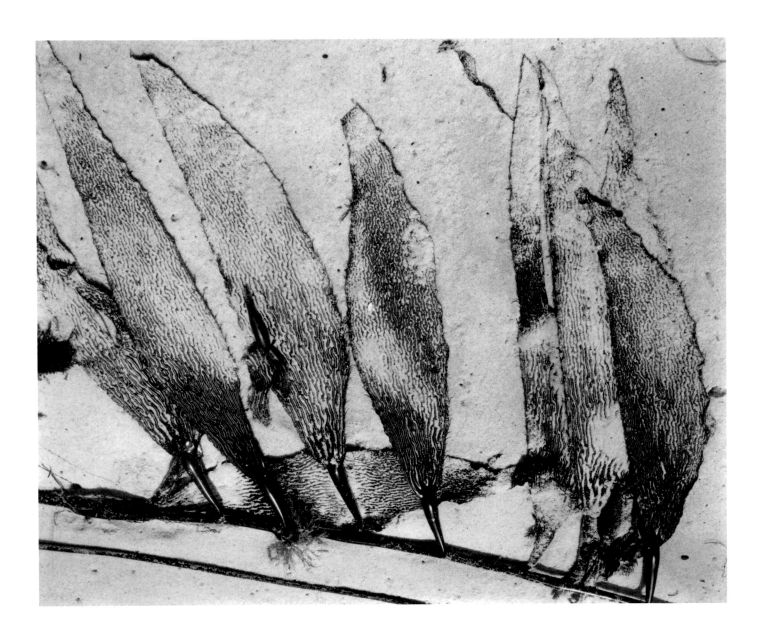

Kelp, 1930

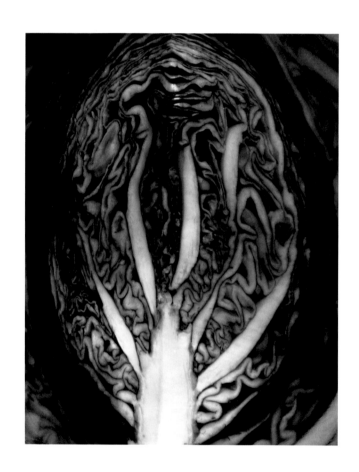

Red Cabbage Quartered, 1930

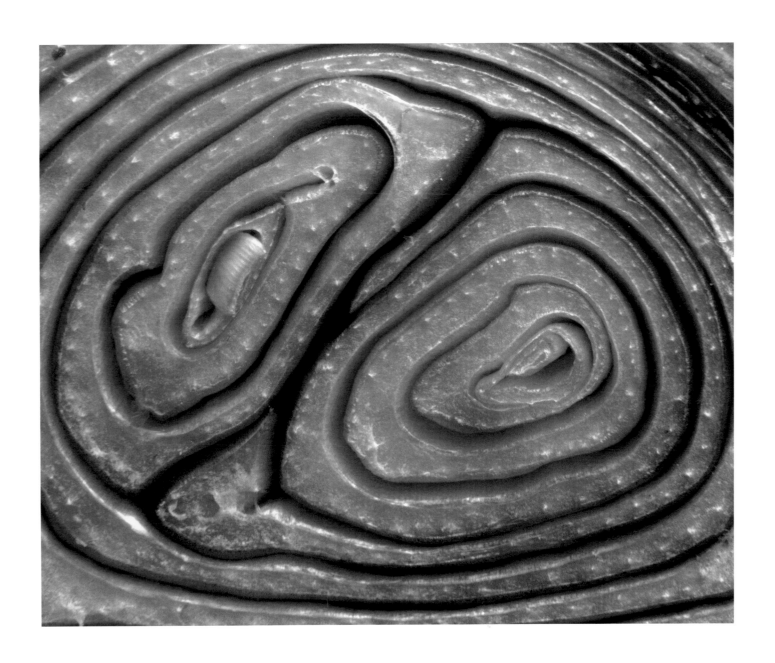

Onion Halved, 1930

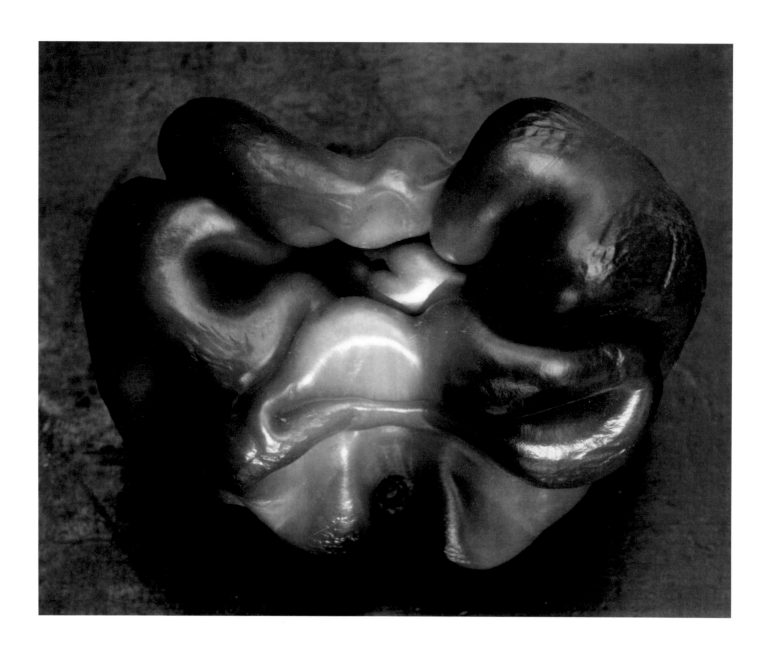

Pepper, 1930

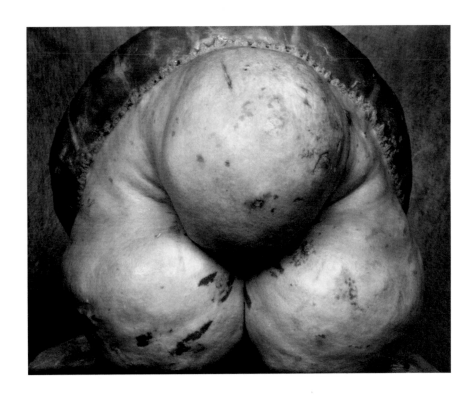

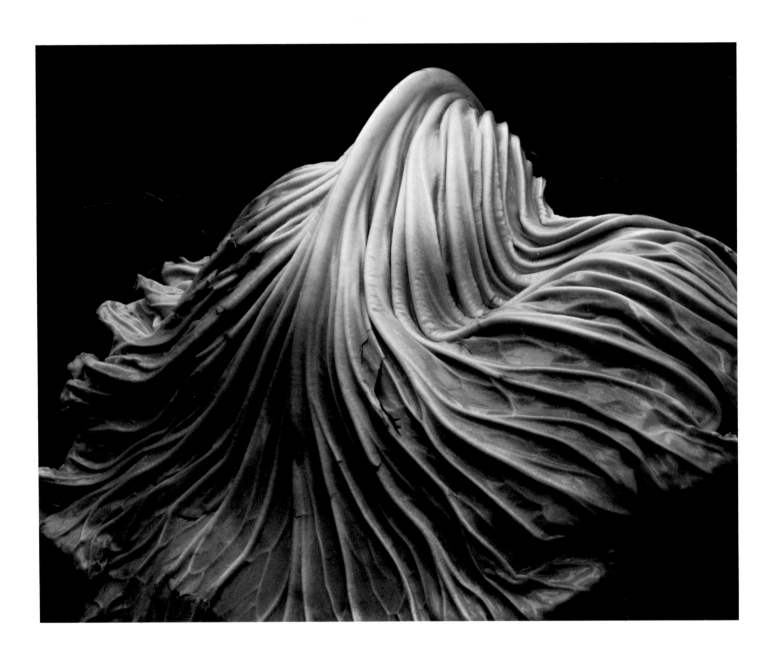

Cabbage Leaf, 1931

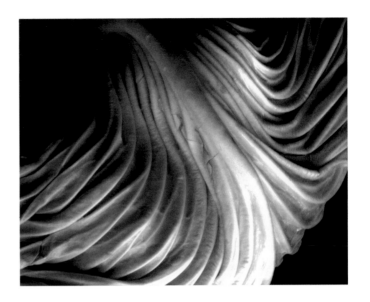

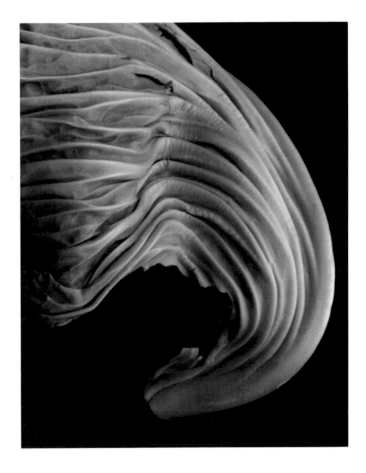

Cabbage Leaf, 1931

Cabbage Leaf, 1931

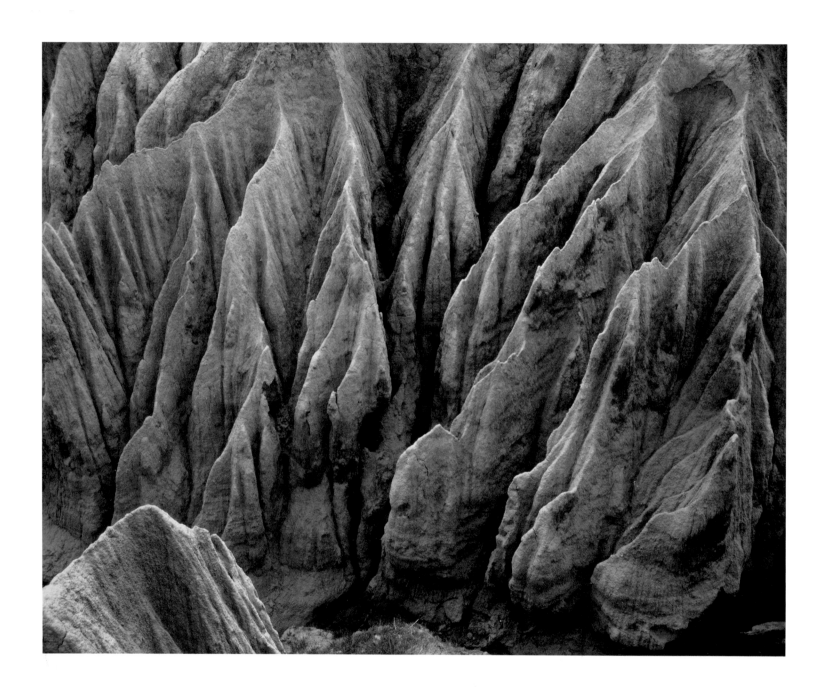

Soil Erosion, Carmel Valley, 1932

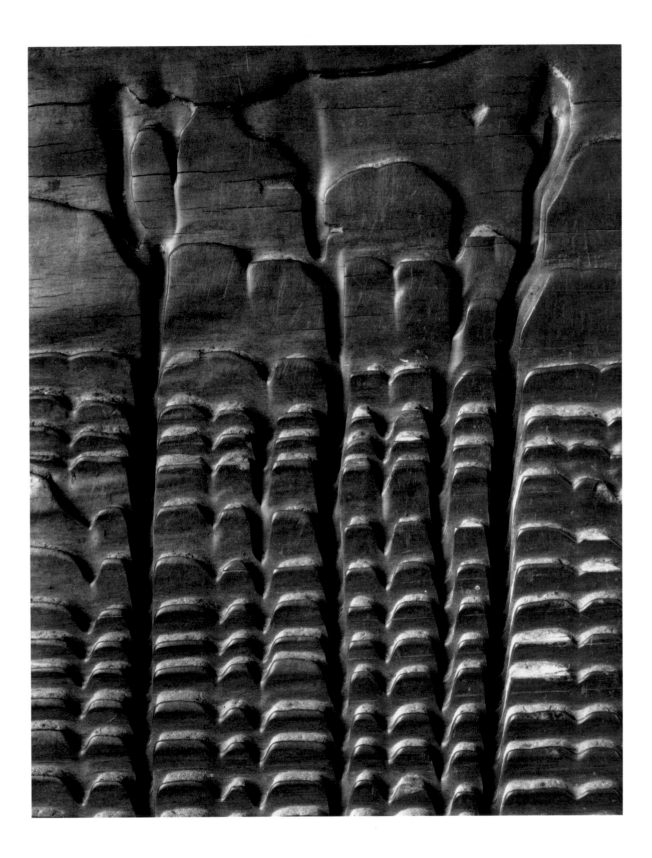

Eroded Plank from Barley Sifter, 1931

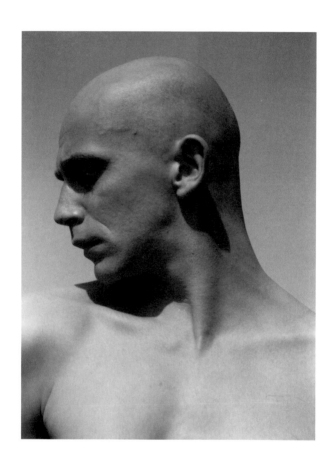

Harald Kreutzberg, 1932

Hollywood, 1931

Church at "E" Town, 1933

Barn, Castroville, 1934

Deserted Landing, 1932

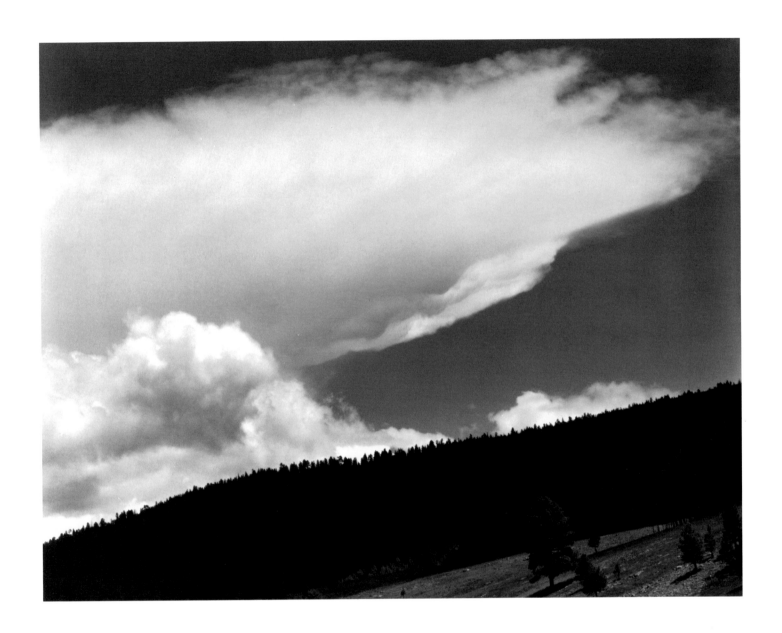

New Mexico, 1933

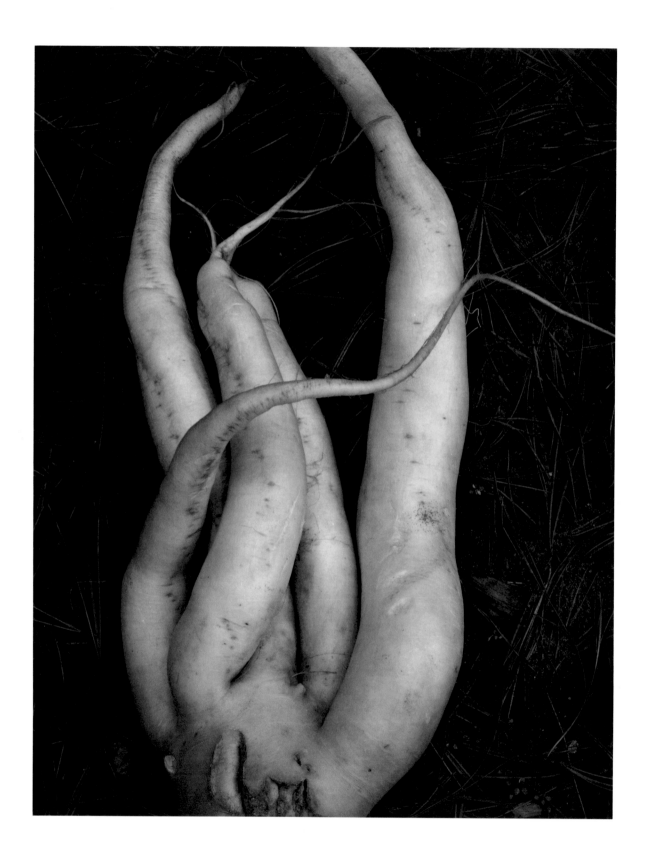

White Radish, 1933

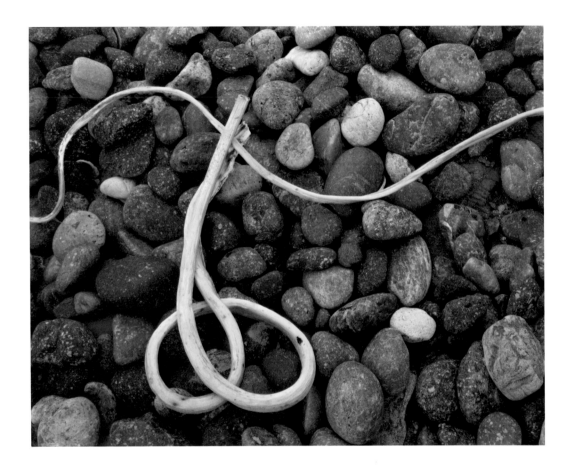

Dry Kelp, Point Lobos, 1934

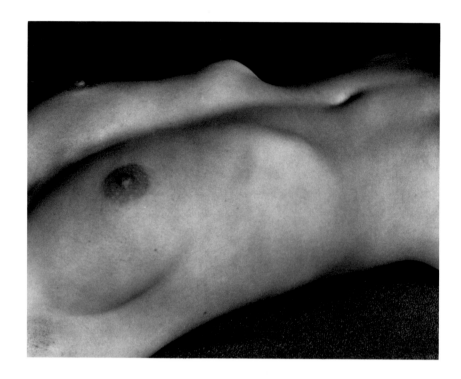

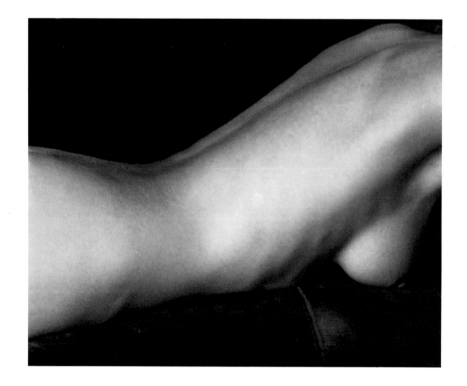

Nude, 1933

Nude, 1933

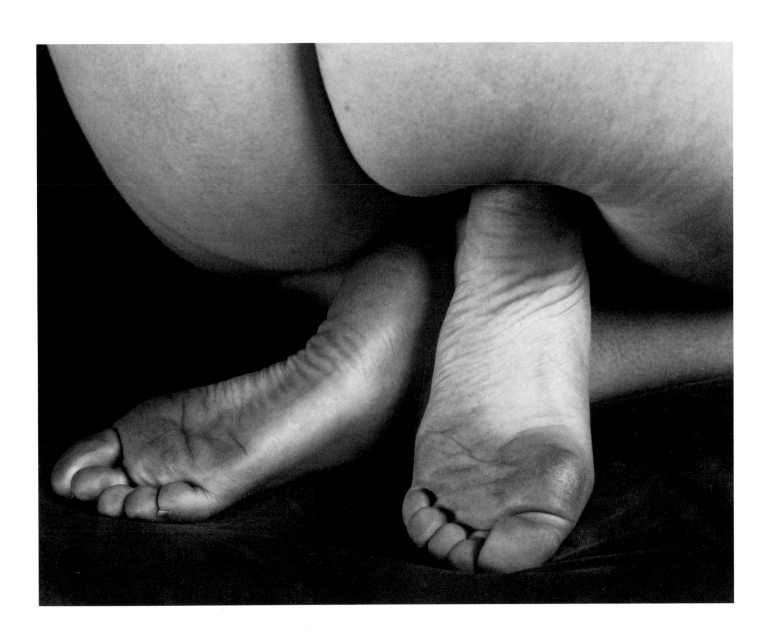

Nude, 1934

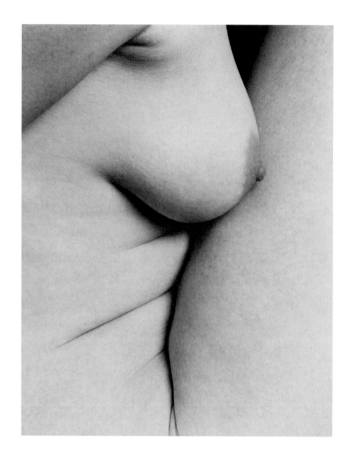 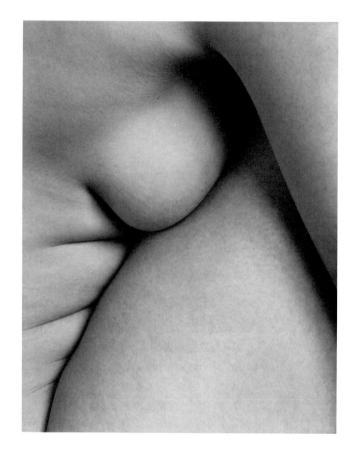

Nude, 1934

Nude, 1934

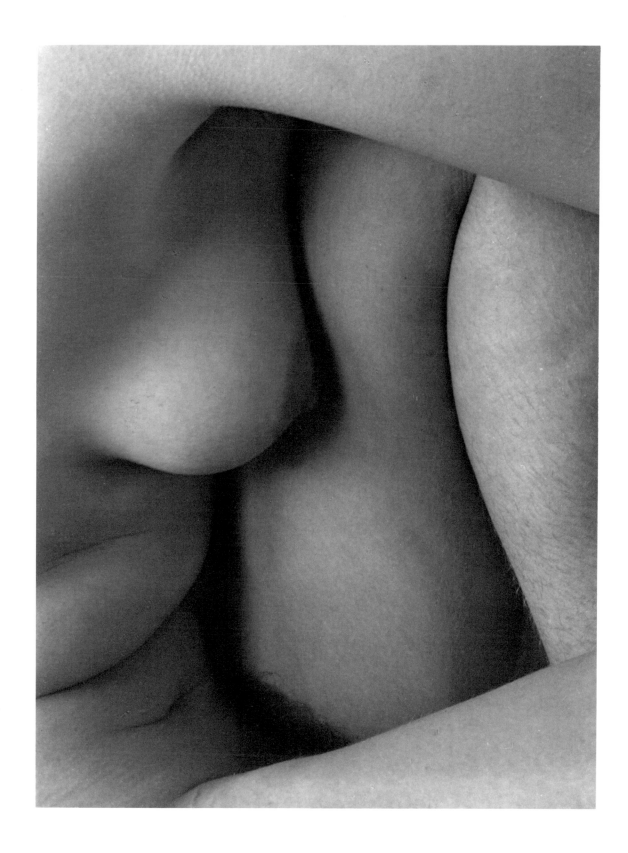

Nude, 1935

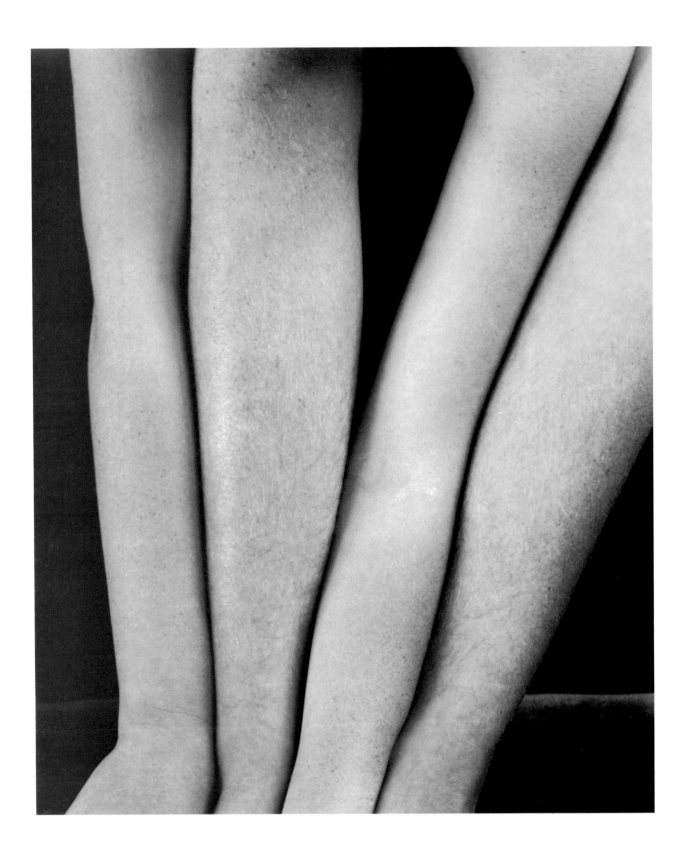

Nude, 1934

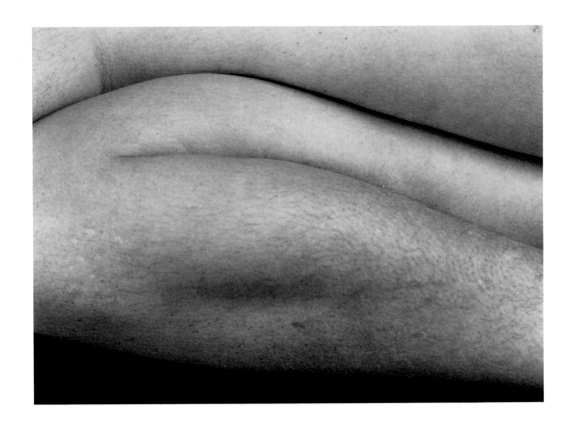

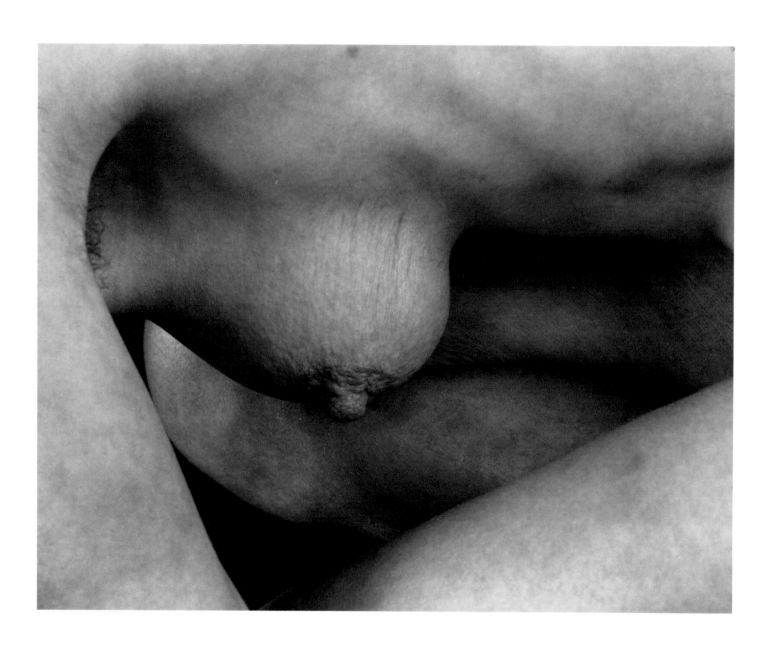

Nude, 1935

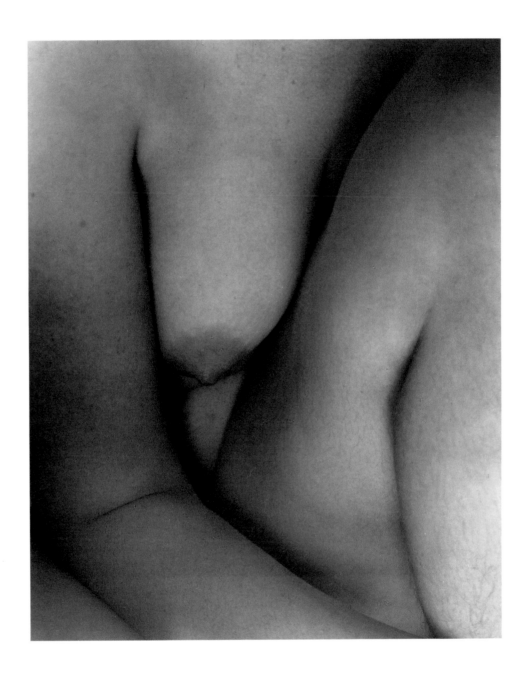

Nude, 1935

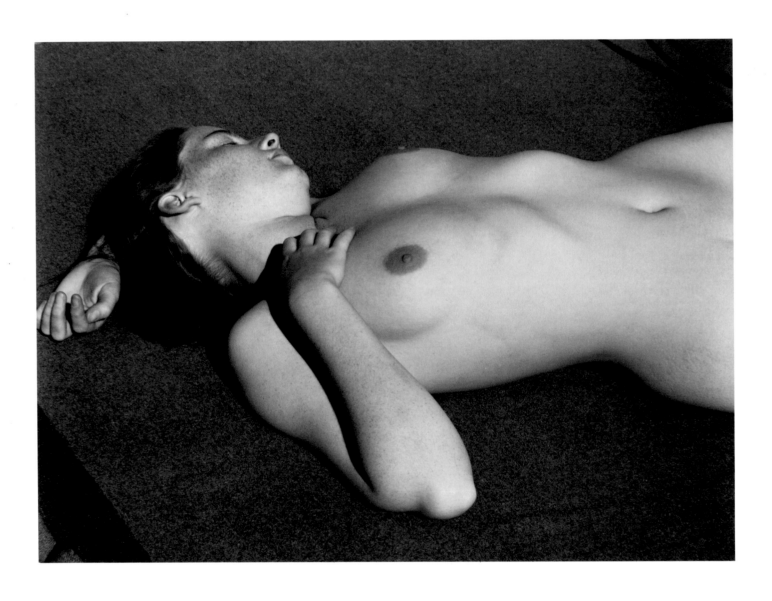

Nude, 1935

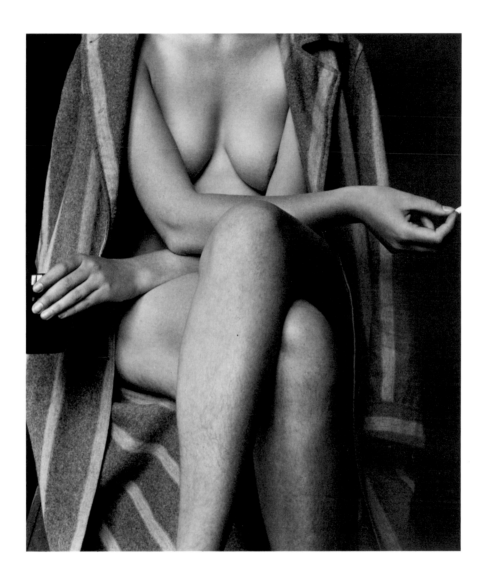

Nude, 1934

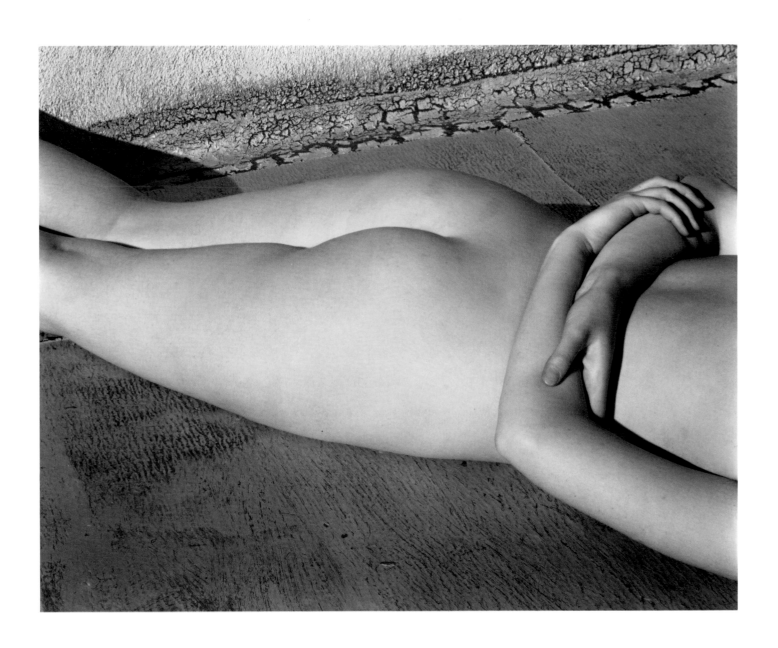

Nude, 1935

Bug Tracks in Sand, 1935

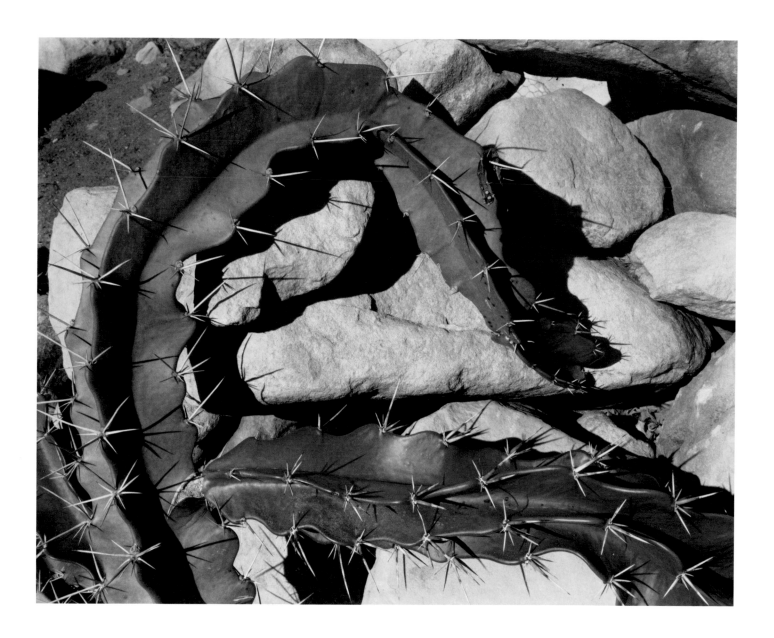

Cactus, 1933

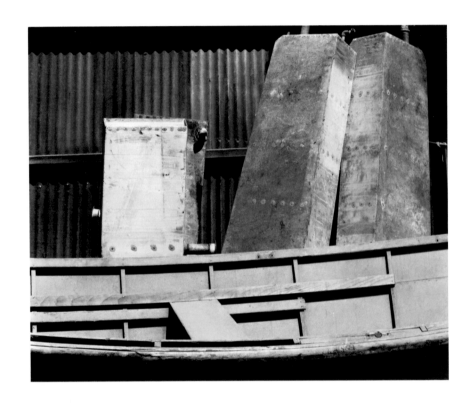

Shipyard Detail, 1935

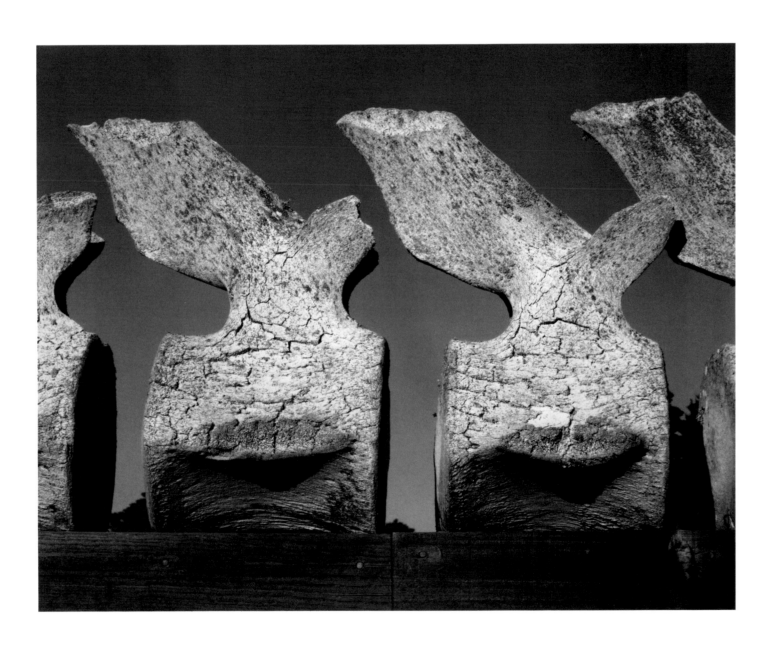

Whale Vertebrae, 1934

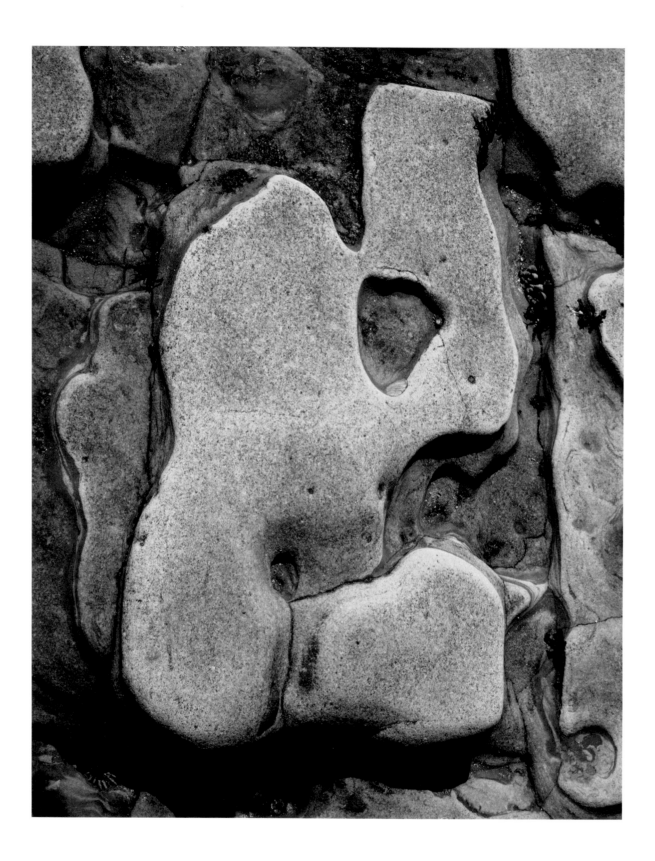

Eroded Rock, Point Lobos, 1935

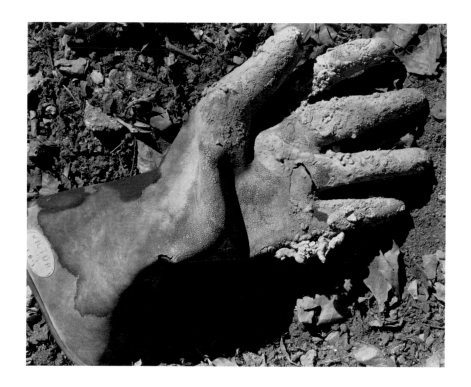

Cement Glove, 1936

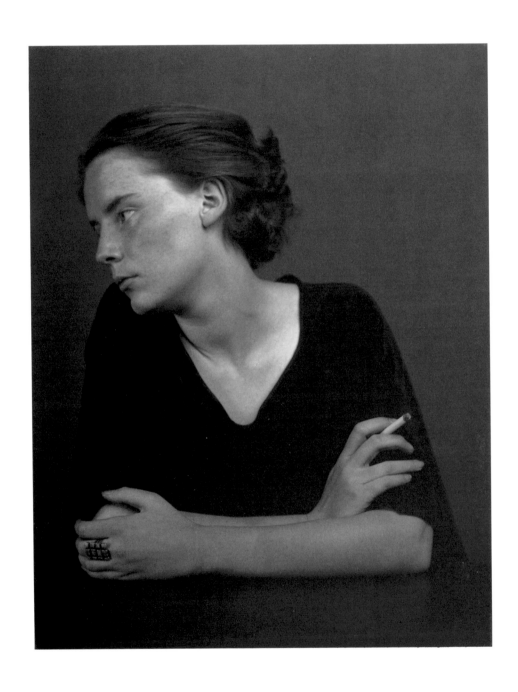

Charis Wilson, 1935

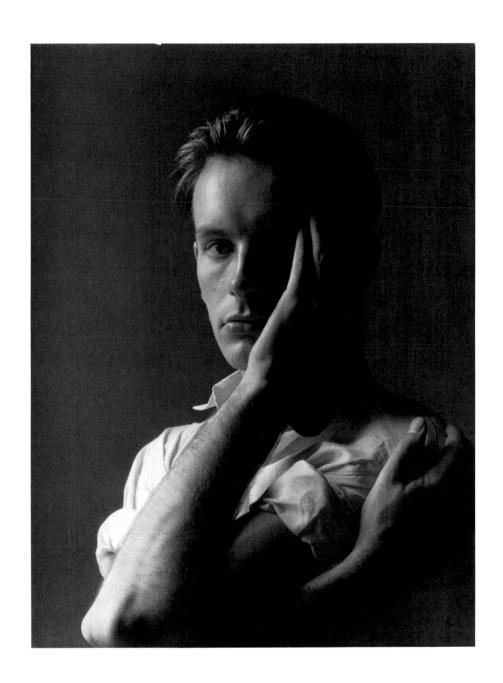

Leon Wilson, 1935

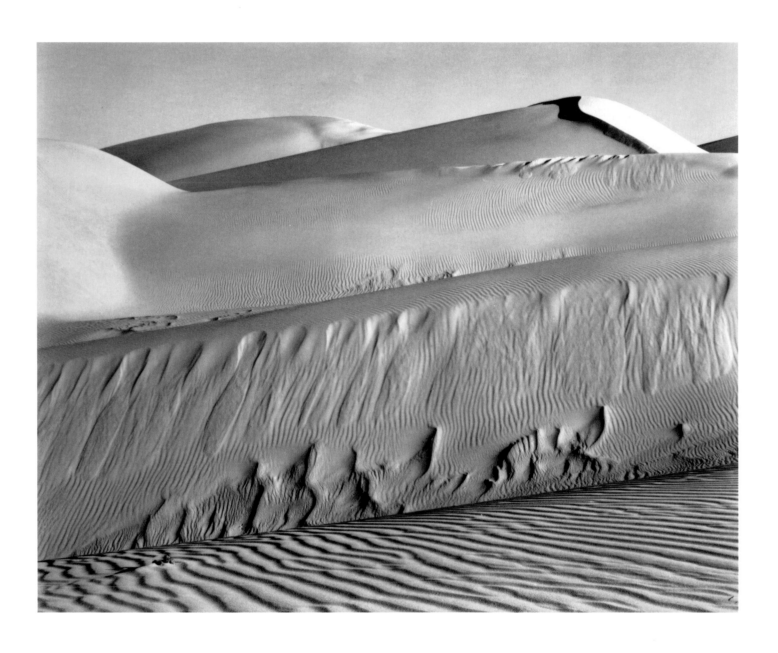

Dunes, Oceano, 1936

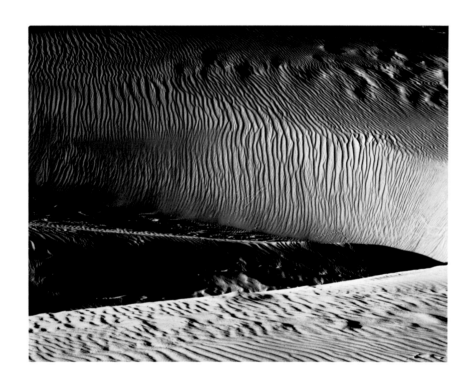

Wind Erosion, Dunes at Oceano, 1936

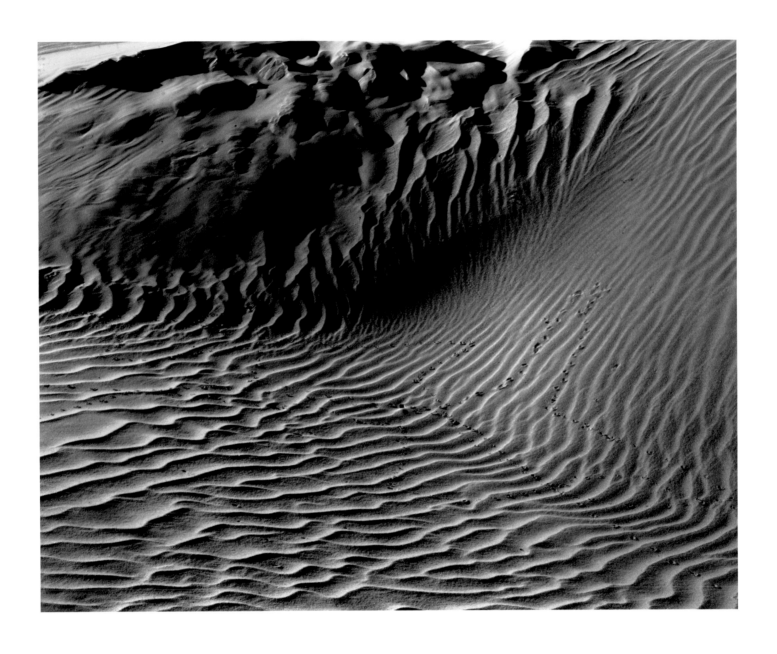

Dunes, Oceano, 1936

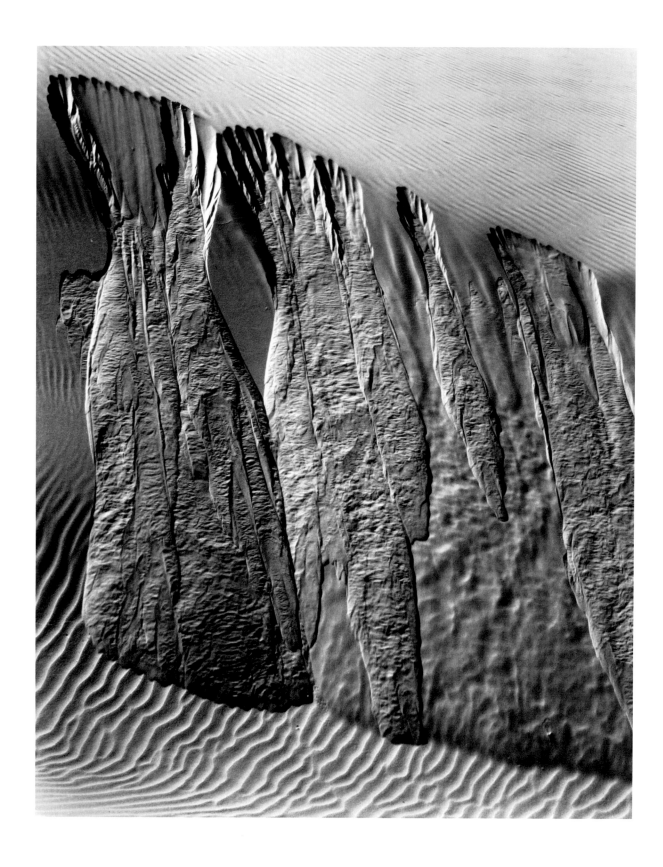

Sand Dunes, Oceano, 1934

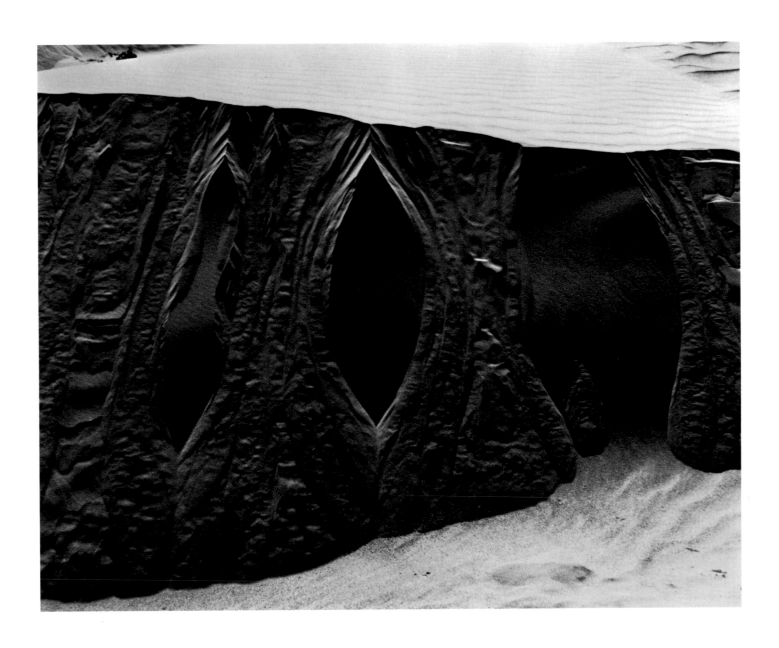

Dunes, Oceano, 1936

216

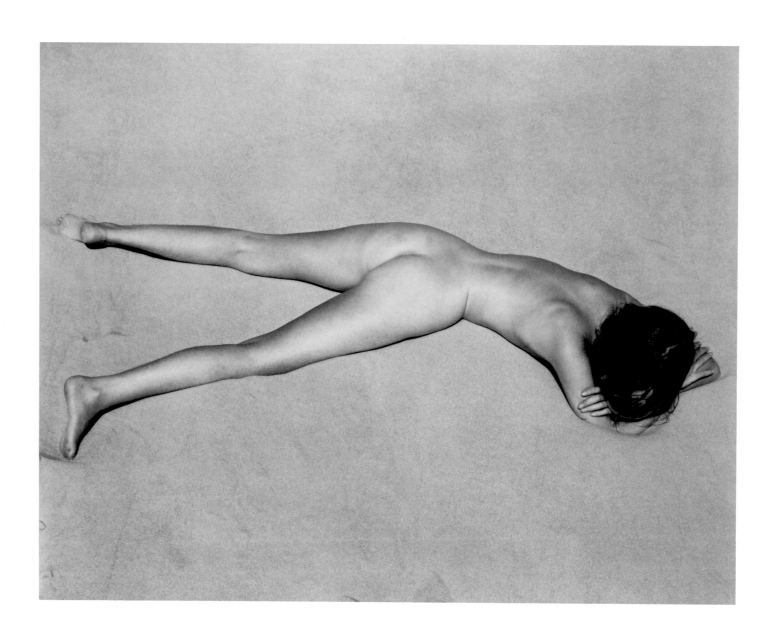

The series following is of Charis, Oceano, California. *Nude*, 1936

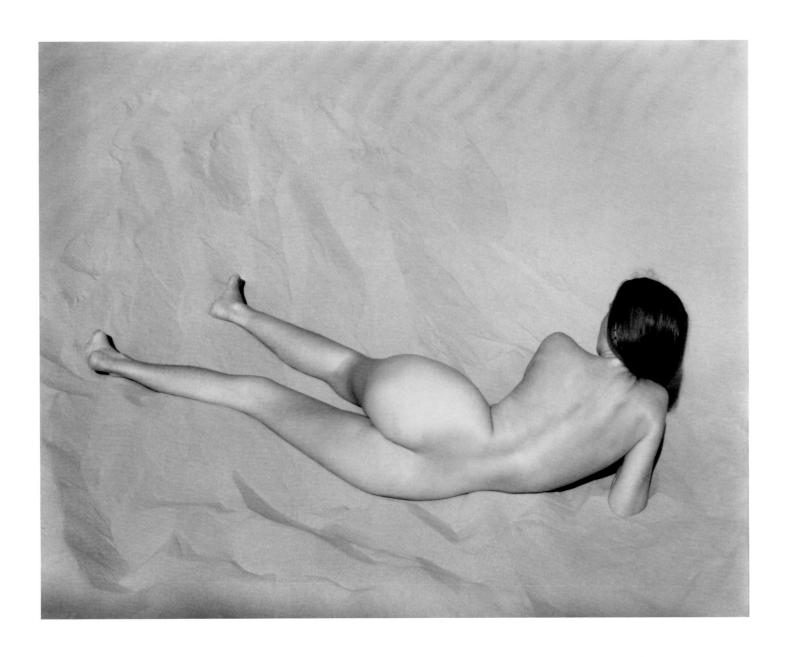

Nude, 1936

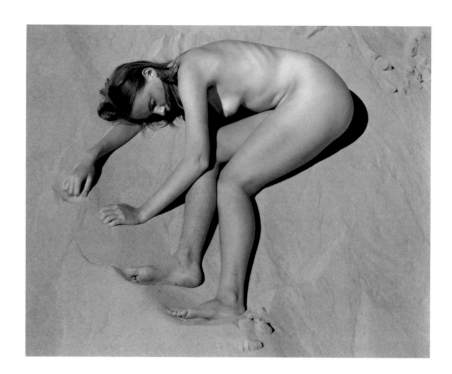

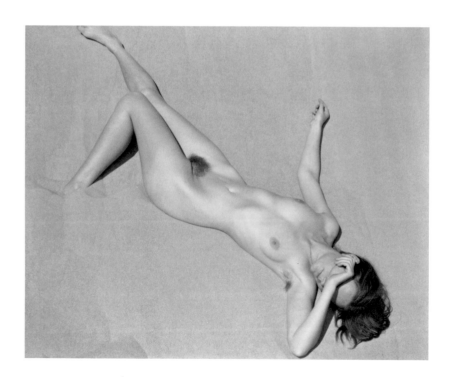

Nude, 1936

Nude, 1936

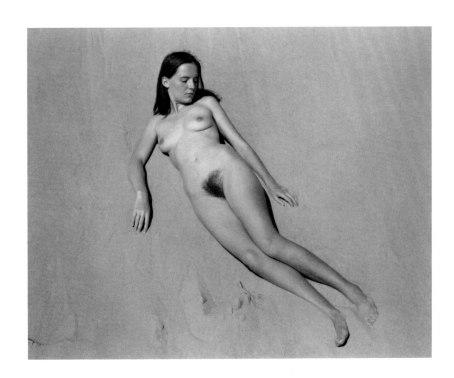

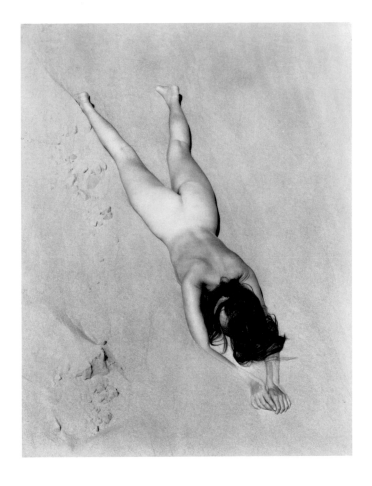

Nude, 1936

Nude, 1936

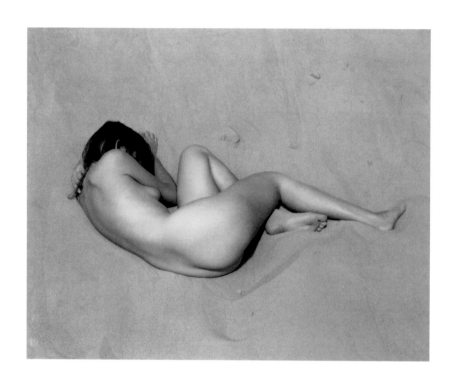

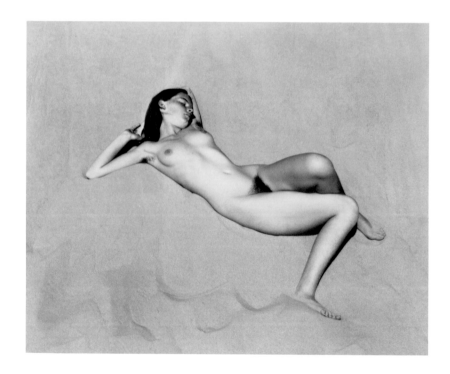

Nude, 1936

Nude, 1936

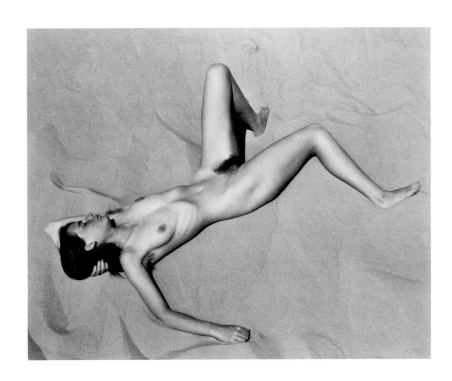

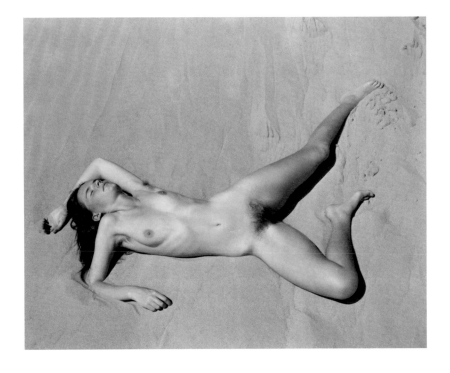

Nude, 1936

Nude, 1936

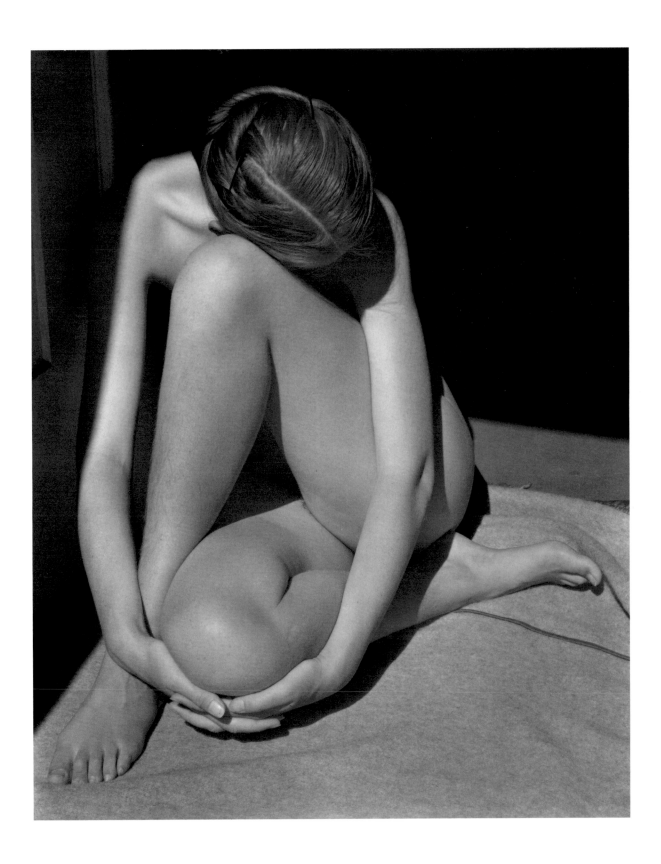

Nude, 1936

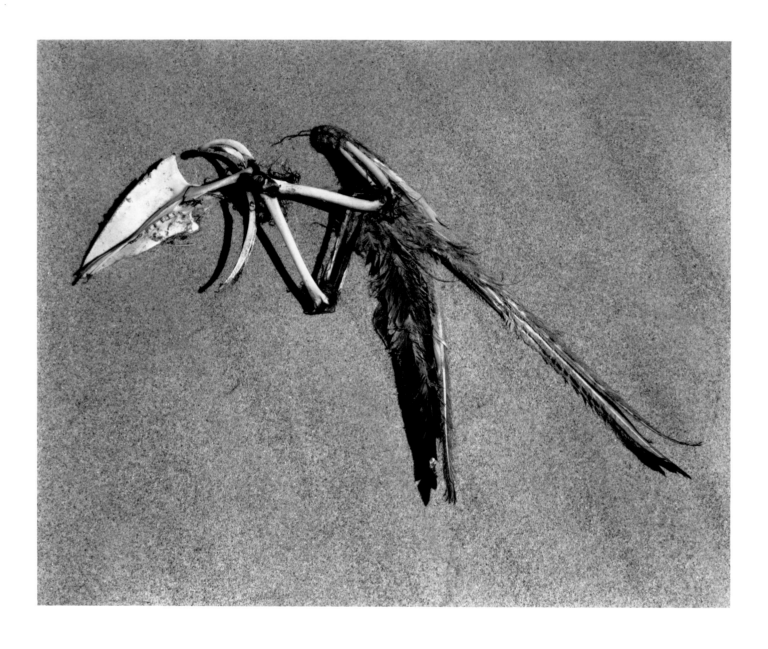

Bird Skeleton, 1936

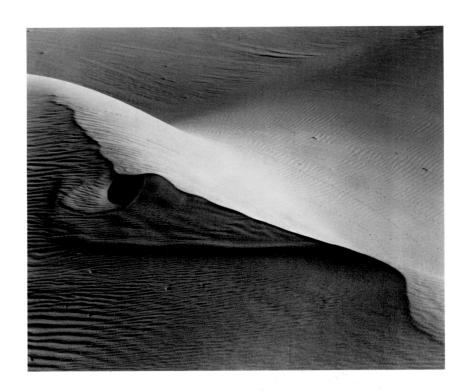

Dunes, Oceano, 1936

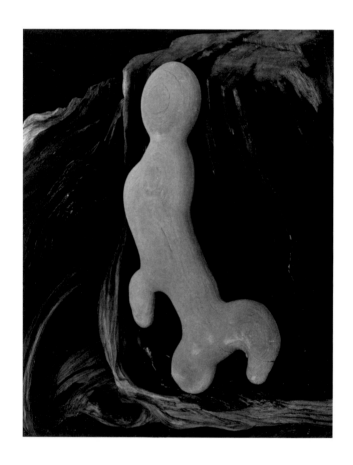

Sandstone Erosion and Root, 1936

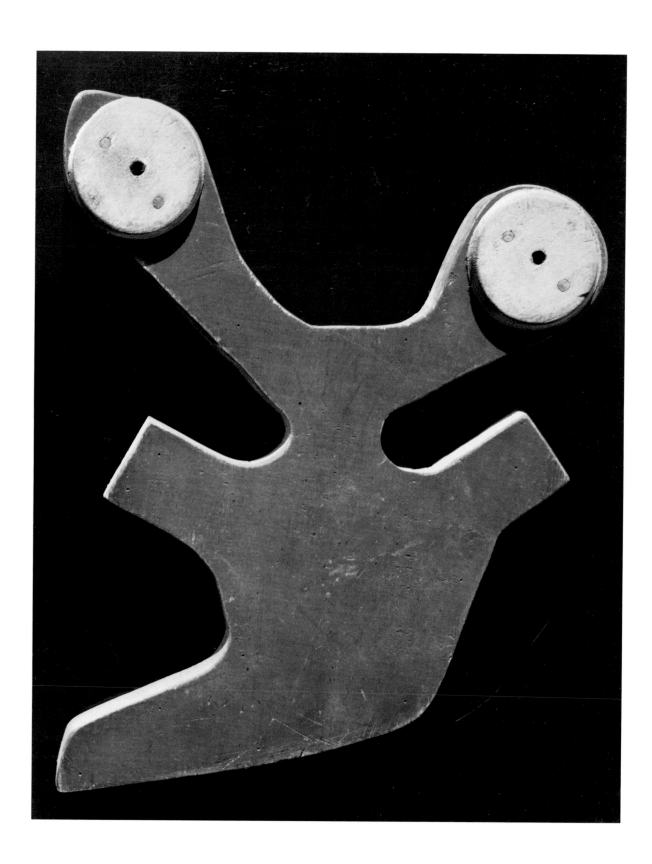

Model for Mould, 1936

1937
1939

The years 1937 to 1939 were ones of great change and extraordinary productivity for Edward Weston. During this period, Weston's long-established working methods, subject matter, and even his own lifestyle were all transformed. The photographer, who had worked so slowly and painstakingly, spending days on the creation of a single work, now worked quickly and freely, making series after series of highly varied images. Formerly a specialist in figurative and still-life subjects, this creator of iconic shells and peppers, of dramatic heads and perfect nudes, now turned exclusively to landscape. And the resolutely unfettered Weston, who had never had a permanent home or a lasting monogamous relationship with a woman, fell in love with Charis Wilson, formed a stable and mutually inspiring relationship with her, and in 1938 moved with her into a beautiful small house overlooking the Pacific Ocean that they called "Wildcat Hill."

This brief but important period in Weston's life is often called his Guggenheim Years, because of the two grants from the John Simon Guggenheim Memorial Foundation in New York that made possible his new freedom. Since 1925 the Guggenheim Foundation had been making awards to liberal-minded members of the American avant-garde including the poet e.e. cummings, sculptor Isamu Noguchi, and composer Aaron Copeland. Late in 1936 Weston applied to the foundation for a year's support so that he might, in his words, "continue an epic series of photographs of the West, begun about 1929."[1] In his application the photographer envisaged taking up a wide variety of new subjects, "from satires on advertising to ranch life, from beach kelp to mountains." On March 22, 1937 he was notified of his appointment as a Guggenheim Fellow, with an annual stipend of two thousand dollars. This proved adequate to support Charis and himself frugally, with enough left over for his film and other photographic expenses. The dollar went much further in those days than it does now: as Charis Wilson recorded in her journal, food for the two of them and Weston's son, Cole, for a nine-day trip cost just thirteen dollars. On the same excursion they bought sixty-six and a half gallons of gasoline for some fifteen dollars.[2] Early in 1938 the foundation renewed his grant for a second year, which he devoted largely to developing the negatives he had made during the preceding months.

Thus, the term Weston's Guggenheim Years refers specifically to the twenty-four months from April 1, 1937 to March 31, 1939. During this time Weston traveled widely in his home state of California, photographing voraciously, with trips also to Arizona, New Mexico, Oregon, and Washington. In this two-year period, he made some fourteen hundred negatives, about one-quarter of all his life's work. In the process he transformed himself, becoming for the first time in his life a full-time landscape photographer, and his working methods and his style both changed dramatically.

Weston's life to this point had been marked by poverty. In the remarkable diary that he called his "Daybooks", he speaks frequently of being without money for food, despite his very simple lifestyle. He had always relied on portrait sittings to pay his way and make possible his creative work. But he despised his

Willard van Dyke
Edward Weston and his camera, Northern California, 1937

Heimy in Golden Canyon, 1937
(Heimy was the name given to the car purchased for the trip
with money from a magazine sale.)

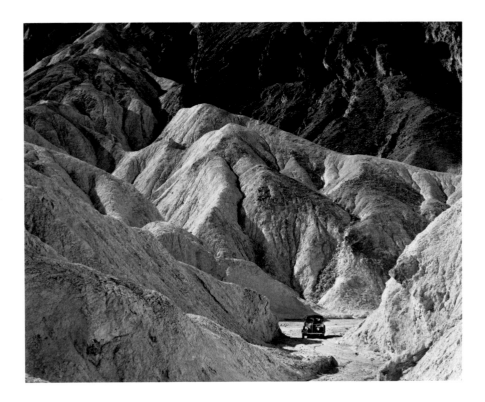

1.
John Simon Guggenheim Memorial Foundation
Fellowship Application Form. A copy of the Edward
Weston application is in the archives of the
Huntington Library, San Marino, California: the original
is in the archives of the Guggenheim Foundation.

2.
Charis Wilson. *Journal of the Guggenheim Year
1937–1938*, unpublished manuscript in the collection of
the Huntington Library, San Marino, California.

3.
Daybooks, volume II, p. 242.

commercial portraiture, writing on one occasion, "for a price, I become a liar,"
and summing up, "I hate it all, but so do I support not only my family, but *my own
work.*"[3] The Guggenheim grants liberated Weston from the prison of always hav-
ing to stay at his studio, waiting for a portrait sitter to come along. For the first
time in his life, at the age of fifty-one, he became free to do what he wanted.

Like every great artist, Weston was always experimenting, always seeking to
extend his range. He must have realized that the classical purity of the abstract
vegetable, shell, nude, and dune images that he had made earlier could not be
surpassed. During the early 1930s he was experimenting increasingly with the
accidental and the temporary. More and more, he became aware that a photog-
rapher could express reality. During the Guggenheim years, Weston worked like
a journalist, making pictures of everything in nature except people. He now trust-
ed his own eye completely: turning to the outdoors with a sense of liberation, he
stopped relying on the essentially artificial, studio-bound approach of earlier
years. The magnificent work of 1927 to 1936 was painstakingly crafted, as
Weston brought the modernist American tradition in photography to its culmina-
tion. In these images he built on the precedents of Stieglitz, Sheeler, and Strand,
in the same way that Pollock and de Kooning reached a climax with their paint-
ings of 1947–50. For Weston the question became: where to go next? As with
Abstract Expressionist painting of a decade later, the answer inevitably lay in
retreating from a finely-honed abstract perfection to a new subjectivity; in both
cases, the artists ceased their study of pure form and came to examine themselves
and the contemporary environment more closely.

Weston's earlier work reflects his great ability, but not his whole character. His
masterpiece *Pepper No. 30*, for example (page 171), suggests sexual repression

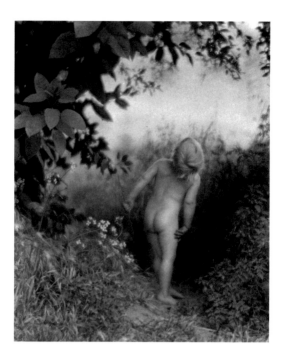

Fig. 1
I Do Believe in Fairies, 1913, Lane Collection

above all else. It is an image of a common vegetable (one, in fact, that might provide a meal for the Westons) that masquerades as muscular, sculptural form. Smooth and fleshy in reality, the pepper in the photograph looks hard and indestructible; though actually unmoving, it appears to flex and sway like a human dancer. It reeks with sexuality: it seems real, yet dreamlike. Everything about it has a double meaning, reminding us of the double life that Weston was leading, making portraits that embarrassed him, constantly unfaithful to his lovers, never having time to be the good father to his sons that he hoped to be.

With the Guggenheim grant came a new personal wholeness. Weston could now give up the lies involved in commercial portraiture: so, too, he gave up seeking for a single perfect image. Loosening his control over things, enjoying a highly charged and joyful relationship with Charis, Weston produced a body of work that reflected the changes in his own life, one that revealed his true self in ways he had never before allowed. His natural exuberance, his energy and curiosity, his antiestablishment political views, his wit, his willingness to take chances, now all were given free rein. The photographer's life and his work became one during the Guggenheim years. The result was a new, multifarious Weston imagery, one that reflected contemporary American life with all its vast inconsistencies while foreshadowing the concerns of many photographers to come.

Turning in 1937 to landscape, Weston also returned to his roots: his earliest photographs—made when he was sixteen—had been pictures of farm scenes, winter views, Lake Michigan, and other sites near his boyhood home in Illinois. When Weston became a professional photographer at the age of twenty, however, it was as a door-to-door portraitist, followed by several years as a printer for commercial portraitists. His earliest successes came with carefully posed, artfully blurred compositions such as the one of his baby son Chandler in a work of about 1913 that he titled, *I Do Believe in Fairies* (Fig. 1). During his years as a Pictorialist, which lasted to about 1920, Weston lived a lie that later embarrassed him terribly, making artificial, mannered works while affecting the pose of the Bohemian artist, complete with windsor tie and green velvet jacket. In Mexico (1923–26), then at Point Lobos, California, beginning in 1929 he made some superb landscapes, though still relying on portraiture for his living and on nudes and still-life subjects for the bulk of his creative work. Thus, his turn to landscape in 1937 with the Guggenheim Fellowship meant far more for him than an artistic strategy; for Weston it marked both an acknowledgment of his childhood dream and his coming of age as an integrated adult.

It is difficult to think of another artist in any medium who interpreted landscape so broadly and in so many diverse ways as Weston. In terms of numbers, the largest group of his Guggenheim pictures portrays the desert landscapes of Death Valley (including Dante's View, Golden Canyon, and Corkscrew Canyon) and the Mojave Desert (pages 250–51, 267–69, 276, 286). Their barren, undramatic scenery had not appealed to other photographers. These areas lack the picturesque contrasts of trees, lakes, and high peaks, for example, that appealed so much to Weston's friend, Ansel Adams (Fig. 2). Adams's photographs are sentimental, while Weston's images of Death Valley and similar places are devoid of sentiment. Weston's images do not make viewers long to visit the places they represent. Rather, one reads them simply for their visual content. Weston's

4.
Daybooks, volume I, p. 55.

5.
Daybooks, volume II, p. 154.

landscapes generally have a very high horizon (page 272) or lack a horizon altogether (pages 248, 266-67). In addition, they provide no clues about scale, and they often offer few hints whether the viewer is looking over a few dozen feet or several dozen miles of topography. Their most striking quality is the way they reveal the rhythmic patterns inherent in landscape. What strikes one most powerfully is the abstract rhythm of the land. Photographing hills and valleys, desert earth and rocks, Weston reveals in the landscape an animal vitality, a distinct life and meaning.

In some ways Weston's underlying aim in his work changed little from the early twenties to the Guggenheim period. In his *Daybook* during 1924 he had written that "The camera should be used for a recording of *life,* for rendering the very substance and quintessence of the *thing itself.*"[4] It is easy to understand Weston's theory when he speaks of photographing a rock in order to "have it look like a rock, but be *more* than a rock."[5] More difficult but still important is recognizing the same Bergsonian sensitivity in Weston's images of the peaks and canyons, and the dead and living trees of California's deserts. Similarly, when he walked up the long hill and looked out over the whole of Death Valley from what has long been called Dante's View—for early visitors it seemed like a view into the Inferno—he saw not desolation but rather a visual paradise as his camera recorded a rare instance when sinuous streams of water flowed through the valley. And when he photographed sandstone concretions in the Colorado Desert on California's Mexican border (pages 254-55) he found life, even humor, in these small relief sculptures made by nature herself.

If Weston sought to discover and depict life in unlikely places, in the vast arid

Fig. 2
Ansel Adams, *Half Dome, Winter, Yosemite, circa 1940*
Lane Collection

6.
Charis Wilson Weston and Edward Weston.
California and the West.
(New York: Duell, Sloan and Pearce, 1940), p. 50.

7.
Edward Weston to Minor White, ca.1946.
Newhall Collection, Santa Fe, as quoted in
Amy Conger, *Edward Weston: Photographs from the
Collection of the Center for Creative Photography.*
(Tucson, Arizona: Center for Creative Photography, 1992),
Figure 1013/ 1937.

landscape of the place called Death Valley, for example, or in the endless, ever-repeating roll of the surf and crash of the waves onto the rocky California coast, during the Guggenheim years he also became much interested in death. The inherent rhythms of life had long been his chief concern: now during a joyful time, ironically, he began to consider the inevitable end of life. During one of his early Guggenheim trips with Charis to the Colorado Desert, in mid-May, 1937, they found the body of a man who had recently died. Never one to waste film, Weston made just two pictures of the body, a full-length view of the figure with a can of water and bottle of milk beside him, and a half length featuring the man's head and shoulders (page 245). Weston and Wilson later discovered to their great disappointment that they had made one of their rare errors in recording the negatives, and had not two separate photographs, but a double exposure of the full-length shot, which they regarded as the better of the two.[6] In retrospect, we can wonder whether the subject was simply too powerful for them, and whether their sense of its forbidden nature may not have subconsciously caused either of them to make this mistake, thus rendering the image unusable.

The photographer Minor White is said to have commented in an article on Weston's "obsession with death." Weston wrote to him denying any such thing, saying that "death was not a theme—it was just a part of life—as simple as that."[7] Nonetheless, if death did not become an obsession for Weston, it surely did become the subject of a great many of his works during these years. One of his very first Guggenheim images portrays a dead buzzard lying on the cracked, hard surface of the Mojave Desert (page 239), and during the ensuing years he took up many related subjects. In addition to the dead man and several dead birds, he made two superbly composed studies of a dead rabbit on an Arizona highway (page 238), and a group of images of a cow's skull (page 264). Apart from these direct and obvious representations, Weston also made picture after picture in which death is suggested or implied. Primary examples would surely

8.
Karen E. Quinn. "Weston's Westons: California and the West" in Karen E. Quinn and Theodore E. Stebbins, Jr., *Weston's Westons: California and the West.* (Boston: Museum of Fine Arts, 1994), p. 26.

9.
Edward Weston to Neil Weston, May 7, 1942. Center for Creative Photography, Tucson, Arizona.

include the "ghost towns" that Weston photographed, including the Harmony Borax Works, Golden Circle Mine, and Leadfield, all in Death Valley, and the nearby abandoned town of Rhyolite, Nevada (page 240). Particularly at Rhyolite, the photographer sought out geometric forms that he juxtaposed against the natural landscape. They look, as Karen Quinn writes, "like a stage set deposited in the landscape."[8] Like those seventeenth-century Dutch still-life paintings that include a skull or an overturned hourglass, these pictures can be properly considered "vanitas" images, reminding the viewer of the shortness of human life and of the ephemeral quality of human structures of every kind. At the same time, this message, this interest in the abandoned and forlorn, does not imply that Weston was preoccupied with thoughts of death and despair; rather, I would suggest only that Weston was consciously or unconsciously considering his own mortality at this time, and that he frequently allowed such considerations to enter his work in one way or another.

Weston' s pictures of discarded shoes also fall into this category, as do the several elegiac images of rusted and abandoned automobiles (page 241), which rank among his most memorable. *Burned Car, Mojave Desert,* (page 244), a subtle, close-up view of the crackled, peeling body of an old black car, inspired many imitations by later photographers. Its meandering linear patterning foretells the abstract paintings of the New York School, especially those of de Kooning, of a decade later (Fig. 3). Weston also photographed numerous burned and charred trees, sometimes making use of the whole stump or tree, and at other times closing in on a patterned detail, just as he had done with the car. And at Palm Canyon in the Borrego Desert he made more than a dozen pictures that successfully contrast the blackened trunks of the trees with the whitish rocks and soil surrounding them. Sometimes he photographed the dark forms of dead trees gesticulating in writhing patterns against the sky; on other occasions—equally successfully—he made pictures of white tree-trunks and branches that dance gracefully and mournfully against backgrounds of dark water (page 256).

Weston had promised in his Guggenheim application that one of his subjects would be ranch life, but, in fact, his few images of ranch buildings are weatherbeaten and forlorn, and they look lonely and abandoned. Similarly, when he photographed California's towns, such as Albion on the North Coast, he produced dark images devoid of human life, ones which have a sense of anguish and poverty about them.

The photographer had also expressed an interest in making photographic satires on advertising, but in the end he did little work of this kind. Advertising did make him angry at times: in a 1942 letter to his son Neil, he complained vigorously about a recent advertisement for Pepsi Cola, writing, "In such ads a striking low ebb in decency and deceit is reached."[9] Though Weston felt strongly about such issues, and though in addition he was known for his sense of humor, he simply wasn't a satirist. Even his wonderful picture of the "Hot Coffee" sign in the desert (page 271), seems more ironic than satiric, and there are few such images in his oeuvre. There is, however, certainly a sense of irony, and perhaps some satiric intention as well, in his 1939 photographs of the MGM storage lot in Hollywood. Rummaging amid a variety of discarded movie sets, Weston made one of his most unusual, thought-provoking series. These included several images

of a painted backdrop of Marseilles harbor from the 1938 film *Port of Seven Seas* starring Maureen O'Sullivan and Wallace Beery. (This is as close as Weston would come to working in France.) There are also several intriguing pictures of stairways leading to nowhere that have a surrealistic quality, as well as ones of columns, windows, and other architectural elements. The most interesting of this group, however, may be the three pictures of mannequins. The one reproduced in this volume (page 285) includes a naked figure standing helplessly with open palms in front of two shelves; directly behind it are stacked human figures, and a lower shelf holds a row of dead horses. As if to make his point about closeness of reality and unreality, life and death, completely clear, Weston has included closed and open garbage cans in the left foreground of his composition.

Weston did make a few photographs of a living human being during the Guggenheim years. In each case, his model was Charis Wilson, who had posed for him for many of his greatest nudes between 1934 and 1936. The new pictures of Charis, however, were very different from the earlier ones. In some instances she was included in one of the desert landscapes, and her figure forms only a barely visible fleck in the composition. On another occasion Weston made a portrait of her fully dressed, with a large scarf around her head to protect against mosquitos, and produced a very evocative, highly sensual image (Fig. 4). In 1937, he also made two more series of nude images of Charis Wilson, both highly unusual and both quite dissimilar from the classic nude images of the previous year. The first group was made in mid-June at Laguna Beach, California: Charis was apparently lying naked in a hammock, but Weston photographed only her long bare legs with criss-crossing shadows and other linear elements (pages 280–81). The legs seem disembodied and hardly human; they look no more real than the mannequins at MGM. Then, later in the same year, Weston photographed Wilson sunbathing in the nude on a patio in New Mexico; here Charis lies on Weston's black cape in an unposed, natural manner, with an oven door directly behind her (page 259).

All American art before the 1960s results from an interplay between European sophistication and American innocence, between memory and experience, between the roots of American culture in Paris and London, Rome and Berlin, and the facts of American democracy, the wilderness, and the western frontier. Weston's own development provides a quintessential example of these polar opposites that confront every American artist. As a boy he had admired Manet and Cézanne at the Art Institute of Chicago. As a young man he had learned of European modernism through the German-American Alfred Stieglitz, who, during the first two decades of the twentieth century in New York, introduced Americans to the modernism of Matisse and Picasso, Brancusi and Picabia, as well as to children's drawings, African sculpture, and to the best contemporary photography. Though he never traveled to Europe and was in New York only three times (1922, 1941, 1946), Weston in California was not so isolated that he wasn't aware—through exhibitions, publications, private collections, and word-of-mouth—of the latest international developments in painting, sculpture and photography. Furthermore, his eye was formed in part in the crucible of the Mexican Renaissance during its formative years. Weston was the first major American artist from the Far West; though he knew the art of Europe and New York, he knew it

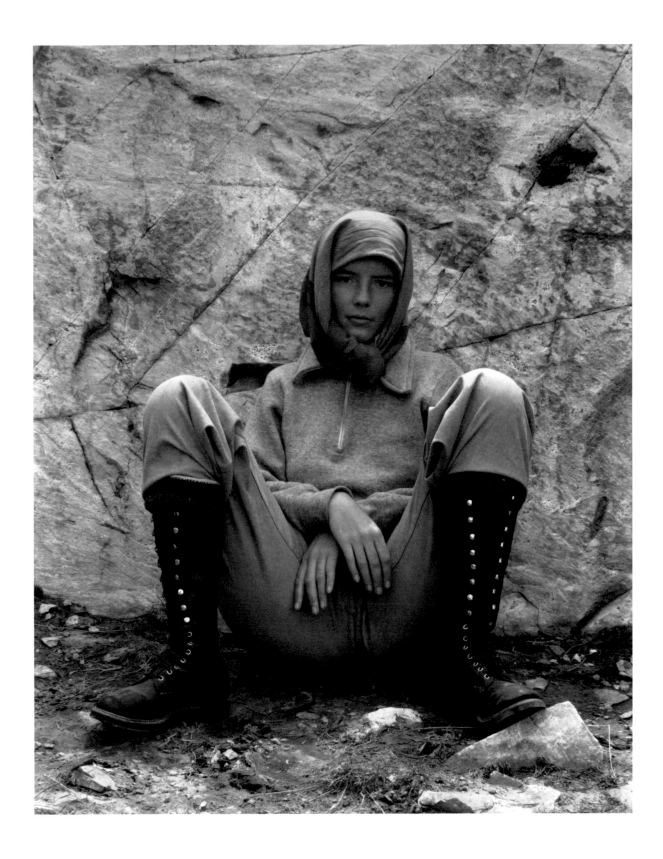

Fig. 4
Charis, Lake Ediza, 1937, CCP

10.
Daybooks, volume II, p. 202.

11.
Daybooks, volume II, p. 278.

12.
R.W.B. Lewis. *The American Adam: Innocence, Tragedy, and Traditions in the Nineteenth Century.* (Chicago, 1955), p. 5.

13.
Edward Weston to Willard Van Dyke, April 18, 1938. In Leslie Squyres Calmes, *The Letters between Edward Weston and Willard Van Dyke* (Tucson, Arizona: Center for Creative Photography, 1992), p. 35.

from afar, which in the end may have been to his advantage. In 1930, for example, Weston's friend Jean Charlot sent him a book about Atget's work. Weston admired it (writing about Atget, "his intimate interiors—the bedrooms—are as fine as a Van Gogh: and his store windows a riot,—superb"), but he was neither overwhelmed, nor much influenced.[10] A few years later a critic called him "of the Man Ray School" but he knew that this was inaccurate and commented, "I have never, except in a few examples, cared for Man Ray—too clever."[11]

Weston's photographs of the Guggenheim years rank among the most American of his works. His earlier work owed debts in varying degrees to European modernist sculpture, to Stieglitz, and to many other sources, but the Guggenheim work represents the artistic production of a confident, innocent American exploring his own country with a fresh eye. One of the major traditions in American culture is that of "the American Adam." Speaking of American writers of the nineteenth century, but in terms that apply equally well to the artists of the present century, Professor R.W.B. Lewis wrote of this central American character as "a radically new personality, the hero of the new adventure." Lewis further described him as "an individual standing alone, self-reliant and self-propelling, ready to confront whatever awaited him with the aid of his own unique and inherent resources."[12] If the American Adam was a fictional hero in the work of Cooper, Hawthorne, and Melville, if he figures large in Walt Whitman's epochal poem, *Leaves of Grass,* so, too, does the concept help to describe real Americans—from the frontiersman Daniel Boone, to the self-reliant writer Henry David Thoreau at Walden Pond, to the lonely painter by the sea Winslow Homer. Weston is very much a real American Adam in his innocence and freshness, his openness to every kind of person and experience. Like Thoreau, he was a capable individualist who lived very simply. He rejected conventional morality, but was puritanical in his honesty and his work ethic. He despised materialism and hated what he called "those excrescences called cities." Above all, he loved the land and the landscape, and he especially regretted the way American culture, as he saw it, was being "severed from its roots in the soil—cluttered with nonessentials, blinded by abortive desires."[13]

For two years, Weston and the writer Charis Wilson, his lover, model, driver, and organizer, thanks to the Guggenheim grants, lived a life that seems almost fictional in its perfection. Exploring California and the west, creating superb works of art, loving each other, living for the moment, working hard, rejecting society and its rules, having, as Charis wrote, "no destination, no routine," they formed their own community of two (a community occasionally enlarged by the addition of one of Weston's sons or friends).

Generations of American painters, illustrators, and photographers before Weston had portrayed the Far West as a magnificent wilderness, as a Promised Land beckoning to dissatisfied eastern city-dwellers and farmers. The western frontier had promised open land, physical beauty, and natural resources. It also held the promise of wealth. The discovery of gold led to the Gold Rush of 1849 in the area north of San Francisco, and the discovery of the Comstock Lode during the 1860s redoubled the West's image as the land of plenty. Painters such as Albert Bierstadt (Fig. 5) and Thomas Moran in their popular canvases glorified the west as a serene, unimaginably picturesque place, while photographers including

Carleton Watkins, William H. Jackson, and Timothy O'Sullivan did much the same in their work, which frequently emphasized the scale and emptiness of this new Eden. This romantic tradition continued into the twentieth century: it was practiced by Weston's good friend Ansel Adams from the 1930s until his death in 1984, and other photographers and painters carry it on even today.

During the 1930s, however, an alternative, realistic manner of depicting the West sprang up in both American literature and in the visual arts, responding to the long, harsh years of the Great Depression, which lasted throughout the decade. John Steinbeck wrote of California's darker side in *Of Mice and Men* (1937), *The Grapes of Wrath* (1939), and other novels and stories, telling the story of migrant farm and factory workers, of hunger and strikes, of courage and despair. During the same years, photographers, including Dorothea Lange, Arthur Rothstein, Russell Lee, and Walker Evans toured the country under the aegis of the Farm Security Administration, part of Roosevelt's New Deal, recording forlorn, lonely places and hard-working people. Edward Weston knew these documentary photographers and their work, just as he knew Ansel Adams and his celebratory images. Weston's own work of the Guggenheim years owes a debt to each of these divergent strands of documentary realism and of romantic idealism, and it relies as well in varying degrees on Weston's own continuing dedication to the spare, unsentimental dictates of modernism.

During his two productive Guggenheim years, Weston explored the lost Western frontier with an innocent eye, drawing on all his own skills and knowledge and on the full range of his moods, his likes, and his dislikes. In these works we see his ability to find underlying patterns and abstraction in the most popular sights, as well as his willingness to explore the meaning of unfamiliar subjects. In many ways the Guggenheim years were the most productive and inventive of his life: these were years of voracious seeing, which few artists in any medium have equalled.

Fig. 5
Albert Bierstadt, *Valley of the Yosemite, 1864*
Museum of Fine Arts, Boston

New Mexico Highway, 1937

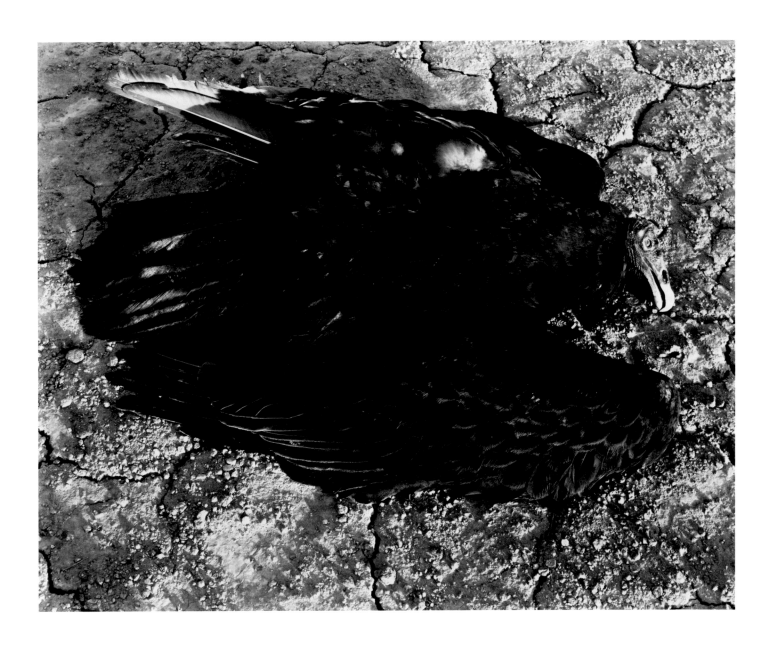

Dead Vulture, 1937

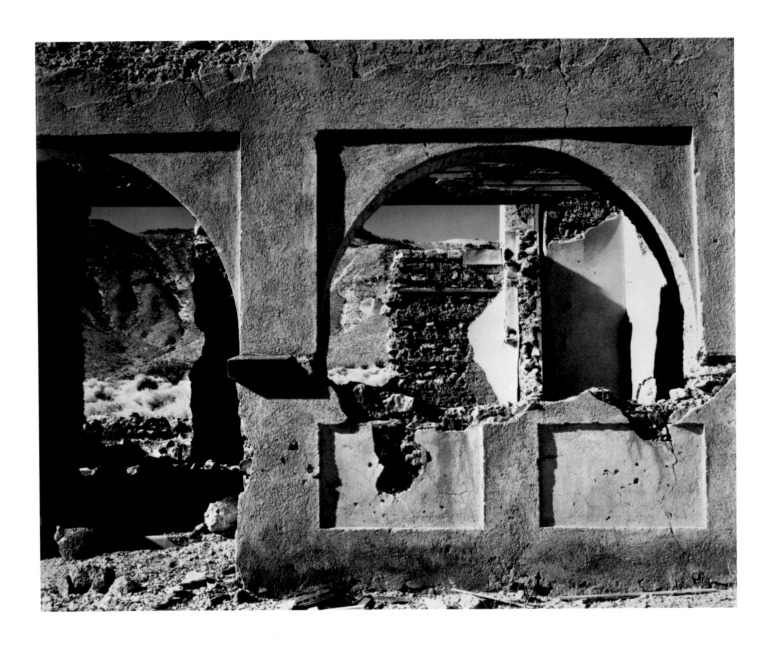

Rhyolite, Nevada, 1938

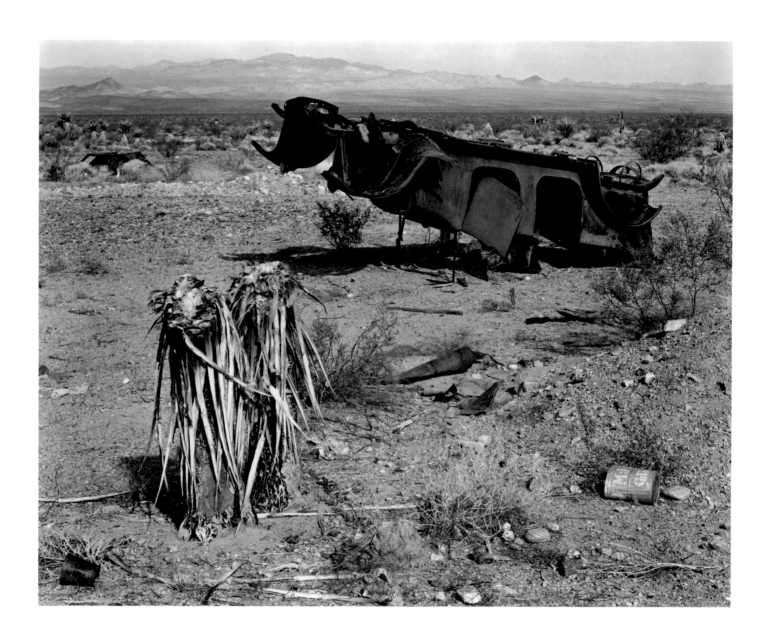

Mojave Desert, 1937

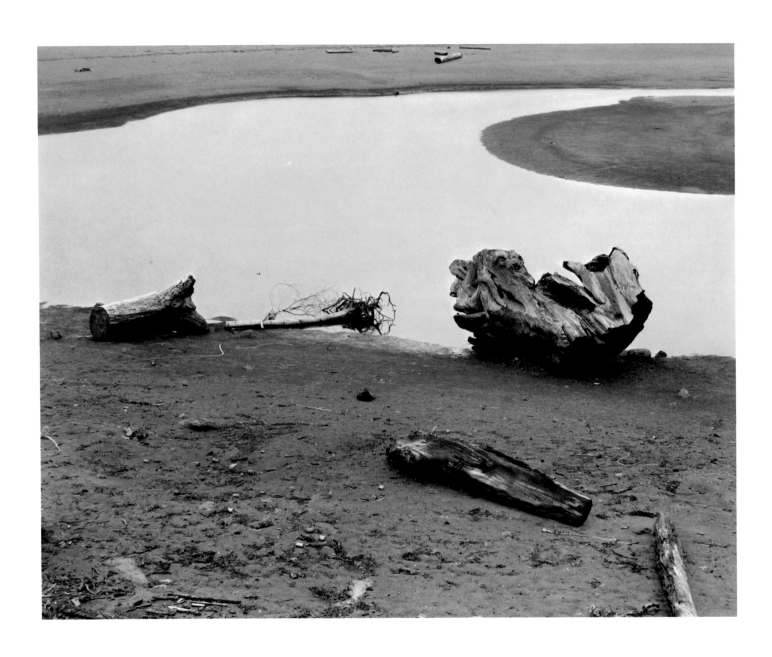

Point Arena, 1937

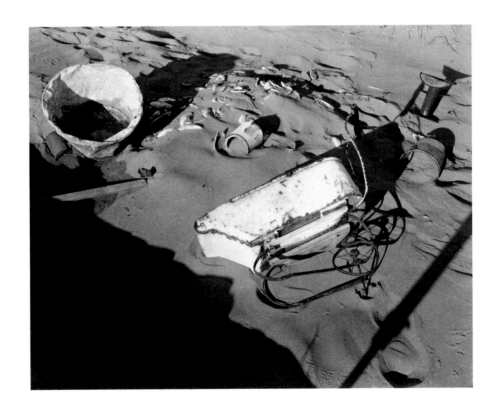

Rubbish Pile, Little River Beach Park, 1937

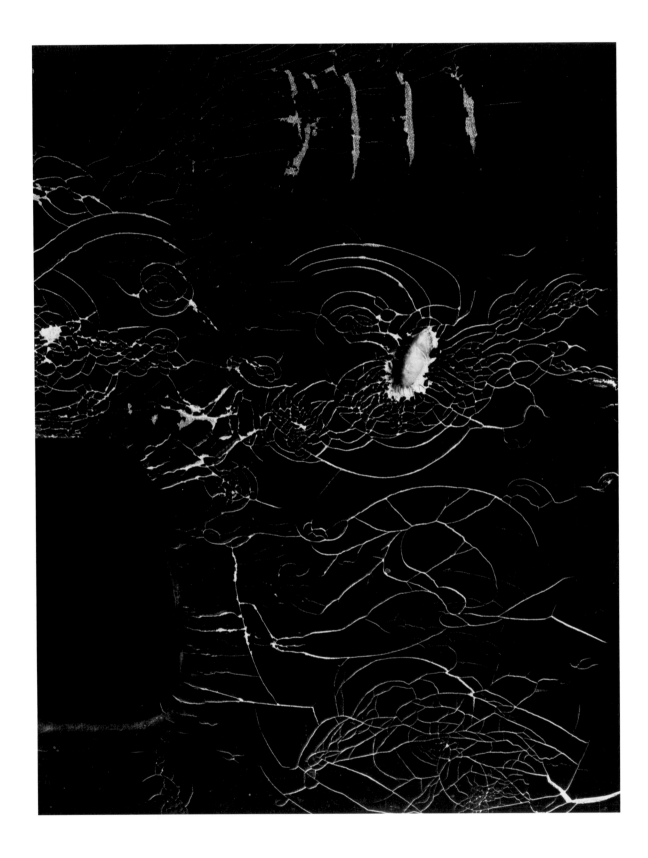

Abandoned Auto, 1937

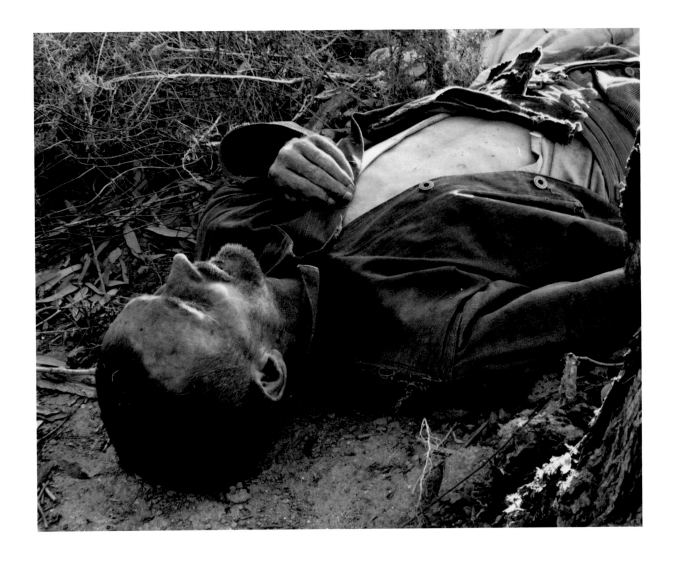

Dead Man, Colorado Desert, 1937

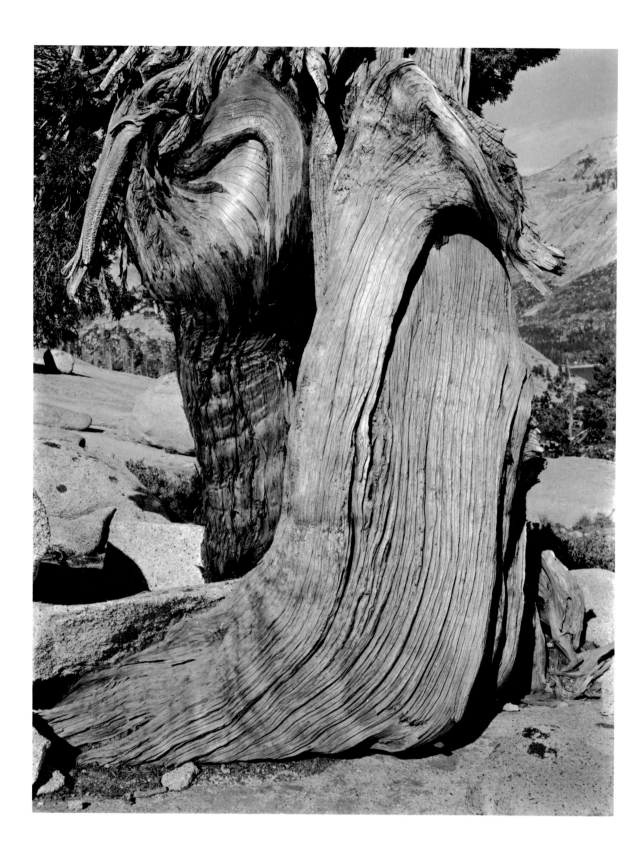

Juniper, Lake Tenaya, 1937

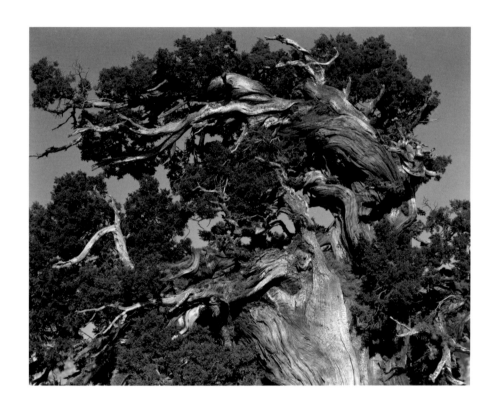

Juniper, Lake Tenaya, 1937

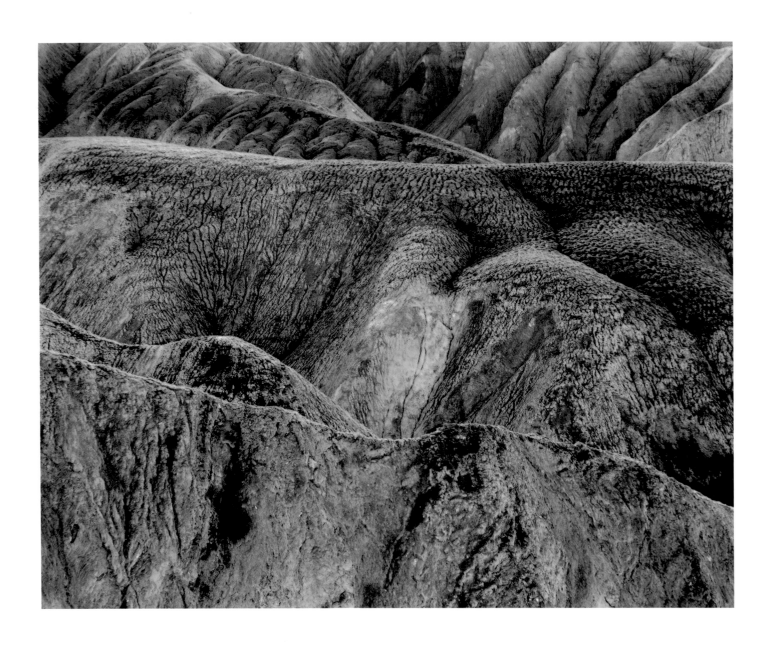

Golden Canyon, Death Valley, 1938

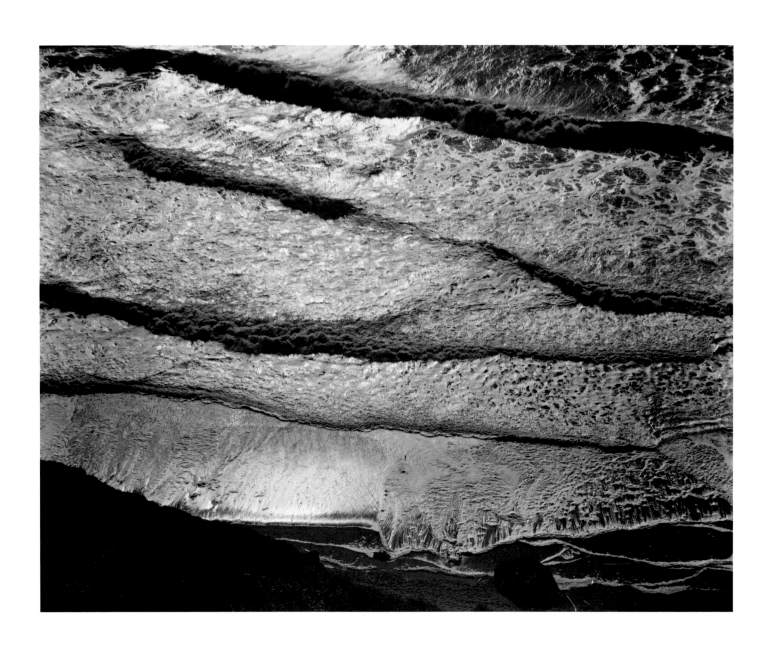

Surf, Orick, 1937

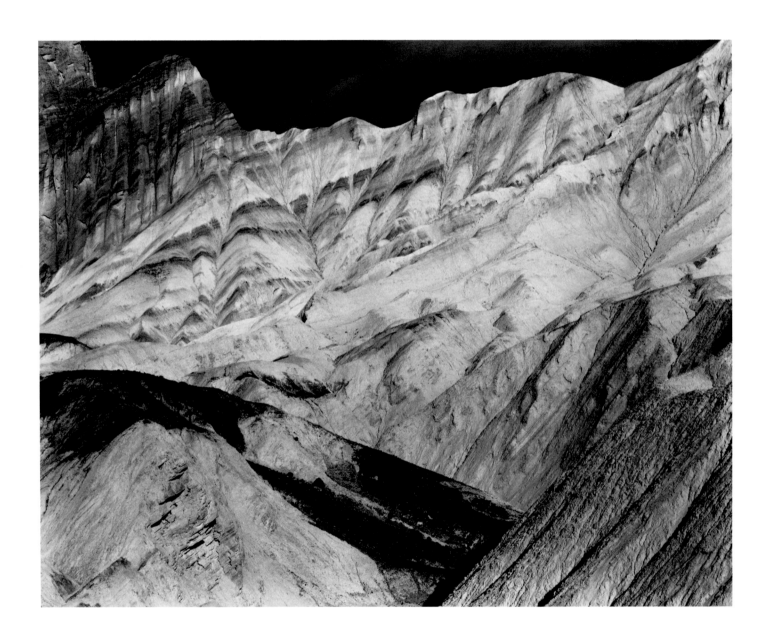

Golden Canyon, Death Valley, 1938

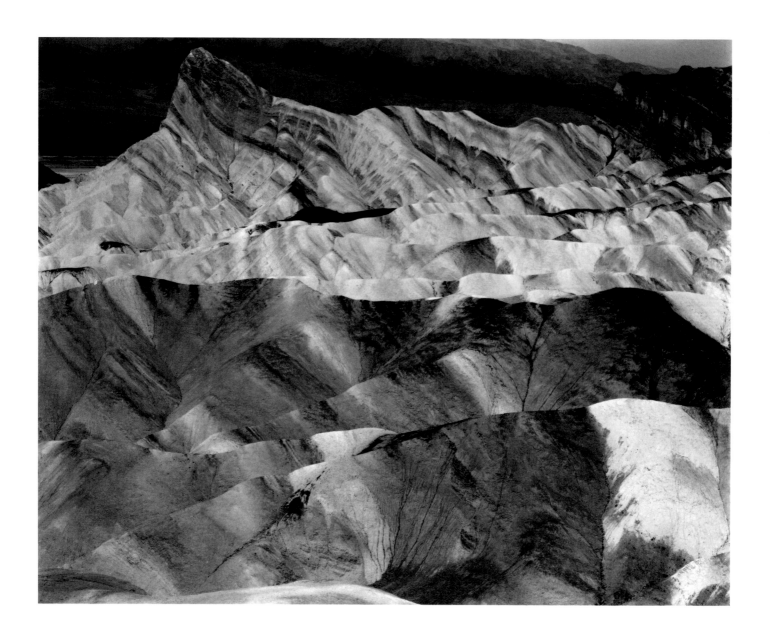

Zabriskie Point, 1937

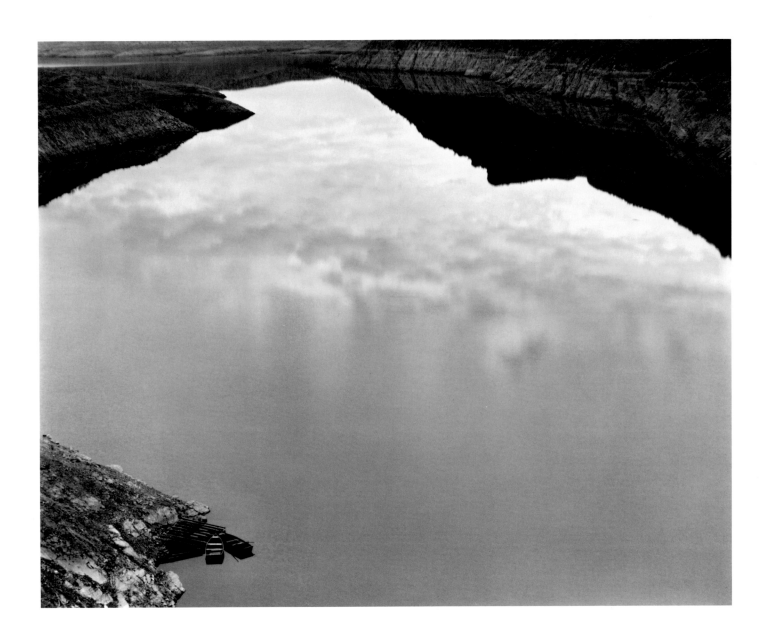

San Carlos Lake, Arizona, 1938

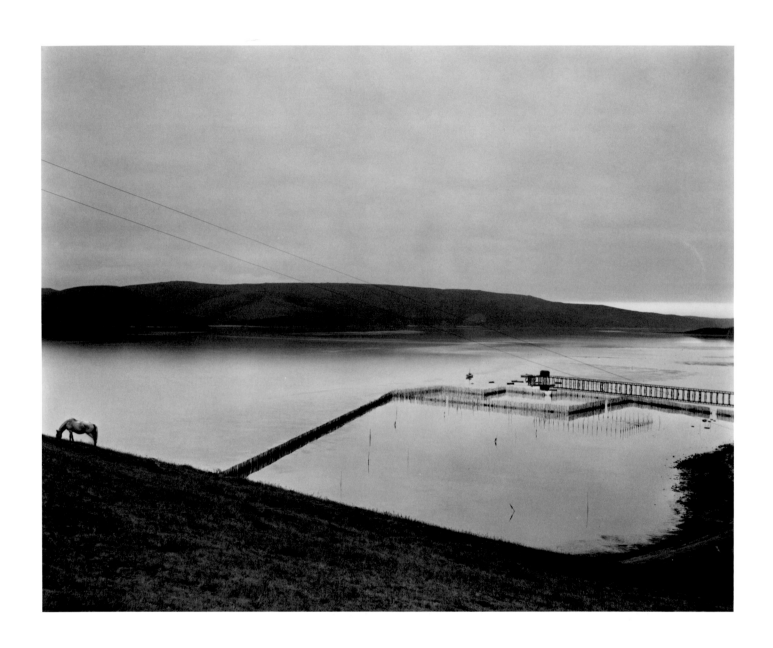

Tomales Bay, 1937

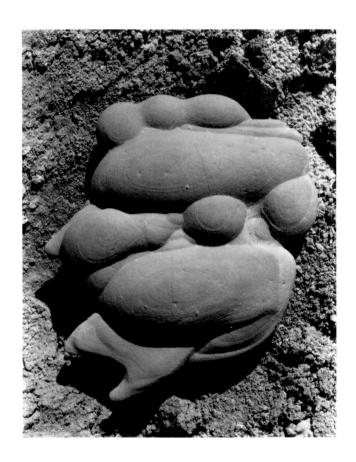 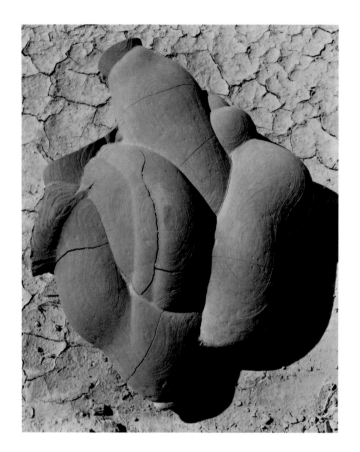

Concretion, Colorado Desert, 1937

Concretion, Colorado Desert, 1937

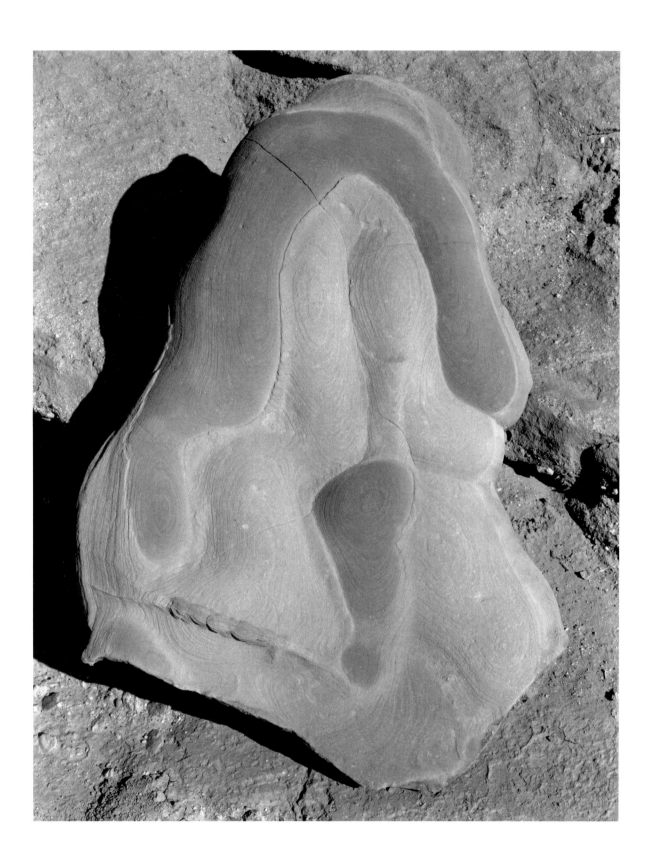

Concretion, Colorado Desert, 1937

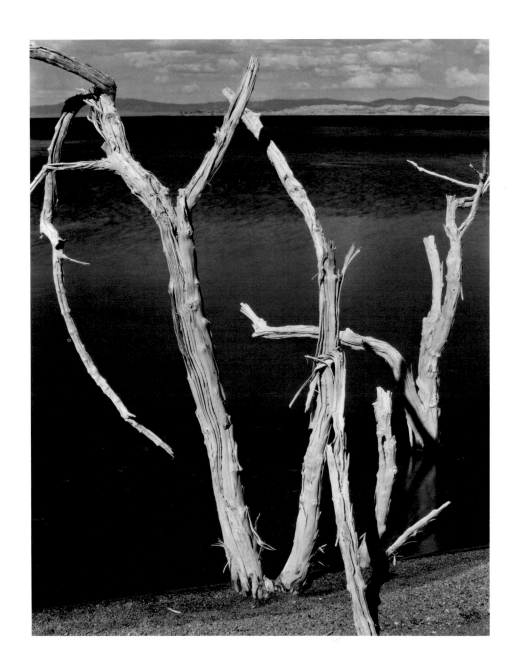

Mono Lake, Eastern Sierra, 1937

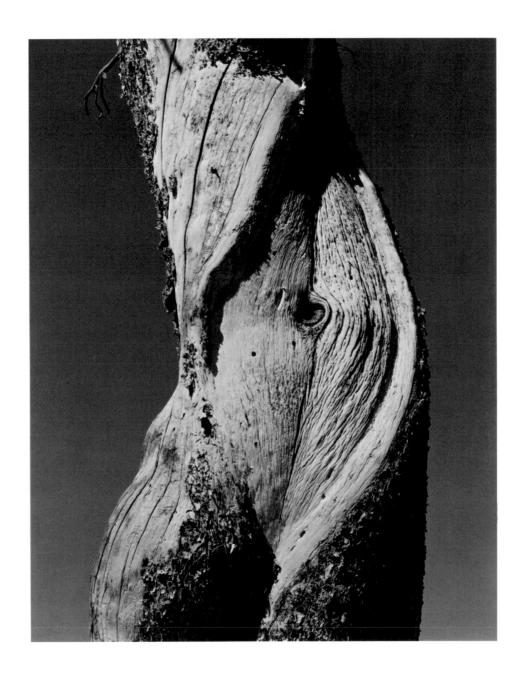

Tree, Lake Tenaya, 1937

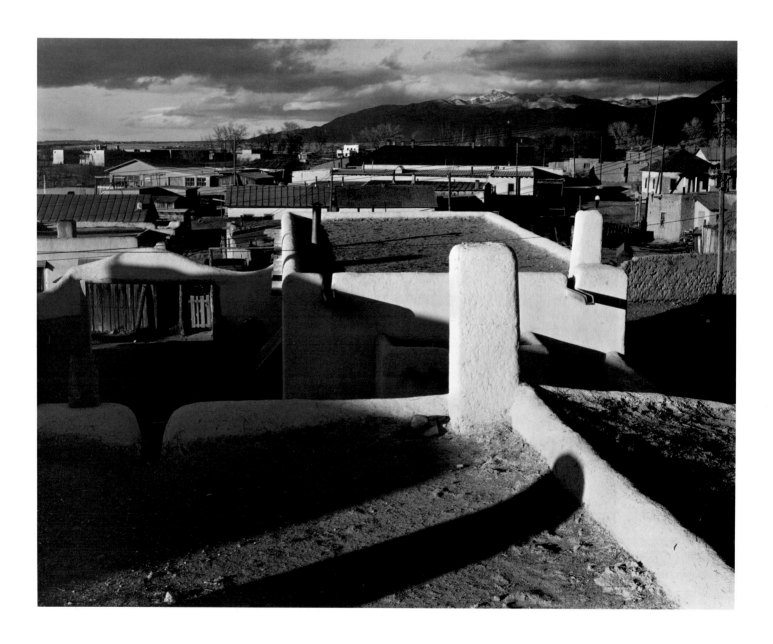

Taos, New Mexico, 1937

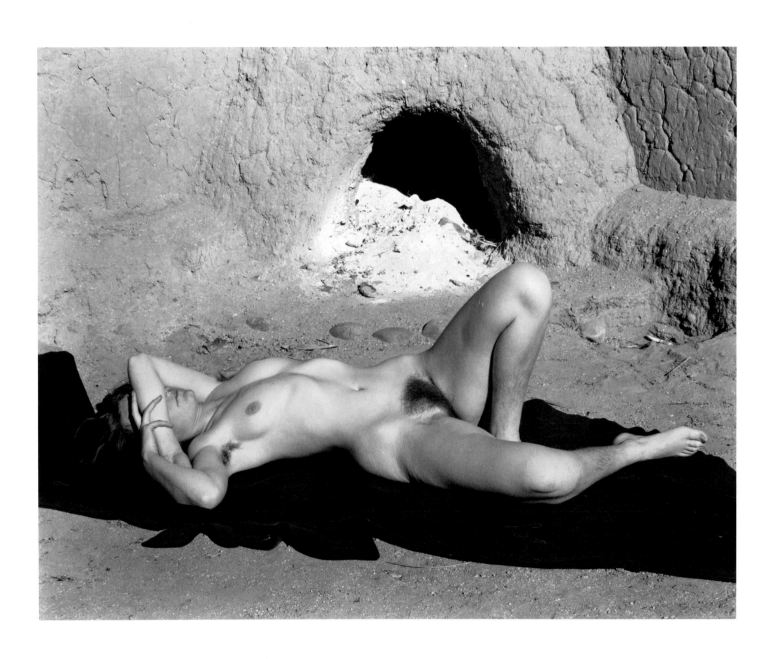

Nude, 1937

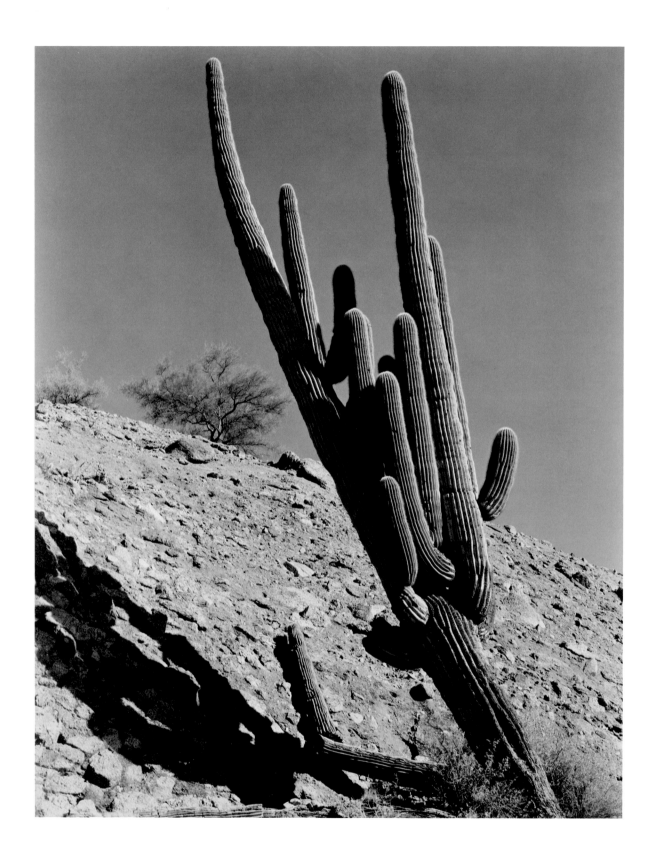

Saguaro, Arizona, 1938

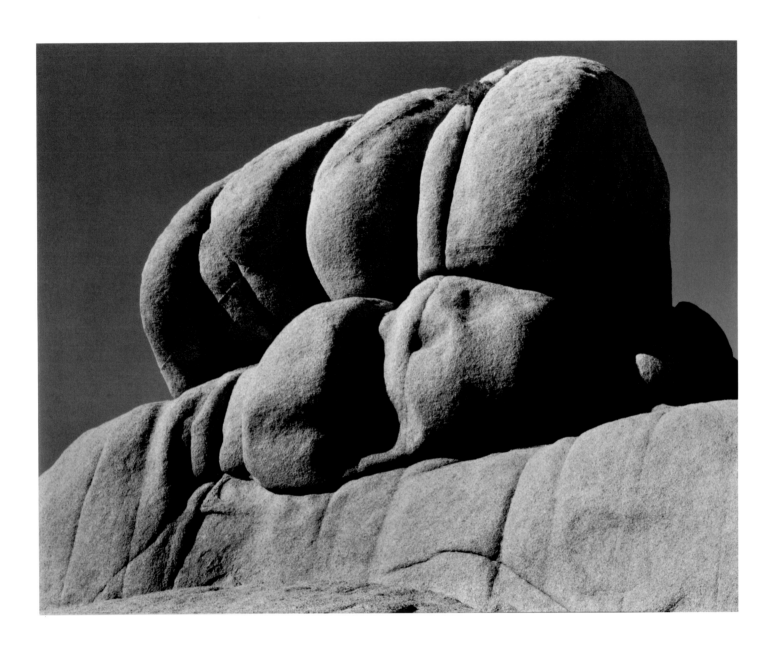

Wonderland of Rocks, Mojave Desert, 1937

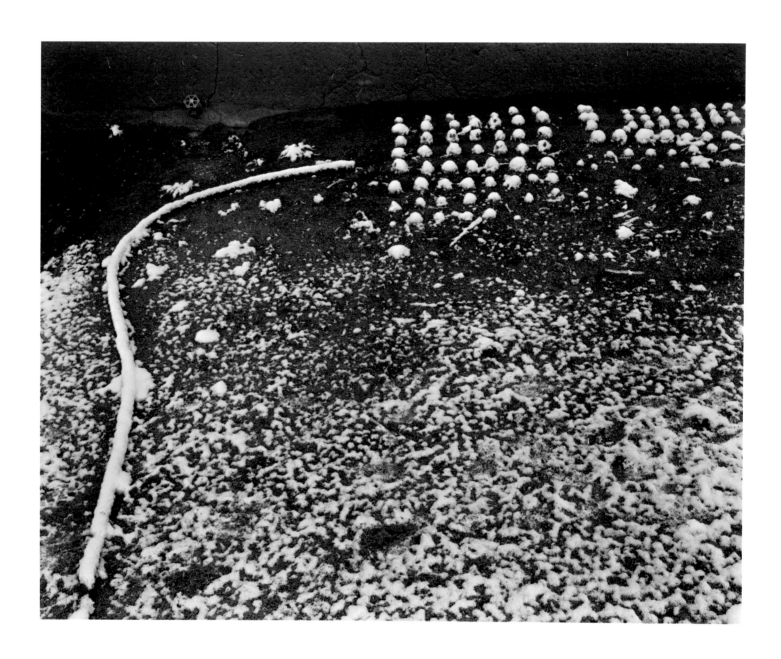

Santa Fe, New Mexico, 1937

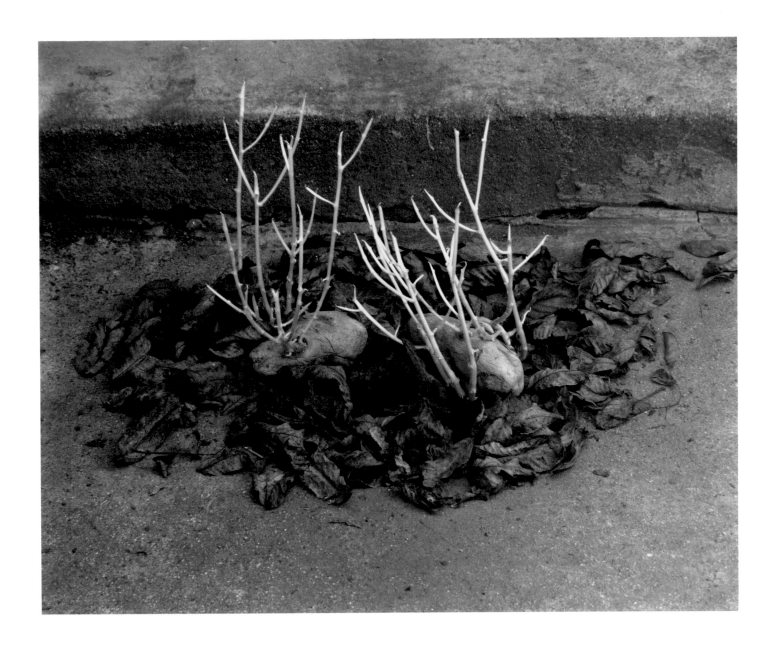

Potatoes, Los Angeles, 1937

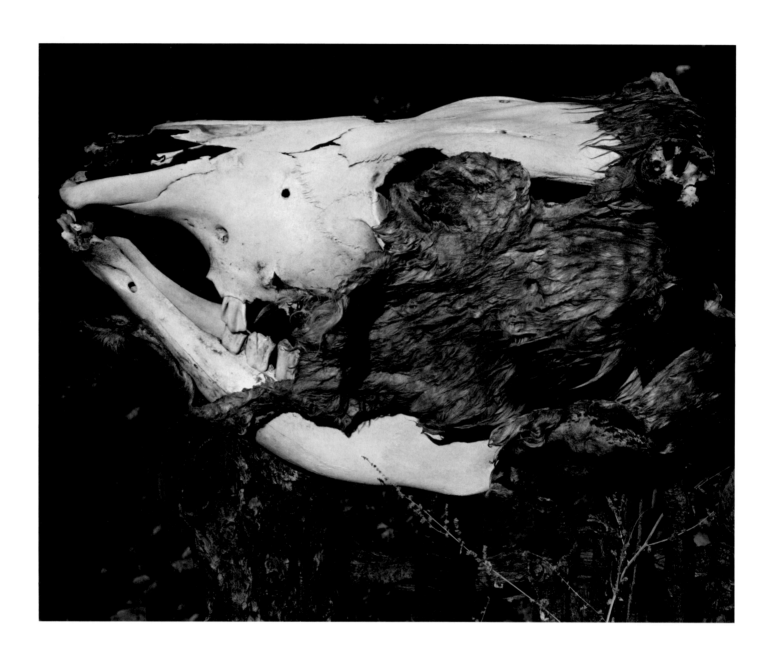

Prescott, Arizona, 1938

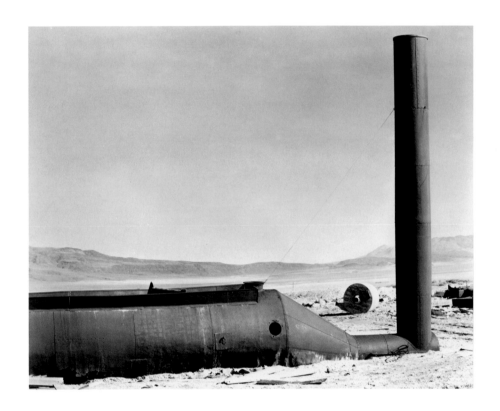

Owens Valley, Eastern Sierra, 1937

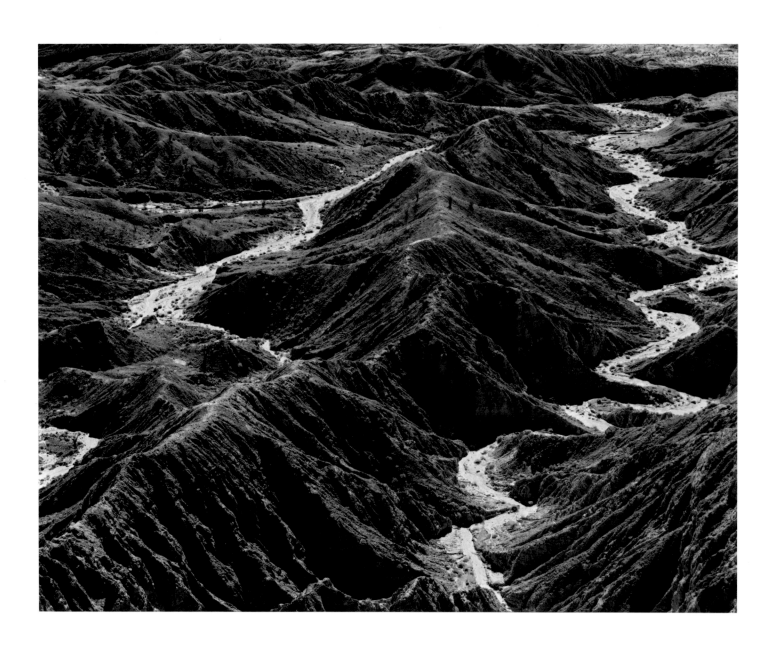

Badlands, Borego Desert, 1938

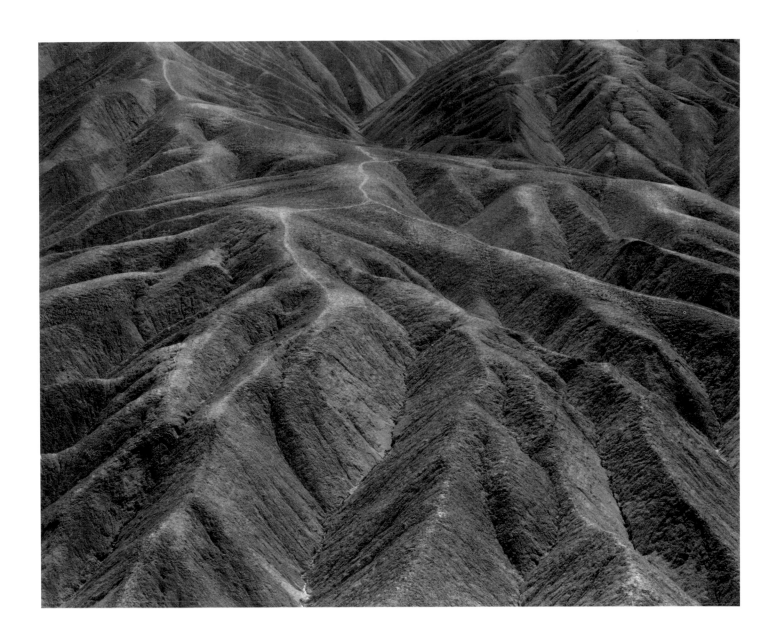

Zabriskie Point, Death Valley, 1938

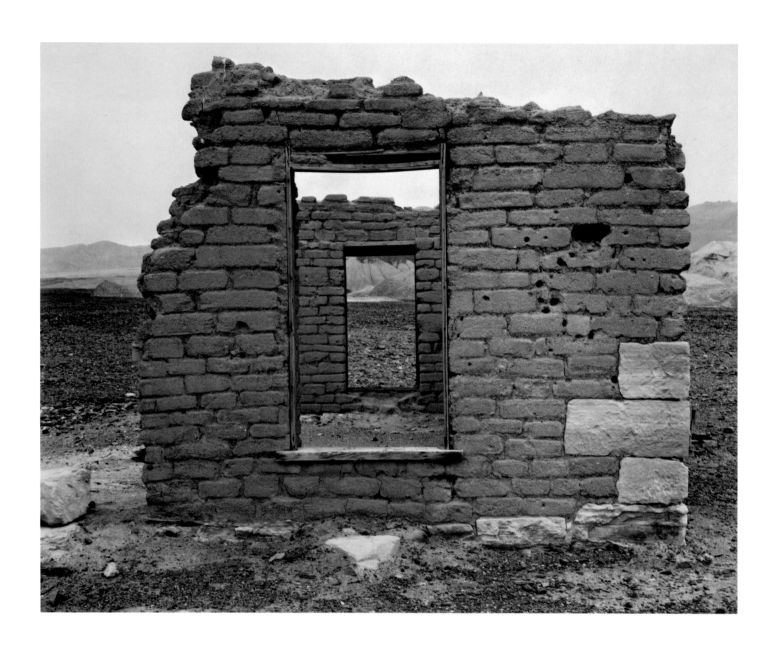

Harmony Borax Works, Death Valley, 1938

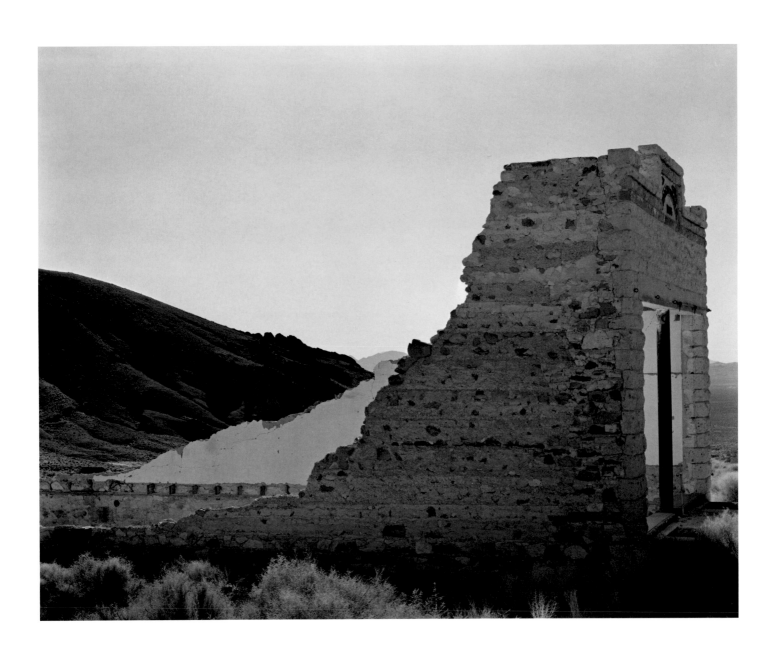

Rhyolite, Nevada, 1938

Tomales, 1937

"Hot Coffee," Mojave Desert, 1937

Jerome, Arizona, 1938

Albion, 1937

Horse, KB Dude Ranch, 1938

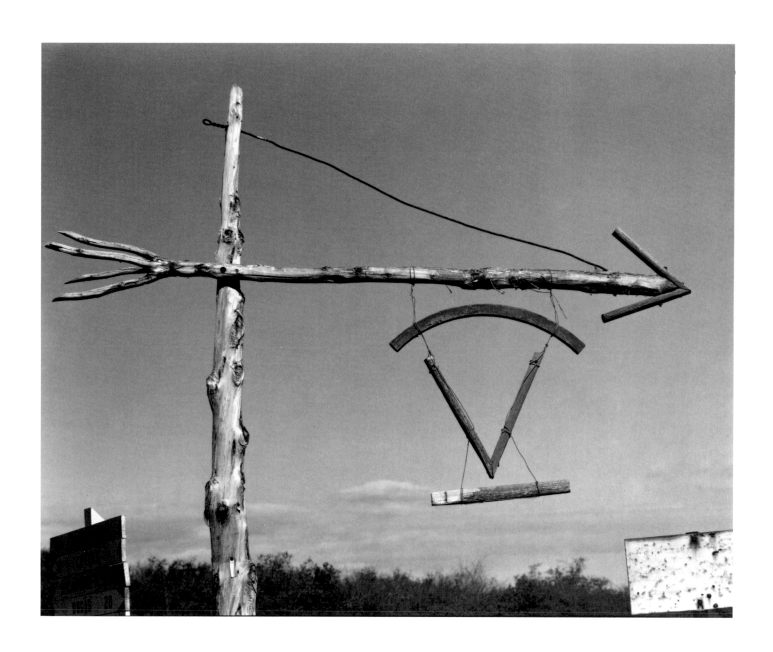

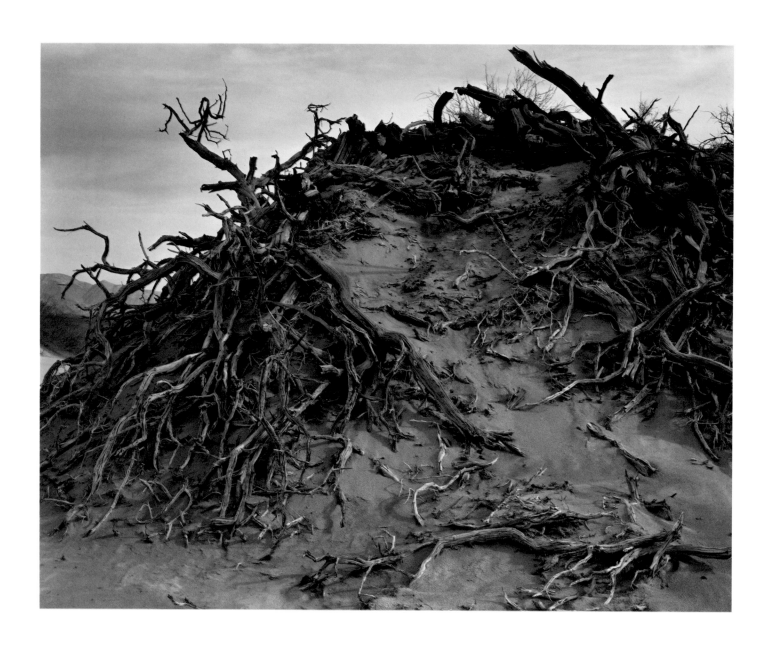

Dunes, Death Valley, 1938

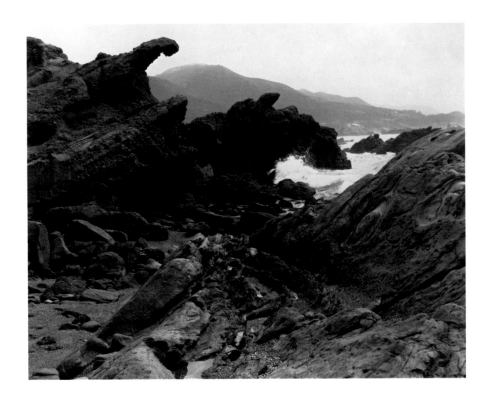

South Shore, Point Lobos, 1938

278

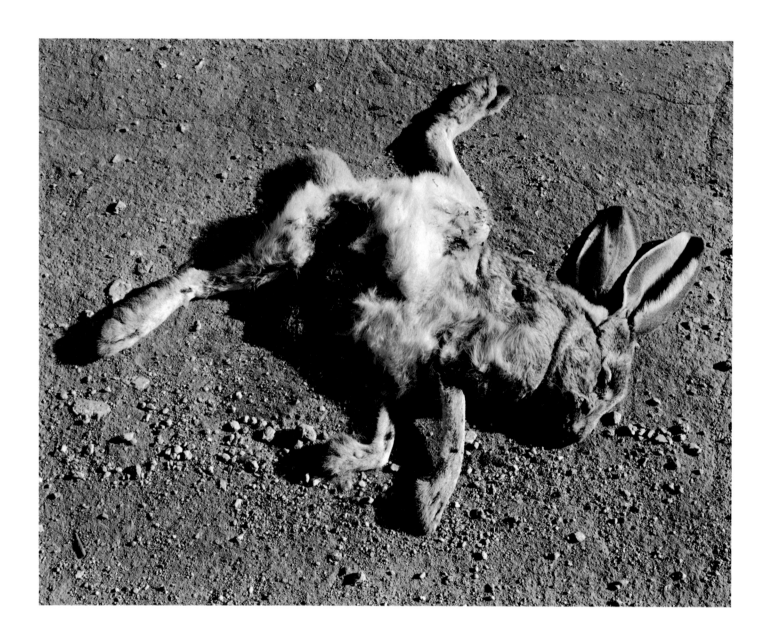

Dead Rabbit, Arizona, 1938

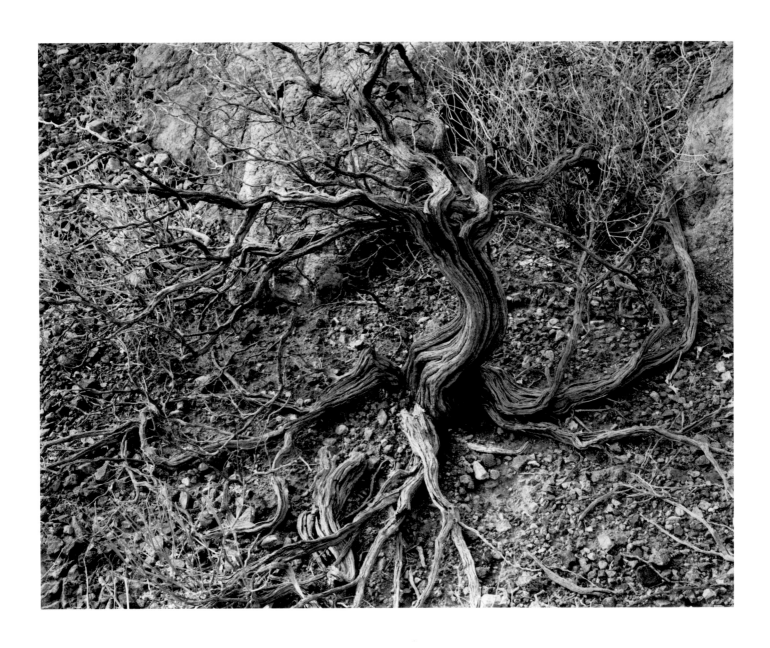

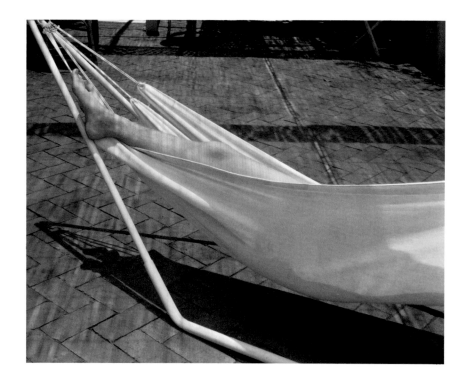

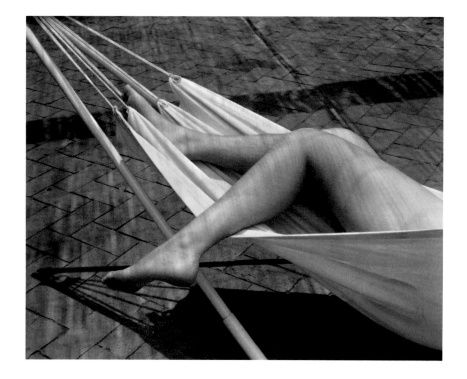

Legs in Hammock, 1937

Legs in Hammock, 1937

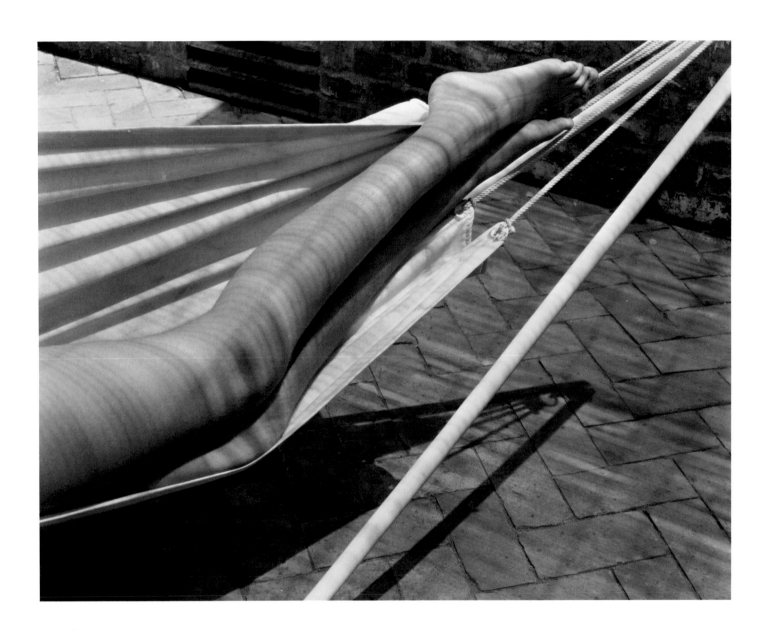

At Ted Cook's, 1937

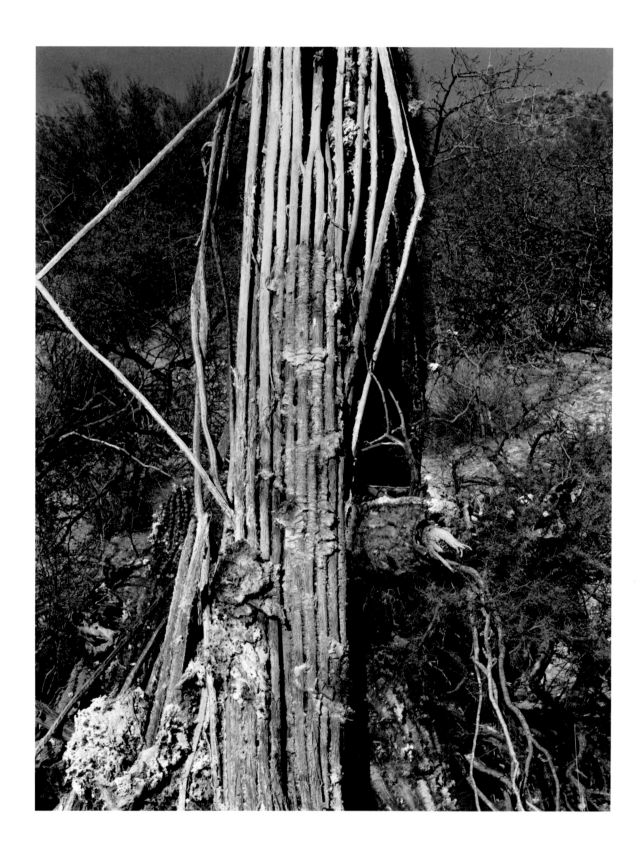

Saguaro, Arizona, 1938

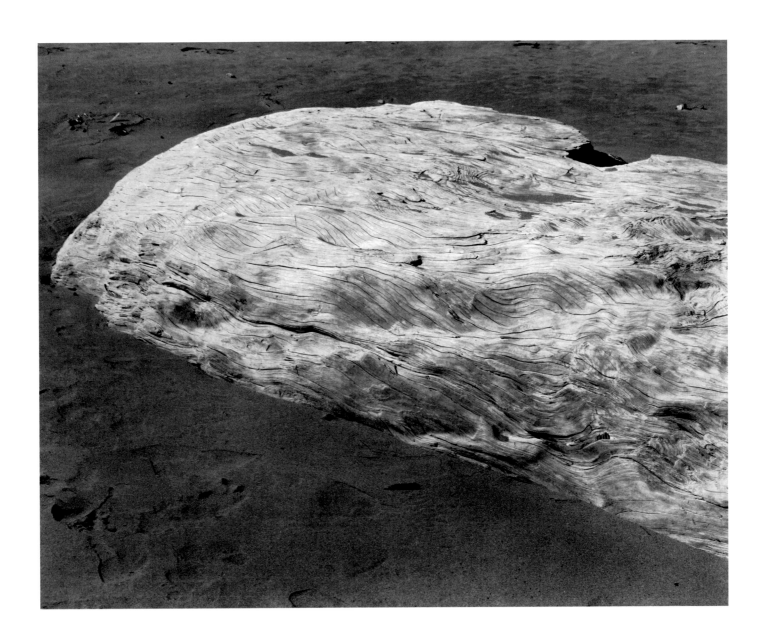

Drift Log, Crescent Beach, 1937

284

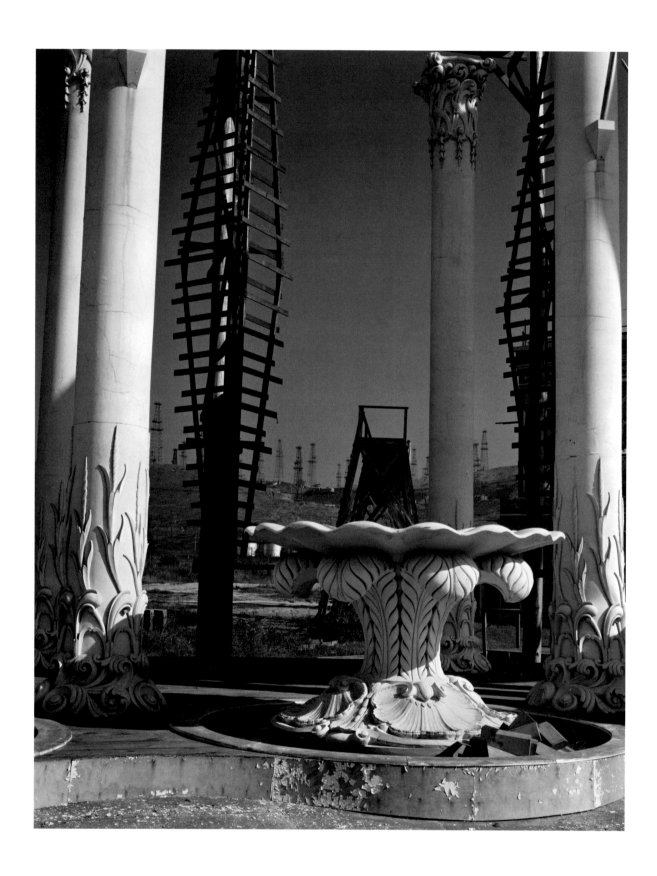

Metro-Goldwyn-Mayer, Los Angeles, 1939

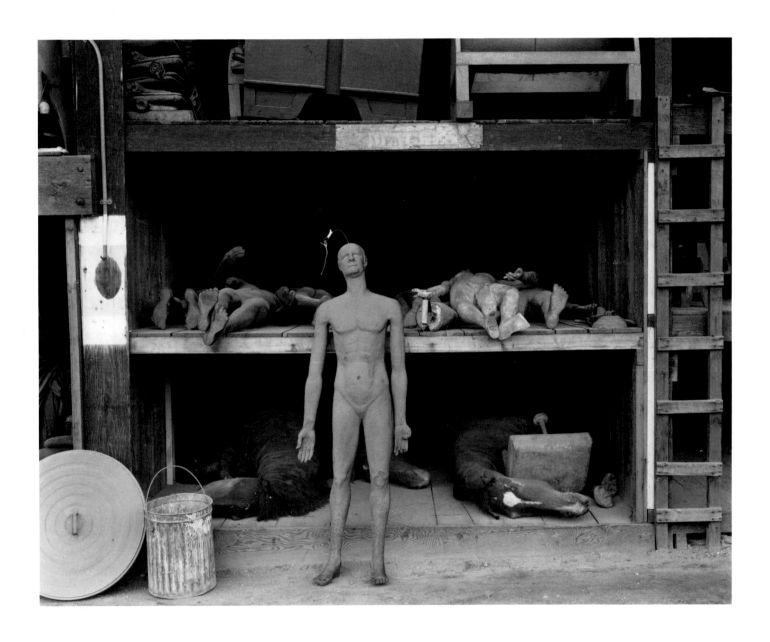

Rubber Dummy, Metro Goldwyn Mayer, 1939

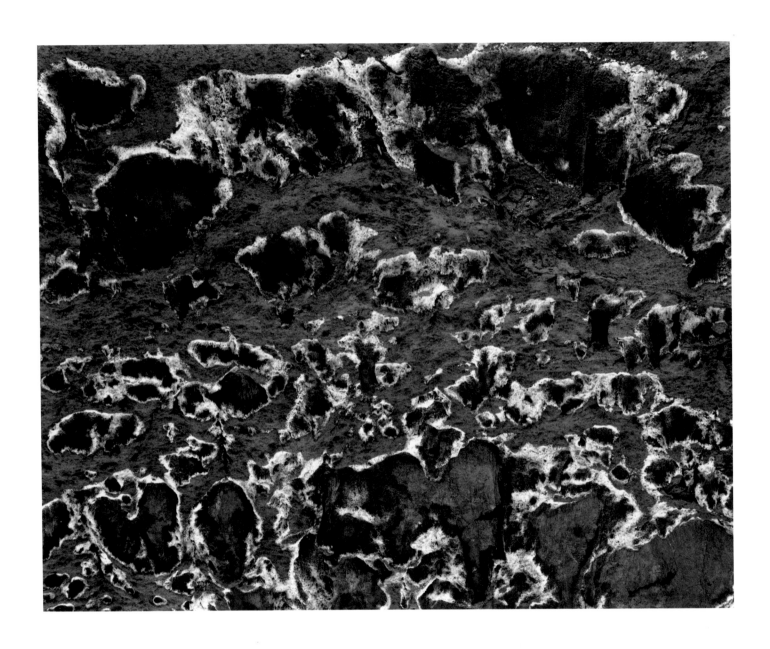

Mustard Canyon, 1939

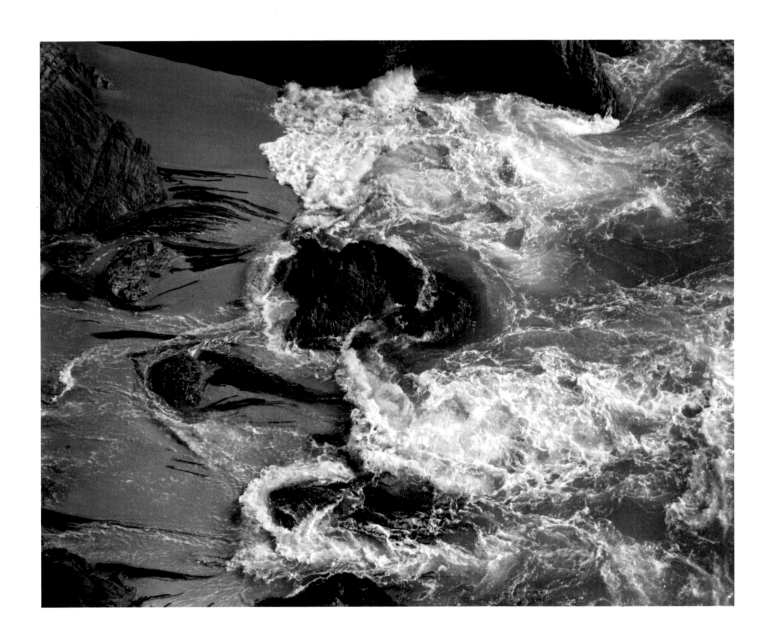

Surf, China Cove, Point Lobos, 1938

1939
1948

The Final Years Alan Trachtenberg

Edward Weston made his last picture in 1948. It appears in *My Camera on Point Lobos* (1950) as *Eroded Rocks, South Shore* and shows a small area of finely powdered black sand sprinkled with some twenty small rocks of various sizes, shapes, and tones.[1] The brighter rocks cluster in the bottom half of the horizontal picture-plane, which rises across open spaces of sand toward darker stones and deep black shadows above. There is no way to know whether Weston realized the finality of this image. He would live another ten years, afflicted terribly by the progressive loss of motor control of Parkinson's disease, years of pain, depression, and dependency, made all the worse by his unhampered lucidity. His body literally shriveled away while his mind remained strong, not a pleasant paradox for the close of a life. The scourge first showed its symptoms in 1945, though it may have begun to erode his powers even earlier; by 1948 he was quite disabled and made only two pictures that entire year.

It is tempting to see in *Eroded Rocks* a recognition of the breaking asunder of physical powers, the encroaching darkness of an unhappy death, the shattering of vision. But to make an allegory of it fails to answer all the questions provoked by this difficult picture. Lacking a commanding center, the picture consists of intervals: stone and sand, light and dark, open and closed shapes. Its figures are exactingly concrete, its structure mysteriously abstract. We hear a melody more than we see a distinct form. The image seems to lend evidence to Charis Wilson's observation about Weston, that he "liked to find the coded messages, the surfaces behind surfaces, the depths below depths, that gave ambiguous accounts of the nature of things."[2] We are not accustomed to thinking of Weston as an artist either of ambiguity or of coded messages, of meanings of any sort. Crystalline exactness of perception, with an absolutely certain sense of what is being pictured, marks his major work—the tightly framed portraits, shells, nudes, sand dunes, mushrooms, roots, and undulating horizon lines. In *Eroded Rocks* everything enclosed by the frame seems in ambiguous relation to everything else. Without a center the picture exposes the camera's willfulness in drawing a four-sided boundary around this particular scene. The scene appears less scene than event, an event of seeing, a construction of perception itself. Is the construction a translation of an inner state, a feeling, a mood? *Eroded Rocks* seems as close to an "equivalent"—to use Stieglitz's term—as one can find in Weston's work.

The picture's difficulty and the character of its difficulty tempt us to see in it something like the artist's final reflection on his career, a commentary on what he meant a few years before by saying that he tries to "sublimate" his subject matter, "to reveal its significance and to reveal Life through it."[3] We might narrow the range of its retrospection to the period immediately preceding, the years from 1941 to 1948, when his work began to assume a different look. Not just darker tones but a more open form, a less intense concentration on a center, seems during the Guggenheim years to have filtered into the "high modernist" ambience of his clouds, trees, peppers, and torsos. Of course there is a risk of retroactively imposing a unity by making too much of *Eroded Rocks* as a summary image, but

Imogen Cunningham
Edward Weston at Point Lobos No. 2, 1945
Courtesy Imogen Cunningham Trust

1.
Edward Weston.
My Camera on Point Lobos.
(New York: Da Capo Press, 1968).

2.
Quoted in Ben Maddow. *Edward Weston: Fifty Years.*
(Millerton, NY: Aperture, Inc., 1973), p. 240.

3.
Quoted in Amy Conger. *Edward Weston: Photographs.*
(Tuscon, Arizona: Center for Creative Photography,
1992), p. 35.

4.
See Alan Trachtenberg, "Edward Weston's America: The
Leaves of Grass Project," in *EW 100: Centennial Essays
in Honor of Edward Weston* (Carmel, California:
The Friends of Photography, 1986), pp. 103–116.

5.
Quoted in Conger, p. 37.
It should be noted that the publisher, not Weston, made
the final selection of the forty-nine published images out
of the seventy-three submitted. Among the excluded
images were two or three portraits, including rather ten-
der pictures of a black school teacher, Mr. Brown Jones,
in Georgia and a black sculptor, William Edmunston, in
Nashville. One of the stronger portraits included in the
published text is of a man who by appearance may be
Hispanic.

6.
Edward Weston, *Leaves of Grass by Walt Whitman.*
(New York: Paddington Press Ltd., 1976).

7.
Richard Ehrlich in *Leaves of Grass by Walt Whitman,*
p. viii.

the risk is worth taking. That final image may help us better see and understand essential undercurrents of the major undertaking of the post-Guggenheim years, the *Leaves of Grass* project in 1941–42, and the subsequent work at Carmel.

Although its immediate product was a botched publication, the nine months Weston and his wife Charis spent on the road in 1941–42 was a period of impor- tant discovery and perhaps, if the disease had not interfered, of significant change. Like the Mexican experience in the 1920s, Weston's travels through regions of the United States he had not yet seen, especially the South, the Middle Atlantic states, and New England, opened his eyes to new vistas of possibility for his art. He journeyed some twenty-thousand miles through twenty states on a com- mission to produce what the publisher called "illustrations" for a luxury two-volume edition of Walt Whitman's *Leaves of Grass,* and made some seven-hundred nega- tives.[4] In the end forty-nine images appeared in the publication, about which Weston remarked simply that "it stinks." Although the reproductions were "excel- lent," the treatment of the pictures appalled him; printed on green-tinted pages, "the photographs look like paste-ins in an old scrap album."[5] Reprinted in 1976 but still hard to find, the book remains the only published source for a major sam- pling of Weston's work during his cross-country travels.[6]

Admirers of Weston's more famous work are made a bit uncomfortable by many of the Whitman images. They lack the familiar electrical charge, the arrest- ing incandescence, the aura of transcendence of the earlier work. Their effect, as one critic puts it, seems subdued and chastened.[7] The tone has darkened, become grave, even a touch melancholy. Occasionally there is a flash of wit, as in the "Bottle Farm" pictures made in Ohio, especially the image of shoes strung along a clothes line, and some charming folk emblems on Pennsylvania barns. (These might have lightened the mood of the Whitman publication, but none appears in the book.) Predominantly, however, the feeling is elegaic.

Indian Emblem on Barn, Landis, Pennsylvania, 1941, CCP

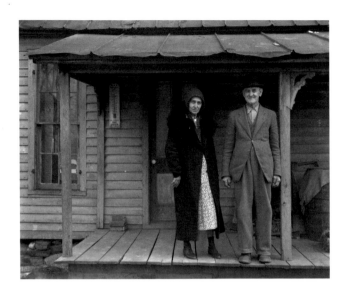

Mr. and Mrs. Summer of Monteagle, Tennessee, 1941, CCP

A sense of age and aging hangs over the pictures made in 1941–42. The decrepitude and deterioration of Lousiana plantations and graveyards strike a chord with abandoned houses and distant views over old rooftops in Eastern and Midwestern cities. Old places, old things, old faces settle into an impression of inertness. Moreover, the pictures seem to hold the viewer at a distance, as if vistas are needed for contemplating the visible facts of the American scene. Weston's earlier work had struck a note of passionate lyricism; now, contemplation seems the dominant mode. Landscapes heavy with clouds seem brooding. Houses seem empty and still. And the handful of portraits (eight of forty-nine published images) suggest a human presence that is lost, distant, remote, in some instances sullenly withdrawn. In one case the face is hidden, in another it grudgingly reveals itself from beneath the shadow of a hat. There are no smiles, no laughter, no gestures of exuberance, nothing like the dancing eyes and formidable heads of *Galván Shooting* and *Guadalupe Marin de Rivera* in Mexico.

A different time, a different place: this may be explanation enough for the signs of change in the 1941–42 pictures. But there is more to the difference than an environmental or contextual account alone can explain. There are different intentions at work in these pictures, hints of new goals, a changing purpose. We find less of a desire or need to coerce material into significant form, a greater willingness to accept what is given on its own terms, more openness to variety, contingency, the unexpected. The compositions now seem willing to concede that the world continues beyond the frame, that there may be something else worth seeing elsewhere in the same world depicted in the image. If the great pictures of the early 1930s take place in a realm apparently free of history or conflict, the new pictures have Weston venturing into a world already transfigured by a human past, a world of collective artifacts like cities and farms and cemeteries.

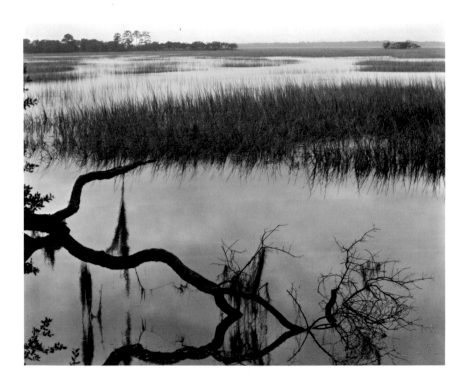

Marshes of Glynn, Sea Island, Georgia, 1941, CCP

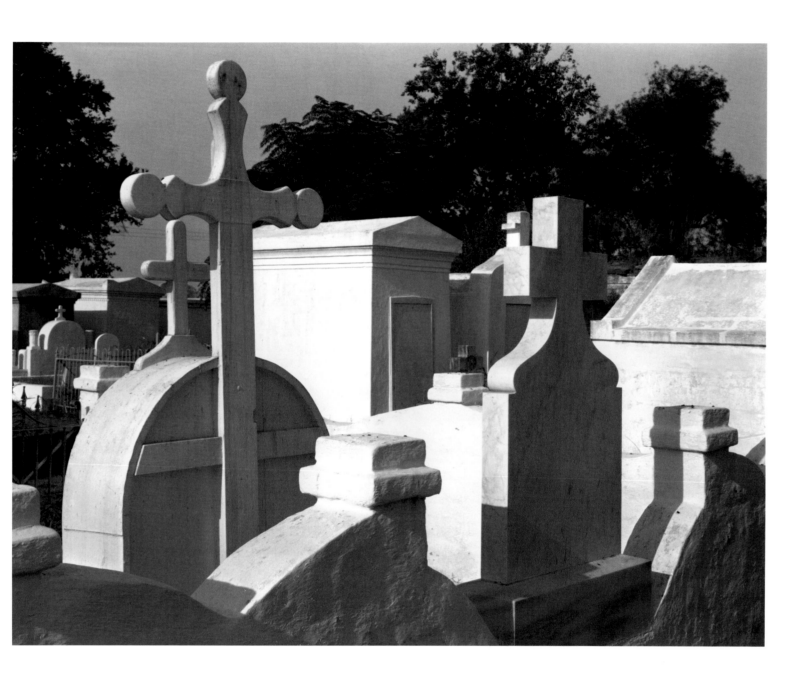

St. Bernard Cemetery, New Orleans, Louisiana, 1941, CCP

8.
Quoted in Conger, p. 35.

9.
Quoted in E. John Bullard, "Edward Weston in Louisiana," in *Edward Weston and Clarence John Laughlin: An Introduction to the Third World of Photography.* (New Orleans: New Orleans Museum of Art, 1982), p. 11.

The new pictures seem less autonomous, less concerned to be autonomous, more openly attached to a world not bounded by Weston's ego.

The terms of the commission certainly played a role in shaping Weston's outlook and purpose. While he rejected the notion that he would illustrate the book, Whitman's poem, perhaps mediated through Charis's readings, surely put ideas into his head, along with rhythms and images. Charis selected lines from the poetry to accompany the seventy-three pictures he submitted, although Weston had insisted in a letter to the publisher that "the photographs were not to be tied in to any specific lines." Instead, "the pictures as a whole were to embody the kind of vision of America that Whitman had. . . . [They] will present the same kind of broad, inclusive summation of contemporary America that Whitman himself gave."[8] Another letter speaks of "rendering visual the underlying themes, the objective realities, that make up Whitman's vision of America."[9] He would try to

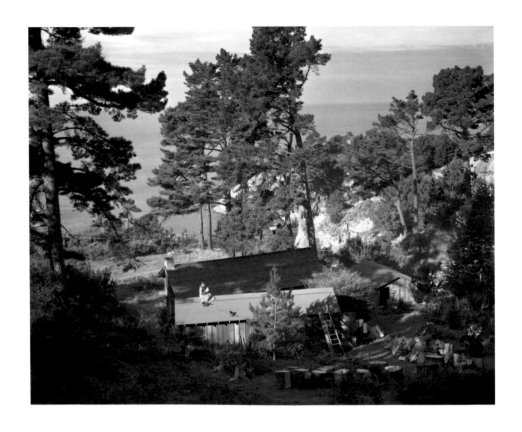

Wildcat Hill, 1942, CCP

Franky, 1945, CCP

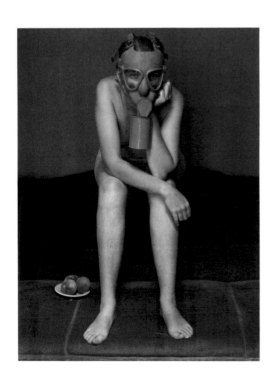

Civilian Defense (with peach), 1942, CCP

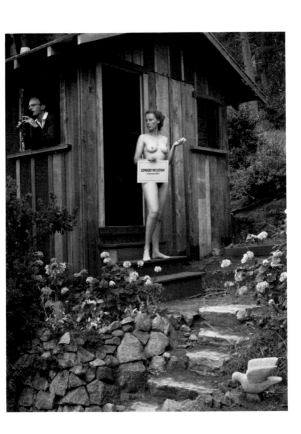

My Little Grey Home in the West, 1943, CCP

produce in photographs, in images of things as they are, an equivalent to Whitman's vision of how things were in his day. In another letter two months later he writes that the pictures will be of "my America."[10]

The commission offered Weston a new horizon and he seized it eagerly, not just for the "great freedom" it promised but because he believed that he "will do the best work of my life."[11] He accepted a new challenge, to produce a vision of his own comparable to that of Whitman, a vision of "my America." The changes we detect in the resulting pictures represent the new intention, the desire not just for significant pictures but pictures whose significance includes their role in defining an emerging vision of an entire nation. The more somber tonality and weaker visual effects of these pictures say something about what Weston saw. They also say something about *how* he pictured what he saw. We can only speculate, but might he not have come to feel that the way of seeing embodied in his strongest earlier pictures was not appropriate to the making of a Whitmanlike vision of the country as a whole? Had he come to feel that his earlier mode harbored limitations, a sense that the isolated, autonomous image would not serve the present purpose? The differences lie in nuances, subtleties of tone, slight shifts of compositional emphasis: elusive differences but distinct enough to notice. Did Weston have less heart for this project than earlier ones? Or is it a different kind of heart, an attentiveness to possibilities within himself for commanding a larger, more *cultural* vision than his earlier purism and intensely personal formalism had allowed? Whatever the causes, the pictures project solitude, distance, withdrawal, as much in the receding distances of the many long urban views as in the self-enclosure of the few portraits. Weston seems disconnected from his "my America," or perhaps, disconnectedness is what defines the America he discovered.

The questions remain unanswerable. In the brief years of work remaining to him after 1942, Weston seemed to relax his creative demands upon himself. He continued to photograph, though, as it seems in retrospect, with less verve and excitement. Perhaps he was in retreat from the likely stress of testing his limits against the challenge of Whitman's "vision of America." Perhaps the disease that would strike in 1945 had already entered his system. His marriage with Charis began to unravel, and its end in 1945 added another tension. And wartime conditions in Carmel, with his four sons in military service, also took its toll. Apart from good camera trips to the rocky terrain and beach at Point Lobos and stunning portraits of family and friends, Weston tried out some new kinds of pictures, perhaps (there's no way of knowing for sure) stimulated toward experiment by the incompleteness of his "my America." The new work disturbed some of his friends, and he became testy and defensive. Because of the imminent onset of the disease, there is no knowing whether a change in direction might indeed have emerged.

The work in Carmel included a group of pictures of cats, made in 1944–45 —"Pussygraphs" he called them—apparently for a book about cats Charis had in mind. More important were a group of pictures of staged scenes at his cabin at Wildcat Hill to which Weston gave tantalizing titles. They seem playful commentaries on the war with a hint of black humor. *Civilian Defense* and *Victory*, both 1942, show a nude Charis wearing a gas mask. *Springtime, My Little Grey Home in the West,* and *Exposition of Dynamic Symmetry,* all made in 1943, are fanciful tableaux including the nude figure of Charis. *Good Neighbor Policy,* 1943, is an

10.
Quoted in Nancy Newhall. *Edward Weston: The Flame of Recognition.* (New York: Grossman Publishers, An Aperture Monograph, 1971), p. 70.

11.
Quoted in Conger, p. 35.

12.
Quoted in Conger, p. 39.

13.
Quoted in Conger.

14.
Quoted in Conger, p. 43.

15.
Quoted in Newhall, p. 82.

apparently symbolic setup of a six-pack of Dr. Pepper, a small sculpted figure, and a pocket watch. A mordant humor coupled with private allusions may be the inner principle of these curious works, and it is not exactly clear what they suggest about Weston's artistic concerns at this time. It *is* clear, however, that he took this work seriously enough to defend against the reservations of friends. Nancy Newhall confessed herself "upset by the backyard setups and their titles."[12] Weston replied: "Your reaction follows a pattern which I should be used to by now. Every time that I change subject matter, or viewpoint, a howl goes up from some Weston fans."[13] How Weston understood the changed viewpoint represented by this work, and whether he saw it connected with the Whitman work, is unrecorded.

A suggestive thought is that, as with the Whitman pictures, the setups show Weston seeking to compose discordant elements into a unified image, an image, moreover, inscribed with a conceptual title, that is, an idea. The idea seems often satiric, surely a new note for him. It also seems at once public in its reference yet private in its visual allusions. These pictures show Weston in command of his private domain, Wildcat Hill, yet aware of a larger world of war and politics. Does it make any sense to wonder if he might have had in mind, even unconsciously, the logic and inner tensions of his earlier project to produce a vision of "my America?" We search in vain for any residue of the Whitman project in the Carmel work after 1942, but perhaps in the oblique ways of art the opportunities and frustrations remained at least unconsciously present to him.

In these painful years Weston produced his most satisfying and lasting work in the familiar mode of his extended Point Lobos series. Although he would deny in a note to Minor White in 1946 that he was any more interested in death now than earlier, the late Point Lobos pictures, with their many signs of lifeless creatures, tell a different story. But more than images of dead birds and decaying matter fill these stunning pictures. There is also the enfolding image of the sea, its constant presence, its work of simultaneously eroding and renewing, and by eroding, producing new forms of matter, new occasions for a deeply satisfying perception of form. With his camera at Point Lobos Edward Weston was in his element, the setting that elicited his strongest and truest work. As his final picture of eroded rocks and the spaces among them so poignantly reveals, in that element Weston was able to look at death, in the way Whitman did, as another mode of life. Renewal lay in that act of seeing, that perception of an order which is the work, the labor, of art. While the tones of his Point Lobos prints in 1946 and 1947 may seem darker than earlier, the labor of art continues unabated in them. Perhaps Point Lobos was his truest America, a place he transformed into one of the most coherent and resonant visions of the natural realm in American art. It was also a place where, even while lingering at death's door, Weston could renew himself picture by picture. "Whatever has happened to me," he wrote some months before the final negative in 1948, "I've brought on myself, and only I can lift myself out of the abyss."[14] Earlier, in 1945, he had written: "I am a prolific, mass production, omnivorous seeker."[15] The work of his final years confirms that self-portrait of a seeker, and as the final picture of eroded rocks reveals, also very much a finder.

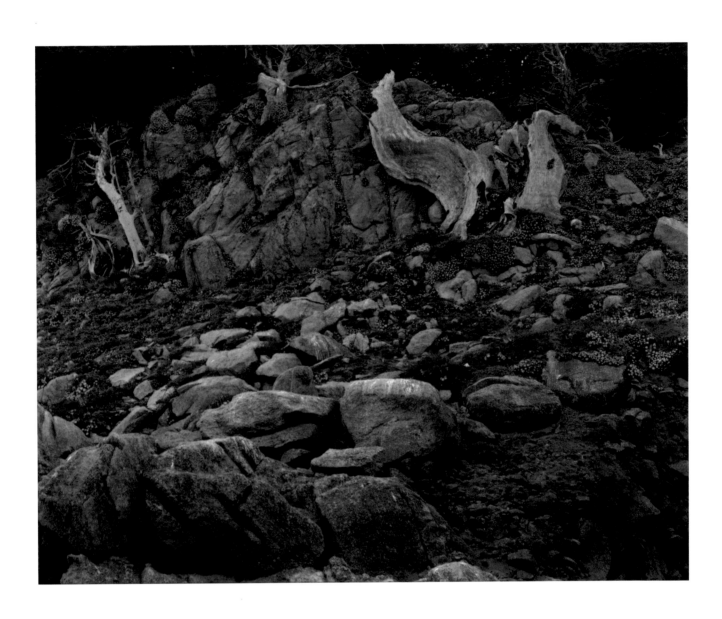

North Shore, Point Lobos, 1946, CCP

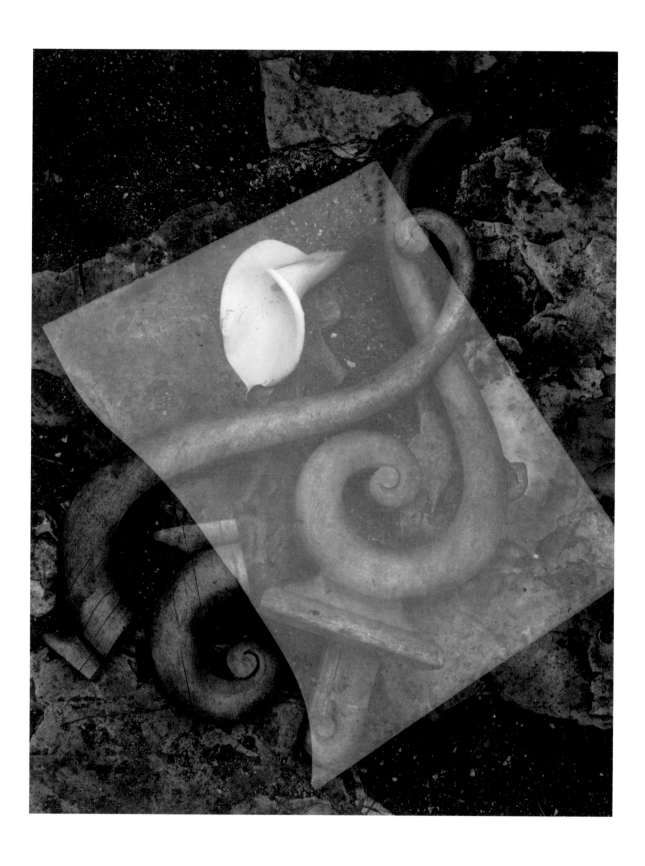

Glass and Lily, 1939

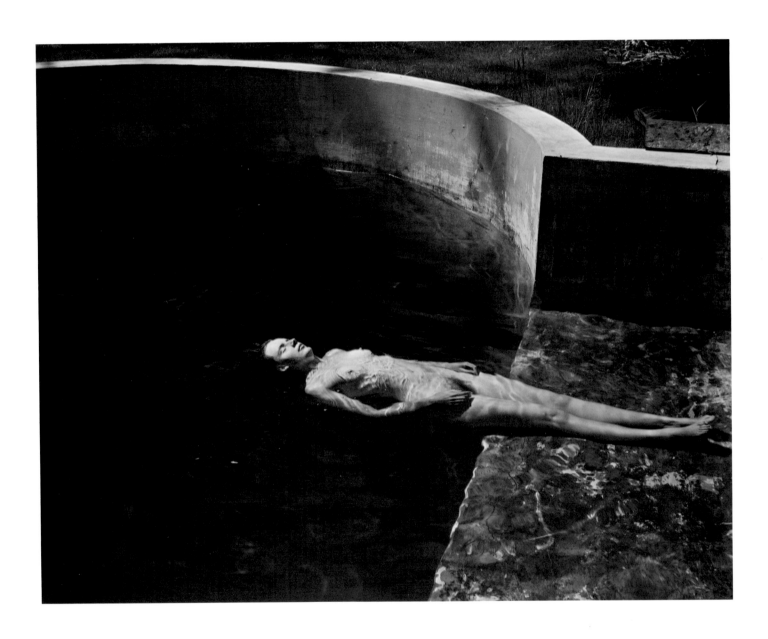

Floating Nude, 1939

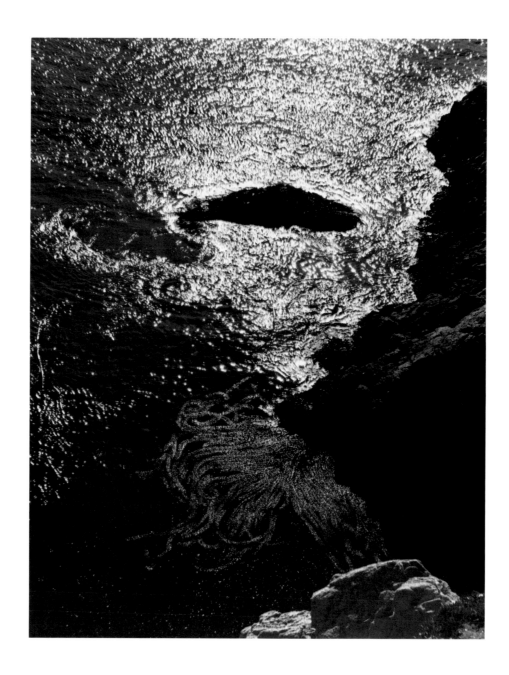

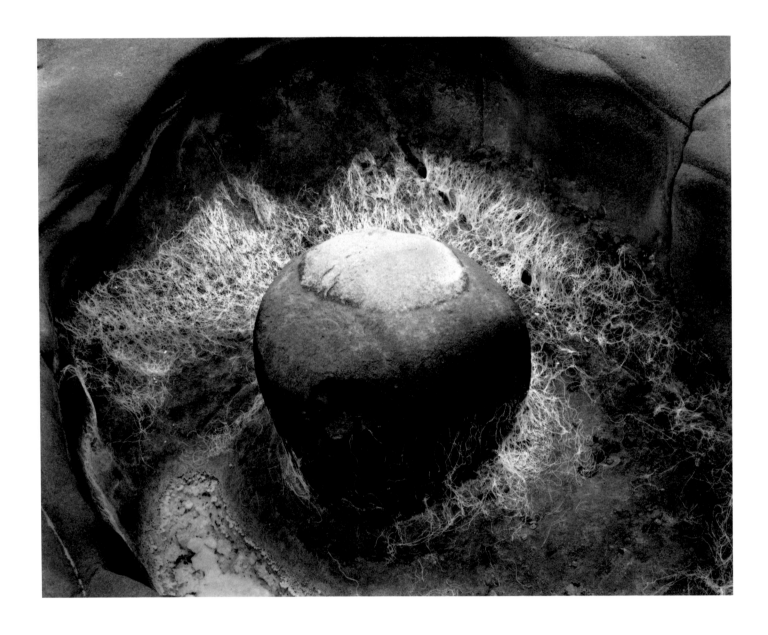

Dry Tidepool, Point Lobos, 1939

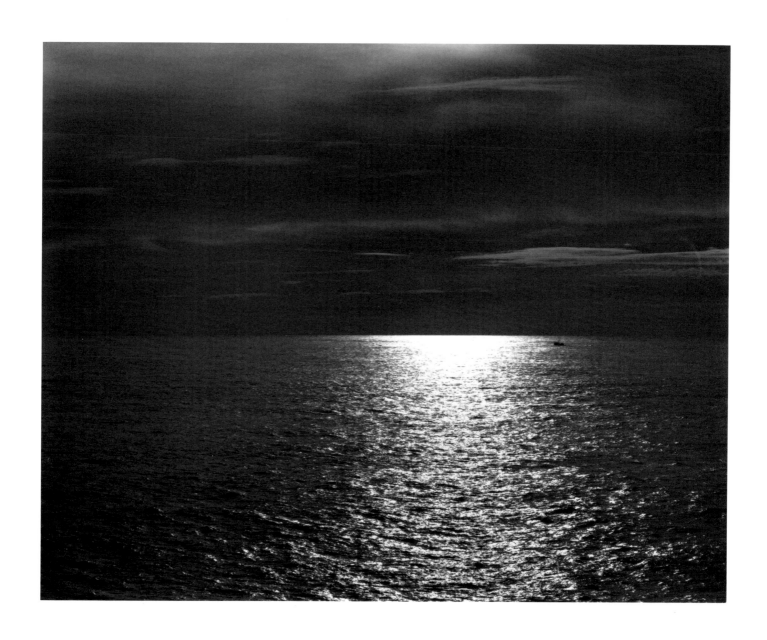

Point Lobos, 1940

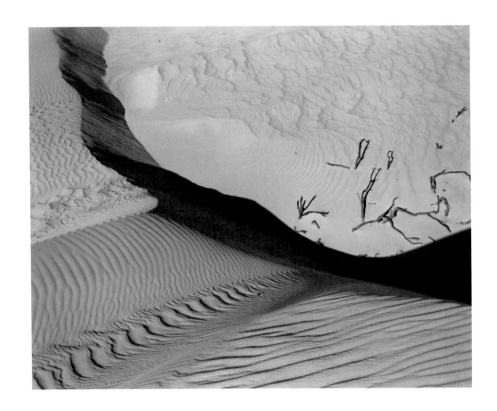

Dunes, Oceano, 1939

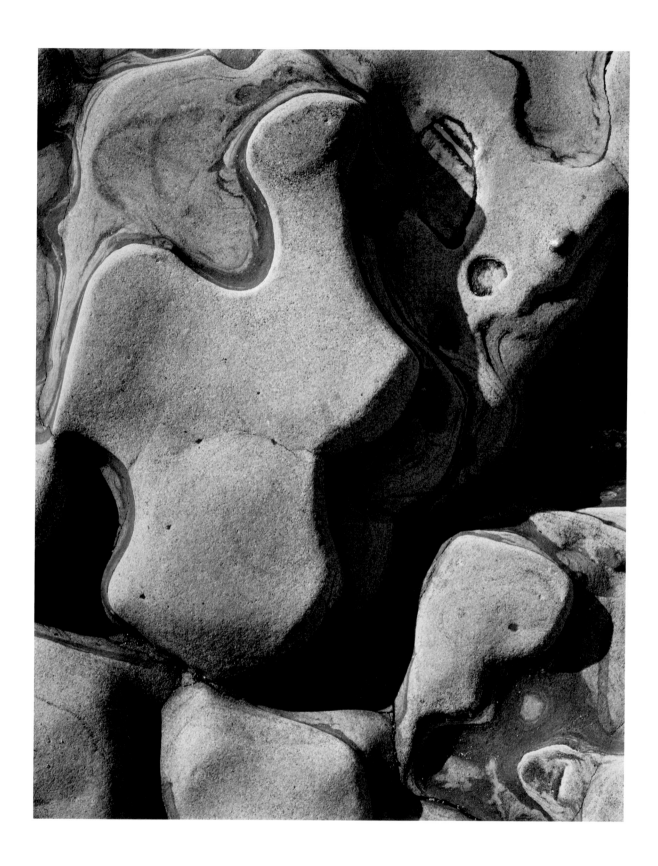

Point Lobos, 1946

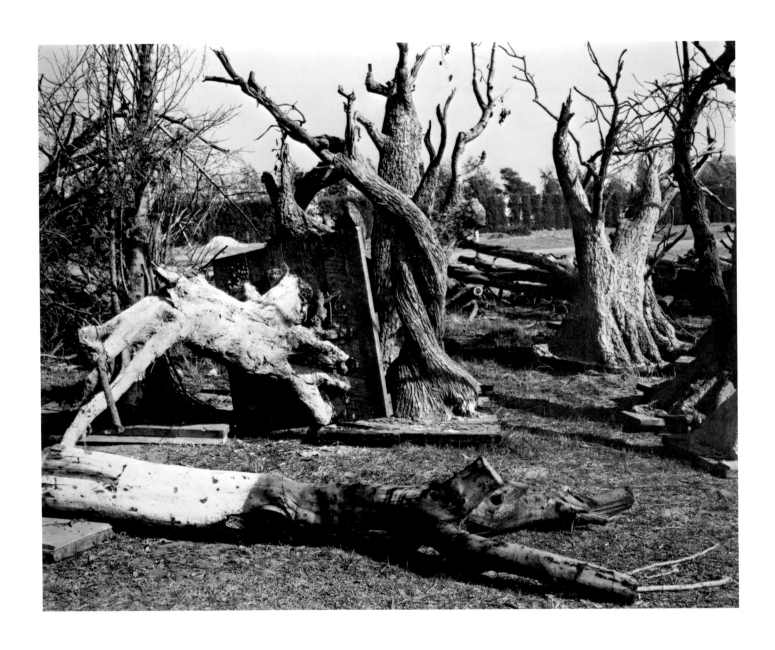

Untitled [Twentieth Century Fox], 1940

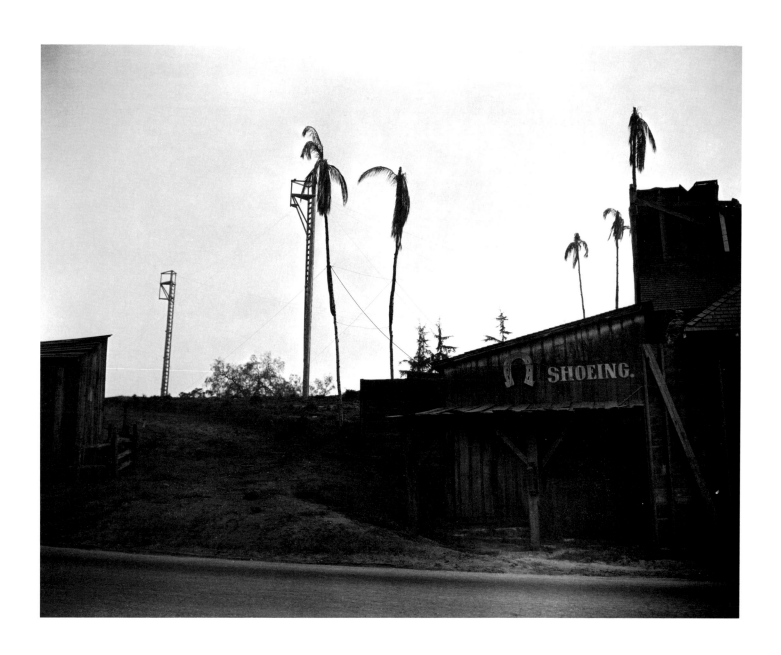

Twentieth Century Fox, Los Angeles, 1940

[Powerhouse, Connecticut], 1941

Santa Fe Engine, 1941

Wall Scrawls, Hornitos, 1941

Tombstone, Old Deerfield, Massachusetts, 1941

Wedding Cake House, Kennebunkport, Maine, 1941

Fig Trees, New Jersey, 1941

Stone Sculpture, William Edmondson, 1941

William Edmondson, Sculptor, Nashville, Tennessee, 1941

Winter Zero Swartzel's Bottle Farm, Ohio, 1941

Winter Zero Swartzel's Bottle Farm, Ohio, 1941

Winter Zero Swartzel's "Bottle Farm," Farmersville, Ohio, 1941

Storm, Arizona, 1941

Mammy, US 61, Mississippi, 1941

Meraux Plantation House, Louisiana, 1941

Willie, New Orleans, 1941

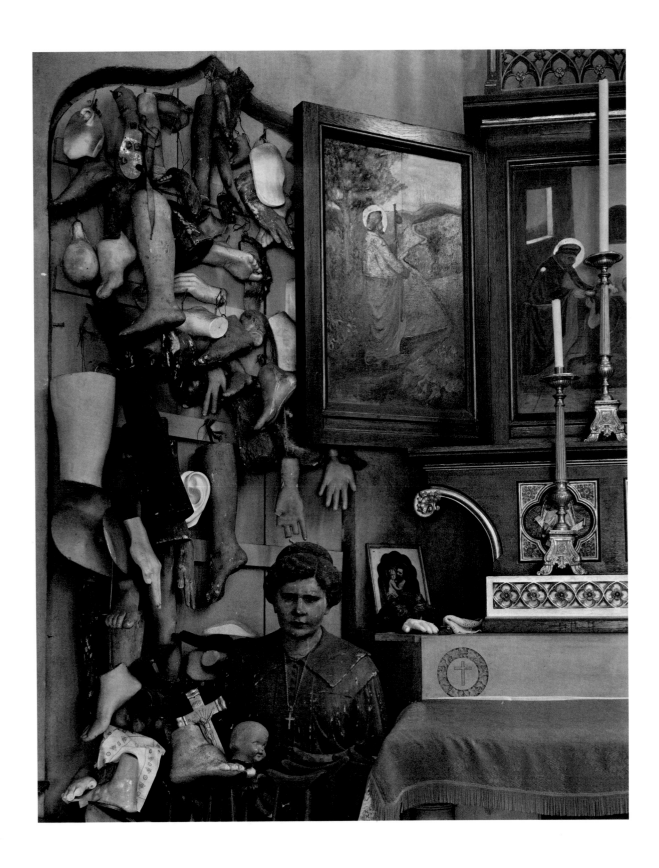

St. Roch Cemetery, New Orleans, 1941

Girod Cemetery, New Orleans, 1941

Girod Cemetery, New Orleans, 1941

Ruins, Plantation Home, New Orleans, 1941

Woodlawn Plantation, Louisiana, 1941

Pittsburgh, 1941

Union Station, Nashville, 1941

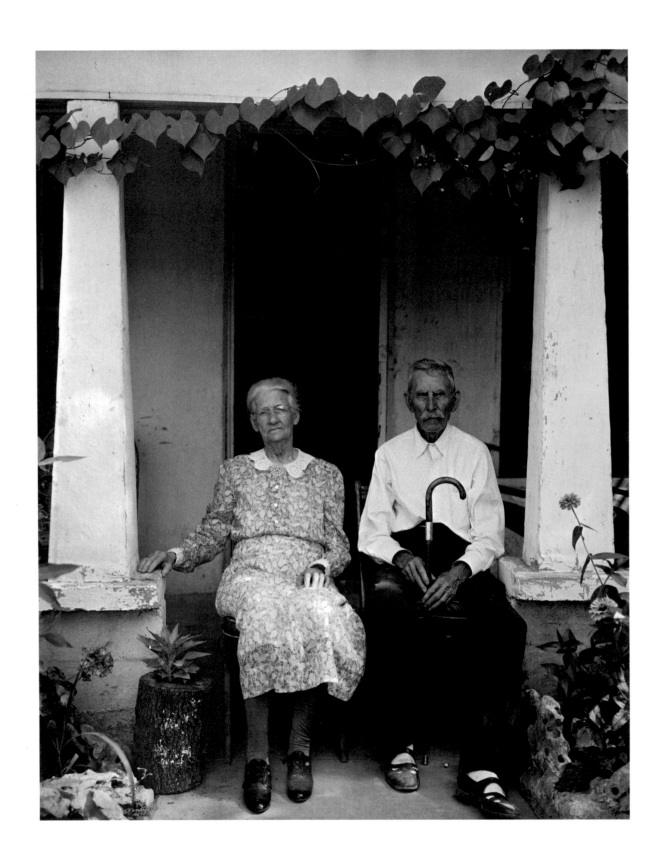

Mr. and Mrs. W. P. Fry, Burnet, Texas, 1941

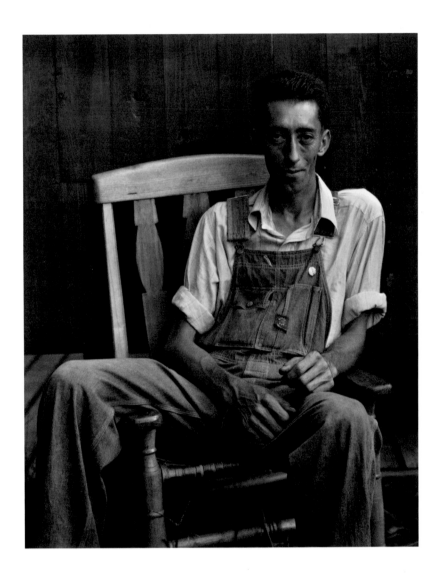

Dillard King, Monteagle, Tennessee, 1941

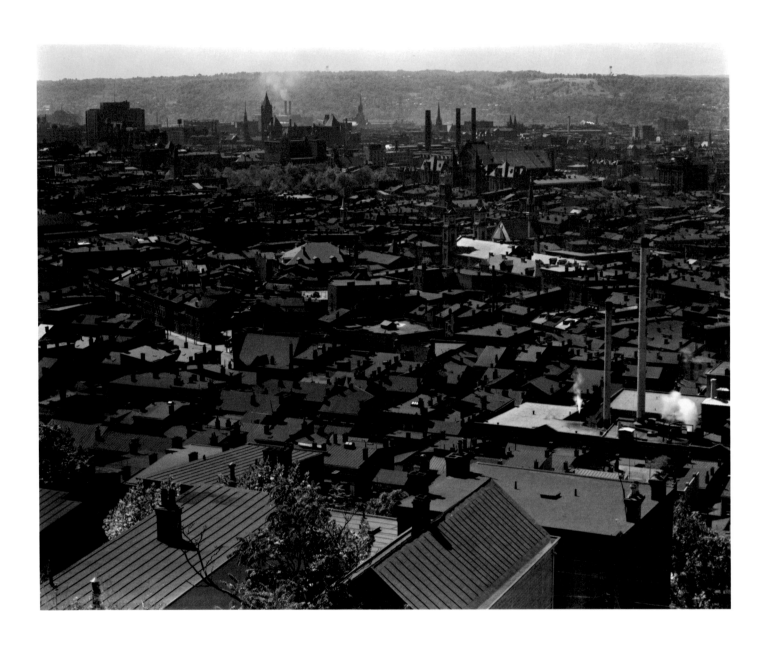

Cincinnati, 1941

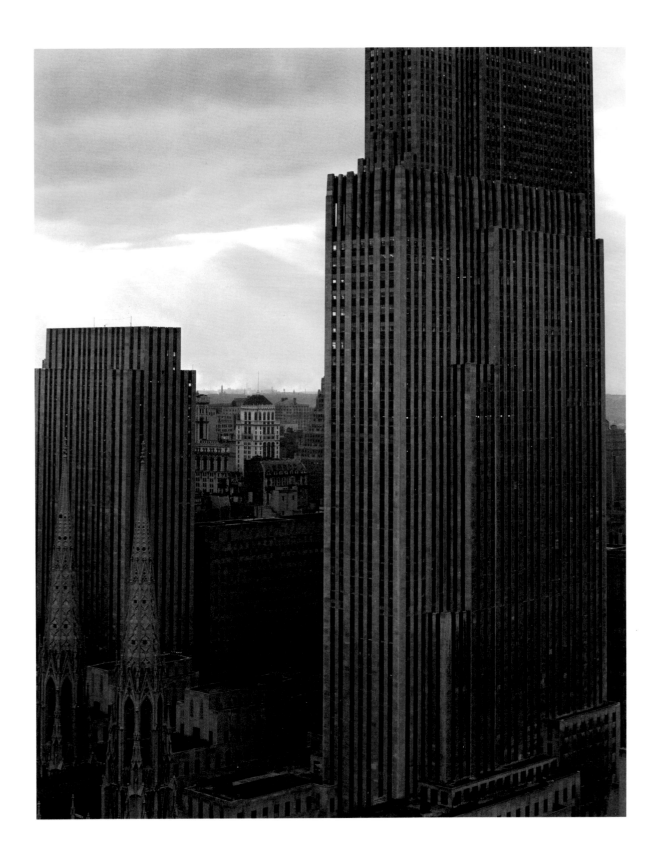

New York, 1941

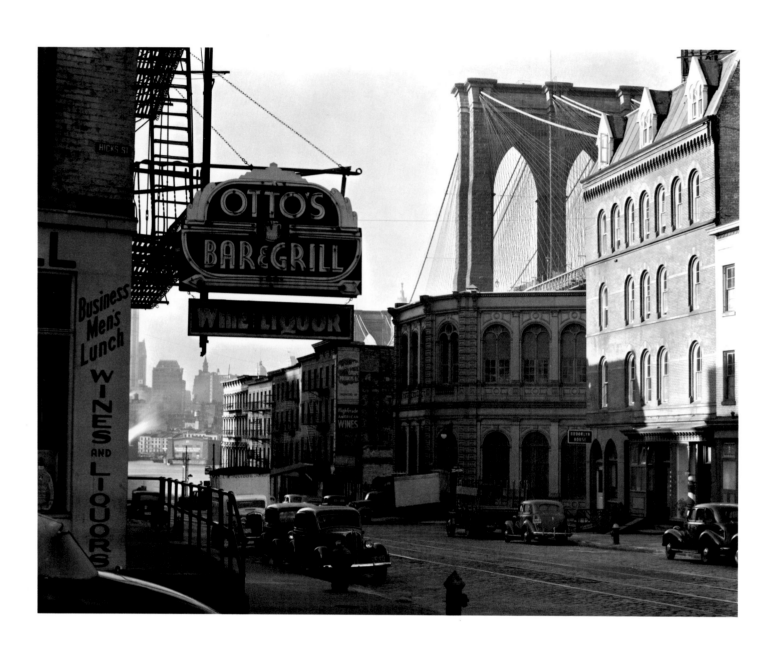

Brooklyn Bridge, 1941

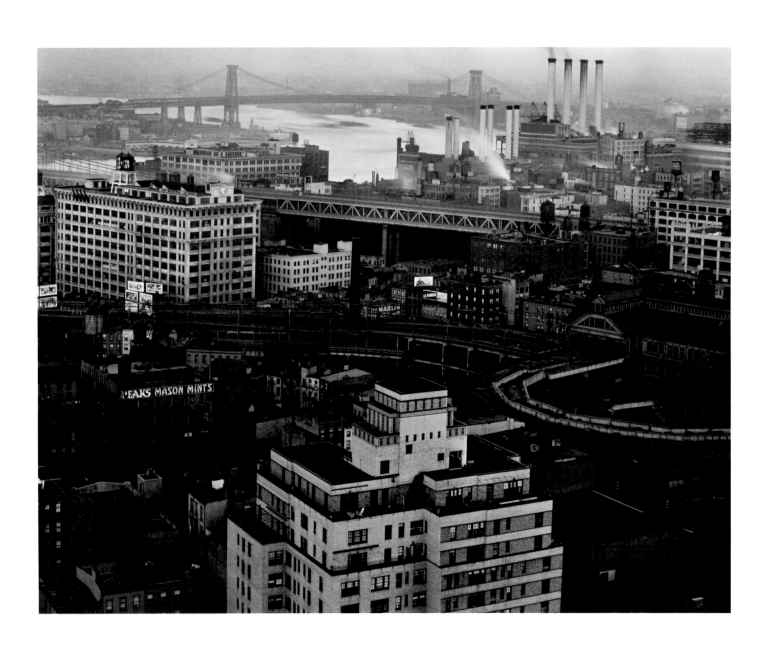

Brooklyn, 1941

Eroded Rock, Point Lobos, 1942

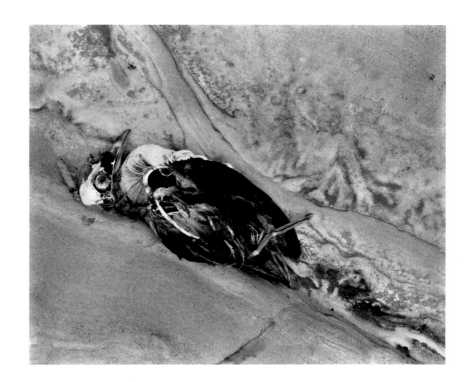

Dead Bird, Point Lobos, 1942

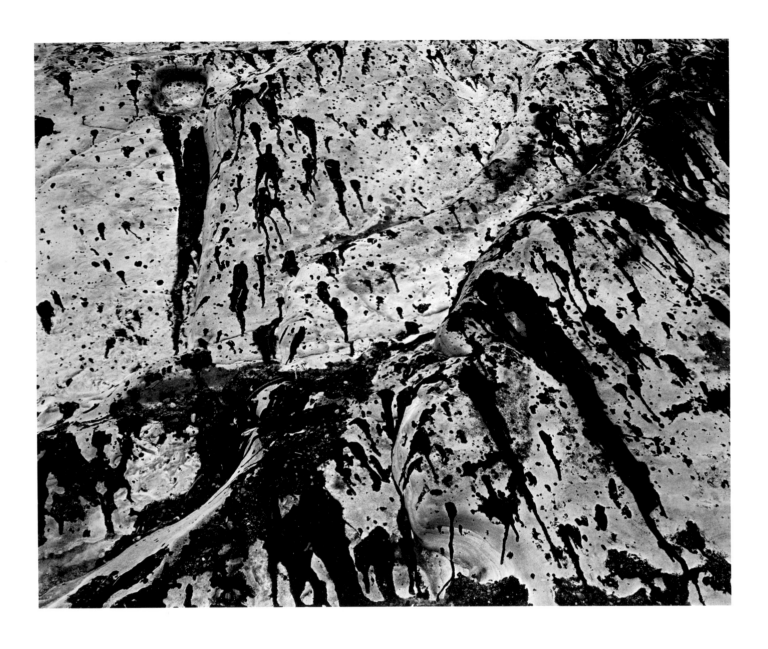

Oil on Rocks, Point Lobos, 1942

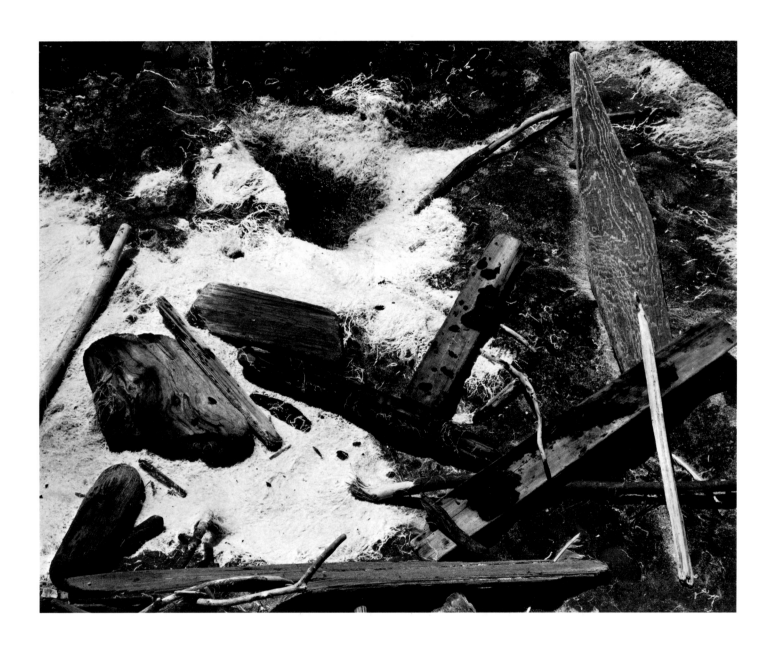

Point Lobos, 1942

Carving by a Penitente, 1942

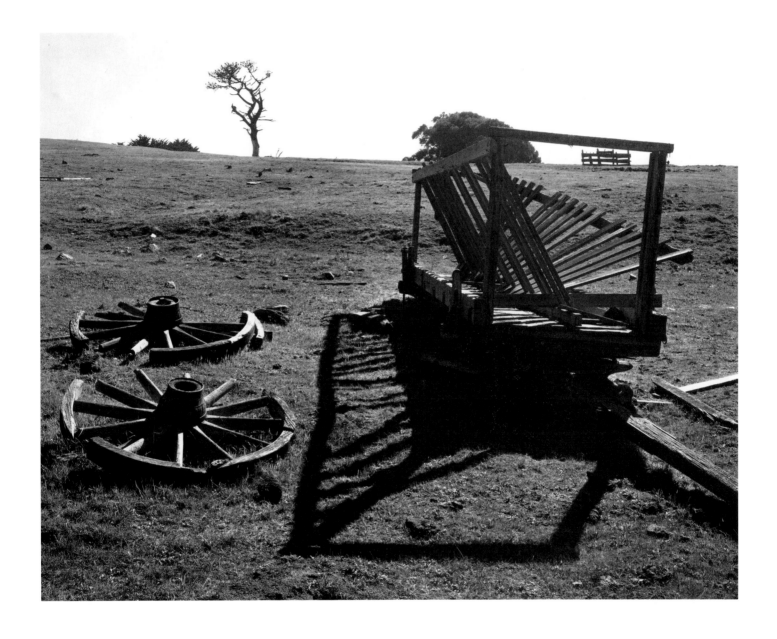

Victorine Ranch, 1943

Good Neighbor Policy, 1943

Yaqui Church, Tucson, 1941

Civilian Defense, 1942

Johnny, 1944

Nude, 1945

Nude, 1945

7 A.M. Pacific War Time, 1945

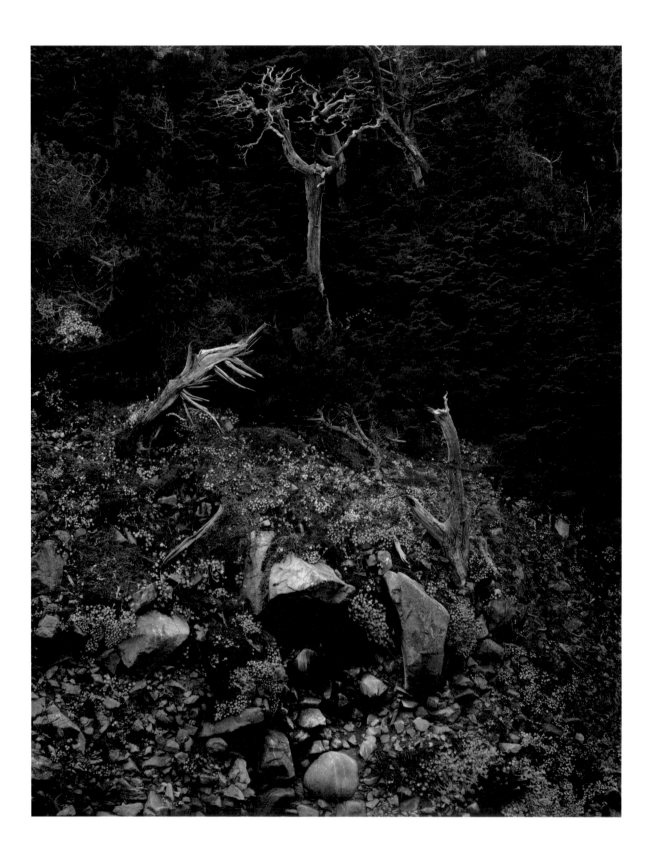

Point Lobos, 1946

Eroded Rocks, South Shore, Point Lobos, 1948

Acknowledgments

The author-editor wishes to thank two institutions whose complementary collections have made possible the realization of this book. Without the Center for Creative Photography at Tucson, Arizona, and the Lane Collection at the Museum of Fine Arts, Boston it would be impossible to understand deeply the work of Edward Weston.

At the Center for Creative Photography, the director, Terence Pitts, opened the Edward Weston Archives with trust and enthusiasm. Access to the Weston negatives was facilitated with friendly professionalism by archivist Amy Rule, assisted by Leslie Calmes, and by Tim Troy, librarian. Dianne Nilsen rigorously oversaw the problems of identification and interpretation of the negatives. Along with Terence Pitts, Curator of Exhibitions and Collections Trudy Wilner Stack has generously contributed knowledge in her text for this monograph. All the members of the staff of the Center must equally share these thanks.

Mr. and Mrs. William H. Lane and the Department of American Paintings at the Museum of Fine Arts, Boston, directed by Theodore E. Stebbins, Jr., assisted by Karen E. Quinn, placed at the disposal of this project the inestimable body of 2,000 original Weston prints that comprise the Lane Collection. Examination of this material has greatly enriched my understanding of Weston's work and permitted me to complete this study. Special thanks to Mr. and Mrs. Lane for their confidence and cooperation. Additional appreciation must go to Theodore E. Stebbins for his written critical appraisal.

Peter C. Bunnell, Director of the Department of Photography at the Modern Art Museum of Princeton University, graciously opened the collections and gave the benefit of his advice, as did Toby A. Jurovics. The J. Paul Getty Museum at Malibu, California, the Oakland Museum, and the Dayton Art Institute generously loaned photographs in their possession: they and other institutions and private galleries equally deserve thanks. Staff members at Editions du Seuil, in Paris, once again demonstrated their expertise in the service of photography.

This project has been blessed with innumerable generous contributors, official and otherwise. Their advice and criticism give this volume added dimension. We are indebted to them all and here we list only a few. Hiram Ash; Pierre Bonhomme, Director of Le Patrimoine Photographie, Paris; Keith Davis, Fine Art Program Director, Hallmark Cards, Inc.; Carol Ehlers, Ehlers Caudill Gallery; Alvin Eisenman; Jeffrey Fraenkel, Fraenkel Gallery; Peter Galassi, Curator of Photography, The Museum of Modern Art; Robert Morton, Harry Abrams, Inc.; Denis Roche, Editions du Seuil; Julie Saul, Julie Saul Gallery; Robert A. Sobieszek, Curator of Photography, The Art Institute of Chicago; Dominique Vasseur, Curator of Photography, The Dayton Art Institute; Rick Wester, Christie's, New York; Matthew Weston, The Weston Gallery; and Cole Weston.

Thanks, finally, to John T. Hill for the artistic conception and design of this book. With his talent and unflagging friendship, he has done more than simply give form to this book: he has actively shared editorial choices and infused the whole with his photographic intelligence. Together, we hope to have contributed a new presentation of the work of Edward Weston.

Gilles Mora

Annotations

Images from the Lane Collection, on loan to the Museum of Fine Arts, Boston, were reproduced from the original vintage prints.

Images from the Edward Weston Archive at the Center for Creative Photography were made from the original negatives by Dianne Nilsen. The Edward Weston Archive contains both vintage prints and "project prints" produced in the early 1950's under Edward Weston's close supervision by Brett Weston and others. Where no negative existed, a copy negative was produced from the original print by Keith Schreiber.

First number indicates page. Last number indicates Weston's log number.

Introduction

8. *Shell,* 1927. Courtesy of Howard Greenberg Gallery. Gelatin silver, 9 1/4 x 7 in. Mounted, signed and dated in pencil with edition number on mount (3/50)
9. *Portrait of My Father,* 1917. Lane Collection. Platinum or palladium, vintage, 7 9/16 x 9 9/16 in., double mounted. signed "Weston" in ink on print, upper left; initialed and dated "EW 1917" below print on mount bottom right; inscribed, signed and dated "Portrait of my Father/ 1917–18 ("18" crossed out)/Edward Weston" verso of second mount, center.
10. Photographer unknown. *Edward Weston,* 1920. CCP. Gelatin silver, 14.2 x 11.7 cm., from Weston papers
11. Untitled [Edward and Flora swimming at the creek], 1909. CCP. Gelatin silver, 11.8 x 8.4 cm. 81:286:004
12. *Alfred Kreymborg–Poet,* 1920. Lane Collection. Palladium, vintage, 8 9/16 x 7 7/16 in. Signed and dated "Edward Weston/1921 [sic]," on mount, lower right. Inscribed: "Alfred Kreymbourg — Poet" on mount, lower left.
13. *Margrethe,* 1921. CCP. PLatinum or palladium, 18.8 x 23.5 cm. 81:207:021
14. *Blind,* 1922 [Ramiel McGehee]. CCP. Gelatin silver, 24.3 x 19.0 cm. 81:276:003. 60PO
15. *Tina,* 1924. CCP. Gelatin silver, 9.4 x 7.2 cm. 81:271:002

16. Brett Weston. *Family Portrait, 1937.* CCP. Gelatin silver, 19.0 x 24.1 cm. Courtesy Dianne Nilsen © 1995 The Estate of Brett Weston
16. *Sonya,* 1929. CCP. Gelatin silver, 18.5 x 19.8 cm. 76:010:024
21. *Charis,* 1935. CCP. Gelatin silver, 11.6 x 9.1 cm. 81:252:203. 209N
23. *Exposition of Dynamic Symmetry,* 1943. CCP. Gelatin silver, 19.2 x 24.3 cm. 21A8, PO43-CNLJ-1
24. *Point Lobos,* 1940. CCP. Gelatin silver, 19.4 x 24.3 cm. 81:110:071. PL40-T-9
25. Fritz Henle. *Edward Weston at Carmel, California,* 1942. CCP. Gelatin silver, 22.7 x 35.4 cm. 84:052:001

Early Years

26. [Edward Weston in front of his first California studio], ca. 1911. Courtesy Dayton Art Institute. Gelatin silver, 3 1/8 x 4 1/8 in. L19.1993.6
27. *Edward Weston–Self-portrait,* 1911. Courtesy of Los Angeles County Museum of Art. Toned gelatin silver. 9 x 7 in.
28. *Air for the G String,* 1919 [Johan Hagemeyer]. CCP. Platinum or palladium, 19.3 x 24.1 cm. 76:005:010
29. *Franz Geritz,* 1920. Lane Collection. Platinum or palladium, vintage, 9 9/16 x 7 1/2 in. Inscribed "EW 1920," on mount, below print, right; "Franz Geritz 1920/Edward Weston" on verso of mount, center.
31. James McNeill Whistler. *Caprice in Purple and Gold No. 2 – The Golden Screen,* 1864. Courtesy Freer Gallery of Art, Washington, DC.
31. *Betty in her Attic,* 1920. CCP. Platinum or palladium, 23.3 x 19.0 cm. 81:207:003. 15PO
32. Margrethe Mather. *Johan Hagemeyer and Edward Weston,* 1921. Courtesy of Hallmark Photographic Collection. Platinum, 7 5/8 x 7 3/8 in. 76:005:054
33. Untitled. [Margrethe and Ramiel with camera on beach], 1923. CCP. 7.3 x 9.9 cm. from Weston papers
34. *Snow Scene, Jackson Park, Chicago,* 1903. CCP. Gaslight print, 8.3 x 11.1 cm. 81:207:007
35. *Lake Michigan, Chicago,* 1904. CCP. Platinum, 9.0 x 11.9 cm. 81:207:008

36. *The Fan,* 1917 [Margrethe Mather]. CCP. Platinum or palladium, 24.5 x 19.3 cm, 81:207:020
37. *Ted Shawn* [Dancer and Choreographer], 1915. Courtesy of Christie's. Platinum print, signed and dated on the recto, 16 x 11 3/4 in. mounted.
38. *Nude,* 1918. CCP. Reproduction print from original negative. 2N
39. *Nude,* circa 1918. Lane Collection. Platinum or palladium, vintage, 9 9/16 x 7 5/16 in. Inscribed: "2.00" on verso of print, lower left. Possibly 1N
40. *Epilogue,* 1918. CCP. Platinum or palladium, 24.4 x 18.5 cm. 76:005:020
41. Untitled [Margarita Fisher in fur coat and hat, for Willard George Furs], 1919. CCP. Gelatin silver, 24.4 x 19.2 cm. 81:286:011
42. *Bathers,* 1919. Malibu, The J. Paul Getty Museum. Gelatin silver print, 24.1 x 19.3 cm. 85.xm.257.1
43. *Betty Brandner,* 1920. Malibu, The J. Paul Getty Museum. Gelatin silver print, 19.1 x 24.4 cm. 85.xm.170.12
44. *Roi Partridge,* ca. 1921. CCP. Reproduction print from original negative.
45. *Torso,* circa 1918. Lane Collection. Platinum or palladium, vintage, 9 5/8 x 7 1/2 in. Inscribed: "2.00" on verso of print, lower left
46. *The Breast,* 1921. Private collection. Platinum print, signed, dated and titled on verso, 18.7 x 23.8 cm.
47. *Refracted Sunlight on Torso,* 1922. CCP. Gelatin silver, 24.1 x 19.0 cm. 81:275:001. 7N
48. *Jean-Christophe,* 1920. [Johan Hagemayer] CCP. Platinum or palladium, 19.0 x 24.2 cm. 76:005:009
48. Untitled [Margrethe on couch, Glendale Studio], 1920. CCP. Platinum or palladium, 18.9 x 24.0 cm. 81:207:002
49. *Prologue to a Sad Spring,* 1920. Lane Collection. Palladium, vintage, 9 3/8 x 7 3/8 in. Inscribed, signed and dated, also titled "Shadow of a Barn Door/Edward Weston/ Glendale 1920," on verso of print center; "EW 1920," on mount, below print, left; also titled "Shadow on a Barn — 1920/and Margrethe/ Edward Weston" on verso of mount, center. 54PO
50. *Ramiel in His Attic,* 1920. CCP. Platinum or palladium, 23.5 x 18.8 cm. 76:005:022

Gelatin silver, 22.9 x 19.0 cm. 81:252:121. 59PO

51. *Scene Shifter,* 1921. CCP. Platinum or palladium, 24.1 x 19.2 cm. 81.207.015

51. *Sunny Corner in an Attic,* 1921 [Johan Hagemeyer]. CCP. Platinum or palladium, 19.0 x 24.0 cm. 76:005:014. Gelatin silver, 19.0 x 22.7 cm, 82:010:032. 55PO

52. *Tina,* 1922. CCP. Gelatin silver, 18.1 x 24.3 cm. 81:207:018. 8N

53. *Neil,* 1922. CCP. Gelatin silver, 24.2 x 19.1 cm. 81:252:059. 12N

54. *Tina Modotti,* 1922. Also titled *Girl in Canton Chair,* 1921. Lane Collection. Platinum or palladium, vintage, 7 1/2 x 9 5/8 in. Initialed and dated "EW 1922," on mount, below print, right; inscribed, signed and dated "Tina Modotti/1922/Edward Weston," on verso of mount, center. 49PO

55. *Margrethe,* 1923. CCP. Platinum or palladium, 19.0 x 24.1 cm. 81:207:005. 20N

55. *Margrethe,* 1923. CCP. Gelatin silver, 18.9 x 24.2 cm. 81:252:061. 24N

56. *Ruth Shaw–A Portrait,* 1922. Lane Collection. Palladium, vintage, 7 1/2 x 9 9/16 in. Signed and dated "Edward Weston/ California/1922," on verso of print, lower right. Initialed and dated "EW 1922," on mount, below print, right; "R.S. - a portrait/1922/Edward Weston" on verso of mount, center. 31PO

57. *Armco Steel,* 1922 Lane Collection. Gelatin silver, vintage, 9 3/8 x 6 7/8 in. Signed and dated "Edward Weston 1922" below print, right; inscribed "16-50" on mount, below print, left; "1M/2500" verso of mount, upper left; "Armco Steel" upper center. 1M

58. *Armco, Ohio,* 1922. Also titled *Pipes and Stacks: Armco, Middletown, Ohio.* Lane Collection. Gelatin silver, vintage, 9 1/4 x 7 5/8 in. Initialed and dated "EW 1922" on mount, below print, right; inscribed "2M/1922" verso of mount, upper left; inscribed, signed and dated "Armco," Ohio/Edward Weston 1927 ("7" crossed out and replaced with a "2") upper center; "Original on Palladio" upper right. 2M

59. *Armco,* 1922. Lane Collection. Platinum or palladium, vintage, 7 5/16 x 8 1/16 in. Signed "Edward Weston/(Ohio - cropped) verso of print bottom right.

60. *Nude,* 1923. CCP. Reproduction print from original negative. 17N

60. *Nude,* 1923. CCP. Gelatin silver, 18.9 x 23.5 cm. 81:151:031. 19N

61. *Nude,* 1923, Lane Collection. Gelatin silver, vintage, 7 1/2 x 9 1/2 in. Initialed and inscribed: "EW 6/50" on mount, below print, left; "18N/1923" on verso of mount, upper left. 18N

Mexican Years

62. Photographer unknown. *Tina and Edward in Mexico,* 1924. CCP. Gelatin silver, 14.5 x 10.1 cm. 76:005:073

63. *Revolución,* 1926. Lane Collection. Platinum or palladium, 5 3/16 x 9 5/8 in. Signed and dated "Edward Weston/Mexico 1926" verso of print, lower leftl initialed and inscribed "EW 8/50" on mount, below print, left; signed and dated "Edward Weston 1926" lower right; inscribed "Revolucion" lower left and verso of mount, upper left. 23J

64. *Caballito de Cuarenta Centavos,* 1924. CCP. Gelatin silver, 18.6 x 23.0 cm. 81:252:078. 28J

66. *Circus Tent,* 1924. CCP. Gelatin silver, 23.5 x 17.8 cm. 81:120:004. 6MI

67. *Gourds,* 1924. CCP. Gelatin silver, 19.1 x 23.3 cm. 81:151:017. 31J

67. *Melon,* 1927. CCP. Gelatin silver, 18.7 x 23.9 cm. 81:252:104. 4V

68. *San Cristobal Ecatepec,* 1923. CCP. Gelatin silver, 10.1 x 22.9 cm. 80:028:001. 10L

69. *Palma Cuernavaca,* 1924. CCP. Gelatin silver, 23.3 x 18.8 cm. 81:252:096. 1T

71. *The White Iris,* 1921. CCP. Platinum or palladium, 24.2 x 19.0 cm. 76:005:027

71. *Tina Reciting,* 1924. CCP. Gelatin silver, 8.4 x 6.6 cm. 81:271:003

72. *Chandler,* 1924. Lane Collection. Platinum or palladium, vintage, 9 1/2 x 7 5/8 in. Inscribed: "-Chandler-" verso of print, bottom left; signed and dated "Edward Weston/Mexico 1924" lower right; "13PO" verso of mount upper left. 13PO

73. *Pintao,* 1924 Lane Collection. Platinum or palladium, vintage, 9 3/8 x 7 1/4 in. Inscribed: "-Pintao-" verso of print, bottom left; signed and dated "Edward Weston/Mexico 1924" bottom right; "not for sale" verso of mount upper left.

74. *The Great Cloud, Mazatlàn, Mexico,* ca. 1924. Collection of the Oakland Museum, Oakland. Platinum, 9 x 7 in. A69.19.1

75. *Cloud, Mexico,* 1926. CCP. Reproduction print from original negative. 11CL

76. *Maguey,* 1926. Lane Collection. Gelatin silver, vintage, 8 x 10 in., unmounted 6C ?

77. *Tres Ollas,* 1926. Lane Collection. Gelatin silver, 7 1/2 x 8 9/16 in. Initialed and dated: "EW 1926" on mount, below print, right. 12Mi

78. *Piramide del Sol,* 1923. Lane Collection. Gelatin silver, 7 7/16 x 9 5/16 in. Initialed and dated "EW 1923" on mount, below print, right. 6A

79. *Nahui Olin,* 1925. CCP. Gelatin silver, 23.0 x 17.4 cm. 82:010:029. 16PO

80. *Tina,* 1923. CCP. Gelatin silver, 19.1 x 24.3 cm. 81:252:087 40PO

81. *Bomba en Tacubaya,* 1923. Lane Collection. Gelatin silver, 9 1/2 x 7 9/16 in. Initialed and dated "EW 1923" on mount, below print, right; inscribed "8M" upper left; inscribed, signed and dated "Bomba en Tacubaya/Mexico 1923/Edward Weston" verso of mount, upper center. 8Mi

82. *Diego Rivera,* 1924. Lane Collection. Gelatin silver, vintage, 7 9/16 x 9 5/16 in. Inscribed, signed and dated "Diego Rivera/Mexico 1924/by Edward Weston" verso of mount, upper, center. 5PO

83. *Guadalupe Marín de Rivera,* 1923. CCP. Gelatin silver, 22.9 x 17.8 cm. 82:010:028. 20.8 x 17.9 cm. 76:021:007. 8PO

85. *Tina on the Azotea,* 1923. CCP. Gelatin silver, 17.6 x 23.8 cm. 3D7. 67N

86. *Hands, Mexico,* 1924. CCP. Gelatin silver, 23.1 x 19.1 cm. 82:010:009. 1H

87. *Tina,* 1924. CCP. Reproduction print from original negative

88. *Tina on the Azotea,* 1924. CCP. Reproduction print from original negative. 35N

89. *Tina on the Azotea,* 1924. CCP. Gelatin silver, 23.5 x 18.6 cm. 81:120:010. 34N

90. *Tina Reciting,* 1924. CCP. Gelatin silver, 24.2 x 19.1 cm. 81:252:089. 36PO

90. *Tina Reciting,* 1924. CCP. Gelatin silver, 24.0 x 19.0 cm. 81:275:002. 24.3 x 19.1 cm. 81:275:003. 37PO

91. *Tina Reciting,* 1924. CCP. Gelatin silver, 24.1 x 19.0 cm. 82:010:031. 34PO

92. *Hand of Amado Galván,* 1926. Private collection. Gelatin silver, 23.8 x 18.0 cm.

93. *Galván Shooting,* 1924. Lane Collection. Gelatin silver, 8 3/8 x 7 5/16 in. Initialed and dated "EW 1924" on mount, below print, right; "Galván, Shooting —/Mexico 1924/made with 3 x 4 Graflex" verso of mount, upper center. 6PO

94. Untitled [bell tower, Pátzcuaro], 1926. CCP. Reproduction print from original negative.

95. *Arch, Tepotzotlán,* 1924. CCP. Gelatin silver, 19.2 x 24.1 cm. 81:252:067. 18A

96. *Plaza Tepotzotlàn,* 1924 . CCP. Gelatin silver, 9.9 x 7.4 cm. 81:286:007

97. *Tepotzotlàn, Mexico,* 1924. CCP. Gelatin silver, 19.0 x 24.0 cm. 82:010:003. 21A

98. *Desde la Azotea,* 1924. Lane Collection. Platinum or palladium, vintage, 7 5/8 x 9 5/8 in., double mounted. Signed and dated "Edward Weston/Mexico 1924" verso of print, lower left; inscribed: "—from our azotea" lower right; initialed and dated "EW 1924" on second mount, below print, right; inscribed, signed and dated "Desde la Azotea/1924/Edward Weston" verso of mount, upper center. 13A

99. *Cuernavaca,* 1924. Lane Collection. Platinum or palladium, vintage, 7 5/8 x 9 5/8 in. Signed and dated "Edward Weston/Cuernavaca 1924" verso of print, lower left; initialed and inscribed "EW 1/50" on mount, below print, left; signed and dated "Edward Weston/Cuernavaca 1924" lower left; "2000" verso of mount upper left. 2A

100. *Nude,* 1924. Lane Collection. Platinum or palladium, vintage, 9 1/8 x 6 1/2 in. Signed and dated "Edward Weston/Mexico 1924" on verso of print, lower left; inscribed "2/50" on mount, below print, left; signed and dated "Edward Weston 1924" right; "-Nude-" (erased) lower left corner; "50N" verso of mount, upper left. 50N

101. *Nude,* 1925. CCP. Gelatin silver, 17.8 x 21.5 cm. 81:252:062. 40N

102. *Neil,* 1925. CCP. Palladium, 9.7 x 7.3 cm. 78:001:004 44N

103. *Neil,* 1925. CCP. Gelatin silver, 17.8 x 16.4 cm. 81:252:063. Palladium, 9.6 x 7.2 cm. 78:001:005. 45N

104. *Factory, Los Angeles,* 1925. CCP. Gelatin silver, 24.1 x 19.0 cm. 81:252:051. 15M

105. *Plaster Works, Los Angeles,* 1925. CCP. Gelatin silver, 20.1 x 25.3 cm. 81:252:052. 16M

106. *Arcos, Oaxaca,* 1926. CCP. Platinum or palladium, 24.2 x 18.9 cm. 76:020:031

107. *Palma Cuernavaca,* 1925. Lane Collection. Gelatin silver, vintage, 9 5/8 x 6 1/2 in. Initialed and inscribed: "EW 10/50" in mount, below print, left; signed and dated "Edward Weston/Mexico 1925" lower right; inscribed "2T/1000/Palma — Cuernavaca" verso of mount, upper left. 2T

108. *Washbowl,* 1925. CCP. Gelatin silver, 24.1 x 19.1 cm. 81:252:050. 7M

109. *Excusado,* 1925. CCP. Gelatin silver, 24.1 x 19.2 cm. 81:252:049. 5M

110. *Gourds, Three Fish,* 1925. CCP. Gelatin silver, 19.1 x 24.2 cm. 81:252:032. 35J

111. *Angelito,* 1926. CCP. Gelatin silver, 24.2 x 19.2 cm. 81:252:033. 41J

113. *Nude,* 1925. CCP. Gelatin silver print, 22.2 x 18.9 cm. 82:010:018. 51N

114. *Casa de Vecindad,* 1926. CCP. Gelatin silver, 18.9 x 24.0 cm. 82:010:017. 19.0 x 24.1 cm. 82:008:345. 5Ml

115. Untitled [interior of Nuestra Señora de Guadalupe, Pàtzcuaro], 1926. CCP. Gelatin silver, 24.2 x 19.2 cm. 82:008:335

116. *Pulquería, Mexico City,* 1926. CCP. Gelatin silver, 23.9 x 19.1 cm. 81:252:016. 62A

117. Untitled [bullfight, Mexico City], 1926. CCP. Gelatin silver, 7.4 x 9.1 cm. from Weston papers.

118. *Pulquería, Mexico City,* 1926. CCP. Gelatin silver, 19.2 x 24.2 cm. 76:010:029. 19.0 x 23.7 cm. 82:010:002. 8A

119. *Pulquería, Mexico City,* 1926. CCP. Gelatin silver, 23.6 x 18.0 cm. 82:008:368

119. *Pulquería, Mexico City,* 1926. CCP. Gelatin silver, 24.0 x 17.3 cm. 81:151:004. 57A

120. *Rose Roland de Covarrubias,* 1926. CCP. Gelatin silver, 22.9 x 15.6 cm. 4B12. 32PO

121. *Tehuana Costume,* 1926 [Rose Roland de Covarrubias]. Lane Collection. Gelatin silver, vintage, 7 5/16 x 9 3/4 in. Inscribed "Tehuana Costume" on mount, below print, lower left; signed and dated "Edward Weston/Mexico 1926" lower right; inscribed "1000" verso of mount, upper left.

122. *Descanso, Pátzcuaro,* 1926. Lane Collection. Platinum or palladium, vintage,

8 13/16 x 5 5/16 in., double mounted. Signed and dated "Edward Weston/Pátzcuaro 1926" verso of print lower left; initialed and dated "EW 1926" on second mount, below first mount, right; inscribed, signed and dated "Descanso/Pátzcuaro 1926/Edward Weston" verso of second mount, upper center. 9Mi

123. Untitled [woman seated on petate], 1926. CCP. Gelatin silver, 19.1 x 24.0 cm. 82:008:354

124. Untitled [fountain, Pátzcuaro], 1926. CCP. Gelatin silver, 19.0 x 23.5 cm. 82:008:363

125. *Dr. Atl,* 1926. CCP. Gelatin silver, 23.6 x 18.8 cm. 81:120:006. 9PO

126. *Nude,* 1926. CCP. Gelatin silver, 24.1 x 18.5 cm. 81:207:016

127. Untitled [ceramic sculpture of angel], 1926. CCP. Gelatin silver, 23.8 x 14.1 cm. 82:008:357

128. *Palmilla,* 1926, Lane Collection. Platinum or palladium, vintage, 9 1/2 x 7 5/8 in. Signed and dated "Edward Weston/Mexico 1926" on verso of print lower left; intialed and dated "EW 6/50" on mount, below print, right; signed and dated "Edward Weston/Mexico 1925 (sic); inscribed "2J" verso of mount, upper left; "Palmilla/1925 (sic)" upper center. 2J

129. *Palma Bendita,* 1926. Lane Collection. Platinum or palladium, vintage, 9 5/8 x 7 1/8 in. Signed and dated "Edward Weston/Mexico 1926" verso of print, lower left; initialed and inscribed "EW 6/50" on mount, below print, left; inscribed "—Palma Bendita—" lower left; signed and dated "Edward Weston/Mexico 1926" lower right. 4J

129. *Pascua,* 1926. Lane Collection. Platinum or palladium, vintage, 9 1/2 x 7 5/8 in. Signed and dated "Edward Weston/Mexico 1926" verso of print, lower left; initialed and inscribed "EW 1/50" on mount, below print, left; signed and dated "Edward Weston/Mexico 1926" lower right. 20J

130. *Victoria Marin,* 1926. Lane Collection. Platinum or palladium, vintage, 9 15/16 x 7 1/8 in. Inscribed " —Victoria Marin—" verso of print, lower left; signed and dated "Edward Weston/ Mexico 1926" lower right; signed "Edward Weston" on mount, below print, right; signed "Edward Weston/Mexico 1926 (erased) lower right; inscribed "17PO/1500" verso of mount, upper left. 17PO

131. *Nude,* 1925. CCP. Reproduction print from

original negative. 49N

132. *Pátzcuaro*, 1926. Lane Collection. Platinum or palladium, vintage, 7 9/16 x 9 5/8 in., double mounted. Signed and dated "Edward Weston — 1926/ Patzcuaro - Michoacan" verso of print, lower left; initialed and dated "EW 1926" on second mount, below first mount, right; inscribed, signed and dated "Patzcuaro/ 1926/Edward Weston" verso of second mount, upper center.

133. *Pátzcuaro*, 1926, CCP. Gelatin silver, 18.9 x 24.0 cm. 81:252:039. 5L

Formal Years

134. Brett Weston. *Edward Weston's Favorite Portrait*, 1929. Lane Collection. Gelatin silver, 9 1/4 x 7 in. Inscribed "Carmel 1929/Edward Weston's Favorite Portrait" verso of mount, center.

136. Ansel Adams. *Rose and Driftwood, San Francisco*, 1934. CCP. Gelatin silver, 26.3 x 33.1 cm. 76:083:065. © Trustees of the Ansel Adams Publishing Rights Trust

136. Imogen Cunningham. *Water Hyacinth 2*, 1920's. Gelatin silver, 19.1 x 15.3 cm. 76:060:006. © The Imogen Cunningham Trust

137. Karl Blossfeldt. *Papever orientale*, 1900–1928. Gravure plate from *Urformen der Kunst*, 1928.

138. *Chard*, 1927. CCP. Gelatin silver, 23.8 x 18.3 cm. 81:252:103. 1V

139. Marcel Duchamp (R. Mutt). *Fountain*, 1917. Collection of Centre Georges Pompidou

141. *Nude*, 1934. CCP. Gelatin silver, 9.1 x 11.6 cm. 81:252:199.
9.2 x 11.8 cm. 81:282:015. 168N

143. *Nude*, 1927. CCP. Gelatin silver, 24.0 x 18.9 cm. 81:275:006. 56N

144. *Nude*, 1927. CCP. Gelatin silver, 23.7 x 18.5 cm. 82:010:019. 55N

145. *Nude*, 1928. CCP. Reproduction print from original negative.

146. *Dancer*, 1927. Also titled, *Bertha, Glendale*. Lane Collection. Gelatin silver, vintage, 7 1/4 x 8 3/16 in. Inscribed "Dancer; Edward Weston 1927/62N/27" verso of print upper center. 62N

147. *Dancing Nude*, 1927. Also titled *Bertha, Glendale*. Lane Collection. Gelatin silver, vintage, 9 15/16 x 7 1/8 in. Initialed and dated

"EW 7/50" on mount, below print, left; signed and dated "Edward Weston/1927" on mount, below print, right; inscribed "Dancing Nude" on mount, lower left. 64N

148. *Nude*, 1927. CCP. Gelatin silver, 18.2 x 23.9 cm. 81:252:108. 58N

149. *Nude*, 1927. Lane Collection. Gelatin silver, vintage, 6 7/8 x 9 1/8 in. Initialed and dated "EW 1927" (cropped) on mount, below print, right; initialed and dated "EW 1927" verso of mount, center. 61N

151. *Chambered Nautilus*, 1927. Lane Collection. Gelatin silver, vintage, 9 1/2 x 7 5/16 in. Inscribed "26-50" on mount, below print, left; signed and dated "Edward Weston 1927" below print, right; inscribed "1927/1S/ 1500 (crossed out)/2000" verso of mount, upper left; "Chambered Nautilus" upper center. 1S

152. *Shells*, 1927. Reproduction print courtesy of Cole Weston. 14S

152. *Shells*, 1927. CCP. Gelatin silver, 19.2 x 24.2 cm. 76:561:001, 81:252:132. 6S

153. *Shell*, 1927. CCP. Reproduction print from original negative. 2S

154. *Still Life with Bananas and Orange*, 1927. Malibu, The J. Paul Getty Museum. Gelatin silver print, 18.8 x 23.6 cm. 84.xm.860.4

155. *Gourd*, 1927. CCP. Reproduction print from original negative. 21V

156. *Rock, Point Lobos*, 1930. Lane Collection. Gelatin silver, vintage, 7 9/16 x 9 1/2 in. Initialed and inscribed "EW 6/50" on mount, below print, left; inscribed "R32" lower left; signed and dated "Edward Weston 1930" lower right. 32R

157. *Rock Erosion, Point Lobos*, 1929. Lane Collection. Gelatin silver, vintage, 7 9/16 x 9 5/16 in., double mount Inscribed "4-50" on mount, below print, left; signed and dated "Edward Weston 1929" on mount, below print, right; inscribed "Rock Erosion/Point Lobos" verso of mount upper center. 24R

158. *Pepper*, 1929. CCP. 23.2 x 18.4 cm. 81:151:034. 14P

159. *Peppers*, 1929. CCP. Reproduction print from original negative. 5P

160. *Ramiel*, 1929. Also titled *Ramiel McGehee*. Lane Collection. Gelatin silver, vintage, 9 3/16 x 7 7/8 in. Inscribed "Ramiel" on mount, lower left; signed and dated

"Edward Weston 1929" lower right.

161. *Preston Holder Asleep*, 1930. Lane Collection. Gelatin silver, vintage, 7 9/16 x 9 5/8 in. Inscribed "65PO" verso of mount, upper left. 65PO

162. *Cypress and Stonecrop*, 1930. Lane Collection. Gelatin silver, vintage, 9 1/2 x 7 9/16 in. Inscribed "24-50" on mount, below print, left; signed and dated "Edward Weston 1930" below print, right; inscribed "Cypress and Stone-Crop/Point Lobos. 42T

163. *Cypress, Point Lobos*, 1929. Lane Collection. Gelatin silver, vintage, 7 1/2 x 9 3/8 in., unmounted. Inscribed, signed and dated "9T/1929/Cypress, Pt. Lobos/1929/Edward Weston" verso of print, upper right. 9T

164. *Kelp*, 1930. CCP. Gelatin silver, 23.9 x 19.0 cm. 81:151:018. 5K

165. *Eroded Rock*, 1930. CCP. Gelatin silver, 16.1 x 23.9 cm. 82:010:036. 51R

166. *Bedpan*, 1930. CCP. Gelatin silver, 23.4 x 13.9 cm. 81:151:026. 19M

167. *Egg Slicer*, 1930. CCP. Gelatin silver, 19.1 x 23.7 cm. 81:151:027. 24M

168. *Winter Squash*, 1930. Lane Collection. Gelatin silver, 7 1/2 x 9 3/8 in. Initialed and dated "EW 1930" on mount, below print, right. 33V

169. *Jose Clemente Orozco*, 1930. Lane Collection. Gelatin silver, vintage, 3 11/16 x 2 7/8 in. Signed and dated "Edward Weston/ 1930" on mount, below print, right; inscribed "-Jose Clemente Orozco-" on mount, lower left.

171. *Pepper*, 1930. Also titled *Pepper No. 30*. Lane Collection. Gelatin silver, vintage, 9 1/2 x 7 9/16 in. Inscribed "21-50" on mount, below print, left; signed and dated "Edward Weston 1930" belwo print, right; inscribed "2500" verso of mount, upper left. 30P

172. *Kelp*, 1930. CCP. Reproduction print from original negative. 21K

173. *Kelp*, 1930. CCP. Gelatin silver, 18.9 x 23.7 cm. 76:020:002, 81:252:027. 12K

174. *Red Cabbage Quartered*, 1930. CCP. Gelatin silver, 24.1 x 19.1 cm. 81:252:156. 30V

175. *Onion Halved*, 1930. CCP. Gelatin silver, 19.0 x 24.1 cm. 81:252:158. 36V

176. *Pepper*, 1930. CCP. Gelatin silver, 19.1 x 24.0 cm. 81:252:114. 32P

177. *Squash,* 1932. CCP. Gelatin silver, 19.4 x 24.1 cm. 76:010:009. 52V

178. *Cabbage Leaf,* 1931. Lane Collection. Gelatin silver, 7 5/8 x 9 1/2 in. Initialed and dated "EW 1931" on mount, below print, right. 39V

179. *Cabbage Leaf,* 1931. CCP. Gelatin silver, 19.1 x 24.1 cm. 81:120:016. 41V

179. *Cabbage Leaf,* 1931. CCP. Gelatin silver, 23.1 x 19.4 cm. 81:252:159. 40V

180. *Soil Erosion, Carmel Valley,* 1932. Lane Collection. Gelatin silver, vintage, 7 5/8 x 9 9/16 in. Initialed and inscribed "EW 1/50" on mount, below print, right; inscribed "14SO" verso of mount, upper left. 14SO

181. *Eroded Plank from Barley Sifter,* 1931. Lane Collection. Gelatin silver, vintage, 9 1/2 x 7 9/16 in. 53T

182. *Harald Kreutzberg,* 1932. CCP. Gelatin silver, 9.8 x 7.4 cm. 81:274:022, 81:276:007

183. *Hollywood,* 1931. Also titled *Ivanos and Bugatti.* Lane Collection. Gelatin silver, vintage, 7 3/16 x 9 1/2 in. Signed and dated "Edward Weston/1931" on mount, below print, right; inscribed "1500/66PO" verso of mount, upper left; inscribed, signed and dated "-'Hollywood'-/Edward Weston 1931" center. 66PO

184. *Church at "E" Town,* 1933. Lane Collection. Gelatin silver, vintage, 7 9/16 x 9 9/16 in. Inscribed "22-50" on mount, below print, left; signed and dated "Edward Weston 1933" below print right; inscribed "34A/3500" ("2" written over "3"); inscribed, signed and dated "-Church at "E" Town-/Edward Weston 1933" 34A

185. *Barn, Castroville,* 1934. Lane Collection. Gelatin silver, vintage, 7 5/8 x 9 5/8 in. Inscribed "2-50" on mount, below print, left; signed and dated "Edward Weston 1934" below print, right. 50A

186. *Deserted Landing,* 1932. CCP. Gelatin silver print, 19.2 x 24.2 cm. 81:252:040. 19L

187. *New Mexico,* 1933. Lane Collection. Gelatin silver, vintage, 7 7/16 x 9 5/8 in. Inscribed "4/50" on mount, below print, left; signed and dated "Edward Weston 1933" below print, right; inscribed "2000 (crossed out)" verso of mount, upper left; "-New Mexico-" upper center. 13Cl

188. *White Radish,* 1933. Lane Collection.

Gelatin silver, vintage, 9 9/16 x 7 1/2 in., unmounted Inscribed, signed and dated "White Radish/1933/E.W./58V (crossed out)/33 (crossed out)/58V (circled)" verso of print upper center. 58V

189. *Dry Kelp, Point Lobos,* 1934. CCP. Gelatin silver, 19.0 x 24.1 cm. 82:010:011. 29K

190. *Nude,* 1933. Lane Collection. Gelatin silver, vintage, 3 11/16 x 4 11/16 in. Inscribed "2/50" on mount, below print, left; "96N/1933" verso of mount, upper left. 96N

190. *Nude,* 1933. CCP. Gelatin silver, 9.3 x 11.9 cm. 81:252:173. 110N

191. *Nude,* 1934. Lane Collection. Gelatin silver, vintage, 3 11/16 x 4 11/16 in. Inscribed "2-50" on mount, below print, left; signed and dated "Edward Weston 1934" below print, right; inscribed "161N/1500" verso of mount, upper left. 161N

192. *Nude,* 1934. Lane Collection. Gelatin silver, vintage, 4 5/8 x 3 5/8 in. Inscribed "3-50" on mount, below print, left; signed and dated "Edward Weston/1934" on mount, below print, right; inscribed "140N" verso of mount, upper left. 140N

192. *Nude,* 1934. Lane Collection. Gelatin silver, vintage, 4 9/16 x 3 5/8 in. Inscribed "4-50" on mount, below print, left; signed and dated "Edward Weston 1934" on mount, below print, right; inscribed "141N/1934" verso of mount, upper left. 141N

193. *Nude,* 1935. Lane Collection. Gelatin silver, vintage, 4 1/2 x 3 7/16 in. Signed and dated "Edward Weston 1935" on mount, below print, right; inscribed "211N" verso of mount, upper left. 211N

194. *Nude,* 1934. Lane Collection. Gelatin silver, vintage, 4 3/8 x 3 11/16 in. Inscribed "3-50" on mount, below print, left; signed and dated "Edward Weston 1934" below print, right; inscribed "159-N" (circled) verso of mount, upper left. 159N

195. *Nude* 1934. Lane Collection. Gelatin silver, vintage, 3 3/8 x 4 11/16 in. Inscribed "1-50" on mount, below print, left; signed and dated "Edward Weston 1934" below print, right; inscribed "162N" verso of mount, upper left. 162N

196. *Nude,* 1935. Lane Collection. Gelatin

silver, vintage, 3 11/16 x 4 11/16 in. Inscribed "3-50" on mount, below print, left; signed and dated "Edward Weston 1934" [sic] below print, right; inscribed "135N" verso of mount, upper left. 135N

197. *Nude,* 1935. Lane Collection. Gelatin silver, vintage, 4 1/2 x 3 5/8 in. Signed and dated "Edward Weston 1935" on mount, below print, right; inscribed "214N" verso of mount, upper left. 214N

198. *Nude,* 1935. Lane Collection. Gelatin silver, vintage, 7 1/16 x 9 11/16 in. Signed and dated "Edward Weston 1935" on mount, below print, right; inscribed "219N" verso of mount, upper left. 219N

199. *Nude,* 1934. Lane Collection. Gelatin silver, vintage, 4 3/16 x 3 5/8 in. Inscribed "2-50" on mount, below print, left; signed and dated "Edward Weston 1934" below print, right; inscribed "192N" verso of mount upper left. 192N

201. *Nude,* 1935. CCP. Gelatin silver, 19.3 x 24.5 cm. 81:252:084. 222N

202. *Bug Tracks in Sand,* 1935. Lane Collection. Gelatin silver, vintage, 7 3/16 x 8 7/8 in., double mounted, initialed and dated "EW 1935" on second mount, below print, right; inscribed "20SO" verso of second mount, upper left; "Bug tracks in Sand/1935" upper center. 20SO

203. *Cactus,* 1933. Lane Collection. Gelatin silver, vintage, 7 9/16 x 9 5/8 in. Inscribed "5/50" on mount, below print, left; signed and dated "Edward Weston 1933" below print, right; inscribed "1500" verso of mount, upper left. 16C

204. *Shipyard Detail,* 1935. Lane Collection. Gelatin silver, vintage, 7 5/8 x 9 5/16 in. Signed and dated "Edward Weston 1935" on mount, below print, right; inscribed "35M" verso of mount upper left; "EWPOMC Nov./"Shipyard detail" upper center. 35M

205. *Whale Vertebrae,* 1934. Lane Collection. Gelatin silver, vintage, 7 1/2 x 9 9/16 in. Signed and dated "Edward Weston 1934" on mount, below print, right; inscribed, signed and dated "Whale Vertebrae"/1934/ by/Edward Weston" verso of mount upper center. 20B

206. *Eroded Rock, Point Lobos,* 1935. Lane Collection. Gelatin silver, vintage, 9 9/16 x 7 5/8 in. Inscribed "13-40" on mount, below print, left; signed and dated "Edward Weston

1935" below print, right; inscribed "94R" verso of mount, upper left; "Eroded Rock - Point Lobos" upper center. 94R

207. *Cement Glove,* 1936. Lane Collection. Gelatin silver, 7 5/8 x 9 9/16 in. Initialed and dated "EW 1936" on mount, below print, right. 28Mi

208. *Charis Wilson,* 1935. Lane Collection. Gelatin silver, vintage, 4 5/8 x 3 5/8 in. Signed and dated "Edward Weston/1935" on mount, below print, right.

209. *Leon Wilson,* 1935. Lane Collection. Gelatin silver, vintage, 4 1/4 x 3 1/4 in. Signed and dated "Edward Weston/1935" on mount, below print, right; inscribed "-Leon Wilson-" on mount, lower left.

211. *Dunes, Oceano,* 1936. CCP. Gelatin silver, 19.2 x 24.3 cm. 81:285:013, 82:010:041. 47SO

212. *Wind Erosion, Dunes at Oceano,* 1936. Lane Collection. Gelatin silver, vintage, 7 1/2 x 9 5/8 in. Signed and dated "Edward Weston 1936" on mount, below print, right; inscribed "53SO/2500" verso of mount, upper left; "Wind Erosion/Dunes at Oceano" upper center. 53SO

213. *Dunes, Oceano,* 1936. CCP. Gelatin silver, 19.3 x 24.4 cm. 81:208:005. 55SO

214. *Sand Dunes, Oceano,* 1934. Lane Collection. Gelatin silver, vintage, 9 3/8 x 7 9/16 in. Inscribed "3-50" on mount, below print, left; signed and dated "Edward Weston 1934" on mount, below print, right; inscribed "16SO/1934" (circled) verso of mount, upper left; "Sand Dunes/Oceano" upper center. 16SO

215. *Dunes, Oceano,* 1936. CCP. Gelatin silver, 19.2 x 24.5 cm. 76:010:001. 42SO

216. *Nude,* 1936. Reproduction print courtesy of Cole Weston. Gelatin silver, 19.0 x 24.0 cm. 82:010:024. 237N

217. *Nude,* 1936. CCP. Gelatin silver, 17.8 x 24.0 cm. 82:010:023. 235N

218. *Nude,* 1936. CCP. Gelatin silver, 19.1 x 24.2 cm. 82:010:022. 228N

218. *Nude,* 1936. CCP. Reproduction print from original negative. 232N

219. *Nude,* 1936. Reproduction print from original negative. 234N

219. *Nude,* 1936. Lane Collection. Gelatin silver, vintage, 9 1/2 x 7 9/16 in. Signed and dated "Edward Weston 1936" on mount, below

print, right.

220. *Nude,* 1936. Reproduction print from original negative. 238N

220. *Nude,* 1936. CCP. Gelatin silver, 19.2 x 24.3 cm. 81:252:111. 233N

221. *Nude,* 1936. CCP. Gelatin silver, 18.9 x 24.2 cm. 3D11. 231N

221. *Nude,* 1936. CCP. Reproduction print from original negative. 229N

223. *Nude,* 1936. Reproduction print courtesy of Cole Weston. Gelatin silver, 24.2 x 19.3 cm. 76:021:005. 24.0 x 19.1 cm. 82:010:021. 227N

224. *Bird Skeleton,* 1936. Lane Collection. Gelatin silver, 7 9/16 x 9 9/16 in. Initialed and dated "EW 1936" on mount, below print, right. 22B

225. *Dunes, Oceano,* 1936. Lane Collection. Gelatin silver, vintage, 7 5/8 x 9 5/8 in. Signed and dated "Edward Weston/1936" on mount, below print, right; inscribed "2000" (abraded) verso of mount, upper left; "Dunes - Oceano" upper center. 65SO

226. *Sandstone Erosion and Root,* 1936. Lane Collection. Gelatin silver, vintage, 9 11/16 x 7 5/8 in. Signed and dated "Edward Weston 1936" on mount, below print, right; inscribed "To my beloved Brett/Dad 1936" verso of mount, upper center. 105R

227. *Model for Mould,* 1936. Lane Collection. Gelatin silver, vintage, 9 5/8 x 7 5/8 in. Signed and dated "Edward Weston 1936" on mount, below print, right; inscribed "26Mi/2000 (crossed out)" verso of mount, upper left; "-Printer's Block(crossed out)/"Model for Mould" upper center. 26Mi

Guggenheim Years

228. Willard Van Dyke. *Edward Weston and his camera, Northern California,* 1937. Courtesy of Christie's. Gelatin silver, 6 1/2 x 4 1/2 in.

229. *Heimy in Golden Canyon,* 1937. Lane Collection. Gelatin silver, vintage, 7 1/2 x 9 9/16 in.

230. *I Do Believe in Fairies,* 1913. Lane Collection. Platinum or palladium, vintage, 13 1/16 x 10 1/2 in. unmounted. Sign in ink on pt. b. 1: Weston c. '13; verso pt. black crayon, c.: Edward Weston 1913. Loaned by Mrs. Flora

Chandler Weston.

231. Ansel Adams. *Half Dome, Winter, Yosemite,* ca. 1940. Lane Collection. Gelatin silver, vintage, 7 x 9 1/16 in.

232. Willem de Kooning. *Painting,* 1948. The Museum of Modern Art, New York. 42 5/8 x 56 1/8 in.

235. *Charis, Lake Ediza,* 1937. Lane Collection. Gelatin silver, vintage, 9 5/8 x 7 5/8 in. Inscribed "E-MI-1G/"37" verso of mount, upper left. E-MI-1g

237. Albert Bierstadt. *Valley of the Yosemite,* 1864. Museum of Fine Arts, Boston. Oil on artist's board, 11 3/4 x 19 1/4 in. Gift of Martha C. Karolik for the M. and M. Karolik Collection of American Paintings, 1815–1865.

238. *New Mexico Highway,* 1937. Lane Collection. Gelatin silver, vintage, 7 5/8 x 9 1/2 in. Signed and dated "Edward Weston 1937" on mount, below print, right; inscribed "NM-Mi-1G" verso of mount, upper left; "New Mexico Highway" center. NM-Mi-1G

239. *Dead Vulture,* 1937. Lane Collection. Gelatin silver, 7 5/8 x 9 5/8 in. Initialed and dated "EW 1937" on mount, below print, right; inscribed "Dead Vulture" verso of mount, center. MD-V-1G

240. *Rhyolite, Nevada,* 1938. CCP. Gelatin silver print, 19.0 x 24.2 cm. 9D2. DV-R-10g

241. *Mojave Desert,* 1937. Lane Collection. Gelatin silver, vintage, 7 5/8 x 9 1/2 in. Signed and dated "Edward Weston 1937" on mount, below print, right; inscribed "MD-HSS-6G" verso of mount, upper left; "Mojave Desert" center. MD-HSS-6G

242. *Point Arena,* 1937. Lane Collection. Gelatin silver, vintage, 7 5/8 x 9 1/2 in. Inscribed "NC-PA-2G" verso of mount, upper left; "No. 661 (crossed out)/Point Arena" center. NC-PA-2G

243. *Rubbish Pile, Little River Beach Park,* 1937. Lane Collection. Gelatin silver, vintage, 7 5/8 x 9 5/8 in. Inscribed "NC-LR-4G" verso of mount, upper left; "No. 626 (crossed out)/Rubbish Pile/Little River Beach Park" upper center. NC-LR-4G

244. *Abandoned Auto,* 1937. Lane Collection. Gelatin silver, 9 1/2 x 7 1/2 in. Initialed and dated "EW 1938 (sic)" on mount, below print,

right. MD-HSS-13G

245. *Dead Man, Colorado Desert*, 1937. Lane Collection. Gelatin silver, vintage, 7 11/16 x 9 9/16 in. Signed and dated "Edward Weston 1937" on mount, below print, right; inscribed "CD-B-2G" verso of mount, upper left; "No. 4, Dead Man/Colorado Desert" center. CD-B-2G

246. *Juniper, Lake Tenaya,* 1937. CCP. Gelatin silver, 24.2 x 19.1 cm. 81:251:120. J3-2g

247. *Juniper, Lake Tenaya,* 1937. CCP. Gelatin silver, 19.4 x 24.3 cm. 81:251:119. J2-C-3g

248. *Golden Canyon, Death Valley*, 1938. Lane Collection. Gelatin silver, vintage, 7 5/8 x 9 5/8 in. Inscribed "DV-GC-11G" verso of mount, upper left. DV-GC-11G

249. *Surf, Orick*, 1937. Lane Collection. Gelatin silver, 7 5/8 x 9 9/16 in. Initialed and dated "EW 1937" on mount, below print, right; inscribed "Oregon [sic] — 1937" verso of mount, center. NC-O-2G

250. *Golden Canyon, Death Valley*, 1938. CCP. Gelatin silver, 19.1 x 24.1 cm. 81:251:002. DV-GC-10g

251. *Zabriskie Point*, 1937. CCP. Gelatin silver, 19.3 x 24.6 cm. 81:251:104. DV-Z-14g

252. *San Carlos Lake, Arizona*, 1938. CCP. Gelatin silver, 19.0 x 24.1 cm. 81:251:009. A-CD-3G

253. *Tomales Bay*, 1937. CCP. Gelatin silver, 18.8 x 23.8 cm. 81:280:004, 82:010:065. NC-TB-1g

254. *Concretion, Colorado Desert*, 1937. Also titled *Sandstone Concretion, Colorado Desert.* Lane Collection. Gelatin silver, vintage, 7 9/16 x 9 5/16 in. Inscribed "CD-C-12G" verso of mount, upper left. CD-C-12G

254. *Concretion, Colorado Desert*, 1937. Also titled *Sandstone Concretion, Colorado Desert.* Lane Collection. Gelatin silver, vintage, 7 11/16 x 9 9/16 in. Inscribed "CD-C-14G" verso of mount, upper left. CD-C-14G

255. *Concretion, Colorado Desert*, 1937. Also titled *Sandstone Concretion, Colorado Desert.* Lane Collection. Gelatin silver, vintage, 9 11/16 x 7 11/16 in. Inscribed "CD-C-31G" verso of mount, upper left. CD-C-31G

256. *Mono Lake, Eastern Sierra*, 1937. Lane Collection. Gelatin silver, vintage, 9 1/2 x 7 9/16 in. Inscribed "ES-ML-3G" verso of

mount, upper left. ES-ML-3G

257. *Tree, Lake Tenaya*, 1937. Lane Collection. Gelatin silver, vintage, 9 9/16 x 7 5/8 in. Inscribed "T-T-1G" verso of mount, upper left T-T-1G

258. *Taos, New Mexico*, 1937. Lane Collection. Gelatin silver, vintage, 7 5/8 x 9 5/8 in. Signed and dated "Edward Weston 1937" on mount, below print, right; inscribed "NM-T-4G" verso of mount, upper left; inscribed, signed and dated "Taos, New Mexico/Edward Weston 1937" center. . NM-T-4G

259. *Nude*, 1937. Lane Collection. Gelatin silver, vintage, 7 5/8 x 9 9/16 in. Signed and dated "Edward Weston 1937" on mount, below print, right; inscribed "NM-A-N2G" verso of mount, upper left. NM-A-N2G

260. *Saguaro, Arizona*, 1938. Lane Collection. Gelatin silver, vintage, 9 9/16 x 7 9/16 in. Inscribed "A-S-18G" verso of mount, upper left. A-S-18G

261. *Wonderland of Rocks, Mojave Desert*, 1937. Lane Collection. Gelatin silver, vintage, 7 5/8 x 9 5/8 in. Inscribed "MD-W-22G" verso of mount, upper left MD-W-22G

262. *Santa Fe, New Mexico*, 1937. Lane Collection. Gelatin silver, vintage, 7 5/8 x 9 9/16 in. Inscribed "NM-SF-2G" verso of mount upper left. NM-SF-2G

263. *Potatoes, Los Angeles*, 1937. Lane Collection. Gelatin silver, vintage, 7 5/8 x 9 9/16 in. Inscribed "LA-Mi-5G" verso of mount upper left LA-Mi-5G

264. *Prescott, Arizona*, 1938. Lane Collection. Gelatin silver, vintage, 7 5/8 x 9 9/16 in. Inscribed "A-P-8G" verso of mount, upper left A-P-8G

265. *Owens Valley, Eastern Sierra*, 1937. Also titled *Abandoned Soda Works, Owens Valley, Eastern Sierra.* Lane Collection. Gelatin silver, vintage, 7 1/2 x 9 1/2 in. Inscribed "ES-OV-17G" verso of mount, upper left. ES-OV-17G

266. *Badlands, Borego Desert*, 1938. CCP. Gelatin silver, 19.1 x 24.2 cm. 81:251:023. B-BL-2g

267. *Zabriskie Point, Death Valley*, 1938. CCP. Gelatin silver, 19.0 x 24.1 cm. 81:251:102. DV-Z-5g

268. *Harmony Borax Works, Death Valley*,

1938. Lane Collection. Gelatin silver, vintage, 7 1/2 x 9 1/2 in. Inscribed "DV-Mi-36G" verso of mount, upper left. DV-Mi-36G

269. *Rhyolite, Nevada*, 1938. Lane Collection. Gelatin silver, vintage, 7 5/8 x 9 5/8 in. Inscribed "DV-R-12G" verso of mount, upper left. DV-R-12G

270. *Tomales*, 1937. Lane Collection. Gelatin silver, vintage, 7 5/8 x 9 3/16 in. Inscribed "RC-T-2G" verso of mount, upper left. RC-T-2G

271. *"Hot Coffee," Mojave Desert*, 1937. Lane Collection. Gelatin silver, vintage, 7 7/16 x 9 7/16 in. Inscribed "MD-HSS-1G" verso of mount, upper left. MD-HSS-1G

272. *Jerome, Arizona*, 1938. Lane Collection. Gelatin silver, vintage, 7 5/8 x 9 1/2 in. Signed and dated "Edward Weston 1938" on mount, below print, right; inscribed "A-J-7G" verso of mount, upper left; "Jerome/Arizona" center. A-J-7G

273. *Albion*, 1937. Lane Collection. Gelatin silver, vintage, 9 11/16 x 7 5/8 in. Inscribed "NC-A-1G" verso of mount, upper left. NC-A-1G

274. *Horse, KB Dude Ranch*, 1938. CCP. Gelatin silver, 19.1 x 24.1 cm. 81:251:222. PPH-2g

275. *Prescott, Arizona*, 1938. CCP. Gelatin silver, 19.1 x 24.1 cm. 81:251:013. A-P-2g

276. *Dunes, Death Valley*, 1938. Lane Collection. Gelatin silver, vintage, 7 11/16 x 9 5/16 in. Inscribed "DV-D-5G" verso of mount, upper left. DV-D-5G

277. *South Shore, Point Lobos*, 1938. CCP. Gelatin silver, 19.2 x 24.1 cm. 81:251:013. A-P-2g

278. *Dead Rabbit, Arizona*, 1938. Lane Collection. Gelatin silver, vintage, 7 5/8 x 9 9/16 in. Inscribed "A-Mi-5G" verso of mount, upper left. A-Mi-5G

279. *Death Valley*, 1938. Lane Collection. Gelatin silver, vintage, 7 5/8 x 9 9/16 in. Inscribed "DV-Mi-26G" verso of mount, upper left. DV-Mi-26G

280. *Legs in Hammock*, 1937. Lane Collection. Gelatin silver, vintage, 7 5/8 x 9 5/8 in. Inscribed "SC-LB-11G" verso of mount, upper left. SC-LB-11G

280. *Legs in Hammock*, 1937. Lane Collection. Gelatin silver, vintage, 7 5/8 x 9 5/8 in.

Inscribed "SC-LB-13G" verso of mount, upper left. SC-LB-13G

281. *At Ted Cook's*, 1937. Also titled *Legs in Hammock*. Lane Collection. Gelatin silver, vintage, 7 5/8 x 9 9/16 in. Signed and dated "Edward Weston 1937" on mount, below print, right; inscribed "SC-LB-3G" verso of mount, upper left; "—at Ted Cook's" center. SC-LB-3G

282. *Saguaro, Arizona*, 1938. Lane Collection. Gelatin silver, vintage, 9 5/8 x 7 9/16 in. Inscribed "A-S-5G" verso of mount, center. A-S-5G

283. *Drift Log, Crescent Beach*, 1937. Lane Collection. Gelatin silver, vintage, 7 11/16 x 9 9/16 in. Signed and dated "Edward Weston 1937" on mount, below print, right; inscribed "NC-CC-3G" verso of mount, upper left; "No. 349 (crossed out)/Drift log/Crescent Beach" center. NC-CC-3G

284. *Metro-Goldwyn-Mayer, Los Angeles*, 1939. Lane Collection. Gelatin silver, vintage, 9 5/8 x 7 5/8 in. Inscribed "LA-MGM-18G" verso of mount, upper left. LA-MGM-18G

285. *Rubber Dummy, Metro Goldwyn Mayer*, 1939. Lane Collection. Gelatin silver, vintage, 7 5/8 x 9 5/8 in. Signed and dated "Edward Weston 1939" on mount, below print, right; inscribed "LA-MGM-19G" verso of mount, upper left; "Rubber Dummy/Metro-Goldwyn-Mayer" center. LA-MGM-19G

286. *Mustard Canyon*, 1939. CCP. Gelatin silver, 19.3 x 24.4 cm. 81:251:077. DV-MI-12g

287. *Surf, China Cove, Point Lobos*, 1938. CCP. Gelatin silver, 19.5 x 24.4 cm. 76:020:035. 19.2 x 24.3 cm. 81:209:030. PL-S-9g

Final Years

288. Imogen Cunningham. *Edward Weston at Point Lobos No. 2*, 1945. ICT. Gelatin silver.

289. *Indian Emblem on Barn, Landis, Pennsylvania*, 1941. CCP. 19.3 x 24.4 cm. 81:278:058

290. *The Summers, Tennessee*, 1941. CCP. Gelatin silver, 19.2 x 24.2 cm. 81:110:109. T41-HFS-3

290. *Marshes of Glynn, Sea Island, Georgia*,

1941. CCP. Gelatin silver, 19.2 x 24.2 cm. 82:010:082. G41-C-1

291. *St. Bernard Cemetery, New Orleans*, 1941. CCP. Gelatin silver, 18.7 x 24.2 cm. 81:110:122. L41-NOC-4

292. *Wildcat Hill*, 1942. CCP. Gelatin silver, 17.0 x 24.1 cm. 81:110:142. C42-WCH-1

292. *Franky*, 1945. CCP. Gelatin silver, 19.5 x 24.5 cm. 76:003:029. 19.2 x 24.4 cm. 81:285:005. C45-CTS-6

292. *Civilian Defense*, 1942. CCP. Gelatin silver, 24.2 x 18.6 cm. 19A1. N42-CH-1

293. *My Little Grey Home in the West*, 1943. CCP. Gelatin silver, 24.2 x 19.3 cm. 81:110:047. N43-CH&L-2

295. *North Shore, Point Lobos*, 1946. CCP. Gelatin silver, 19.2 x 24.4 cm. 81:110:089. PL46-L-3

297. *Glass and Lily*, 1939. CCP. Reproduction print from from original negative. C39-MI-5

298. *Floating Nude*, 1939. Lane Collection. Gelatin silver, vintage, 7 1/2 x 9 9/16 in., unmounted. Signed and dated"Edward Weston 1939" on verso of print, center; inscribed "Floating Nude N39-C-2" verso of print, center. N39-C-2

299. *Point Lobos*, 1940. Lane Collection. Gelatin silver, vintage, 9 5/8 x 7 5/8 in. Inscribed "PL40-K-4" verso of mount, upper left. PL40-K-4

300. *Dry Tidepool, Point Lobos*, 1939. CCP. Gelatin silver, 19.3 x 24.3 cm. 81:110:068. PL39-R-1

301. *Point Lobos*, 1940. CCP. Gelatin silver, 19.4 x 24.3 cm. 81:110:079. PL-40-S7

302. *Dunes, Oceano*, 1939. Lane Collection. Gelatin silver, vintage, 7 5/8 x 9 5/8 in. Inscribed "O39-C-4" verso of mount, upper left. O39-C-4

303. *Point Lobos*, 1946. Also titled *Sandstone, Erosion, Point Lobos*. Lane Colletcion. Gelatin silver, 9 1/2 x 7 5/8 in. Initialed and dated "EW 1946" on mount, below print, right; inscribed "PL46-R-2" verso of mount, upper left; inscribed, signed and dated "Point Lobos/Edward Weston 1946" center. PL46-R-2

304. Untitled [Twentieth Century Fox], 1940. CCP. Gelatin silver, 19.3 x 24.6 cm. 81:278:065, 81:278:066

305. *Twentieth Century Fox, Los Angeles*, 1940. Lane Collection. Gelatin silver, vintage, 7 11/16 x 9 11/16 in. Inscribed "LA40-20C-4" verso of mount, upper left. LA40-20C-4 CCP print: gelatin silver print, 19.3 x 24.6 cm. 81:278:066. LA40-20C-4

306. [Powerhouse, Connecticut], 1941. Courtesy of Dayton Art Institute. Gelatin silver, 7 1/2 x 9 1/2 in. 1994.34

307. *Santa Fe Engine*, 1941. CCP. Gelatin silver, 19.2 x 24.3 cm. 81:110:040. LA41-SF-1

308. *Wall Scrawls, Hornitos*, 1940. Lane Collection. Gelatin silver, 7 5/8 x 9 5/8 in. Initialed and dated "EW 1940" on mount, below print, right. ML40-H-5

309. *Tombstone, Old Deerfield, Massachusetts*, 1941. Lane Collection. Gelatin silver, vintage, 7 5/8 x 9 5/8 in. MA41-OD-7

310. *Wedding Cake House, Kennebunkport, Maine*, 1941. Lane Collection. Gelatin silver, vintage, 7 5/8 x 9 5/8 in. Initialed and dated "EW 1941" on mount, below print, right; inscribed "ME41-K-1" verso of mount, upper left; inscribed, signed and dated "Wedding Cake House/Kennebunkport, Me./Edward Weston 1941" upper center. ME41-K-1

311. *Fig Trees, New Jersey*, 1941. Also titled *Fig Trees, Winter, Lyndhurst, New Jersey*. Lane Collection. Gelatin silver, vintage, 7 5/8 x 9 5/8 in.

312. *Stone Sculpture, William Edmondson*, 1941. CCP. Gelatin silver, 19.1 x 24.4 cm. 81:110:103. T41-ED-2

313. *William Edmondson, Sculptor, Nashville, Tennessee*, 1941. CCP. Gelatin silver, 24.3 x 19.3 cm. 81:110:105. T41-ED-8

314. *Winter Zero Swartzel's Bottle Farm, Ohio*, 1941. Lane Collection. Gelatin silver, vintage, 7 5/8 x 9 5/8 in. Initialed and dated "EW 1941" on mount, below print, right; inscribed "O41-WZ-7" (cropped) verso of mount, upper left; signed and dated "Edward Weston/Ohio 1941" upper center. O41-WZ-7

315. *Winter Zero Swartzel's Bottle Farm, Ohio*, 1941. Lane Collection. Gelatin silver, vintage, 7 5/8 x 9 9/16 in. Inscribed "Winter Zero, (sic) Swartzels' (sic)/"Bottle Farm"/Ohio" verso of mount, center. O41-WZ-8

316. *Winter Zero Swartzel's "Bottle Farm,"*

Farmersville, Ohio, 1941. CCP. Gelatin silver, 19.2 x 24.2 cm. 19C12. O41-WZ-xx

317. *Storm, Arizona,* 1941. CCP. Gelatin silver, 19.2 x 24.2 cm. 81:110:001. A41-CC-3

318. *Mammy, US 61, Mississippi,* 1941. CCP. Reproduction print from original negative. M41-N-1

319. *Meraux Plantation House, Louisiana,* 1941. CCP. Gelatin silver, 24.3 x 19.3 cm. 81:110:036. L41-PH-13

320. *Willie, New Orleans,* 1941 Also titled *"Willie", St. Roch Cemetery, New Orleans, Louisiana.* Lane Collection. Gelatin silver, 9 9/16x 7 1/2 in. Initialed and dated "EW 1941" on mount, below print, right. L41-NOC-5

321. *St. Roch Cemetery, New Orleans,* 1941. CCP. Gelatin silver, 24.2 x 19.2 cm. 81:110:026. L41-NOC-6

322. *Girod Cemetery, New Orleans,* 1941. Lane Collection. Gelatin silver, vintage, 7 9/16 x 9 9/16 in. Inscribed "EW 1941" on mount, below print, right. L41-NOC-14

323. *Girod Cemetery, New Orleans,* 1941. Lane Collection. Gelatin silver, vintage, 7 5/8 x 9 5/8 in. Inscribed "EW 1941" on mount, below print, right. L41-NOC-12

324. *Ruins, Plantation Home, New Orleans,* 1941. Lane Collection. Gelatin silver, vintage, 9 9/16 x 7 9/16 in., unmounted. Inscribed, signed and dated "Ruins, Plantation Home/New Orleans/Edward Weston/1941" verso of print, upper center. L41-PH-12

325. *Woodlawn Plantation, Louisiana,* 1941. Lane Collection. Gelatin silver, vintage, 7 7/16 x 9 1/2 in. L41-PH-9

326. *Pittsburgh,* 1941. Lane Collection. Gelatin silver, vintage, 7 5/8 x 9 9/16 in. Initialed and dated "EW 1941" on mount, below print, right; inscribed "P41-P-1" verso of mount, upper left; inscribed and dated "Pittsburgh/ Edward Weston 1941" upper center. P41-P-1

327. *Union Station, Nashville,* 1941. Lane Collection. Gelatin silver, vintage, 7 5/8 x 9 5/8 in. T41-N-1

328. *Mr. and Mrs. W. P. Fry, Burnet, Texas,* 1941. CCP. Gelatin silver, 24.3 x 19.3 cm. 81:110:111. TX41-A-2

329. *Dillard King, Monteagle, Tennessee,* 1941. CCP. Gelatin silver, 24.0 x 19.1 cm.

21C3. T41-HFS-4

330. *Cincinnati,* 1941. CCP. Gelatin silver, 19.3 x 24.4 cm. 81:110:064. O41-C-1

331. *New York,* 1941. Lane Collection. Gelatin silver, vintage, 9 5/16 x 7 9/16 in. Initialed and dated "EW 1941" on mount, below print, right; inscribed "NY41-515M-1" verso of mount, upper left; inscribed, signed and dated "New York/ Edward Weston 1941" upper center. NY41-515M-1

332. *Brooklyn Bridge,* 1941. CCP. Reproduction print from original negative. NY41-B-1

333. *Brooklyn,* 1941. Lane Collection. Gelatin silver, 7 5/8 x 9 9/16 in. NY41-B-2

334. *Eroded Rock, Point Lobos,* 1942. CCP. Gelatin silver, 19.1 x 24.3 cm. 81:110:072. PL42-R-2x

335. *Dead Bird, Point Lobos,* 1942. CCP. Gelatin silver, 19.3 x 24.2 cm. 81:110:078. PL42-Bi-2

336. *Oil on Rocks, Point Lobos,* 1942. Lane Collection. Gelatin silver, vintage, 7 5/8 x 9 5/8 in. Initialed and dated "EW 1942" on mount, below print, right; inscribed "PL42-R-3" verso of mount, upper left; "Oil on Rocks, Point Lobos/Edward Weston 1942. PL42-R-3

337. *Point Lobos,* 1942. Lane Collection. Gelatin silver, vintage, 7 5/8 x 9 5/8 in. Inscribed "PL42-Mi-1" verso of mount, upper left. PL42-Mi-1

338. *Carving by a Penitente,* 1942. Lane Collection. Gelatin silver, vintage, 9 11/16 x 7 11/16 in. Signed and dated "Edward Weston 1942" on mount, below print, right; inscribed "Carving by a Penitente/S.Fe, N. Mexico" verso of mount, upper center.

339. *Victorine Ranch,* 1943. Lane Collection. Gelatin silver, vintage, 7 5/8 x 9 5/8 in. Inscribed "C43-V-2" verso of mount, upper left. C43-V-2

340. *Good Neighbor Policy,* 1943. Lane Collection. Gelatin silver, 9 5/8 x 7 5/8 in. Initialed and dated "EW 1943" on mount, below print, right; inscribed "SL43-C-4" verso of mount, upper left; inscribed and signed "-Good Neighbor Policy-/Edward Weston" upper center. SL43-C-4

341. *Yaqui Church, Tucson,* 1941. Also titled *Yaqui Indian Church, Tucson.* Lane Collection.

Gelatin silver, vintage, 7 5/8 x 9 5/8 in. Initialed and dated "EW 1941" on mount, below print, right; inscribed "A41-Y-2" verso of mount, upper left; inscribed, signed and dated "Yaqui Church/Tucson/Edward Weston 1941" upper center. A41-Y-2

342. *Civilian Defense,* 1942. Lane Collection. Gelatin silver, vintage, 7 5/8 x 9 5/8 in. Initialed and dated "EW 1942" on mount, below print, right; inscribed "N42-C-1" verso of mount, upper left; inscribed, signed and dated "Victory (crossed out)/Edward Weston/Civilian Defense/1942" center. N42-C-1

343. *Johnny,* 1944. CCP. Gelatin silver, 19.3 x 24.4 cm. 81:110:014. C44-CTS-4

344. *Nude* 1945. CCP. Gelatin silver, 19.4 x 24.5 cm. 81:110:048. N45-CH-1

345. *Nude,* 1945. CCP. Gelatin silver, 19.1 x 24.3 cm. 81:275:014. N45-CH-5

346. *7 A.M. Pacific War Time,* 1945. CCP. Gelatin silver, 18.9 x 24.0 cm. 82:010:080. C45-FOG-1

347. *Oceano Primitive,* 1947. Lane Collection. Gelatin silver, vintage, 9 5/8 x 7 9/16 in. Initialed and dated "EW 1947" on mount, below print, right; inscribed "O47-M-1" verso of mount, upper left; "-Oceano Primitive-" upper center. O47-M-1

348. *Point Lobos,* 1946. Also titled *Cypress and Stone Crop, Point Lobos.* Lane Collection. Gelatin silver, vintage, 9 9/16 x 7 5/8 in. Initialed and dated "EW 1946;" inscribed verso of mount, center "–Point Lobos–" PL46-L-1

349. *Eroded Rocks, South Shore, Point Lobos ,* 1948. Lane Collection. Gelatin silver, 7 5/8 x 9 5/8 in. Initialed and dated "EW 1948" on mount, below print, right; inscribed, signed and dated "-Point Lobos-/Edward Weston/1948" verso of mount, upper center. PL48-R-1

Chronology

1886 Edward Henry Weston born in Highland Park, Illinois, on March 24.

1890 His mother dies.

1892 Attends grammar school in Chicago for about 8 years.

1902 Weston's father gives him a Kodak Bull's-Eye no. 2 camera. Makes his first photographs at his aunt's farm and in Chicago parks. Buys a 5 x 7 inch camera and a tripod.

1903 Begins working as an errand boy and clerk in Marshall Field Department Store, Chicago. Sees his first photographic exhibit at the Chicago Art Institute.

1906 The April issue of the magazine *Camera and Dark Room* includes a photograph by Weston, *Spring, Chicago*, his first publication. Arrives in California to visit his sister, May. Decides to stay; finds work as a surveyor for a railroad company and later as an itinerant photographer in Tropico, a Los Angeles suburb.

1907 Meets Flora Chandler, member of a well-to-do southern California family. He is seven years her junior. Becomes interested in learning photography as a trade and returns to Chicago for six months to attend a school of photography.

1909 Returns to Californa. Marries Flora Chandler. Works in the studios of George Steckel and A. Louis Mojonier.

1910 First of four sons, Edward Chandler Weston, is born on April 26.

1911 Weston decides to open his own portrait studio in Tropico. Theodore Brett Weston is born. Publishes an article, "Artistic Interiors," in *Photo Era*, the first of many essays to appear in photographic publications.

1912 Meets photographer Margrethe Mather.

1915 Sees many modern works of art at the Panama-Pacific International Exposition, San Francisco. Wins a bronze medal for a photograph he has entered in the exhibit.

1916 An issue of *Camera* magazine is devoted to his work. Laurence Neil Weston is born.

1917 Meets photographer Johan Hagemeyer in Los Angeles. Elected an acting member of the London Salon of Photography.

1919 Cole Weston is born.

1920 Among bohemian-intellectual circle of friends in Los Angeles, meets Tina Modotti, who later becomes his mistress and favorite model. Meets Imogen Cunningham and Dorothea Lange.

1921 Shares his studio with Margrethe Mather. Judges and exhibits at several national and international photographic salons.

1922 With the help of Modotti's husband, Weston's work is exhibited at the Academia de Bellas Artes, Mexico City. Travels to Middletown, Ohio to visit his sister May and her family and photographs the ARMCO steel plant. Travels on to New York, where he finally meets Stieglitz, along with Paul Strand, Clarence White, Gertrude Kasebier, and Charles Sheeler.

1923 Photographs nudes of Mather at Redondo Beach. Sails for Mexico on July 30 with son Chandler and Modotti. Photographs first clouds. Exhibits at the Aztec Land Gallery, Mexico City. Lives in Mexico City.

1924 Returns to Los Angeles with Chandler in December for a nine-month stay. Shares a studio in San Francisco with Dorothea Lange. Exhibits at Japanese Club, Los Angeles.

1925 Returns to Mexico with son Brett in August, the same month he exhibits with Modotti in Guadalajara.

1926 Travels through southern Mexico with Modotti and Brett, making photographs for Anita Brenner's book, *Idols Behind Altars*. Leaves Mexico permanently in November.

1927 Living in Glendale. Meets Ansel Adams. Befriends painter Henrietta Shore and begins photographing series of shells, nudes, and vegetables. First typewritten copy of his Mexico daybooks.

1928 Publishes an excerpt from his daybook in *Creative Art* magazine. Opens portrait studio with Brett in San Francisco.

1929 Moves to Carmel, opens studio, and lives with photographer Sonya Noskowiak. Sends twenty photographs to *Film und Foto* exhibit in Stuttgart, Germany and curates American contribution to the event.

1930 First New York exhibition at Delphic Studios. Later, thanks to Lincoln Kirstein and Edward Warburg, exhibits at the Harvard Society of Contemporary Arts with Stieglitz, Sheeler, Modotti, the French photographer Eugéne Atget, and Walker Evans. Becomes a grandfather.

1932 Book designer Merle Armitage publishes *The Art of Edward Weston*. Exhibition of f/64 group at de Young Museum in San Francisco includes nine Weston photographs.

1933 Acquires 4 x 5 inch Graflex camera. Walker Evans given first solo photography show at the Museum of Modern Art, New York.

1934 Meets Charis Wilson. Though exhibited widely, Weston still supports himself with portraiture but decides to make only unretouched contact prints of his negatives. Employed by Public Works of Art project.

1935 Opens portrait studio in Santa Monica with Brett.

1936 Applies for the first-ever Guggenheim Fellowship in photography. Photographs dune landscapes and nudes with Charis.

1937 Awarded $2,000 Guggenheim Foundation fellowship to photograph the West. Buys first automobile with proceeds from a magazine sale. Begins traveling with Charis and Cole.

1938 Guggenheim Fellowship renewed.

1939 *Seeing California with Edward Weston* published. Marries Charis.

1940 Meets Nancy and Beaumont Newhall. Museum of Modern Art in New York establishes first Department of Photography, headed by Beaumont Newhall. Teaches at Ansel Adams's first Yosemite Workshop. *California and the West* published.

1941 Commissioned by Limited Editions Club to illustrate a new edition of Walt Whitman's *Leaves of Grass*. Travels across the United States with Charis from May to December photographing for this project. Meets Clarence John Laughlin in New Orleans and photographs with him.

1943 In Beaumont Newhall's absence in war service, Nancy Newhall and Weston begin selecting prints for his retrospective at Museum of Modern Art, New York.

1945 Charis and Weston divorce.

1946 Attends the opening of the Weston retrospective at MoMA, curated by Nancy and Beaumont Newhall. Begins to experience symptoms of Parkinson's disease. Experiments with 8 x 10-inch Kodachrome. *Fifty Photographs: Edward Weston* is published.

1948 Makes his last photographs at Point Lobos, California.

1950 *My Camera on Point Lobos* is published.

1955 Brett and Cole Weston, and Dody Warren, with whom Weston has lived and worked at Carmel since 1948, begin printing a master set of five or six prints each of 832 negatives under Weston's supervision.

1958 Weston dies at his home in Carmel on January 1.

1961 *The Daybooks of Edward Weston*, volume 1, is published.

1966 *The Daybooks of Edward Weston*, volume 2, is published.

1986 Retrospective exhibition in honor of Weston's centennial at Center for Creative Photography, Tucson, Arizona. *Supreme Instants: The Photography of Edward Weston* by Beaumont Newhall is published in association with the Center.

Exhibitions

This list, which is not exhaustive, gives the principal
exhibitions of Edward Weston during his lifetime and the most
important shows of his work following his death in 1958.

1913 Toronto Camera Club, New York
1916 National Arts Club, New York
 Brooklyn Institute of Arts and Sciences, New York
 Fotocraft of Bangor, Maine
 John Wanamaker, Philadelphia, Pennsylvania
 Wilkes-Barre Camera Club, Pennsylvania
 Exposition Park Gallery, Los Angeles
1923 Academia de Bellas Artes, Mexico City
 Aztec Land Gallery, Mexico City
1924 Aztec Land Gallery, Mexico City
 Palacio de Mineria, Mexico City
1925 Museo de Estado, Guadalajara, Mexico
1927 University of California, Berkeley
 Royal Photographic Society of London
 Seattle Fine Arts Society, Washington
 Los Angeles Museum
 Shaku do Sha, Los Angeles
1928 Los Angeles Public Library
 East West Gallery of Fine Arts, Los Angeles
1929 Fine Arts Society of San Diego, California
 California Art Club, Los Angeles
 Courvoisier Little Gallery, San Francisco
 Los Angeles Museum
 Film und Foto, Stuttgart, Germany
 Universidad Nacional Autonoma de Mexico, Mexico City
1930 Braxton Gallery, Hollywood, California
 Film und Foto, Stuttgart, Germany
 Denny Watrous Gallery, Carmel, California
 Central Public Library, St. Louis, Missouri
 Museum of Fine Arts, Houston, Texas
 Jake Zeitlin Gallery, Los Angeles
 Delphic Studios, New York
 Vickery, Atkins and Torrey Gallery, San Francisco
 Grace Horne's Galleries, Boston
 Brick Row Gallery, Hollywood, California
 Harvard Society for Contemporary Art, Cambridge,
 Massachusetts
1931 Galerie Jean Naert, Paris
 Vanderpant Galleries, San Francisco
 Denny Watrous Gallery, Carmel, California
 Santa Maria Little Theatre, Santa Maria, California
 San Diego Fine Arts Gallery, California
 Brooklyn Botanic Garden, New York

 Delphic Studios, New York
1932 Brooklyn Museum, New York
 Julien Levy Gallery, New York
 Wisconsin Union, Madison
 Albright Art Gallery, Buffalo, New York
 Chappell House, Denver, Colorado
 Stanford Art Gallery, Stanford, California
 Scripps College, Claremont, California
 M.H. de Young Museum, San Francisco
 Denny Watrous Gallery, Carmel, California
 Delphic Studios, New York
1933 Ansel Adams Gallery, San Francisco
 Increase Robinson Galleries, Chicago
 Exposition Internationale de la Photographie et du Cinéma,
 Brussels, Belgium
 683 Brockhurst Gallery, Oakland, California
 Biltmore Book Shop, Los Angeles
 University of Nebraska, Lincoln
 San Joaquin Pioneer Museum, Stockton, California
 Los Angeles Public Library
1934 Denny Watrous Gallery, Carmel, California
 Gelber Lilienthal Gallery, San Francisco
 683 Brockhurst Gallery, Oakland, California
 Public Works of Art Project, Los Angeles Museum
 International Arts Theater, Singapore
 Mills College Art Gallery, Oakland, California
 Denny Watrous Gallery, Carmel, California
 Brentano's Bookstore, New York
 Cleveland Museum of Art, Ohio
 Dallas Museum of Fine Arts, Texas
1936 Jake Zeitlin Gallery, Los Angeles
 Fort Dearborn Camera Club, Chicago
1937 American Museum of Natural History, New York
 International Salon of Pictorial Photographers of America
 San Jose State College, San Jose, California
 San Francisco Museum of Art
 Putzel Gallery, Hollywood, California
1938 Crocker Art Gallery, Sacramento, California
 Philadelphia Photographic Society, Pennsylvania
 Musée du jeu de Paume, Paris
1939 Photographic Arts Society, San Diego, California
 Vancouver Art Gallery, British Columbia
 Harry Champlin Gallery, Beverly Hills, California
 International Salon of Photography,
 Katherine Kuh Galleries, Chicago
 Morgan Camera Shop, Hollywood, California
 St. Paul Gallery and School of Art, Minnesota

Fort Dearborn Camera Club, Chicago
J. Walter Thompson Co., New York
Photographic Club, Syracuse University, Syracuse, New York
Newark Camera Club, New Jersey

1940 Palace of Fine Arts, San Francisco
Sternberg-Davis Photography, Tucson, Arizona
Taylor Museum, Colorado Springs, Colorado
Blackstone Hall, Art Institute, Dallas, Texas
Museum of Modern Art, New York
Boston Camera Club

1941 Mills College Art Gallery, Oakland, California
College of Journalism, University of Colorado, Boulder

1942 Pat Wall Gallery, Monterey, California
Port Arthur Chamber of Commerce, Texas

1944 Outlines Gallery, Pittsburgh, Pennsylvania
Museum of Modern Art, New York

1945 University of Oklahoma, Norman

1946 Museum of Modern Art, New York

1947 Syracuse University, Syracuse, New York
Honolulu Academy of Arts, Hawaii

1948 Shigeta-Wright Gallery, Chicago

1949 Stedelijk van Abbe Museum, Eindhoven, Netherlands

1950 Kodak Pathé, Paris
Infinity Gallery, Pacific Grove, California

1952 Art Institute of Chicago
Creative Arts Gallery, Lexington, Kentucky
Museum of Modern Art, New York
Cercle Photographique de Charleroi, France
State University of Iowa, Ames

1954 Symphony Hall, Boston
Fine Arts Gallery, University of Kentucky, Lexington
CS Association, London

1955 Family of Man, Museum of Modern Art, New York
Baldwin-Kingrey Gallery, Chicago

1956 Chicago Art Institute
World of Edward Weston, Smithsonian Institution,
Washington, DC
Milwaukee Art Institute
Art Wood Gallery, Boston

1957 Brand Library, Glendale, California
Photo Maxima, New York
San Francisco Museum of Art
UCLA Library, University of California, Los Angeles

1966 International Museum of Photography, George Eastman
House, Rochester, New York
Washington Gallery of Modern Art, Washington, D.C.
Museo de Arte Moderno, Mexico City (with Brett Weston)

1970 Metropolitan Museum of Art, New York

1975 Museum of Modern Art, New York
Galerie Le Chateau d'Eau, Toulouse

1976 Stedelijk Museum, Amsterdam

1978 *Edward Weston's Gifts to his Sister*, Dayton Art Institute, Ohio

1981 *50 nudi*, Palazzo Fortuny, Venice

1983 *Edward Weston in Mexico*, San Francisco Museum of Art

1986 *Supreme Instants*, Center for Creative Photography, Tucson
The Huntington Library and the J. Paul Getty Museum, Malibu

1990 *Weston's Westons: Portraits and Nudes*, Museum of Fine Arts,
Boston

1994 *Weston's Westons: California and the West*, Museum of Fine
Arts, Boston

Bibliography

At the present time the most complete bibliography on Edward Weston is the one by Amy Conger that accompanies the book, *Edward Weston: Photographs from the Collection of the Center of Creative Photography.*

This selected bibliography does not pretend to such ambition. It comprises only what the author regards as the most important books and articles, in particular those available since 1992, when Amy Conger's work was published. For her aid in the present work, the author wishes to thank Amy Rule, archivist at the Center for Creative Photography.

Adams, Ansel.
"The Art of Edward Weston." *Creative Art*, May 12, 1933, pp. 386-87.

"The Daybooks of Edward Weston: Volume One, Mexico."
Contemporary Photographer, 3:1, Winter 1962.

Other important articles by Ansel Adams devoted to Weston are reprinted in *Edward Weston Omnibus: A Critical Anthology*, edited by Beaumont Newhall and Amy Conger.

Adams, Robert.
"The Achievement of Edward Weston: The biography I'd like to read."
In *EW 100: Centennial Essays in Honor of Edward Weston.*
Untitled 41. By Bunnell and Featherstone.

Aikin, Roger.
"Brett and Edward Weston: An essay in Photographic Style."
Art Journal, 32:4, Spring 1973, pp. 394-404.

"Henrietta Shore and Edward Weston."
American Art, Vol. 6, no.1, 1992, pp. 42-62.

Alinder, Mary Street and Andrea Gray **Stillman.**
Ansel Adams: Letters and Images 1916-1984.
Boston: Little Brown and Company, 1988.

Armitage, Merle.
The Art of Edward Weston. New York: E. Weyhe, 1932.

Fifty Photographs: Edward Weston.
New York: Duell, Sloan and Pearce, 1947.

Baltz, Lewis.
"Beyond Romance: Weston Landscape."
Creative Camera 10, 1986, pp. 30-32.

"Landscape Problems: A review of Edward Weston: California Landscapes." *Aperture 98*, Spring 1985, pp. 2-3, 78.

Bauret, Gabriel.
"Edward Weston et Tina Modotti."
Photographies Magazine, no. 34, Spring 1992, pp.42-45.

Brenner, Anita.
Idols Behind Altars. New York: Payson and Clark, 1929.
(117 photographs, with a large number attributed to Edward Weston).

Brown, Robert.
"For the Photographer: Edward Weston's work under Guggenheim Fellowship Results in Work on West." *New York Times*, Dec. 8, 1940.

Bullard, John E.
Edward Weston and Clarence John Laughlin: An Introduction to the Third World of Photography. Essay by Clarence J. Laughlin.
New Orleans: New Orleans Museum of Art, 1982.

Bunnell, Peter C.
Edward Weston on Photography.
Salt Lake City: Peregrine Smith Books, 1983.

Bunnell, Peter C. and David **Featherstone**.
EW 100: Centennial Essays in Honor of Edward Weston.
Untitled 41. Carmel, California: Friends of Photography, 1986.

Calmes, Leslie Squyres.
The Letters Between Edward Weston and Willard Van Dyke.
Tucson: Center for Creative Photography, 1992.

Coleman, A.D.
"Beyond Peppers and Cabbages." *The New York Times*, Sept. 12, 1971.

Conger, Amy.
Edward Weston in Mexico.
Albuquerque: University of New Mexico Press, 1983.

Edward Weston: Photographs from the Collection of the Center for Creative Photography. Tucson: Center for Creative Photography, 1992.

"Tina Modotti and Edward Weston: A Re-evaluation of their Photography." In *EW 100: Centennial Essays in Honor of Edward Weston. Untitled 41.* By Bunnell and Featherstone.

Constantine, Mildred.
Tina Modotti: A Fragile Life. San Francisco: Chronicle Books, 1993.

Cravens, R.H.
Edward Weston. Millerton, New York: Aperture, 1988.

Danly, Susan and Weston **Naef.**
Edward Weston in Los Angeles. San Marino: The Huntington Library, and Malibu: The J. Paul Getty Museum, 1986.

Davis, Keith F.
Edward Weston: One Hundred Photographs from the Nelson-Atkins Museum of Art and the Hallmark Photographic Collection.
Kansas City: Rockhill Nelson Trust, 1982.

Dieuzaide, Jean. *Edward Weston.* Text by J. Dieuzaide.
Toulouse: Catalogue of the exhibition "Edward Weston,"
Galerie Municipal "Le Château d'Eau," Toulouse: April 15-May 2, 1975.

Enyeart, James.
Edward Weston's California Landscapes.
Boston: Little Brown and Company, 1984.

Foley, Kathy Kelsey.
Edward Weston's Gift to His Sister. Dayton: Dayton Art Institute, 1978.

Greenberg, Clement.
"The Camera's Glass Eye." *Nation*, March 6, 1946.
Reproduced in *Omnibus*, by Newhall and Conger.

Grundberg, Andy.
"Edward Weston's Late Landscapes." In *EW 100: Centennial Essays in
Honor of Edward Weston. Untitled 41.* By Bunnell and Featherstone.

"Photography: Edward Weston Rethought."
Art in America, July and August 1975, pp. 29-31.

Heyman, Therese Thau.
Seeing Straight: Group F. 64. Oakland: The Oakland Museum, 1992.

Higgins, Gary.
"Tina and Edward."
Creative Camera, no. 314, Feb/March 1992, pp. 20-23.

Hooks, Margaret.
Tina Modotti Photographer and Revolutionary.
San Francisco: Pandora, 1993.

Hulick, Diana.
"Edward Weston: The Mexican Photographs."
Latin American Art, vol.3, Autumn 1991, pp. 65-67.

Jasud, Lawrence.
"Questions of Influence."
Center for Creative Photography, no. 11, Dec. 1979, pp. 54-60.

Jussim, Estelle.
"Quintessences: Edward Weston's Search for Meaning."
In *EW 100: Centennial Essays in Honor of Edward Weston.
Untitled 41.* By Bunnell and Featherstone.

Jussim, Estelle, and Diana **Hulick.**
*Edward Weston, Ansel Adams : Through Their Own Eyes: The Personal
Portfolios of Edward Weston and Ansel Adams.*
Seattle: Henry Art Gallery, University of Washington, 1991.

Karuizawa Museum of Photography.
The Dody Weston Thompson Collection. Karuizawa, Japan: 1992.

Lorenz, Richard.
"A Lifetime of Camera Portraits."
The Archive, no. 16, June 1982, pp. 5-21.

Maddow, Ben.
Edward Weston: His Life. Millerton, New York: Aperture, 1973.

Edward Weston: His Life and Photographs.
Millerton, New York: Aperture, 1979.

Malcolm, Janet.
"The Dark Life and Dazzling Art of Edward Weston."
New York Times, Feb. 2, 1975. Reproduced after modification
in *Diana and Nikon*, by Janet Malcolm, Boston: David R. Godine, 1980.

Masclet, Daniel. *Le Paysage en Photographie.*
Paris: Editions Paul Montel, 1947.

Newhall, Beaumont.
"Edward Weston in Retrospect." *Popular Photography*, March 18, 1946.
Reproduced in *Omnibus*, by Newhall and Conger.

Supreme Instant: The Photography of Edward Weston.
Boston: Little Brown and Company,
and Tucson: Center for Creative Photography, 1986.

Focus, Memoirs of a Life in Photography. Boston: Bulfinch, 1993.

Newhall, Beaumont, and Amy **Conger.**
Edward Weston Omnibus: A Critical Anthology.
Utha: Peregrine Smith, 1984.

Newhall, Nancy.
The Photographs of Edward Weston. New York: Museum of Modern Art,
1946. (catalogue of the retrospective of Edward Weston at MoMA)

The Daybooks of Edward Weston. 2 Volumes.
Rochester, New York: 1961.

Edward Weston: The Flame of Recognition.
Millerton, New York: Aperture, 1971, 1975.

Oles, James.
"Las últimas fotografías mexicanas de Edward Weston,"
in *Luna Cornea No. 5,* Mexico, 1994.

Oren, Michael.
"On the Impurity of Group f. 64 Photography."
History of Photography, vol. 15 summer 1991, pp.119-27.

Peeler, David.
"The Art of Disengagement: E. Weston and A. Adams."
Journal of American Studies, vol. 27, no.3, Dec. 1993, pp.309-35.

Pitts, Terence.
Edward Weston: Color Photography.
Tucson: Center for Creative Photography, 1986.

Edward Weston: Photographs and Papers. Guide Series No. 6,
Tucson: Center for Creative Photography, 1980.

*Photography in the American Grain: Discovering a Native American
Aesthetic* 1923-1941. Tucson: Center for Creative Photography, 1988.

Quinn, Karen E. and Theodore E. **Stebbins**, Jr.
Weston's Westons: California and the West.
Boston: Bulfinch Press/Little Brown and Company, 1994.

Rice, Shelley.
"The Daybooks of Edward Weston: Art Experience, and Photographic
Vision." *Art Journal* 36:2, Winter 1976-77, pp.126-29.

Rivera, Diego.
"Edward Weston and Tina Modotti."
Mexican Folkways 2, April-May 1926, pp.6-9.
Translated and reproduced in *Omnibus* by Newhall and Conger.

Siqueiros, David Alfaro.
"Una Trascendal Labor Fotografica: La Exposición Weston-Modotti."
El Informador, Guadalajara: Sept. 5, 1925.
Translated and reproduced in *Omnibus* by Newhall and Conger.

Stark, Amy.
Edward Weston Papers. Guide Series No.13,
Tucson: Center for Creative Photography, 1986.

"The Letters from Tina Modotti to Edward Weston."
The Archive 22. Tucson: Center for Creative Photography, 1986.

Stebbins, Theodore E., Jr.
Weston's Westons: Portraits and Nudes.
Boston: Museum of Fine Arts, 1990.

Szarkowski, John.
"Edward Weston's Later Work." *MOMA* 2, Winter 1974-75.
Reproduced in *Omnibus* by Newhall and Conger.

American Landscapes. New York: Museum of Modern Art, 1981.

Thompson, Dody Weston.
"Edward Weston." In *Omnibus* by Newhall and Conger.

Trachtenberg, Alan.
"Edward Weston's America: *Leaves of Grass* Project."
In *EW 100: Centennial Essays in Honor of Edward Weston,*
by Bunnell and Featherstone.

"Weston's Thing Itself." *Yale Review* 65:1, Oct. 1975, pp. 105-15.

Van Lier, Henri.
Historie Photographique de la Photographie.
Paris: Les Cahiers de la Photographie, 1992.

Weston, Edward.
The principal aesthetic, theoretical, or technical texts on photography
written by Edward Weston throughout his career are brought together in
the indespensible work by Peter Bunnell: *Edward Weston on
Photography.* Salt Lake City: Peregrine Smith Books, 1983.

"Camera Touring New Mexico with Edward Weston."
New Mexico, June, July, Aug., Sept. 1939, Jan. 1940.

The Daybooks, Volume 1, Mexico and Volume 2, California.
Selection and Introduction by Nancy Newhall. Millerton, New York:
Aperture, 1973.

Edward Weston: The Flame of Recognition. See: Nancy Newhall.

Fiftieth Anniversary Portfolio, "Foreword." Carmel, Edward Weston.
San Francisco: Grabhorn Press, 1952. Limited edition of 100 copies?

Leaves of Grass. Text by Walt Whitman.
New York: Limited Editions Club, 1942, 2 Volumes.
New edition in one volume, New York: Paddington Press, 1976.

My Camera on Point Lobos. New York: Houghton Mifflin
and Yosemite National Park, 1950. New York: Da Capo Press, 1968.

Seeing California with Edward Weston.
Westways and the Autombile Club of Southern California, 1939.

Weston, Edward, and Charis **Wilson.**
California and the West, "A Statement by Edward Weston."
New York: Duell, Sloan and Pearce, 1940. Reprinted with some
modifications: Millerton, New York: Aperture, 1978.

Weston, Edward, and Charis **Wilson.**
The Cats of Wildcat Hill. New York: Duell, Sloan and Pearce, 1947.

White, Minor.
"The Daybooks of Edward Weston." *Aperture* 10, 1962.

"Lobos 1944-48: A Selection of Photographs by Edward Weston."
Aperture 1:4, 1953.

Wilson, Charis.
The Cats of Wildcat Hill. See Weston, Edward, and Charis Wilson.

Edward Weston: Nudes. Millerton, New York: Aperture, 1977.

Wilson, Charis, and Edward **Weston.**
"The Weston Eye." In *EW 100: Centennial Essays in Honor of Edward
Weston. Untitled 41.* By Bunnell and Featherstone.

About this book

One volume can never completely explore the work of a prolific major artist. The goal of this book, however, is to present in one volume an overview of the career of Edward Weston. Its aim is to show the development of themes, the flow, rhythm, and evolving changes. Many, but by no means all, of the greatest and more well known Weston images are included. As context for these we include approximately 20-30% of new or rarely seen material. The chronological structure allows the reader to examine in some detail the major periods of his life.

Several aspects of the design process need mentioning. In many previous Weston publications the format limited one picture to a page. This general effect isolates the image and for a moment partially neutralizes the effect of images from previous or following pages. Even though a strong case may be made for such sequences, such books often become catalogs of great images but fail to exploit the potential offered by a book and its mechanics.

In devising a format for a more comprehensive volume it was found necessary to include as many images as possible without their destroying each other. This meant that two or more pictures should be shown for every two pages. It is at once obvious that images seen together dramatically affect the perception of the respective images. These images either support and enhance each other or they are in conflict. The design of this book assumes the responsibility of organizing several images on facing pages and strives to make a coherent orchestration of text and photographs.

Nothing can equal seeing or handling a fine vintage print made by Weston. The richness, patina, size, and other subtleties are all part of this experience. Unfortunately, it is not possible to duplicate that experience in a volume such as this, which is limited in means although ambitious in scope.

Only a few photographs reproduced here coincide with the original print sizes. Image sizes have been determined by the book's page size and how photographs interact when juxtaposed. Size is clearly not intended to suggest a value system. Some of the more important images are shown in a relatively small size.

This book cannot presume to satisfy all the expectations of the purist. However, we believe that it presents a large body of Weston's work in a coherent manner, and it is supported by the writing of eminent Weston scholars.

J. H. and D. H.

Text for this book is set in Paul Renner's original 1927 cutting of Futura. This earliest version provides the alternate non-aligning numerals.

Type for the jacket, title page, and all bold face represents more recent drawings of Futura.

Typographic composition was produced by Teresa Fox, Winsted, Connecticut.

Camera duotone negatives were made by Thomas Palmer, Newport, Rhode Island.

Printing and binding are the work of Arte Grafiche Amilcare Pizzi, Milan, Italy.

Henri Cartier-Bresson
Edward Weston, California, 1946
Courtesy Magnum Photos